GEORGE GROSZ

Cross Section, 1920. EH, no. 68.

GEORGE GROSZ

Art and Politics in the Weimar Republic

Beth Irwin Lewis

THE UNIVERSITY OF WISCONSIN PRESS

Madison, Milwaukee, and London

Published 1971
The University of Wisconsin Press
Box 1379, Madison, Wisconsin 53701

The University of Wisconsin Press, Ltd.
27–29 Whitfield Street, London, W.1

FIRST PRINTING

Printed in the United States of America
North Central Publishing Company, St. Paul, Minnesota

ISBN 0-299-05901-4; LC 79-143764

To Ruth Irwin, John Mark Irwin,
and Paul D. Hoffman.

Contents

vii

Illustrations

ix

Illustrations

Preface

IN THE EARLY 1960s when I began to study the work of George Grosz, I had several questions in mind. The dominant one was: what is the responsibility of the artist-intellectual critic within a troubled democratic society? The corollary question to this was: how influential is the artist-intellectual upon the actual political or social workings of society? Restating these general questions to apply specifically to George Grosz, I asked to what extent Grosz's bitter attacks upon the republic had served to reenforce the anti-democratic attitudes of the German middle classes, or whether his acerbic portrayal of night life in Berlin had helped to alienate those middle classes who, scandalized by such behavior, tended to identify immorality and decadence with political democracy. In other words, did Grosz actually bear a certain measure of responsibility for undermining the weak democratic republic and admitting the horror of the Nazi regime? My thinking on these questions was shaped by my own acceptance of liberal western democratic ideals and by the historical hindsight that the Weimar Republic, with all of its obvious weaknesses, was worth preserving when the alternative was the Third Reich. A lucid statement of this position has been made by Gordon Craig, who charged the left-wing intellectuals with destroying public confidence in the republic and so opening the way to the evils which they were fighting.[1]

As I studied Grosz, two factors subverted my thinking and challenged the validity of my questions. The first, which is probably inherent in any concentrated study, was that I steadily realized George Grosz was far more complex than I had initially thought. The second was the disintegration of the American political scene in the late sixties which has prompted both historians and political commentators to write about the "Weimar analogy."[2] This interest in the Weimar Republic has been motivated not only by the intrinsic fascination of the period but also by

the sense that America is experiencing a crisis similar in many ways to that of Germany in the 1920s. Carl Schorske, who has very competently analyzed the current literature on intellectuals in the Weimar Republic, points out the interaction between recent writers' attitudes towards the contemporary political scene and their view of Weimar.[3] This conclusion confirms my own realization that contemporary developments have both challenged my easily held liberal assumptions and forced me to look at Grosz in a different light.

The question of Grosz's responsibility for weakening the republic, I realized, was both simplistic and based on the erroneous assumption, as Istvan Deak has written in his study of left-wing intellectuals, that the right-wing opponents of the republic could not have destroyed the republic by themselves. Furthermore, to judge Grosz's actions primarily in the light of the alternatives which led to the Third Reich may be useful for a history of the origins of National Socialism, but it results in a pallid and lifeless view of the actual situations which Grosz encountered, because the essence of human actions is their ambiguity and complexity. The alternatives which may appear clear-cut to the historian are unfortunately rarely obvious to the participant and are, moreover, not infrequently shown to be questionable by later historians.

A good example of this is the view which has been often expressed by historians that the extremism of the radical left in the first months of the German republic forced the socialist government into an alliance with reactionary forces which in the end spelled doom for the republic. From the point of view of Grosz and his Spartacist friends, however, the Weimar Republic was itself reactionary from its inception because the revolution had not really been carried through and the old imperial system had not really been overthrown. They believed that only continued revolutionary action would bring about the defeat of the reactionary forces. The Spartacists have been condemned for this position by historians who oppose extremism in a democratic society. Recently, other historians are questioning the assumption that the republic would have tamed the reactionary forces if the radical left had not interfered.

Because of the complexity of these issues, I have tried to comprehend Grosz and his work within his own context and in terms of the ideological and political alternatives which he believed he was confronting. Ultimately, historical value judgments will have to be made, especially since Grosz became preoccupied with this himself after he fled Germany. The main purpose of this study, however, is an attempt to record the activi-

ties and to interpret the attitudes of a sensitive and articulate artist-intellectual who was both a part of and a critic of the left wing in Germany from World War I to the advent of the Third Reich. The questions of responsibility and influence with which I began my study have given way to a search for an understanding of the man and the choices which he made in a critical period. Out of this search has emerged my own conviction that George Grosz raised issues and posed problems, in both the 1920s and which we are confronting now in America. I say this reluctantly, because I am uneasy with the Weimar analogy and because I shrink from both his searing criticism of modern industrial society and from his final despair. Nevertheless, at a time when students are being shot at our universities and young revolutionaries are throwing bombs, portfolios, and papers which are in the George Grosz Estate in Princeton, it is worth pondering the tale of a young activist whose brief dreams of a new humanity were consumed by a nightmare vision of a new inhumanity emerging from a world of total chaos.

To study George Grosz and the Weimar Republic when one is living in a small town in midwestern America would be difficult without a great deal of help from other people. I am deeply indebted to Peter Michael Grosz, who went to considerable lengths to enable me to study his father's books, who spent hours talking to me about his father, I was able to glimpse the man and father who hid behind the caustic drawings. I also want to thank Dr. Walter Huder for making available to me the materials in the George Grosz Archive of the Akademie der Künste in West Berlin. Wieland Herzfelde and Richard Huelsenbeck were kind enough to talk to me about their memories of George Grosz. Herzfelde followed up our conversation with long detailed letters in answer to my queries about Grosz's political position and the activities of the Malik Verlag. His criticism of the first three chapters of the manuscript has been helpful, and, though we differ in our interpretation of various points, I have cited his lengthy comments in the notes. Walter Mehring not only gave me permission to use some of his published accounts of George Grosz, but, more than that, took the time to translate the poem he wrote at Grosz's death.

Dr. Lothar Lang very generously shared with me the results of his research for his recently published George Grosz bibliography. Andrew De Shong, who is preparing a doctoral dissertation at Yale on Grosz's

theatrical designs, has read and corrected my treatment of this area of Grosz's work. Allan C. Greenberg also shared with me his bibliographic discoveries in German archives while he was completing research for his doctoral dissertation at the University of Illinois on dadaism and the Bauhaus. These men have helped me in the specific task of studying George Grosz, and I thank them for their help.

On a broader level, I would like to express my great appreciation to George L. Mosse of the University of Wisconsin, who guided me through a graduate program in which my primary interest shifted from seventeeth-century French Calvinism to twentieth-century German intellectuals, a not entirely illogical progression, and whose criticism shaped this study of Grosz into a doctoral dissertation, of which this book is an extensively revised version. I am grateful to Aileen Dunham and Clayton S. Ellsworth of the College of Wooster for introducing me to the study of art and literature in history.

I have been fortunate in having friends willing to read and criticize my manuscript at various stages: James Watrous, Sterling Fishman, John Hondros, John H. Pierson, and Eila Kokkinen. I turned for help with specific problems to Daniel F. Calhoun, William I. Schreiber, and Otto Siebenmann. Mrs. Milda Carroll translated the Russian article by Grosz; Herbert Hagens and Mrs. Ilse Stauffer each translated complex German articles on Grosz. Todd Hanlin has made the superb translations of the Grosz poems and the selections from Oskar Kanehl's poems. The prose translations in the text are my own unless an English edition is indicated in the notes. Mrs. Lou Christianson has tried to correct my writing style. Otto Siebenmann and Beth Magner have helped me with proofreading. To each of these friends, I give my thanks.

The staff of the College of Wooster Library have been generous in allowing me the use of their facilities, particularly the Interlibrary Loan Service, which has been invaluable.

Finally, I would like to thank the innumerable students and friends, particularly Laurie MacKenzie and Deborah Burnham, who have acted as surrogate mothers for my three young children who believe all real mothers have to write a book. Above all, I thank my husband, Arnold Lewis. Without his gently insistent pressure, coaxing, encouragement, and help—both academic and domestic—I would not have completed this book.

Wooster, Ohio
November 1970

B.I.L.

Acknowledgments

PERMISSION TO REPRODUCE the George Grosz drawings, photographs, and poems has been granted by the Estate of George Grosz, Princeton, New Jersey, except for the following:

Fig. 7. George Grosz, "Self-Portrait for Charles Chaplin," Collection of the Philadelphia Museum of Art.

Fig. 78. George Grosz, "Portrait of the Writer Max Herrmann-Neisse," Kunsthalle, Mannheim.

Fig. 93. George Grosz, "The Painter of the Hole," watercolor on paper. Collection Whitney Museum of American Art, New York.

Permission to quote copyright material has been granted by:

The Arche Verlag, Peter Schifferli, Zurich, and by Walter Mehring for his poem, "George Grosz," and for his anecdote about Grosz on p. 108, which are taken from the book, Walter Mehring, *Berlin Dada: eine Chronik mit Photos und Dokumenten* (Zurich: Arche Verlag, 1959).

Grove Press, Inc., to quote Christopher Middleton's translation of Else Lasker-Schüler's poem, "George Grosz," from *Modern German Poetry 1910–1960: An Anthology with Verse Translations*, edited and with an introduction by Michael Hamburger and Christopher Middleton. Copyright © 1962 by Michael Hamburger and Christopher Middleton.

Henry Pachter for permission to quote his translation of Max Herrman-Neisse's poem, which was printed in "On Being an Exile," *Salmagundi*, no. 10–11 (Fall 1969–Winter 1970), p. 26, and which appears here as the headnote to the Epilogue.

Allan C. Greenberg for his translation of the George Grosz poem from the "Dada Plakat" ([Berlin], n.d.), in his "Artists and the Weimar Repub-

xviii **Acknowledgments**

lic: Dada and the Bauhaus, 1917–1925" (Ph.D. dissertation, Univ. of
Illinois, 1967), p. 80.

Marietta Nettl-Meltzer for J. P. Nettl's translation of "Hundepolitik"
by Rosa Luxemburg, in his *Rosa Luxemburg*, 2 vols. (London: Oxford
University Press, 1966), 2:614.

Walter Mehring for portions of his poems "Jazzband" and "If the man
in the moon were a coon"

GEORGE GROSZ

LIST OF ABBREVIATIONS

These abbreviations are used only in the legends to figures.

Gmu *"Gott mit uns,"* 1920

GhK *Das Gesicht der herrschenden Klasse,* 1921, 3rd ed.

Af *Abrechnung folgt!,* 1923

EH *Ecce Homo,* 1923

Gez. *Die Gezeichneten,* 1930

ÜaL *Über alles die Liebe,* 1930

NGhK *Das neue Gesicht der herrschenden Klasse,* 1930

THE MERCHANT FROM HOLLAND

Watch out! Here comes Grosz,
The saddest man in Europe,
"A phenomenon of grief,"
Derby hat pushed back,
No puny weakling!!!!
GEORGE GROSZ, *"Gesang an die Welt"*

IN THE SUMMER OF 1915, Wieland Herzfelde, an aspiring poet who at nineteen had already been discharged from the army for insubordination, met with a group of friends in the Berlin studio of the eccentric expressionist artist, Ludwig Meidner. The friends were intellectuals, mostly expressionist writers and artists who habitually met in the old Café des Westens to pool their grievances against the war.[1] Gathered at Meidner's studio one night, they were discussing what one of them should do about his order to report for military service. The mood of the conversation was strongly anti-war; some urged noncooperation because they felt the war could not last much longer. Into this pacifist conversation came the polite voice of a stranger, a stranger immaculately dressed as a prosperous business man. He announced that he had no desire to see the end of the war because, as a business man from Holland, he had devised a scheme which would make millions out of it. He proposed to collect shell splinters from the battle fields, have war cripples paint them with the Iron Cross framed in oak leaves and such slogans as "God gave us and saved us" or "Every shot hit the spot," and sell them to the Germans for paperweights and ashtrays. His statement fell

into a startled silence; then came vigorous protest. After the gathering, Herzfelde told Heinrich Maria Davringhausen: "He must belong to us somehow. Only where we have what we call our souls—you may call it religion or belief in humanity; you know what I mean, there he has nothing. Just nothing. Or only doubts. Or an empty hole. Nothing. Not such a simple person, you can bet."[2]

This was Herzfelde's introduction to George Grosz. Half a century later Herzfelde commented that Grosz's effect upon those who encountered him was "like a cold shower: sobering in a shocking way and uncommonly invigorating."[3] Certainly this first meeting was sobering, shocking, and invigorating. It drove Herzfelde to try to visit this artist who masqueraded as a business man in the midst of war-time Berlin. After first refusing to open his studio door, Grosz reluctantly admitted Herzfelde and even more reluctantly allowed Herzfelde to look at his many sheets of drawings. When Herzfelde waxed enthusiastic about the drawings, Grosz emphatically disclaimed their worth. The worth of a work of art, said Grosz, "is determined not by me or by enthusiasts like you, but by those whose profession it is to do so. And these are united— in rejecting them. That's what counts. . . . If these things were really worth something they would be bought." Herzfelde protested with some comments upon the difference between money value and artistic value, but Grosz jumped at this: "You damned fool! It's the same thing. A Rembrandt costs more because he was a better painter. And that's perfectly all right, whether you like it or not." Herzfelde then told Grosz of his desire to publish a journal which would take a stand against the war, explaining that his desire was intensified by seeing Grosz's drawings, which he believed should be published. Grosz replied again in squelching terms, asking where Herzfelde thought he could get the tremendous amount of money needed for such a project, and telling him to forget the whole thing as a fantasy or pipe dream.[4]

These two confrontations between Grosz, posing as a cynical merchant, and Herzfelde, the young idealist, had considerable significance for both men. On the one hand, there was the practical outcome. Since his return from the front, Herzfelde and his brother, John Heartfield,[5] had been talking with their friends of the Café des Westens about the possibility of forming a pacifist journal. These encounters with Grosz made Herzfelde determined to turn his dream into reality. They provided the decisive push that resulted in Herzfelde's becoming the editor of the *Neue Jugend* in July, 1916, which, in turn, expanded into the Malik Verlag

in 1917. The story of the *Neue Jugend* and the Malik Verlag is not only the story of the fruitful collaboration of Herzfelde, Heartfield, and Grosz, but it is part of the history of communist intellectuals during the Weimar Republic.

Apart from the historical outcome, Herzfelde still feels today that the meeting with Grosz at Meidner's studio is significant in an understanding of the man, George Grosz. The merchant from Holland was a role through which Grosz could starkly and cynically parody the irrationality of contemporary society. Herzfelde and his wife, reminiscing upon that evening, claimed that Grosz was always role-playing. George Grosz was rarely George Grosz; he was often pretending to be someone else. He was extremely gifted in his ability to portray another person, another mentality.[6] Other friends have attested to this ability on Grosz's part. Walter Mehring writes of watching Grosz in his studio in Berlin during the war—probably early 1916. While he painted, Grosz would explain the entire life of the people he was caricaturing, but more than that, he was continually changing himself into these people. He could express their bearings, their weaknesses, their attitudes, their ways of thinking, in such a remarkably convincing and arresting manner that anyone watching him could immediately identify these same types wherever he went. As Mehring exclaimed, watching Grosz: "Mensch! Böff! [Grosz's nickname] Das ist ja mein seliger Onkel Max . . . wie er leibte und lebte!" ("Man! Böff! That really is my late Uncle Max . . . as he lived and breathed!")[7] Kurt Tucholsky, who became famous for his essays portraying German types, dedicated one, "Face of a German," to "George Grosz who taught us to see such faces."[8] Richard Boyer, who spent several days interviewing Grosz in his home on Long Island in 1943, was struck by this same facet of Grosz's character, his ability completely to absorb himself in the creation of another personality, especially when he was viewing his German drawings and trying to explain the people he had portrayed. Tales of Grosz's answering his studio door in the role of a butler and announcing that George Grosz was not home are not uncommon.[9]

These instances of role-playing could be dismissed as part of the important ability of an artist to recreate personalities in his painting, if there were not other indications of the importance of role-playing in Grosz's life. He himself, in talking to Thomas Craven soon after he immigrated to America, described the many George Groszes who lived within him. The "alte Georg," the German political activist and graphic

artist, and "George, the businessman from Manhattan," became a dominant combination in his life in America.[10] In 1951, on his first return to Germany after the war, Grosz again played the role of the typical Yankee business man. Carefully dressed to fit the European idea of the typical Yankee — loud-colored ties, flannel suit, Panama hat — he traveled in Germany as a businessman from Manhattan, was delighted when someone in Munich cheated him in changing money, and surprised a group of his German friends at a reunion by talking not about his art but about his moth-proof, rain-proof, and suicide-proof American suit.[11] Not only did the businessman role reappear, on occasions the cynic who would capitalize on the slaughter of humans by weapons also reappeared. Ulrich Becher told of a group in New York who were deploring the dropping of the bomb over Hiroshima. Again, as in that Berlin gathering in 1915, Grosz startled everyone by commenting that the bomb was a nice thing, for now more than ten million people could be killed in one movement of the hand; all at once, there would be ten to twenty million fewer people; certainly one could not do better than that. His friends argued, indignant.[12]

Here, indeed, we have come full circle. Seeking to understand the meaning of the cynical merchant, one finds both a hint and a warning from Grosz himself. In his autobiography, when nostalgically recalling life in rural Germany before humanistic attitudes were destroyed by class and race hatred or concentration camps and war, Grosz suddenly paused to query: "How many persons really live within us? One above, one in the middle, one in the cellar? Perhaps one also chained somewhere in a barred secret room? I mistrust psychology and psychoanalysis. One explains and explains and seeks to get at the secret of the human heart and human instincts — and yet I say: One can no doubt describe the demon in man indirectly, but one can not dissect it."[13] Sharing Grosz's skepticism and not being equipped with the tools of psychology and psychoanalysis, I shall not, in this book, reach the chained men in Grosz's secret recesses. That they existed is abundantly evident. The many roles of Grosz were both an acting out of and a camouflage of the different Groszes within him. The layers of reality and pretense are difficult to separate, much less to determine the motives behind each. By citing the complexity of the men-within-the-man, however, the historian can not simply absolve himself of searching to understand the man. An effort to describe the demon must be made, even if — to use Grosz's terms — a dissection is not possible.

Wieland Herzfelde wrote his account of the merchant from Holland in an effort to understand the contradictions within the personality of his friend. He presented the essay to Grosz for his fiftieth birthday, Grosz was sufficiently pleased with his portrayal that he inscribed a copy of *Neue Jugend* for Herzfelde: "to my old only '*genuine*' friend who has understood me 'from the beginning'—as a small token from the merchant from Holland—Georges Leboeuf."[14] Herzfelde's account captured various facets of Grosz's personality: his elegance in dress, his oft-asserted faith in money as the final determinant of artistic value, his early isolation from the artistic world, his obsessive and prolific production of sketches and drawings, and his macabre imagination. Of central importance, however, is Herzfelde's discerning the emptiness—the nihilism—which lay behind Grosz's façade of cynicism and hard-headedness: "Only where we have what we call our souls . . . there he has nothing. Just nothing. Or only doubts. Or an empty hole. Nothing."

This nothingness must have been Grosz's demon. Beneath the various roles lay a hard core of doubt, disbelief, skepticism. Erwin Piscator, a close friend, characterized him as a questioning artist. His searching and doubting began in his art student years before 1914 when he summed up his negation of the values of society: "Life has no meaning" Nearly thirty years later he confided to a friend that "now I believe in NOTHING."[15] Despite this constant disbelief, Grosz strove always to find values he could affirm that would give a positive meaning to his life. His own account of his struggle between affirmation and negation was concisely expressed in the title of his autobiography: *A Little Yes and a Big No.* More poignantly, within the book Grosz betrays that, at least after 1933, affirmation of life meant for him a sort of continual conscious lying to himself and to the world in the hope that someday the lies would become truths.[16]

The complexity of Grosz's character is indicated by the intensity with which he committed himself to positive ideals, even while he doubted. Twice Grosz made a major commitment to a way of life and to a set of values; in both instances the affirmation was whole-hearted and passionate, neither hypocritical nor gullible. In 1919 Grosz embraced the role of the artist-intellectual who championed the cause of the proletarian revolution. Until the mid-twenties he was completely involved as a leading communist artist in the Weimar Republic. His communist activism faded as his earlier habits of skepticism and doubt reasserted themselves

in the later twenties. With his immigration to America in 1933, Grosz identified himself totally with his conception of the American dream and the American way of life. He changed from a revolutionary critic of society to a good American businessman, but the cynicism which Grosz believed was part of the character of the pragmatic American only served to reinforce his own skepticism and doubts. The end result, predictably, was that Grosz's negation overwhelmed his attempts to find meaning and security in affirmation. Finally, Grosz turned to a nihilism which embraced chaos, meaninglessness, and death.

Grosz's ideological pilgrimage was certainly not unique among European, especially German, intellectuals at this time. He shared with many others a despair over western values at the eve of World War I. His revulsion against the war and subsequent conversion to communism was also part of the experience of other intellectuals, as was his later disillusionment. This book is an attempt to document the specific and unique characteristics of Grosz's experience and work against the background of cultural and political life in Germany before 1933. By the mid-twenties Grosz, through his politically committed drawings, had attained both fame and notoriety which reached beyond the borders of Germany.

In recent years there has been a revival of interest in George Grosz. From popular accounts of the Golden Twenties to serious studies of Weimar, the work of Grosz is being cited as an important record of the period. Peter Gay, in his recent book on Weimar culture, stated that Grosz's work embodied the Weimar spirit, as did Kandinsky's abstractions, Gropius's buildings, *The Cabinet of Dr. Caligari*, and Marlene Dietrich's legs. In a more serious mood, Hellmut Lehmann-Haupt made much the same claim in his book on totalitarian art when he said that "in the work of George Grosz the peculiar atmosphere of the period was mirrored with particular acuteness and a frightening degree of veracity." [17]

Tributes to Grosz's portrayal of the Weimar period came also from those who lived through the period. Ilya Ehrenburg wrote that Grosz was the portraitist of the inflation days in Germany. Hannah Arendt referred to Grosz's work in justifying her discontent with politics in the republic: "We young students did not read the newspapers in those years. George Grosz's cartoons seemed to us not satires but realistic reportage: we knew those types; they were all around us. Should we mount the barricades for *that*?" Günther Anders believed that Grosz's portrayal of those years was so penetrating and sensitive that many who lived then

rely on his drawings rather than on their own memories of the period. In this sense, Anders claimed that Grosz was not a child of the times, but that the period was Grosz's child: Grosz created the images with which those who lived through it and those who came afterwards would view the Weimar period.[18]

Acceptance of Grosz's drawings as a visual record of his period is widespread; his drawings are the record of a particular point of view. Growing out of a specific ideological vision, George Grosz's drawings formed the visual counterpart to the attitudes of communist intellectuals in the republic. Grosz himself in his actions and statements, as well as in his drawings, was a very good example of the artist-intellectual who turned to revolutionary ideas at the end of the war in Germany.

Despite the bulk of material that has been written on Grosz, little has been written on what he actually did — what organizations he belonged to, for example, or what books he chose to illustrate. His portfolios and books of drawings have been discussed, but never analyzed. Neither have Grosz's statements on art been studied. I have tried in this book to ascertain what Grosz's public position was, what he did, and what he wrote. With this background, I have analyzed in some detail the subject matter of his published drawings. Through these drawings Grosz's ideological affirmations can be clearly traced. I have also tried to establish his relationships during the period. Of particular importance was his friendship and collaboration with Wieland Herzfelde. It is important also to recognize his ties with the expressionist writers before and during the war. Since this aspect of his development has been neglected, I have stressed his poetry, which is quite unknown outside a small circle of his friends.

Grosz himself was partly responsible for the obscurity of his biographical material. During the years of his work in Germany as a communist artist, he was ideologically opposed to the personal glorification of the artist. In 1920 Grosz wrote a brief autobiographical account which was published under two different titles: "Statt einer Biographie" (Instead of a Biography) and "Selbstbekenntnis" (Confession). In this account, Grosz did not talk about his life. He discussed instead his changing ideas as an artist and his development into an ideological artist.

I wrote this instead of the popular ever-welcome biographical notes. It was more important for me to give the facts of my knowledge from my experiences, than to recount the stupid, external accidentals of my life, such

as: birthday, family tradition, visit to school, first trousers, the artist's life from the cradle to the grave, his urges and intoxications of creation, first success, etc., etc. All the fuss about oneself is entirely irrelevant.[19]

What was important to Grosz at this point was not his incidental actions, but his involvement as an artist fighting for the proletariat. There are, therefore, few records of his own activities in Berlin. This may be due in part to the destruction of many of his papers in Berlin during the bombing of that city in World War II, but it was clearly a conscious policy not to make public facts about himself during the early twenties. Later he relented: in 1929 he wrote for *Das Kunstblatt* memories of his early childhood, and in 1930 for *Kunst und Künstler* memories of his youth and early academic training in Dresden. Both of these memoirs were written in a period when Grosz was becoming disillusioned with communism; neither dealt with any part of his life which would reveal actions or attitudes during his period of political involvement.

In 1946, when he published his autobiography in English, Grosz reversed the position he took in 1920 in "Statt einer Biographie." He now consciously suppressed the ideological and political aspects of his life and stressed the "external accidentals" which he had earlier scorned. His treatment of these accidentals was detailed in a descriptive, but not factual way. In the preface Grosz commented upon his autobiography in a paragraph which is curiously reminiscent of the earlier statement:

If, in this my autobiography, I am a bit less graphic than I should be, on occasion, it is not because many of my notes, letters, documents and clippings were destroyed in the attic of a bombed house in Berlin. No. To be honest, even if I had all this material in front of me: notes about the First World War, letters, passports, family photographs, love letters — everything that attaches itself to one during the course of a turbulent life, like barnacles to the keel of a ship, I still would not resort to them. I cannot and will not write a profile of myself. This book is an attempt at an autobiography and the reader must realize that what I do not say I do not choose to say.

Yes, I love the twilight.[20]

Furthermore, his affirmation of the American way of life clouds the issue because he tried to write the book as a businessman, as an American not a German, as a painter not a graphic artist, as a capitalist not a communist. Despite his determination to do this, the demon of his old German pessimism and negation crops out continually: "And yet some-

thing unchangeable remains, something in me — for I am determined to adapt — that is schizophrenic and accursed, that lies in me like a mighty immovable weight of stone."[21] Then, further to complicate the matter, he told Herzfelde that he was writing his autobiography as the story of a *Malerknecht* (a painter who is a hireling), that he was writing it the way "they" — the American capitalists — would want to hear it.[22] The result is that his book provides a fascinating insight into the mind of Grosz during his American period, with provocative glimpses into the earlier period.

For all these reasons — Grosz's refusal to talk about his actions on ideological grounds during the first part of his career, the destruction of his private records in Berlin, his later distortions of his Berlin activities — a reconstruction of his life in Berlin must necessarily be fragmentary.

of the art world in 1903 and stayed only a few weeks because he could find nothing of interest. Emil Nolde was reported to have had the same experience some years earlier.[6]

Returning to Berlin, Grosz was confronted by the first German Autumn Salon, in which the German expressionists and the Italian futurists were heavily represented. The impact of these groups upon both his style and his subject matter was evident for roughly the next five years. Concentrating upon the urban scene, the café, the street, and the brothel—all expressionist themes—Grosz portrayed disturbed people who were involved in emotional crises which their environments reflected and enhanced (Fig. 2).[7]

FIG. 1　Café, 1909.

FIG. 2 The Double Murder in the Rue Morgue—E. A. Poe, 1913.

The debt which Grosz owed to expressionism did not end with the stylistic influences upon his art. Expressionism can be defined not simply as the art movement which began with the Brücke but also as that cultural phenomenon which spread to all the arts in Germany in the first decades of the century. Artists, writers, and intellectuals with widely different interests could be called expressionists, because common to them all was the mood of revolt against established norms, against tra-

ditional authority, and against the past. Peter Gay calls expressionism the revolt of the sons against the fathers.[8] In their revolt against the positivism and rationalism of an industrial and materialistic society, the expressionists came to prize emotions and irrationalism. They utilized erotic and sexual elements in their art, both as shock tactics and as a call for new norms. Disappointed with the order of society which surrounded them, the expressionists called for a totally new order and a new humanity. Their utopianism was vague and the new order was often pessimistic. Nonetheless, expressionism was a revolutionary movement, even if it was not a programmatic or unified movement with distinct aims.

George Grosz, who was roughly ten to fifteen years younger than the first generation of expressionist artists, came to maturity in Berlin surrounded by expressionism. His first public appearances in Berlin in 1912 occurred at the old Café des Westens, then known as the Café Grössenwahn, the meeting place of the expressionists. There Grosz attracted attention by dressing most elegantly in a checked, padded jacket, and bowler hat, carrying a cane, with his face powdered white (Fig. 3). He always sat alone at the edge of the terrace and stared impertinently at the passers-by. He prided himself on his individualistic appearance, on a certain cultivated eccentricity, on the elegance of a dandy.[9] In writing of this Berlin period, 1912–14, Grosz claimed that he was a disillusioned misanthrope, that he consciously isolated himself from men, all of whom seemed stupid and beneath him, and that his disdain and hatred of men grew out of a romantic and idealistic view of art. Grosz was always a voracious reader; at this period he mentioned reading Hauptmann, Wedekind, Strindberg, Ibsen, Tolstoy, Zola, I. P. Mueller, Nietzsche, Gustave Le Bon, Gustav Meyrink, and Hans Heinz Ewer. This combination of pessimistic naturalism, philosophy, and demonical writing would have been sufficient to produce a misanthropic attitude, particularly when combined with an idealistic attitude toward art and when reinforced by childhood memories of the bleakness of the working-class existence and by the fact that Grosz had not yet moved out of the proletarian milieu. He once said of this time in his life: "If we want to understand how a man can hate human beings, we have to study the humiliation he underwent."[10]

Though he was an aspiring artist who made his eccentric presence known in the cafés of the Kurfürstendamm, Grosz lived in an attic in Südende, a dismal, poverty-stricken suburb on the southern outskirts of Berlin, far from the middle class or artistic neighborhoods. His fi-

FIG. 3 The Love-Sick One, 1916, oil. This painting, according to Herzfelde, is a self-portrait of Grosz as he envisioned himself, the eternal civilian and the sophisticated man of the world.

nances at this point were meager. He had a Prussian stipendium while he was at the Kunstgewerbeschule. His sister, Claire, helped as much as she was able. He sold cartoons to journals. The contrast between his aspirations and the reality which he had to encounter could only have exacerbated his sense of the degraded condition of the common worker. Looking back on this experience, he bitterly exclaimed to Herzfelde in 1933: "For the masses the stupidest, the most foolish, and the most tasteless is good enough; that was, is, and remains my motto. If I had thought or experienced otherwise......I would have remained in [the working class district].....in the midst of the dungheap of the 'little workers' and the 'little people'.' . . . I have always struggled to get away from these masses . . . to reach the top was my wish......"[11] Grosz could easily have agreed with the Brücke use of a motto from Horace: *Odi profanum vulgus* ("I loathe the vulgar crowd").[12] As he repeatedly commented, by living in an attic and dressing distinctively, Grosz attempted to set himself literally above and apart from the common man. Feeling a continual revulsion against men, he got drunk when the nausea became too great. Drink was an avenue of escape which he was to use with increasing regularity after moving to America.

His art was also oriented to expressing his disgust, disdain, and hatred of men. In his drawings, Grosz developed a "knife-hard drawing style which enabled me to communicate my observations which were dictated by absolute hatred of men." This style was based upon studies of toilet graffiti and children's drawings — both of which are unequivocal expressions of emotion. His drawings became, as he said, "a precipitation of my feelings of hatred." Repeated themes of the 1913–14 period were the *Lustmord* (the crime of passion) and fighting couples. Remarkably, he planned at this time a three-volume work — why three volumes he never made clear — on "The Hatefulness of the Germans." He summed up his misanthropic philosophy on the eve of the war: "Men are pigs. Talk about ethics is humbug, meant only for the stupid. Life has no meaning other than to satisfy one's appetite for food and women. There is no soul. The important thing is that one has the necessities. The use of elbows is necessary, even if unpleasant."[13]

The picture of Grosz in Berlin, then, before the war was that of an individualist busy with his work at the art school — drawing book covers, menus, advertisements — and industriously filling notebooks with sketches of morbid city life observed outside of school. He may also have taken

part in the Berlin night life as an entertainer, not just an observer. A small book on Grosz published in 1921 claimed that before the war Grosz had an entertainment act, "a head-line single," in metropolitan music halls in Germany. His act was supposed to include singing, eccentric dancing, instrumental music, and satirical monologues. This may have been a mistake in chronology, because Grosz did have a cabaret act in Berlin during the war. There is, however, an intriguing poem by Gottfried Benn called "Nachtcafé, 1912," which Benn dedicated to George Grosz. Whether there was some direct relationship between Grosz and the café scene described in the poem is not clear.[14]

Involved in his own work, cultivating his individuality, holding himself aloof from people in general, associating with a small circle of friends, Grosz, like so many other people, was jolted out of his dream world in August, 1914. His world had been completely unpolitical: he knew little of politics in the empire and was not interested in learning about them. Looking back years later, he recalled that a demonstration of workers in Dresden meant nothing more to him and to his friends than a sensational and exciting evening.[15] In his disdain for politics, Grosz shared an attitude which was part of the German heritage. After generations of political impotence, German intellectuals developed an aversion to politics which was masked under appeals to freedom of thought and culture—*Innerlichkeit, Gedankenfreiheit, Kultur.*[16] Grosz's misanthropy was a variation on this theme; as an artist, he claimed to possess a greater sensitivity than the average man and to deal with things more elevated than politics. Wieland Herzfelde, writing about his artist friends, said that they "had never bothered about politics, had hardly even read the newspapers" before 1914. For them especially the war was a menacing disruption which threatened their way of life, their individuality, and their lives. "No matter what the war was about, it was not about art or things of the spirit."[17] On the eve of the war, a growing number of intellectuals, particularly among the expressionist writers, were advocating a form of intellectual activism. With this kind of thinking, particularly that of Franz Pfemfert as expressed in *Die Aktion,* Grosz apparently came into contact only during the war. It was the war which forced Grosz out of his secure and isolated shell.

Drawn out of his attic studio, Grosz witnessed, but did not participate in, the war hysteria which swept Berlin. His misanthropy, he asserted, made him feel only revulsion for the excited people whom he saw as a mindless mass hypnotized by the military leaders. The inten-

sity of his revulsion against the war hysteria was poured into a drawing titled "Pandemonium, August 1914" (Fig. 4). With a crude acid line, Grosz created a dissonant raw street scene filled with perverted and vicious people. His low opinion of mankind was intensified by this mass stupidity, and he was apprehensive of the threat which war brought to his own individual freedom and separation from men.[18] Despite this misanthropic reaction to the war hysteria, Grosz must have succumbed to the general excitement, as did so many intellectuals, for on November 11, 1914, he entered military service as a volunteer with the Royal Prussian Emperor Franz Grenadier Guard Regiment.[19]

His army experiences were no exception to Grosz's reluctance to document his life. Ulrich Becher, his student and friend, said that Grosz did not like to talk about his experience in the army. In the protocol of Grosz's trial in 1928, the judge asked about his army record, and Grosz replied that he had been sent to the western front in the winter of 1914–15, but that he was immediately returned to a hospital for a sinus infection.[20] In his typewritten notes for the trial in 1930, Grosz was more specific, saying that he became very ill with a high fever while going to the front, was almost given up for dead, was operated upon for a severe sinus infection, remained in a military hospital for some time, and was finally given an honorable discharge, which meant that he could be recalled.[21] The military records state that Grosz was transferred into a reserve company on January 5, 1915, was hospitalized from February 1 to 23, and was released as unfit for service (*dienstunbrauchbar*) on May 11, 1915. During this time he was not at the front nor did he have any war experiences.[22] Later he served a second period similar in nature.

Grosz claimed that his hospital experience was as horrible, hellish, and weird as active battle at the front would have been. Throughout the war, he said, he drew to maintain his sanity. The drawings of the period were chaotic, bitter, apocalyptic scenes, not battle scenes, but scenes which continued and intensified the morbid themes of crime and passion in his 1913–14 drawings — scenes of injured soldiers, leering prostitutes, dark streets, grotesque officers. As he himself said, "I drew and painted out of opposition and attempted through my works to convince the world that this world is hateful, sick, and lying."[23]

His return to Berlin brought him into the artistic circles around the old Café des Westens. Various incidents are reported about this inter-

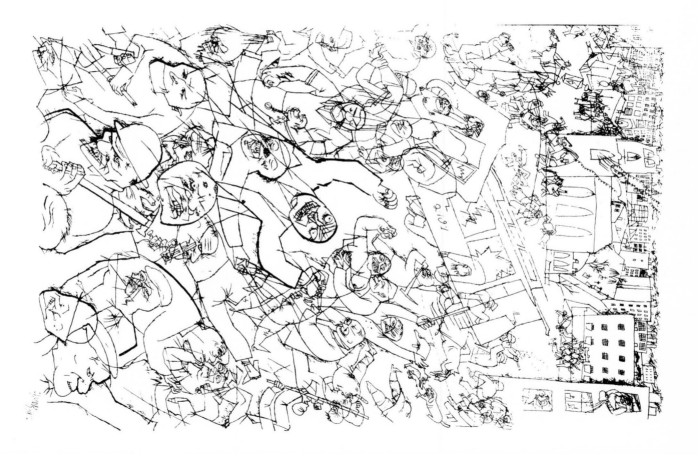

FIG. 4 Pandemonium, August, 1914.

lude in war-time Berlin, the most famous of which is the merchant from Holland meeting Wieland Herzfelde. Grosz was "discovered" by the expressionist poet and critic Theodor Däubler sometime after his return from military duty. Däubler took upon himself the task of introducing Grosz to artists and critics. Paul Westheim, art critic and editor of *Das Kunstblatt*, recalled that Däubler, thrilled at that time with George Grosz and the young poet Johannes R. Becher, took Westheim to Grosz's Südende studio in 1917 to meet him and see his work. Years later, Westheim told of crouching on low stools and smoking pipes in the center of a studio which had been transformed into the interior of an Indian wigwam. Tomahawks, buffalo skins, pipes hung on the walls; whether they were real or merely painted Westheim could not remember. Within this romantic Wild West setting, Grosz taught Westheim how to act like an American—how to box, smoke a pipe, take photographs, sing Negro songs, and dance to ragtime music. On the walls mixed with the Wild West items were letters, photos, and slogans, all having to do with America. (See Figs. 5 and 6.) Grosz was especially proud of large photographs of Americans, such as the one of Edison, supposedly inscribed, "To my dear George Grosz, Thomas A. Edison."[24] Beginning in October, 1915, and continuing for roughly a year, Grosz titled his little pocket sketch books as "Medical journal of Dr. William King Thomas, U.S.A."[25]

Däubler also introduced Walter Mehring to Grosz sometime in 1916. Mehring had first seen Grosz's drawings when Däubler produced a portfolio before a gathering at Herwarth Walden's salon. He was so intrigued that he requested an introduction to the artist. When Grosz welcomed them into his studio, Mehring was overwhelmed by Grosz's painting "Reminiscence of the Entrance to Manhattan." As they discussed the painting, Mehring was startled by the way in which Grosz pointed out the interesting features of the harbor—as if he had been there himself.[26]

This fascination with America and, to a lesser degree, England, was not an eccentricity peculiar to George Grosz. His generation had been brought up on the adventure tales of Karl May which glorified the rugged, rough frontiers of the world, particularly the Wild West. Translations of Fenimore Cooper, Rudyard Kipling, and Conan Doyle were popular before the war. For older and more sophisticated tastes, Rimbaud cultivated the bizarre and the exotic. Within the German dramatic scene at the turn of the century, Frank Wedekind, who was born in America, featured England's Jack the Ripper. By the early 1920s, the revulsion

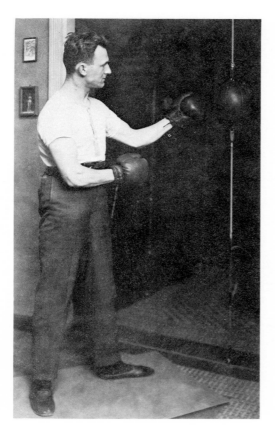

FIGS. 5 and 6 Grosz, in his
studio, around 1920.

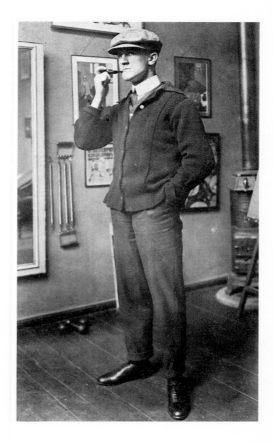

against the war and against German bourgeois society and a romantic yearning for a better life combined to produce what one critic has called a spurious Anglo-Saxon mythology. The symbols of this mythology were jazz, sports — boxing, wrestling, racing — the Salvation Army, the negro, the Virginia cigar, whiskey, and ale. The hero was the gangster or the tough.[27] These symbols cropped up in plays and poems during the twenties. For example, in his play *Von Morgens bis Mitternachts* (From Morn to Midnight, 1916), Georg Kaiser interjected both a bicycle race and a Salvation Army scene; Joachim Ringelnatz featured boxing, wrestling, and bicycle races in his *Turngedichte* (Gymnastic Poems, 1923); and several of Bert Brecht's plays took place in a Chicago which was peopled with gangsters, workers, and Salvation Army heroines. In poetry, the mythology was frequently accompanied by the erratic use of English or American slang, which was intended to heighten the tough gangsterish mood. Walter Mehring's poem "Jazzband" is a good illustration:

I want to be
I want to be
I want to be down home in Dixi
Und cowboys rings
bei echten drinks!
My darling girl schenk ein und mix sie![28]

One of Mehring's "Songs" had the following refrain:

If the man in the moon
Were a coon und im Dun-
 keln liebten die girls —
Schenkten alle weissen ladys
Schwarze Babys
Schwarzen Kerls.
Please
Küss
 mich rein —
Lass mich ein!
Black boy o my black boy
In the niggerparadies, in the niggerparadies.[29]

Or again Ringelnatz:

Scheek hands! Ehrlich und offen
Ich bin gar nicht besoffen.
Gif öss a Whisky, du, ach du! Jesus Chreist![30]

The most important journal of the left-wing intellectuals, the *Weltbühne*, kept its readers informed about American jazz and dissident authors and was proud to have promoted Charlie Chaplin's films. Writing in 1923, Kurt Tucholsky praised Chaplin for his light portrayal of human misery in a stupid world.[31]

As Westheim reported, George Grosz anticipated this post-war fad by several years. By the middle of the war he not only lived and worked in an American setting; he had changed his name from Georg Gross to George Grosz. Helmut Herzfeld had changed his name to John Heartfield. Both of them were partly motivated by their disgust with the blatant anti-English propaganda of the war, but Grosz's change was also rooted in his childhood dream of America. Others who adopted American nicknames were Walt Merin and Bert Brecht. Grosz had the distinction of being—at least in his circle of friends—the first to become enamored with ragtime and jazz. Grosz had heard his first so-called jazz band in the Café Oranienburger Tor before the war, but he said it was really just a Viennese band which pretended to go mad.[32] During the war, he learned jazz songs and steps and collected early records from America. In the summer of 1918 he recorded names of American songs ("Broadway Glide," "You Made Me Love You—I Didn't Want To Do It") in his sketch book.

Grosz's war-time drawings were among the best examples of the gangster and Wild West mythology. A self-portrait of 1919 revealed Grosz as a tough surrounded by symbols of rowdy night life and was dedicated to Charlie Chaplin, whose little man in an alien world became a major figure in the new pantheon (Fig. 7). His first portfolio contained, among drawings of barrooms, gold diggers, and gangsters, the two drawings "Memory of New York" (1915, Fig. 8) and "Texas Scene for my Friend Chingachgook" (1916). In his drawings, Grosz's work was almost a visual counterpart to the early plays of Bertolt Brecht. Both used as their favorite setting the bar or cheap hotel, which was always peopled by sinister, evil characters. Grosz's "John, the Little Sex-Murderer" (drawing, 1917; oil, 1918) could have walked out of Brecht's *Im Dickicht der Städte* (In the Cities' Jungle, 1921). In his drawings, Grosz dropped these themes by 1920; but Brecht continued to write within a curious satirical Anglo-Saxon world until late in the twenties.

Grosz, sitting in his studio filled with American trophies, initiated Westheim and Mehring into his private world of drawings and jazz. They,

FIG. 7 Self-Portrait (for Charlie Chaplin), 1919. The small bony dog which appears in many of Grosz's drawings was almost always present in those which are self-portraits.

in their turn, wrote about Grosz and helped to publicize his work in the twenties. Däubler, who had brought them to Grosz, was not always so successful in attempts to introduce him to prominent critics. Herwarth

FIG. 8 Memory of New York, *Erste George Grosz Mappe*, pl. 1. This drawing may have been similar to the painting which Mehring remembers in the studio.

Walden, impresario of modern art and publisher of *Der Sturm*, was said to have been so offended by Grosz's blasphemous imitations of Klee that he not only rejected Däubler's request for support, but also broke with Däubler.[33] The art dealer J. B. Neumann showed Grosz to the door, though later he became a good friend and patron. Däubler finally succeeded in finding a patron for Grosz in Solly Falk, a wholesaler who bought raw materials for the German army. Falk granted Grosz a hundred-mark monthly stipend. In return, Grosz left a caustic picture of his autocratic, quixotic Maecenas in his autobiography, in addition to

sending Falk his drawings.[34] In 1916 Grosz came into contact with Hans Goltz, owner of the Galerie Neue Kunst in Munich. Taking a fatherly interest in Grosz, Goltz tried to direct him with letters exhorting him to follow bourgeois values and urging him to cease his highly negative portrayals of humanity. Finally, when Grosz's drawings — without the suggested changes — gained popularity, Goltz became his dealer, remaining until Alfred Flechtheim took over around 1923.[35]

Däubler did not confine himself to introducing Grosz to the art world and its patrons. In the fall, 1916, issue of *Die Weissen Blätter* he lent the prestige of his name to an essay on George Grosz which was accompanied by seven of Grosz's drawings, all of which later appeared in the first Grosz portfolio. This essay was followed by others in 1917, 1918, 1919, and 1929. They were the first of a substantial number of critical essays and articles published about George Grosz.

Though Däubler is credited with discovering Grosz and writing the first critical works on him, the first printed study of George Grosz was actually a poem by Else Lasker-Schüler. Published in *Neue Jugend* in August, 1916, it is a romantic view, but quite perceptive:

Sometimes tears of many colors
Play in his ashen eyes.

But always he encounters hearses;
They scare his dragonflies away.

He is superstitious
— Born under a great star —

His handwriting a downpour,
His drawings: letters of cloud.

As though they'd long lain in the river
His subjects bloat their bodies out.

Mysterious vagrants with tadpole mouths
And putrefied souls.

His silver fingers are
Five dreaming undertakers

But nowhere a light in the stray legend,
And yet he is a child,

The Leatherstocking Saga hero,
On intimate terms with the Redskins.

Grosz was drawing and painting steadily at this time. His drawings continued to dwell upon militarism, prostitution, passion, crime, the Wild West; stylistically they were deeply disturbed, chaotic, sinister (Fig. 9). Friends tell of boxes and drawers filled with drawings which he was producing. He was also writing poetry, and in 1915 a poem appeared in *Die Aktion*. He had found that Pfemfert's journal expressed many of his own ideas; thus, it is not surprising that he submitted work to it. "Song" appeared in the November 6, 1915, issue:

All others he hates;
They bring him bad luck.

But Georg Grosz loves his misfortune
Like a dear adversary.

And his sadness is dionysian,
Black champagne his lamentation.

He is a sea with a veiled moon.
His God seems dead, but is not so.[36]

In uns sind alle Leidenschaften
und alle Laster
und alle Sonnen und Sterne,
Abgründe und Höhen,
Bäume, Tiere, Wälder, Ströme.
Das sind wir.
Wir erleben
in unseren Adern,
in unseren Nerven.
Wir taumeln.
Brennend
zwischen grauen Blöcken Häuser.
Auf Brücken aus Stahl.
Licht aus tausend Röhren
umfliesst uns,
und tausend violette Nächte
ätzen scharfe Falten
in unsere Gesichter.[37]

Within us are every passion
and every vice
and every sun and star,
depths and heights,
trees, animals, forests, rivers.

FIG. 9 Café, 1915. EH, no. 41.

That's us.
We experience
in our veins,
in our nerves.
We reel.
Burning
between grey rowhouses.
On bridges of steel.
Light from a thousand neon lights
surrounds us,
and a thousand violet nights
etch deep wrinkles
in our faces.

The sense of tension, heightened suffering and passions, of an existence reeling under the impact of the surroundings—all of these elements are present in both his poetry and his drawings at this time. Four Grosz drawings also appeared in *Aktion* during 1915–16. In the next three years Grosz composed and published a dozen poems. Written in the mood and style of lyrical expressionism, the poems celebrated the night side of life in the city: cabaret and circus artists; drunken nights and prostitutes; the noise and throb of the city with its despair, filth, and crime; the debauchery of café scenes. The exoticism of the New World entered into these poems. "Song of the Gold Diggers" sang of the machines and railroads of America, the brothels of South America and the Orient, the search for gold in Alaska. The poem ended:

Amerika!!! Zukunft!!!
Ingenieur und Kaufmann!
Dampfschiffe und De-Züge!
Über meinen Augen aber
spannen riesige Brücken
Und der Rauch der hundert Krahne.[38]

Bert Brecht struck this same note about America in a poem written a decade later:

What men they were! Their boxers the strongest!
Their inventors most adept! Their trains the swiftest!
And the most crowded!
And it all looked like lasting a thousand years.

America!!! Future!!!
Engineer and salesman!
Steamships and express trains!
But above my eyes
stretch gigantic bridges
and the smoke of the hundred derricks.

Brecht's poem, composed in the midst of the world economic crisis, did not stop with the glorified vision of America. Unlike Grosz in his poem, Brecht maintained that the future did not lie in America, and he closed his poem with the cynical comment:

What a bankruptcy! How great a glory
Here has vanished.[39]

Grosz was writing, however, at a time when his vision of America had not yet dimmed. America was an exotic dream which mixed easily with other inaccessible and fascinating places. Another of Grosz's poems lauded Australia, the land of the sun, Africa with its dark primeval forests, America with its express-train culture. Screaming and shouting, the poem called to Germans, pale-faced, bent with their awe of authority, to wake up. Grosz's characterization of the Germans in this poem was not flattering:

Ihr Hundesöhne, Materialisten,
Brotfresser, Fleischfresser - Vegetarier!!
Oberlehrer, Metzgergesellen, Mädchenhändler!
- ihr Lumpen!!![40]

You sons-of-bitches, materialists,
bread-eaters, flesh-eaters - vegetarians!!
Professors, butcher's apprentices, pimps!
- you bums!!!

In 1918 two poems were published with an essay by Däubler in *1918, Neue Blätter für Kunst und Dichtung*. Däubler, in his first essay introducing Grosz to the literary public in 1916, had characterized Grosz as a writer as well as an artist, so it was quite fitting to publish another Däubler essay with Grosz's poems. It is difficult to tell whether the poems, published in November, were written before or after his second period of military service. Whatever the time of writing, these two poems expressed a deeper personal involvement in the insane and whirling world than did the earlier poems, with the exception of the "Song" of 1915. In "Song to the World" Grosz himself was now in the midst of that crazy world:

Ach knallige Welt, du Lunapark,
Du seliges Abnormitätenkabinett,
Pass auf! Hier kommt Grosz,
Der traurigste Mensch in Europa,
'Ein Phänomen an Trauer.'
Steifen Hut im Genick,
Kein Schlapper Hund!!!!
Niggersongs im Schädel,
Bunt wie Hyazinthenfelder,
Oder turbulente D-Züge,
Über rasselnde Brücken knatternd -

Ragtimetänzer,
Am Staketenzaun wartend mit der Menge
Auf Rob. E. Lee.

· · · · ·

Horido!
Beim Bart des Oberlehrers Wotan -
Nachmittags verbrämte Kloaken,
Überpinselte Fäulnis,
Parfümierter Gestank -
Grosz witterts.
Parbleu! Hier riecht's nach gebratenen Kindern.[41]

O gaudy world, you insane asylum,
You blissful box of abnormalities,
Watch out! Here comes Grosz,
The saddest man in Europe,
"A phenomenon of grief."
No puny weakling!!!!
Derby hat pushed back,
Niggersongs in the back of his head,
Colorful as hyacinth fields,
Or turbulent express trains,
Rattling over clattering bridges -
Ragtime-dancer,
Waiting with the crowd at the picket fence
For Rob. E. Lee.

· · · · ·

Horido!
By the whiskers of Professor Wotan -
In the afternoon bordered sewers,
Freshly painted decay,
Perfumed stench-
Grosz smells it.
Parbleu! Here it smells like fried children.

Piling up references and images, Grosz tried to conjure up the song of the world, a world gone mad. He himself, the saddest man in Europe, but still the aggressive and tough dandy with dreams of America in his head, smelled the rotteness of the world around him. The poem jumped from visions of America with its negroes, jazz, and skyscrapers to a complicated juxtaposition of images from a night club with allusions to the dismal achievements of man whose decaying buildings shelter criminals, masturbators, and suicides. Images of the night club floor show then

included Grosz himself —Georges le Boeuf— before exploding into feverish news headlines:

Prost, Max! Oben läuft die menschliche Fliege auf Glasplatten!!
Bewegung!
Einheizen!
Portweine, schwarz etikettierter, her -
Heidonc, en avant!
Georges le Boeuf!!!!
L'homme masqué!!!!
Champion of the world!!!!
Der Knallspektakel!!
Das Banknotengeflüster!!
Halooo!!!
Die Ermordung Jaurès!!
Die Explosion der Radrennbahn!!
Der sensationelle Wolkenkratzerbrand!!
Das neue Attentat der Telephonmänner!! [42]

Prost, Max! Overhead the human fly is walking on glass plates!!
Movement!
Fuel up!
Portwine, black label, over here -
Heidonc, en avant!
Georges le Boeuf!!!!
L'homme masqué!!!!
Champion of the world!!!!
The crazy show!!
The rustling of bank notes!!
Halooo!!!
The murder of Jaurès!!
The explosion at the bicycle races!!
The sensational skyscraper fire!!
The recent assassination attempt of the telephone men!!

The excitement abruptly dropped to a grim glimpse into a back room strewn with bloody sacks. The final laconic line was "Thousands die, without ever seeing the gulfstream."

The second poem, "Coffee House," moved from the mad world into a mad café where Grosz, drunk on cognac and whiskey, "saw dreadful masks!! [I] am bound around with coral chains of red heads." Plaster angels with green teeth and flaking bronze paint came down from the

ceiling; gaslamps hung like idiotic balls thrown into the air; rotating lights transformed and dissolved colors and forms; notes of music threw little holes into his brain. The plaster angel disappeared—they said she lived upstairs and played billiards for one mark an hour. Grosz pulled himself together:

Herr Ober!! - bitte Selterwasser -
Ich bin eine Maschine, an der der Manometer entzwei ist –!
Und alle Walzen spielen im Kreis -
Siehe: *wir sind allzumal Neurastheniker!* 43

Waiter!! - Seltzerwater, please -
I'm a machine with a broken pressure gauge –!
And all my cylinders are going in circles -
Look: *all of us are neurotics!*

This last nervous cry seems to have ended his career as a publishing poet. In the late twenties, several books of Grosz's poems were published, but these were all reprints. Grosz's poems are important because the images, the abrupt style, and the content are closely related to the work of the young expressionist poets of the pre-war and war period. Kurt Tucholsky, reviewing Bert Brecht's *Hauspostille* in 1928, found the poem, "On the poor B.B." to be evocative of the doubt, pain, coldness, and lyrical diction of George Grosz's poems. 44 The poems place Grosz squarely in the context of the intellectuals who were clamoring about the decadence and despair of society and who were trying to use language and images to shock their readers. By trying to express himself in two different modes, drawing and poetry, Grosz was one of the many expressionist artists who sought to follow the example of Barlach and Kokoschka.

Grosz had a cabaret act in which he sang, danced, and recited his own poetry. Robert Breuer, editor of *Die Glocke*, wrote about his first view of Grosz in May of 1917. It was a time, according to Breuer, when the intellectuals were beginning to become involved in politics, writing about brotherly love, enjoying their schnapps, making a lot of noise, but knowing very little. Breuer first encountered Grosz in such a group of intellectuals, whom he likened to a group of medieval wandering scholars. In a small café on Kurfürstendamm, there was a generally mediocre program, then:

On the podium suddenly a chap, a clown, a nigger, a cowboy who read Stendhal. A circus trumpet, a turner of cartwheels with mathematics in his nerves. An extremely cunning fellow, who laughed wryly in the wings over all who took his nonsense seriously. He ridiculed not only the bourgeois, but also Bohème.[45]

The performance was good enough to convince Breuer that Grosz was an artist of glowing originality, a conclusion which he found justified when he saw the early Grosz portfolios.

CHAPTER 2
IN ANTI-WAR BERLIN

DÄUBLER'S ENTHUSIASM FOR GROSZ'S WORK helped to start Grosz on his way toward becoming a famous artist; however, Grosz's career as a political artist grew out of his encounter with Wieland Herzfelde. Herzfelde introduced Grosz to his brother, John Heartfield, and the three of them formed a life-long friendship. John, born in 1891, the oldest of the three, was a graphic artist and typographer, while Wieland, born in 1896, the youngest, was studying to be a writer. Sons of Franz Held, the socialist poet who, condemned for blasphemy, had fled from Germany to Switzerland, and Alice Stolzenberg, a strike leader among textile workers, the brothers had early absorbed socialist and revolutionary attitudes.[1] During 1915–16 John and George spent much of their time together. They shared a common conviction that the war was not only despicable, but that it was lost.

Grosz, however, did not share the Herzfeldes' optimistic belief in humanity, their belief that only the ruling classes were responsible for the war, or their belief that the natural goodness of man would assert itself in a drive for world peace. While hating the war and believing it was lost for Germany, Grosz also was sure that it would never end, unless people could be motivated to take decisive action against it. He refused to blame only the ruling classes, claiming instead that the war hysteria of 1914 resulted from the stupidity of the masses who wanted war as much as did the ruling classes. He was sure that most people, especially the common soldier, liked the war situation because it not only allowed them free rein for their baser instincts, but also freed them from the concerns of making a living. It made prices, wages, and profits higher. In short, Grosz insisted that a stupid humanity would prolong an inhuman war

out of selfishness.[2] Grosz's "merchant from Holland" was the cynical embodiment of those attitudes which Grosz accused of prolonging the war. It was not only cynical, but a gross caricature which was meant to shock the little group of idealistic socialists into anti-war activity.

Grosz and Heartfield, in their own ways, set about trying to sabotage the mood which favored the war. Heartfield, who was then a letter carrier in a Berlin residential district, deposited all his mail in storm sewers, hoping to create dissatisfaction with war conditions among those families who did not receive their mail. Grosz specialized in sending to the front gift packages which were meant to infuriate the soldiers with the continuing stalemated war. For example, a package to Erwin Piscator, whom he knew only by name from Herzfelde, contained a stiffly starched dress shirt, gloves, tie, and a request for tea, which Grosz said was difficult to obtain at home. Together Grosz and Heartfield worked up postcards to send to soldiers at the front. These cards were made up of pictures and words pasted together in such a way as to convey a message which would not have gotten past the censors if it had been written out. Begun as a war-time dodge, this pasting of pictures and words to carry a political message, as distinct from the art form of the collage, was developed into virulent and inflammatory political photomontages by John Heartfield. It was also picked up and further developed by the dadaist movement.[3]

While Grosz and Heartfield carried on their private feud with the war, Herzfelde searched for the means to publish an anti-war journal, believing that Pfemfert in *Die Aktion* was too closely watched to be able to take a meaningful stand. Herzfelde wanted a journal in which he could sponsor open anti-war statements, essays, manifestos. He was faced with problems of no capital, no experience in publishing, and no way to get a permit from the military authorities to publish a new journal. By July, 1916, he had surmounted all these problems and published the first issue of his journal. Because of the difficulties of getting a government license, he bought the publishing permit of a journal which had become defunct. Since this purchase was illegal, the agreement provided for maintaining the old title, *Neue Jugend*, and keeping the old publisher, Heinz Barger, on the masthead.[4] The first issue of *Neue Jugend* published by Herzfelde contained poems by Johannes R. Becher, an expressionist writer who joined the Communist party in 1918 and later became the president of the East German Culture Union; Albert Ehrenstein, also a politically revolutionary expressionist; Richard Huelsenbeck, who turned to dadaism in 1917; Franz Held, the socialist poet of

the 1880s and 1890s; and Wieland Herzfelde. There were articles by Hans Blüher; Gustav Landauer, the young literary historian who was murdered for his participation in the Munich soviet in 1919; Else Lasker-Schüler, and Theodor Däubler, both elder statesmen in the expressionist movement. Featured were George Grosz's drawings: "The Gold Diggers," a western bar with gambling prospectors, and "Endure to the End!," a macabre street scene featuring a hearse, a prostitute, and an insect-like man with a coffin under his arm (Fig. 10).

FIG. 10 Endure to the End!, 1915. *Neue Jugend.* Herzfelde, *Tragigrotesken der Nacht,* p. 27. Gez, p. 79.

In his statement of purpose Herzfelde stressed the need for a journal to publish the works of new young artists, poets, and writers. By an indirect reference to a suppressed journal called *Revolution*, Herzfelde hoped to make clear to his readers, but not to the censors, the political complexion of his journal. He also renounced the intention of the earlier issues of the *Neue Jugend*, namely, to publish purely literary works of young artists, and he urgently called all intellectuals to take a stand against their enemies. This brave beginning did not evolve into the political journal which Herzfelde had envisioned. Writing about this years later, Herzfelde suggested that part of the trouble lay in the isolation of the writers and artists who contributed to the journal. He cited specifically his failure to realize that the opposition Spartacus group was forming within the Socialist party at the same time that he was beginning the journal; the intellectuals in the Spartacus group could have substantially helped the editors of the new journal, but the latter were too politically naive to realize this.[5]

If the publication did not fully realize Herzfelde's dream of an antiwar journal, it did succeed in publishing George Grosz's drawings. The journal published four issues during 1916, all of which contained contributions from Grosz. The August and October issues each printed a Grosz drawing. The September issue presented a Grosz poem, "Moonlight Night," a parody of German romantic themes. The sentimentality suggested in the title was rapidly dispelled:

Mondnacht, du silbrige, kitschige,
Ich bin alkoholisch erregt,
Und der Schuh des ewigen Juden knarrt fortwährend da vor mir.

Der Mond rund verwest in milchigem Weiss.
Verflucht![6]

Moonlit night, you silvery, gaudy,
I am alcoholically stimulated,
And the shoe of the eternal Jew incessantly squeaks before me.

The moon all around decomposes into milky white.
Damn it!

Having conjured up a mood of maudlin drunkenness, the poem moved through the heaving, weaving landscape of the drunk into the café or brothel and ended with an ironically placed quotation from Goethe: "Sah ein Knab' ein Röslein stehn" (Boy once saw a rosebud rare).

The "shoe of the eternal Jew" — perhaps a reference to Heine — alternated in the last half of the poem with images of a prostitute. This poem revealed an attitude of insolent impertinence towards things German which was to be a hallmark of Grosz's political stance.

The contributors to *Neue Jugend* remained fairly steady, Else Lasker-Schüler had a chapter of her novel, *Der Malik*, in each issue. Those who contributed to the first issue appeared in later issues, along with the expressionist poet, Kasimir Edschmid, the free-lance writer of grotesque tales, Mynona (Dr. Salomo Friedländer), and the visionary poet, Georg Trakl. Poems by Walt Whitman, whose works were greatly admired in left-wing circles, were also included. The October issue was a special one dedicated to Theodor Däubler, in which all the articles and poems were by Däubler, except for a drawing by Grosz. After the October issue, Herzfelde was taken into the army for the second time and sent to the eastern front. This left John Heartfield and Grosz to bring out the journal. They enlisted the help of a friend, Franz Jung, whom Herzfelde described as a paradoxical mixture of utopian radical socialism and individual anarchy. Grosz felt that it was Jung who heightened the negative position of the journal, which reappeared in 1917 for the first time in a February-March double issue. Because of a disagreement with the old editor and publisher, Heinz Barger, this issue was the first to appear with Wieland Herzfelde as the publisher and under the imprint of the Malik Verlag.[7] George Grosz occupied a fairly substantial section of this issue with three poems and four drawings. This was the last of the monthly issues of *Neue Jugend*, for shortly afterwards its publication was prohibited for the duration of the war.

With the banning of the monthly edition, a so-called weekly *Neue Jugend* appeared. It lasted for two issues, one in May, and one in June, 1917, before it too was banned. As an illegal paper, it listed no publisher or editor; however, Grosz, Heartfield, and Jung were listed as "contributors" (*Mitarbeiter*).[8] Apart from the name, the drawings of George Grosz, and the work of Heartfield, the two journals had nothing in common. Heartfield, who was responsible for the typographical setting in both, produced in the weekly versions a revolutionary typography which was to be utilized in the later dada publications. The June issue, printed in three colors, was called "Prospectus of the Little Grosz Portfolio," though it had nothing in it about the portfolio except a remarkable advertisement. It did, however, contain two articles, unsigned, on the title page by Grosz: "One Should be an India-Rubber Man" and "Can You

Ride a Bicycle?" The latter was a witty essay exposing advertising as the ground of modern existence, the purest document of contemporary life, and the controller of culture. Heartfield's typesetting of the essay itself was highly evocative of advertising.

In late 1916, Herzfelde had published a series of anti-war statements under the title *Der Almanach der Neuen Jugend auf das Jahr 1917* which was outspoken enough to be immediately banned. George Grosz was again well represented with a poem and four drawings which were to be published later in his second portfolio. The *Almanach* included several advertisements for the *Erste George Grosz Mappe* (First George Grosz Portfolio), which was published early in 1917, as well as for the sale of any Grosz drawing which had appeared in *Neue Jugend*.

Neue Jugend in one form or another had appeared for a year. Though on a limited scale, Herzfelde had introduced the art and poetry of George Grosz to the intellectual world. Late in 1916, the *Berliner Tageblatt* recognized Grosz as the "most genuine modern" of those around the *Neue Jugend*. In Grosz, the *Tageblatt* recognized a man full of healthy skepticism who had looked behind the stage façade of life and had lost every illusion.[9] Herzfelde and Heartfield did not limit themselves to publishing the work of Grosz in *Neue Jugend*. Under the imprint of the new and clandestine Malik Verlag — hidden in an attic studio on Kurfürstendamm in the Berlin-Halensee district — the *Erste George Grosz Mappe* was published in the spring and the *Kleine Grosz Mappe* (Little Grosz Portfolio) in the fall of 1917. The first portfolio rendered into pictorial form the themes of Grosz's poetry. Using the knife-hard drawing style which he reveled in, Grosz portrayed romantic but frenetic American cities and American Indians, sinister and morbid German cities and suburbs (Fig. 11), and decadent cafés.

The *Kleine Grosz Mappe* made explicit the close relationship between Grosz's poems and his drawings by the inclusion of his longest poem, "From the Songs," in the portfolio. On the title page of the portfolio, a leering, grinning bestial man's head introduced the theme underlying both the poem and the drawings: man is animal; man as animal is besotten, berserk; man's surroundings are staggering, tumultuous, reeling. As in the poems of 1918, this poem seems to be a kaleidoscope of images colliding in Grosz's head while he drank cocktails in a bar. Through a seemingly irrational progression of phrases and ideas, Grosz evoked a vision of the modern city with its stock exchanges, filthy streets, decrepit

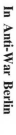

FIG. 11 People in the Street, *Erste George Grosz Mappe*, pl. 5. Published first in *Weissen Blätter* 4, no. 11. Gez., p. 87.

tenement houses, baroque town houses, grey cement factories, and its incessant advertising—all of which conspired to dehumanize man. In the darkness of this city at night gangsters, murderers, executioners, condemned men, lovers, doctors, drunkards, and syphilitics danced their inevitable dance of life and death. The artist, however, drank, stuffed his

bulldog pipe, and saw visions of exotic adventure and freedom in South America—the land one longed for—in Colorado, Cuba, Rio, and London where Jack the Ripper could be found.

The drawings echoed the poem (Fig. 12). Man who is animal moves through the reeling city streets and sinister brothels; rape, violence, lust, and hate motivate him; hearses, mansard roofed buildings, cheap hotels, and factories confine and oppress him; the prostitute, leering and leered at, is the pivot. Grosz's world in these drawings is an evil, sinister, violent world; it is the world viewed through the eyes of the misanthrope or the man to whom all pretense or illusion was denied. These are the drawings with which Grosz wanted to "convince the world that this world is hateful, sick, and lying." Both portfolios grew out of this sense of opposition to the world; they were a bitter and illusionless statement of "what is" with no view of "what might be." The Grosz of these portfolios revealed no reformer or political activist, except in the sense that having no illusions about "what is" was a prerequisite for a vision of "what might be."

Grosz's vision of the world was so stark that, on the one hand, he found it impossible to accept any of the many rationalizations for waging war. On the other hand, he could not subscribe to the various hopes that the masses would revolt and end the war. Hating the powers that created and directed war, he had no faith in the solidarity of workers or the brotherhood of man. Unable to justify the war and having no hope for an end to it, Grosz appears to have decided that he had to fight against the inhumanity and cruelty caused by the war, even though he had no particular faith in humanity. Here is the pattern of Grosz's affirmation of a course of action, not because he believed in the good, but rather because he could not tolerate the evil. By late 1916, Grosz's activities with the Herzfeldes became publicly anti-war.

Under the aegis of *Neue Jugend,* Herzfelde and Heartfield planned author evenings throughout the winter of 1916–17. On these evenings, they were able to realize their goal of taking a stand against the war more openly and clearly than in the journal. Literary evenings featuring anti-war readings by authors had been held before, but Herzfelde maintained that theirs were the first which were open to the public. Well attended, they occasionally became tumultuous. The meetings were announced in *Neue Jugend*; presumably they were also announced by placard if they were considered to be public. The first three took place in Berlin at J. B. Neumann's art gallery, Graphischen Kabinett. On

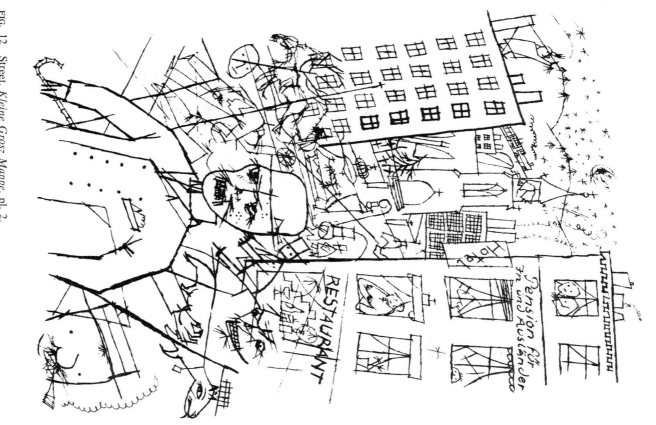

FIG. 12 Street, *Kleine Grosz Mappe*, pl. 2.

September 13, 1916, Johannes R. Becher, Theodor Däubler, Albert Ehrenstein, Wieland Herzfelde, and Grosz read their own works. The following week, September 22, the same group, with Else Lasker-Schüler taking the place of Ehrenstein, performed again. On October 27, J. R. Becher read alone. On November 7, they moved to Dresden, where Dr. Heinrich Stadelmann, a physician who also promoted art and the occult, sponsored the evening and read his own work.[10] Becher, Grosz, and Ehrenstein read their works. Ado von Bernt read from Däubler, and John Heartfield read his brother's poems, since Wieland had been sent to the front. Ten days later, Däubler, Else Lasker-Schüler, Becher, Grosz, and Ado von Bernt read in the Café Luitpold in Munich. The sixth evening was in Mannheim in the Kunsthalle on December 7 with Solly Falk introducing Däubler, Lasker-Schüler, and Grosz. Further evenings were announced in Berlin, Hamburg, and Leipzig in the spring of 1917, but no information is available on them. Though the journals were plagued by censorship, these evenings did not appear to arouse the military authorities, for Herzfelde makes no mention of official opposition.[11]

All of this publishing and traveling on the part of Herzfelde, Heartfield, and Grosz must have been expensive. The receipts from *Neue Jugend* were not enough to pay for the journal itself. Herzfelde has written that much of their publication costs were borne by the good will and credit extended to them by sympathetic printers and suppliers. Grosz may have been selling drawings by late 1916. The portfolios were published in 1917. Mainly, however, Solly Falk was still supporting him. In one of his sketch books there is a rough draft of a note to Falk: "I am miserable—and now you are mad at me, and send only 100 marks—I can well imagine that you are angry with me, because I have not sent you anything—I ask you to excuse this please." Saying that he had sent fourteen drawings to Falk, he blamed his inability to work on the fact that he had no coal to heat his studio and that he was depressed and paralyzed from worrying about being recalled into the army. The same notebook contains several memos of money borrowed from friends.[12]

There is some suggestion that Count Harry Kessler, eminent pacifist, statesman, and patron of artists and writers, was backing the three; whether financially or only in terms of influence is not clear. Specifically, Kessler, introduced to Wieland by J. R. Becher, obtained a job for Heartfield in 1917 with the film company which was the forerunner of Ufa (Universum Film A. G.), a film company formed in late 1917 to

promote official government propaganda and which became one of the major German film producers. Heartfield was to be director of natural science documentaries and of cartoons, still in their infancy. On November 18, Kessler reported that Grosz and Heartfield had visited him to talk about new ideas for films which they wanted to make.[13] Heartfield, therefore, had brought Grosz into the company where they worked together on drawings for a cartoon called "Pierre in Saint-Nazaire." It was to be a spoof about Americans landing in France against the Germans, and they had great fun planning it. Unfortunately, the finished film was unacceptable to the film company because the American invasion took place and because Grosz's portrayal of the German soldier was so negative. Heartfield almost lost his job because of the film, but Kessler's influence helped him keep it and also obtained a job for Wieland when he returned in the summer of 1918.[14]

On January 4, 1917, Grosz was taken into the infantry again. What happened this time is as cloudy as is the earlier army experience. In his 1930 trial notes, he spoke of being sent to Gross Breesen near Güben, but then being returned immediately to a military hospital because of his highly sensitive sinus condition; he then spent the rest of the war in hospitals. In his 1925 autobiographical statement he said he was released the second time from the army after long observation in the Royal Prussian Asylum of Görden. He also commented that the publication of the *Erste Grosz Mappe* had contributed to this dismissal, the implication being that the portfolio convinced the military authorities of his insanity. An article which he published in the Soviet Union in 1928 elaborated on this latter account: "I arrived in Gross Breesen quiet and modest; however, I behaved as a fervent critic of war and I completed a fantastic, typically Prussian comical odyssey. In conclusion, thanks to constantly recurring illness, I was sent for observation to a neurological hospital in Görden." After six months of tests, he was discharged.[15]

In later reminiscences, Grosz mentioned variously that he had been assigned to train troops, to transport troops, and to guard Russian war prisoners. Friends writing about him maintained that Grosz was involved in a serious breach of military discipline. Grosz, in a very tortuous and uncomfortable statement made to Boyer, who was interviewing him for the *New Yorker* in 1943, told of attacking an officer who ordered him out of bed in a military hospital. In his 1946 autobiography,

Grosz said that he was charged with desertion and with striking an officer and that he was saved from being shot as a deserter by the intervention of Count Harry Kessler, who had the sentence mitigated to confinement in a military mental sanatorium.[16]

The military records confirm that Grosz was hospitalized; in fact he was hospitalized on January 5, the day after he was recalled, and remained there until April 27, 1917, when he was sent home on sick leave. He remained at home until May 20, when he was discharged as "persistently unfit for war."[17] Until medical records are released, it is impossible to tell how much of Grosz's accounts were fabrications—roleplaying, perhaps. Desertions and nervous breakdowns, both real and feigned, were common in his circle of friends. One of them, the Bavarian poet Oskar Maria Graf, feigned insanity and spent a year at the Görden asylum.[18] Wieland Herzfelde struck an officer in the face with a glass and was saved only by a general amnesty of military prisoners on the Kaiser's birthday. After he was recalled, he went on a secret hunger strike until he had to be hospitalized and discharged as unfit for duty. John Heartfield spent part of the war in mental sanatoriums.[19] Grosz may have transformed his own hospital stay into a more heroic epic conforming to his friends' experiences. There is no record in the Krankenbuchlager in Berlin that Grosz deserted, was involved in any breach of discipline, or had any punitive measures taken against him. Nor is there any mention of Count Harry Kessler.

Returning to Berlin in May, 1917, Grosz was even more bitter, angry, and convinced of the insanity of society. His pre-war escape from an ugly world into art now seemed futile: "Art for art's sake seemed to me to be simply nonsense...I wanted to protest against this world of mutual annihilation...for at that time everything in me was gloomy protest."[20] Grosz's mood was fertile ground for the message of dadaism.

Dadaism came to Berlin in Richard Huelsenbeck. But dadaism was already in Berlin because dada was a state of mind, a state of mind which rejected not only the war as inhuman but also the society and the culture capable of producing that war, a state of mind which saw German—and European—culture as a massive swindle. In 1915–16 the circle of friends with whom Grosz associated had been humanitarians and liberals who were opposed to the war. By its last years, the war's actual horror and irrationality had shattered their idealism and turned them against the entire society and culture. Similarly disgusted, Richard Huelsenbeck had joined at the Cabaret Voltaire in

Zurich the dadaists who used total nonsense as a weapon against the mental state which could rationalize the human carnage of war. Returning to Berlin in January of 1917, Huelsenbeck maintained that as a dadaist he instinctively saw his mission to be the smashing of the cultural ideology of the Germans. This, he said, was "something startlingly new, since for the first time in history the consequence has been drawn from the question: What is German culture? (Answer: Shit), and this culture is attacked with all the instruments of satire, bluff, irony and finally, violence."[21]

In George Grosz, whom he met later that spring, Huelsenbeck found a man who possessed both the attitude and the ability to attack German society. In Huelsenbeck, Grosz found a man whose arrogance and scorn for all things German struck a responsive chord. For both these men, as for others who grouped around them, dada was not a movement or an ideological "ism." It was an attitude of opposition, it was action against, it was anti-, it was reaction, and it was absolutely real. Later George Grosz was to write:

The German dada movement had its roots in the perception that came to some of my comrades and to me at the same time that it was complete nonsense to believe that spirit or anything spiritual ruled the world. Goethe in bombardments; Nietzsche in knapsacks; Jesus in trenches. But there were still people who thought spirit and art had power. . . . Dada was not an ideological movement, but an organic product which arose as a reaction to the cloud-wandering tendencies of the so-called sacred art which found meaning in cubes and gothic, while the field commanders painted in blood.[22]

The war, Grosz believed, had forced the artist to his senses and had made him face the reality of existence instead of hiding behind his art. Those artists who awoke to the vast deception of society, to the great swindle of culture, became dadaists. "They said it did not matter whether a man blew a 'raspberry' or recited a sonnet by Petrarch or Shakespeare or Rilke, whether he gilded jack-boot heels or carved statues of the Virgin. Shooting still went on, profiteering still went on, people would still go on starving, lies would still be told—what was the good of art anyway? Was not art the pinnacle of deceit—?"[23]

These ideas were embodied in a huge oil painting which Grosz worked on throughout the dadaist period (Fig. 13). Named "Germany, a Winter's Tale," after Heinrich Heine's poem satirizing German philistines and Prussian officers, the painting attacked the world of the German

FIG. 13 Germany, a Winter's Tale, 1917–19, oil. Profile in lower left corner is a self-portrait.

burgher. Dressed in an army uniform, the burgher immovably and glut-
tonously occupied himself with beer, good food, and the local news-
paper while whores, sailors, hearses, violators of graves, and murderers
prowled a chaotic and disintegrating city. His dog lay peacefully and
faithfully beside him. Below him, the three pillars of honor and authority
in German culture bestowed their blessings on the scene: the pastor with
his prayer book, the general with his saber and medals, and the school-
master with his imperial flag and his copy of Goethe. The work stood
in Grosz's studio during the last years of the war and the revolutionary
period. It was destroyed by the Nazis (Fig. 14).

The elegant young man who sat aloof on the terrace of the old Café des
Westens before the war had grown into a dynamic and aggressive figure.
Hans Richter, a fellow dadaist, called him a "savage fighter, a boxer,
and hater His elemental strength was the life-blood of dada even
before the movement got under way." Huelsenbeck characterized him
as an aggressive man, full of contradictions, whose excitement and en-
thusiasm about things knew no bounds.[24]

The strength of his character was depicted by Erwin Piscator, who
came to know him in the excited days of January, 1919. On the streets
in the midst of fighting and rumors of fighting, Grosz, according to Pis-
cator, maintained the cool, detached stance of the cultivated English-
man. In the evenings, however, in the circle of his friends who gathered
in his studio, Grosz lost his cool demeanor. There, in what Piscator
called Grosz's Ministry, Grosz presided, dominated, and let loose a
whole barrage of wit and irony against the political situation and against
the establishment and its types.[25] Grosz was not the only dadaist who
possessed an aggressive, rebellious personality. Grosz's uniqueness lay
in his uncanny ability to translate his aggressive ideas into visual forms.
He could produce a tableau through pantomime and acting which would
vividly clarify the situation he was discussing; more important, he could
draw. He had already perfected a style of drawing which had been
characterized as one which cut through the pretensions and façades of
the time and revealed the essence. This graphic ability to unmask and
tear down Grosz now turned into a dada weapon.

The spirit of revolt and the negation of bourgeois values expressed
by Huelsenbeck attracted others in Berlin: Raoul Hausmann and Franz
Jung, who were publishing an anarchistic journal, Die Freie Strasse;
Johannes Baader and Hannah Höch, friends of Hausmann; Walter

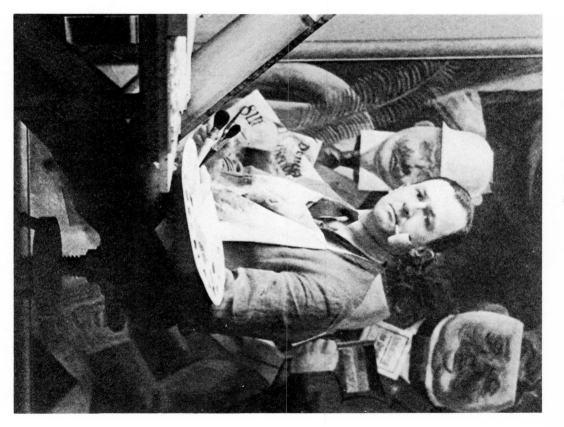

FIG. 14 Grosz in his studio in front of his large oil painting, Pillars of Society, 1926, which elaborated upon the stereotyped figures of Fig. 13.

Mehring, Wieland Herzfelde, and John Heartfield. Each of these was to hold his particular niche in Berlin dada—and his particular name: "Oberdada" Baader, "Dadamonteur" Heartfield, "Dadasoph" Hausmann, and "Propagandada" or "Dada Marchall" Grosz. This adoption

of pretentious names was part of the mask which the dadaists presented to society. Arrogant, scornful, they adopted aristocratic mannerisms in order to underscore their cocksure rejection of accepted bourgeois values, and dressed on occasion to parody the military orientation of German society. Huelsenbeck wore the uniform of an army doctor and a monocle and carried a riding crop; Hausmann and Grosz also wore monocles. Dada Marshal Grosz wore a frock coat or military clothes, carried gloves and a cane with a skull on it, hung around his neck a huge cardboard Iron Cross, and on his head wore a huge papier-mâché death's head. Armored in this insolent caricature of a Prussian general, Grosz carried the parody into his behavior. Even in private, he acted the role of a Prussian general, ordering people around, referring to people as swine, slapping faces with his gloves. He remembered, years later, incidents in which he deliberately insulted aristocrats and officers in bars and on the streets. As part of their effort to ridicule and unsettle the comfortable society, the dadaists all carried little stickers with enigmatic messages — "Dada siegt," "Dada über alles" ("Dada conquers," "Dada, Dada over all") — which they stuck in such unlikely places as office staircases, café restrooms, and police stations.[26]

By the spring of 1918, it became clear that personal behavior and ridicule were insufficient as a means of propagating dada. Starting in February and continuing sporadically for two years, the dadaists held soirées, evenings of readings, and lectures. These were modeled on the nightly cabaret programs of the Cabaret Voltaire in Zurich; but since Berlin dada never had a cabaret base, its evenings of entertainment were not so frequent.

In February, in the Berlin gallery of J. B. Neumann, Huelsenbeck and Hausmann arranged an evening of readings by various authors. It reached its climax with a speech by Huelsenbeck, which included recitation from his *Phantastische Gebete* (Fantastic Prayers, 1916), and with Grosz performing an obscene tap-dance in which he relieved himself in pantomime before a Lovis Corinth painting — "Kunst ist Scheisse!" ("Art is shit!"). The combination of Grosz, Huelsenbeck, and Hausmann, who had performed earlier, was too overwhelming for the audience which literally rose in rage.[27]

On April 12, 1918, in the Neue Sezession hall in Berlin, the dadaists again performed. Huelsenbeck read the first German Dada Manifesto, which was later published over the signatures of Grosz, Huelsenbeck, Hausmann, Franz Jung, four from Zurich dada, and twelve others. The manifesto began with the declaration that: "Art in its execution and

direction is dependent upon the time in which it lives, and artists are creatures of their epoch. The highest art will be that which in its conscious content presents the thousandfold problems of the day, the art which has been visibly shattered by the explosions of last week, which is forever trying to collect its limbs after yesterday's crash."[28]

The manifesto was a ringing condemnation of expressionism as an art form. The dadaists' reason for choosing it as a primary target was, as explained by Huelsenbeck, that expressionism was suddenly coming into vogue in Germany. This, they believed, was the German middle class way of escaping reality. When Germans were unsuccessful as soldiers—or butchers—they tried to become poets and artists. The bourgeois society was trying to take refuge from the realities of war by turning to the soul and emotions of expressionism. Therefore, the dadaists castigated the movement, exposing it as useless.[29] Dadaism was Grosz's first conscious rejection of expressionism.

The manifesto attacked all forms of aesthetic or ethical attitudes and all preoccupation with soul; it called for a new attitude which could express life "as a simultaneous muddle of noises, colors, and spiritual rhythms." The dadaist was the activist who affirmed the screaming and tearing of life in all its brutal forms. "Affirmation-negation: the gigantic hocus-pocus of existence fires the nerves of the true dadaist—and there he is, reclining, hunting, cycling—half Pantagruel, half St. Francis, laughing and laughing."[30] Laughing and laughing, the dadaists in Berlin plunged into their campaign to convince the Germans of the bankruptcy of their society and culture. Their motto became "Kunst ist Scheisse."[31]

Uproarious meetings, provocative meetings, disturbing meetings were held; the bourgeoisie was insulted but kept coming. Other recorded meetings were held in June, 1918, in the Café Austria in Berlin; on December 7 and 13, 1919, in Berlin-Charlottenburg in the avant-garde theater, the Tribune; on April 30, 1919, in the Meister Saal, Berlin. In January and March, 1920, Huelsenbeck, Hausmann, and Baader made a lecture tour to Karlsbad, Leipzig, Dresden, Prague, and Teplitz.[32] Of the participants and programs of each of these evenings, there is no accurate record, though numerous incidents from the soirées have been preserved. For example, at a dada soirée on May 24, 1919, Mehring and Grosz put on a "race between a sewing machine and a typewriter." Mehring was the featherweight at the typewriter and Grosz was the world champion at the sewing machine.[33] As dadaism in Berlin took on a political

complexion in 1919, the meetings became less humorous and much more political. By the 1920 lecture tour, Hausmann, Huelsenbeck, and Baader were considered to be holding frankly revolutionary meetings, favoring the Soviet Union, even though they were definitely not official communist meetings. The dada soirées and matinées were shocking and outrageous; they were, however, ephemeral in their content and ultimate effect, though the police were said to take them very seriously, as did the press.[34] Newspapers wrote of a dadaist conspiracy. Huelsenbeck wrote that the newspapers in Prague had stirred up fury in the city over the coming of the dadaists for lectures on March 1 and 2, 1920. He gave a lively account of seething mobs crowding around the lecture hall, threatening Hausmann and himself before their performance.[35]

By combining insult and humor, dadaism tried to reveal the hollowness of culture and society. With the collapse of the German military machine and the imperial government in November, 1918, established society and culture seemed to crumble, and dadaism had to reorient itself. From its role of "épater les bourgeoisie," dadaism moved into the political arena. At first the dadaists threw themselves into the revolution against the bourgeoisie; under the impact of events, they rapidly moved into the revolution against the Majority Socialist government, which they insisted was still bourgeois. The leaders within Berlin dada in this evolution were Grosz, Herzfelde, Heartfield, and Jung. The others, including Huelsenbeck, Hausmann, Baader, and Mehring, went along in opposition to authority and in vague sympathy with the proletariat.[36]

The insulting laughter of dada was now, in 1919–20, turned into an assault upon the ruling classes. The dadaists attacked the Weimar Republic as a fraudulent bourgeois institution which was deserving only of ridicule. They published several mocking satirical papers which were meant to combine political revolutionary attitudes with dada's outrageous sense of nonsense. The derision in these papers, however, overrode the positive political statements.

Der Dada was the brain child of Raoul Hausmann, who edited the first two numbers in 1919. Grosz was one of several who contributed to the second issue and then he became a co-editor of the third number. The second number expressed well the basic attitudes of the three issues. Its lead article by Hausmann called for an end to all philistine culture and claimed that art was dead, spirit was dead, and German expressionism was dead. The second major article proclaimed Johannes Baader, the "Oberdada," to be the president of the earth and of the terrestrial ball.

A satirical spoof, a dada spoof, this manifesto was a denigration of political action, as was Baader's action in scattering leaflets over the Weimar National Assembly announcing his own presidency of Weimar and the earth. No alternative was given in *Der Dada* to philistine culture and politics except dada and the "Oberdada." Dada was defined by negation. The question, "What is Dada?" was answered by questions: "An art? A philosophy? A politic? A fire-insurance? Or a state religion? Is dada really energy? Or is it Nothing, i.e., Everything?"[37]

Grosz's participation in dadaism was intense and without reservation; dadaism was the perfect revolutionary expression of his own doubt and skepticism. A poem which he wrote for a dada poster summed up the way in which Grosz tried through dada to affirm his disbelief:

Extrablätter fliegen hoch! Friede
Im Westen regnets Granaten
Und zerfetzte Soldaten
Im Pavillon Mascotte wird viel Sekt konsumiert
Heinlich tanzt Lieschen im Kunstclub —
GESTEIGERTE TURBULENZ DER WELT!
rede UND Gegenrede!
!!MUT: den widersinn des daseins zu BEJAHEN!!
!! den GIGANTISCHEN Weltenunsinn!!
Gelang vom Hinterteil der Welt!

Special editions fly high! Peace
In the West rain down grenades
And hacked-up soldiers
Much champagne is drunk in the Mascotte Pavilion
Little Lisa dances secretly at the Art Club —
INTENSIFIED TURBULENCE OF THE WORLD!
confirm AND deny!
!!COURAGE: to AFFIRM the absurdity of existence!!
!! the GIGANTIC nonsense of the universe!!
Accomplished by the rear-end of the world.[38]

Richard Huelsenbeck has claimed that dadaism was inscribed on Grosz's very being. "George Grosz was, as long as I knew him, a man of contradictions. If he said Yes, he usually meant No. He lived to the full the irrational and the paradox of dadaism in his own life."[39] Grosz summed up this period in his thinking as the point when he realized that art and culture had been a great illusion: "Dadaism was our awakening from this self-deception. We saw the final excrescences of the ruling

order of society and we burst out laughing." The laughter did not last long, for with the coming of the November Revolution, Grosz and his friends realized that behind the madness lay a system — capitalism — which could not be fought with laughter alone. Though some of the dadaists remained lost in nihilism, Grosz felt that he had a new duty — to place his art in the service of the revolutionary classes.[40]

PART II

The Angry Artist, 1919-23

CHAPTER 3
SPARTACIST PAMPHLETEER

SINCE THE OCTOBER REVOLUTION IN RUSSIA, both Wieland Herzfelde and John Heartfield had been convinced that revolution was the only and inevitable solution for Germany. Admirers of Karl Liebknecht ever since his vote against war credits in 1914, they thought of themselves as being part of the international revolutionary movement.[1] Grosz remained highly skeptical of these revolutionary hopes. He said that one had only to look at the socialists' talk about the brotherhood of all workers before the war and then their voting for war credits once the war began to realize that a revolution based upon the solidarity of the working classes was an illusion.[2] Nevertheless, the events of November, 1918, appeared at first to have given the lie to Grosz's skepticism, for, following a naval mutiny in Kiel and Wilhelmshaven, revolution spread throughout Germany, culminating on November 9 in the abdication of Kaiser Wilhelm II and in the proclamation of a republic.[3] The equivocal nature of the German revolution was revealed at its inception: a democratic republic was declared by Philipp Scheidemann, a member of the new socialist cabinet, simply to forestall the proclamation of a soviet republic by Karl Liebknecht. Grosz had not been altogether wrong. One of the tragedies of the German revolution was the lack of solidarity in the working class parties. The division of the socialists into the Majority Socialist party (SPD), the Independent Socialist party (USPD), and the Spartacus League — radical wing of the Independents which later became the German Communist party (KPD) — meant that there was a marked difference in revolutionary expectations and aims.[4] The Majority Socialists, who headed the new government under Friedrich Ebert and Philipp Scheidemann, felt that the revolution was achieved with the

fall of the imperial government and saw their task as one of consolidation, of bringing order out of the revolutionary chaos. On the far left, the Spartacists under Liebknecht and Rosa Luxemburg, believing that the revolution was only beginning, called for the continuance of the revolution in the streets by the workers until a true dictatorship of the proletariat was attained. The unhappy and ironic outcome of these fundamental differences was that within a month, December 6, the Majority Socialist government — the traditional working class party — had called in soldiers from the old imperial army to fire upon workers demonstrating in the streets. Thus the pattern was established which ultimately contributed to the demise of the Weimar Republic in which the republic failed to combat, in fact relied too often upon, reactionary forces while it alienated the working classes.

When the revolution began, however, Grosz welcomed it. "To all of us and to me, it seemed as if the gates opened and light came through."[5] The revolutions of 1919 which spread across Europe at the end of the war seemed to many people to herald the springtime of a new world, a great and bold time when visions of a just society held a promise of fulfillment. Workers and intellectuals alike were captured by dreams of brotherhood and equality of men. Romantic projects for the revitalization of society and culture mingled with hopes of abolishing hunger and disease.[6] After first sharing those dreams of a new day, Grosz rapidly lost his illusion that the revolution had been achieved: "Soon the gates were closed and shut with double locks. This alerted many of us to the necessity of defining our political position."[7] Watching the events of November and December and listening to the attacks of Karl Liebknecht and Rosa Luxemburg upon the Ebert-Scheidemann government, both the Herzfeldes and Grosz soon felt that the November Revolution in Germany had been a fraud. The Majority Socialists had substituted new faces in the old imperial regime, but had not carried out a revolution in any sense of the word: the ruling classes were in power still; the proletariat had been betrayed. They agreed with the Spartacus League in its call for continuing the revolution.

Convinced of the necessity for a second revolution in Germany, the radical revolutionaries of the Spartacus League decided to form the Communist Party of Germany–Spartacus League by splitting from the Independents in which they had been an uneasy faction. The founding congress, held in Berlin December 30, 1918–January 1, 1919, had eighty-seven delegates and sixteen guests from Berlin and different parts

of Germany. In all, the KPD in 1919 had only a few thousand members in Germany, with barely fifty members in Berlin itself.[8] With this small but vocal group, Grosz and his friends decided to throw their lot. On the night of December 31, 1918, Grosz, Herzfelde, Heartfield, and Erwin Piscator joined the Communist party, receiving their membership cards from Rosa Luxemburg herself.[9]

The dadaist who thumbed his nose at all values and who proclaimed his independence from illusion was transformed into a Communist party member who had to accept certain propositions about society which were tantamount to articles of faith and which were by no means free of illusions. Grosz's own explanation, while facile, captured the essential reason. Looking back in 1943 he said: "Then the Weimar Republic went reactionary. It formed the Free Corps, composed of ex-soldiers, and they slaughtered thousands of workers. . . . Everything was mixed up, but already one thing was clear. There were the people and there were the fascists. I chose the people."[10] Was the terror levelled against the workers sufficient to overcome his earlier loathing of the common people? Perhaps it was, because Grosz's commitment to Spartacus became strongest after the brutal suppression of the workers in the January and March uprisings of 1919. Furthermore, the use of the newly organized Free Corps of returning soldiers to quell the uprising, and the apparent alliance between the socialist government and the members of the General Staff, made the alternatives seem clear-cut. One supported the old ruling classes or the people. Grosz reiterated constantly throughout his life that he never had any love for or trust in the masses. He stood, therefore, on the side of the masses, not because he had any illusions about them, but because of a shared hatred of their enemy.

Grosz claimed that he lacked the gentle faith of a reformer. He was instead filled with the aggressive hatred of a revolutionary, and for half a decade this revolutionary passion carried him into political affirmation and commitment which, paradoxically, was also grounded in his basic negation. Grosz was an individualist who hated authoritarianism and its adjunct militarism; he was a realist who saw through the weakness, hypocrisy, and stupidity of the average man; he was a pessimist who saw an ever-present evil in the world. In particular, Grosz hated the ruling classes of Germany—the burghers and the aristocrats, the militarists and the judges—the classes responsible for suffering and injustice during and after the war. In the confusion of the revolutionary days at the end of the war, Grosz's attitudes fitted into the Spartacists'

fight against continuing German militarism and against the socialist government which they identified with the ruling classes.

Within two weeks after joining the KPD, Grosz and his friends watched the SPD government crush the revolution. An uprising of workers in Berlin was broken by 150 Free Corps companies rapidly organized by the SPD minister of defense, Gustav Noske. Using machine guns, four-inch artillery, flame throwers, and trench mortars against the rifles and grenades of the workers, the Free Corps left 100 workers dead and 400 wounded, while losing 13 dead and 20 wounded soldiers.[11] Though the uprising was only reluctantly sanctioned after it began by the KPD-Spartacus, the rebels were all known as Spartacists and the term continued to be applied to anyone on the left who revolted against the government. The death toll extended beyond the working classes to the leadership of the party. On January 15, Rosa Luxemburg and Karl Liebknecht, upon whose heads a price had been placed, were captured by the Free Corps and viciously murdered. The official version of Liebknecht's death—he was beaten until semi-conscious and then shot—was "Shot while trying to escape," a phrase which was repeated with ominous frequency in the next years.

Historians agree that the January uprising and the manner of its suppression was decisive in the history of the Weimar Republic. A. J. P. Taylor concludes: "The Spartacists were broken; but broken too was the life of the German republic, for it could not exist without a united Socialist movement, and now the blood of Liebknecht and Rosa Luxemburg ran forever between the associates of Ebert and the men of the Left."[12] Grosz, who was one of those men on the left, expressed the same idea in concrete form. In a drawing published in 1936, Grosz portrayed a threatening German hangman-judge rising out of the coffins of Liebknecht and Luxemburg, from which flows a trail of blood (Fig. 15).

At the time of the deaths, Grosz and his friends decided to dedicate themselves to fighting the traitors of the revolution. Herzfelde and Heartfield immediately tried to organize a strike of the staff at Ufa, where they were both working. Their efforts failed and resulted in their being dismissed.[13] Herzfelde then returned to publishing as a propaganda tool, reviving the Malik Verlag, which had been banned in 1917. The first new publication was *Jedermann sein eigner Fussball* (Every Man His Own Football).

Two days after Luxemburg's murder, on January 18, 1919, Count Harry Kessler talked to Herzfelde about forming a new literary, political,

and artistic journal in the tradition of *Die Aktion*. They decided it should be inexpensive, aimed at sale on the streets, and that its typography should be the work of Heartfield. In reply to Kessler's query as to who among the young writers and artists held Spartacist-bolshevist ideas, Herzfelde mentioned Däubler, Grosz, himself, and others associated with them.[14] Ten days later, Herzfelde breakfasted with Kessler to discuss the preliminary layouts of the new journal. Since it contained a fantasy

FIG. 15 Remember, 1919. *Interregnum*, pl. 35.

by Grosz called "Jeder Mensch sein eigener Fussball," Kessler suggested this should be the name of the paper. Herzfelde told Kessler that Grosz was to be the major co-worker on the journal, which they envisioned as being partly grotesque and partly serious in content. Grosz was planning a series on "der schöne deutsche Mann" (the handsome German man). Their goal for the journal was to drag "all that the Germans have loved up till now into the mud" and expose all the German ideals to fresh air. Kessler was also told that they planned to hawk the first issue on the streets.[15]

Jedermann, according to Herzfelde, was the first journal to make conscious use of photomontage in the cause of political agitation. The cover set the tone for the journal's ridiculing of the Majority Socialist government. On it was an announcement of an essay contest on "Who is the handsomest?" The contestants were to decide among a group of portraits of distinguished men which were displayed within the outline of a Japanese fan on the cover. This beauty contest was an affront to authority and a mocking of the German habit of veneration of those in authority, because the portraits were of General Hindenburg, Ebert, Noske, Scheidemann, and other members of the government.[16]

Walter Mehring and Herzfelde have recorded the story of *Jedermann*'s sale on February 15, 1919. They hired a little band which played sentimental military airs, dressed in frock coats and top hats, and rode in a horse-drawn carriage. Behind the carriage walked the friends who had created and contributed to *Jedermann*, each carrying bundles of the journal and shouting the title of his contribution to the journal. They started at the Kaiser-Wilhelm-Gedächtniskirche in Berlin's west end where they received mostly taunts. As they reached the lower middle and working class districts, they were received with delight. When police on horseback stopped the procession near the Alexanderplatz, the whole edition of 7,600 copies was sold out. According to Herzfelde, the events of the afternoon ended when the friends fled from the police. Mehring, however, recounts an extended sequel: the success of the sales inspired the friends not to disappear, but to serenade the Wilhelmstrasse government offices with a dada song which Mehring had written for *Jedermann*—"a really distressing, obscene piece of anti-militarism." They were arrested, writes Mehring, and were charged with "seeking to bring the Reichswehr into contempt and distributing indecent publications." The charge was brought specifically against Herzfelde as editor and Mehring as author at a hearing

before the Moabit district court. The prosecution, recalls Mehring, demanded eight months' imprisonment for each. The defense called Dr. Gottfried Benn, the physician-poet, to give medical testimony on the relationship between sexual pathology and satire in order to support their plea of mitigating circumstances. Mehring's account of the arrest and trial has a tongue-in-cheek tone and Herzfelde remembers neither the serenade, the arrest, nor the hearing. Whatever happened, the actual outcome was that the publication and sale of *Jedermann* was permanently banned.[17]

Because the sale of *Jedermann* had been so phenomenal and because it had been immediately banned, Herzfelde, Heartfield, and Grosz lost no time in bringing out another issue under a new name, *Die Pleite* (Bankruptcy). The first issue of *Die Pleite*, which appeared early in March, 1919, defined the editors' political position by printing the "Invitation to the First Congress of the Communist International."[18] This invitation had been broadcast on January 24, 1919, by the Soviet government radio to revolutionary groups throughout the world; on the same day it was printed in *Pravda*. The call came primarily from the Russian bolshevik leaders, although representatives of seven other revolutionary parties also signed it.[19] The founding congress of the Third International or Comintern which met on March 2 in the Kremlin, was in session at the time of *Die Pleite*'s publication of the invitation. By publishing it, the three editors both informed their readers of the principles on which the new Communist International was to be based and also endorsed those principles: that the League of Nations was a tool of capitalism to fight revolution, that the socialists — "social traitors" — were working with the bourgeoisie to deceive the proletariat, that the time had come for the proletariat to seize power, to establish its dictatorship, and to begin the immediate nationalization of industry, commerce, and agriculture.

The second article in this issue of *Die Pleite* was a restatement of the principles presented in the invitation to fit the German scene. It spelled out the bankruptcy of the Majority Socialists and pointed to Spartacus as the only way to make a humane society for all men. It accused the SPD of undermining the revolution, of selling out to the bourgeoisie, of spilling the blood of workers, and of promising peace but failing to punish those responsible for the war. Furthermore, it accused them of trying to buy the support of the Entente powers by fighting bolshevik forces and by creating an army of counterrevolution,

instead of allying themselves with their natural friend, the Soviet Union. Lastly, the article chastised the SPD leaders for not realizing that revolution was more than parliamentary deals and changes and for failing to make changes in the educational and judicial systems of the nation.[20]

Grosz's drawings in this issue of *Die Pleite* concentrated upon ridiculing and satirizing the Majority Socialist leaders. On the cover he

FIG. 16 By the Grace of Money Bags, *Pleite*. GhK, p. 4, as Out of the Life of a Socialist.

portrayed a fat, capitalistic chancellor Ebert, sitting in a soft armchair, his feet on a soft pillow, cigar in hand, wearing a monocle, a Kaiser Wilhelm goatee, and the Kaiser's crown with a crooked cross on top. He is being served champagne in an immense wine snifter by a supercilious officer (Fig. 16). On the inside pages, Grosz caricatured Noske, Ludendorff, and Scheidemann: Philipp Scheidemann, who had proclaimed the republic on November 9, is seen as the Apostle Philip who had promised—in vain—daily bread since November; Gustav Noske, who had organized the Free Corps to quell the January uprising, in a Prussian officer's uniform kneels on a prone, ghastly body—possibly Liebknecht—whom he is both throttling and hacking with a sword; General Ludendorff, pulling a toy cannon, returns to the republic, where he is received by an obsequious Ebert and Scheidemann. In a positive vein, Grosz drew a strong but suspicious worker standing before a Prussian general, a clergyman, and a judge, all of whom are hostile and decadent. The title was "Spartacus in Court—Who Is the Hireling?" (Fig. 17). There could be little doubt as to the political position of this news-

FIG. 17 Spartacus in Court—Who Is the Hireling?, *Pleite*. GhK, p. 36. Compare the reversal of roles in Fig. 20.

paper; it considered itself to be a voice of Spartacus in Berlin and of international communism. Grosz considered it to be an outstanding experiment in creating a genuine communist satirical journal.[21]

After the January uprising in Berlin, revolutionary strikes and uprisings had spread across Germany. In one city after another — Bremen, Mühlheim, Halle, Brunswick, Dresden, Leipzig — the Free Corps had ruthlessly crushed the revolts. On March 3, 1919, a general strike was called by the Communist party. Street fighting again broke out in Berlin. The crowds of workers, sailors, and soldiers, estimated at fifteen thousand, took police stations and railroad terminals. This time Noske brought in forty thousand Free Corps who again used heavy machine guns, trench mortars, howitzers, flame throwers, and even strafing and bombing airplanes against the rebels. By March 16 twelve hundred people were dead.[22]

The authorities considered Herzfelde dangerous because of his publications; he was taken into "protective custody" on the evening of March 7 after the police had identified him as editor of *Jedermann*. They had already smashed open the door of the press and had confiscated copies of *Jedermann*, *Neue Jugend*, drawings, posters, and letters. The police took him to the Eden Hotel, headquarters of the Free Corps, where he was neither given a hearing nor allowed to make a statement. Handed over to soldiers, he was confined overnight in a small hut in the zoological gardens, along with a little group of citizens and workers. They were moved the next night by soldiers of the Reinhard brigade to the Lehrter state prison, where the Free Corps soldiers had reached a fever pitch of hatred against the Spartacists. Berlin was swamped with rumors of Spartacist terrorism; the most dreadful rumor was that the Spartacists had massacred the entire Lichtenberg police garrison. Later, it was determined that only five policemen had been killed, but during the height of the street fighting, March 9–13, the "Lichtenberg massacre" was used as an excuse for killing workers or anyone suspected of being a Spartacist.[23]

When Herzfelde's group arrived at the Lehrter prison, a sailor who was with them was beaten to death before the rest of the group was packed into cells. Through the night and the next day, they listened to the blows and the screams as the soldiers beat and killed arriving prisoners who were said to be "Lichtenbergers" or responsible for the Lichtenberg massacre. Again at night Herzfelde was marched with a large group

under harrowing conditions to the Plötzensee prison, where he was held until March 20, four days after the street fighting had died down.

Released from prison, he went to Robert Breuer, deputy press chief of the Reich Chancellery, to inform him of the situation in the prisons. Breuer's response was to warn Herzfelde to stop his publications or he would be arrested again. The warning, Breuer told Herzfelde, applied to George Grosz also. In contrast, Count Harry Kessler obtained hearings for Herzfelde with his friends in influential positions and gave Herzfelde's written report of his experiences to other friends, including Gustav Stresemann. As a result of Kessler's intercession, Herzfelde's report was printed in the liberal republican daily, *Vossische Zeitung*. At the end of March, it was published as a brochure, *Schutzhaft* (Protective Custody), which took the place of the second number of *Die Pleite* and had a Grosz drawing on its cover.[24]

What happened to George Grosz during these days can be inferred from other incidents. Mehring reported that at one point during these revolutionary days, a lieutenant and five men barged into Grosz's studio, searched it, and asked Grosz if he was the artist Georg Grosz. Presenting a false military pass, Grosz answered, rudely, and coldly, in an American accent: "Nope! Tue ich nicht kennen! I'm a cartoonist!" Mehring believed that only Grosz's arrogance saved him from being recognized and arrested. Perhaps this same cool behavior prevented later arrests. Mehring also recalled that on the night Wieland was arrested, he, Mehring, was at Grosz's studio when Carl Einstein came to warn them that Wieland and Johnny had been arrested and that they must flee.[25] Grosz fled to his fiancée's home on Savignyplatz, where his future mother-in-law, Anna Peters, hid him during the most critical days, despite the risk entailed in harboring a Spartacist.

Kessler noted in his diary on March 14 that Grosz appeared to be back, since he had received a letter from him written from his studio. Two days later when Kessler visited his studio, Grosz declared that his experiences of the past ten days had made him into a convinced Spartacist. He told of the artists and intellectuals who were in continual flight from the government soldiers, of the shattering experience of watching the embattled Spartacists fighting to their death for an idea, of the brutal ruthlessness of the Free Corps soldiers who shot revolutionary soldiers and workers in cold blood. In the vicinity of the Eden Hotel, he had seen an officer kill a soldier simply because he had no pass and had not been properly polite. Kessler commented that he was sure Grosz was

sheltering a political fugitive at the time of his visit. More remarkably, he said that Grosz felt himself to be safe and was already preparing the next issue of *Die Pleite* with even more biting caricatures.[26]

The shared experiences of the March days —Herzfelde's accounts of the brutality of the troops towards the prisoners and Grosz's experiences on the streets, fleeing and helping others to flee —were expressed in the bitterness and hatred which Grosz poured into his vision of the republic and the militarists smashing the working class. This hatred received its fullest expression on the cover of the third number of *Die Pleite*, which appeared in early April, 1919. Entitled "Prost Noske! —The Proletariat Is Disarmed!" (Fig. 18), it depicted the prototype of a Prussian officer, with a wine glass and a bloody saber delicately lifted, astride a bloody mangled tangle of bodies and barbed wire. Grosz's macabre use of detail underlined the horror of the gutted and dismembered bodies, the dead women clutching dead babies, and the badly battle-stained wall of monotonous windows stretching across the background. Tucholsky called this drawing, "the strongest political pamphlet of our time."[27] A second drawing in this number hammered on the same theme: death and the officer corps (Fig. 19). In it, a military doctor examining a wormy skeleton declares it to be fit for active service, while around the room are a collection of military types —general, staff officer, enlisted man, medic, each with a particular expression of arrogance or stupidity. The articles in this number called for the abolition of private property, mocked the Reinhard brigade, called on the proletariat not to forget the deaths which resulted from the "Lichtenberg massacre," and attacked the capitalist states for trying to buy off the revolution by exploiting the hunger of the working classes. A brief satirical letter from "one who was arrested but not beaten to death," undoubtedly Herzfelde, purportedly vindicated the honor of the Free Corps by pointing out that they could have murdered *all* of the Spartacists who fell into their hands instead of only a portion of those arrested.

The drawing of the wormy skeleton surrounded by military types became one of Grosz's most famous ones. He reprinted it in 1922 in "*Gott mit uns*" under the title "The Faith Healers" and in 1921 in *Das Gesicht der herrschenden Klasse*. It has peculiar interest because of its striking similarity to Bert Brecht's "The Legend of the Dead Soldier" —a bitter satire on the disinterring of a dead soldier whose corpse was then pronounced fit for military service.[28] These statements of the same idea came from two men whose attitudes and creations were often remarkably

FIG. 18 Prost Noske!—The Proletariat is Disarmed!. *Pleite*, GhK, p. 32, as Prost Noske! The Young Revolution Is Dead. The drawing in *Pleite* does not have the impaled baby.

similar. Frequently Brecht's writing seemed to be a verbal statement of Grosz's drawings. In this instance, both men may have been inspired by the saying "Man gräbt die Toten aus" ("They are digging up the dead"), circulating at the end of the war.[29] Herzfelde, however, in his comments

FIG. 19 Dedicated to the Doctors of Stuttgart, Greifswald, Erfurt, and Leipzig, *Pleite*, Gmu, pl. 5, as The Faith Healers. GhK, p. 30, as The Faith Healers or the Fit-For-Service Machine. Gez., p. 71.

on the manuscript claims that in the 1950s Brecht told him that Grosz's drawing had inspired him to write his ballad.

Three more issues of *Die Pleite* appeared in which Grosz continued to attack the officer caste and the soldier type within the republic while Herzfelde attacked the SPD and its betrayal of the proletariat. In May of 1919, the cover drawing showed workers marching in a circle within the heavy walls of a prison watched over by a vicious-looking officer; the title was "Mayday in Plötzensee." This issue appeared in ten to twelve thousand copies, according to Kessler.[30] The December 15, 1919, cover portrayed "The German Plague," a German soldier, while the back

cover presented Gustav Gessler, defense minister, praying to the hat of liberty, surrounded by the whole panoply of German militarism from the general down to the marching foot soldier. This issue featured a report on the Marloh trial as a means of exposing the connections between the government and the right-wing militarists.[31] On the January, 1920, cover, capitalist and general, each hanging from a gibbet, wished each other a happy New Year. The articles, poems, and short plays were serious or satirical, but they all incorporated the same themes of the betrayal of the revolution, the failure of the SPD, and the increase of militarism. Against these evils, *Die Pleite* upheld communism.

The January, 1920, number of *Die Pleite* was the last one to appear alone. The journal, repeatedly banned by the government, was completely suppressed after the sixth issue. About this time, Grosz collaborated with Carl Einstein to produce another political satirical paper which was similar in format to *Die Pleite*. In their advertising brochure, the two editors guaranteed that their paper, *Der blutige Ernst* (Deadly Earnest), would provide "deadly efficacy against the bourgeois ideologies." Their aim was to appeal to the masses, not to literary cliques, to identify the sickness of Europe, to portray the collapse of the continent, to fight the ideology and establishment which lay behind the war, and to establish the bankruptcy of western culture.

Each issue of *Der blutige Ernst* attacked a portion of the ruling classes: the militarists, the profiteers, or the bourgeois. Published sometime in 1920, the third number was devoted to "the guilty ones." George Grosz's cover made quite explicit the fact that the guilty ones were the old ruling military aristocracy, because it portrayed a tribunal of workers sitting under the portrait of the Spartacist leader Karl Liebknecht, judging monocled and manacled officers. The picture was captioned: "How the State Courts Ought to Look" (Fig. 20). Three other full-page Grosz drawings dominated the issue, each one underscoring the guilt of the military in bringing about the decay of society. One of these drawings is among Grosz's most famous and vitriolic. Entitled "Pimps of Death," it presents Generals Ludendorff and Hindenburg against a background of prostitutes whose heads were death's skulls surmounted by military caps (Fig. 21). Carl Einstein amplified the attack on the military with a bitter satire called "Ludendorff's Diary."

The fourth number of *Der blutige Ernst* attacked "the profiteer." Grosz's cover linked the bourgeois profiteer and the prostitute, both of whom batten upon society. A double-page drawing in the center of the issue portrayed wealthy profiteers enjoying themselves in a whore house.

FIG. 20 How the State Courts Ought to Look!, *Blutige Ernst.* GhK, p. 13.

The verbal counterparts of these drawings were Einstein's long essay on profiteers as the ultimate development of bourgeois democracy, and Mehring's and Huelsenbeck's poems on profiteers and profiteer politics. The theme of the sixth number was "Schulze," the eternal and interna-

FIG. 21 Pimps of Death, *Blutige Ernst*. Signed Böff, 1919. Gmu, pl. 6, GhK, p. 29.

tional bourgeois. Einstein, Hausmann, Max Herrmann-Neisse, and Mehring all contributed delightful satires describing Schulze—his soul, his habitat, his friends, and his occupation. Grosz provided three excellent drawings of Schulze-types, a collage of newspaper clippings and photographs to portray the soul of Schulze, and an obscene drawing of all the memories and drives embodied in Schulze psychoanalyzed. The cover of this issue was a photomontage depicting the cross and generals as Schulze's background.

Though *Der blutige Ernst* was not so explicitly communist as *Die Pleite*, together they constituted a strong attack upon the ruling and exploiting classes in the first years of the republic. *Die Pleite*, which had been banned, appeared again later in 1920 as the satirical section of the journal *Der Gegner* (Adversary), published by Herzfelde and Julian Gumperz under the imprint of the Malik Verlag. Gumperz, who had been publishing *Der Gegner*, now joined with Herzfelde and *Die Pleite* to form a cultural and political monthly dedicated to fighting exploitation and to deepening revolutionary attitudes. For two and a half years, 1920–23, *Der Gegner* supported the struggle of the proletariat by Grosz drawings, by writings about and for the Soviet Union — articles on Soviet literature, economic problems, art, and politics — and by promoting the work of Piscator in the proletarian theater. A typical example of *Der Gegner* was the title page of the March, 1922, issue, which featured a Grosz drawing of a worker with uplifted fist standing over the graves of the March martyrs (see Fig. 49); the drawing accompanied an editorial pointing out the workers' struggles of each March since 1919 and calling for a new March, which would bring fulfillment to the hopes of the proletariat.[32] In the summer of 1923, the KPD was able to bring out its own satirical journal, *Der Knüppel* (The Cudgel).

As a satirical newspaper of the KPD specifically for the working class, *Der Knüppel* was more didactic and heavy handed than *Die Pleite* had been. The caricatures and cartoons constituting a major part of the paper usually had long captions which made the meaning of the cartoon unmistakably clear. Names of editors or major contributors were not listed in the papers. This practice was probably a precaution against police action, as was the use of nicknames to sign articles and cartoons. Herzfelde states that Heartfield and Grosz provided the leadership for *Der Knüppel* and were responsible for gathering their friends to collaborate with them. Among the friends were Rudolf Schlichter, Otto Schmalhausen, Alois Erbach, Frans Masereel, and Otto Dix.[33] Confirmation of Grosz's position of responsibility for the journal exists in a letter written to Grosz by Tucholsky from Paris in March, 1925, in which Tucholsky thanked Grosz for publishing one of his articles in *Der Knüppel* but raised some questions about the poor satirical quality of the paper, and concluded that the contributors must be paid adequately in order to ensure a measure of quality.[34] Grosz not only helped organize the journal, he also published his own drawings. In the twenty issues which appeared from the middle of June, 1924, through early November, 1925,

forty-four drawings can be definitely attributed to Grosz. These drawings were either signed by Grosz as Böff, Ehrenfried, or Baldur, or were published later in one of Grosz's portfolios. There are quite a number of other drawings which are in the George Grosz style, but cannot be definitely identified as his work. The identifiable Grosz drawings fall into categories which reflect the basic themes of the journal.

Grosz's major theme, played with many variations, but never so subtle as to be misunderstood, was the exploitation of the worker by the alliance of military and capital under the blessing of the republic. The most didactic of these drawings appeared on July 25, 1924, and presented a beribboned general with a little Hitler on his lap sitting back to back with a top-hatted capitalist wielding a knout (Fig. 22). The caption is "For the Fatherland." Beneath them, above the caption "To the Slaughterhouse," is a line of emaciated, blindfolded workers bound together with fetters, being pulled along on a rope by an officer.

The betrayal of the worker by the republican government was a variation on Grosz's main theme. The June, 1925, cover depicted a worker with his hands held in surrender above his bloodily bandaged head; an anonymous bayonet is pointed at his chest, but the poem underneath makes it plain that the bayonet was supplied to the ruling classes of Bulgaria by the Social Democrats of Germany in order to quell the Bulgarian workers (see Fig. 51). In the January 25, 1925, issue, Grosz drew a crippled old man with a peddler's tray around his neck and a dog behind him. The drawing was dedicated to the Reichspresident with this couplet: "For what I am and what I have, I thank you, my fatherland."

Grosz had used this theme in the election issue of December, 1924, in a full-page drawing which resembles a poster. Against the colors of the republic, a beggar's hand stuck through his crutch and held out an old soldier's cap. The caption: "The gratitude of the fatherland is always assured you. Shot off limbs, unemployment, 'the ax,' miserable living conditions, illness, permanent infirmity, cold, hunger, ragged clothes, inflation . . . these are the perpetual rewards of the fatherland." The commentary concluded that now the people could repay six years of such rewards from the government by voting for the Communist party in the December elections. In the same election issue, Grosz presented the threat to capitalism by the communists in a drawing of the "Burgher's Nightmare": a fat sweating capitalist knelt before his open safe clutching his bags of gold, while in the background bodies hung from gibbets and from the sky a hand labeled KPD reached down to grab the terrified man.[35]

FIG. 22 For the Fatherland — To the Slaughterhouse, *Knüppel.*

In this election issue Grosz also portrayed the "Donkey of Democracy," a man with donkey ears and blinders who refused to notice that capitalists and soldiers were kicking workers into jail. The caption under the drawing called for all who were not "Donkeys of Democracy" to vote for the KPD.

Grosz shared the general left-wing hatred of the reactionary judiciary. The inequitable treatment of the working classes and communists by the conservative nationalist judiciary was a fact of life in the republic against

which the writers of the *Weltbühne*, *Tagebuch*, and *Justiz*, waged a continuous fight. By 1925 Grosz had personal experience with this prejudice in two trials in which he had been the defendant against government prosecution.[36] One of his drawings in 1925 revealed a judge in his office threatening a worker with an executioner's ax. Another showed an avaricious judge who throve within the republic by putting chains on workers.

Not all of Grosz's drawings revealed the exploitation of the worker by the ruling classes; many simply depicted bourgeois types. Perhaps one could say these were all part of a guide to help the worker recognize the various disguises of his enemy. The burgher was shown in his love of all things Germanic, in his circle of old cronies calling for a crusade against the bolshevists, in lower and upper class discussions of politics, in his volunteer corps, in his guise as an educated snob or a patriotic business man, in his boredom in cafés, tea dances, and cocktail—or cocaine—parties.

Grosz did not confine himself to general attacks upon the ruling classes; he became very specific in his attacks upon persons within the government. In this period he most frequently and consistently caricatured Ebert, and, after the 1925 elections, Hindenburg. In the August, 1924, issue, which celebrated "Six years of freedom," Grosz had a full-page cartoon showing the republic, in the form of a fleshy female, walking home from the constitutional ceremonies with an inebriated Ebert and an amorous general (Fig. 23). Clinging and kissing, the republic declares to the general—who seems to be a caricature of General Hans von Seeckt, commander of the German Reichwehr—"I may be married to him, but to you I remain true." Ebert and Ramsay MacDonald appeared together in several nasty parodies of peace tables in front of battleships and clouds of poison gas. Ebert appeared pear-shaped, reminiscent of Daumier's caricature of Louis Philippe. After the 1925 presidential elections, *Der Knüppel* featured on its cover a drawing of Hindenburg taking his oath not to waver from the black-red-gold, the national colors of the German republic, but praying at the same time that it would not be long before the black-white-red, the colors of imperial Germany, was the victory flag of the rich and the winding cloth of the proletariat (Fig. 24). A month later, Grosz drew Hindenburg and SPD "Comrade" Otto Braun hunting together for KPD deer: "Two souls and one thought; two hunters and one goal."

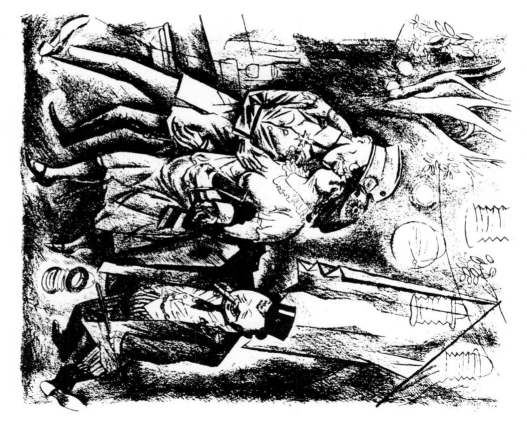

FIG. 23 Return From the Constitutional Celebrations, *Knüppel.*

Most of Grosz's drawings for the Communist party press appeared in *Der Knüppel.* Only a few of his drawings were published in *Die Rote Fahne,* the official Communist party organ. This may have been partly a technical question: many of the issues of *Rote Fahne* had no cartoons, particularly in the first years of the newspaper. By 1925, the paper was utilizing a fair number of cartoons; their quality was poor, and Grosz's drawings were no exception. In fact, most of the cartoons which have Grosz's name printed underneath—none are signed—do not look

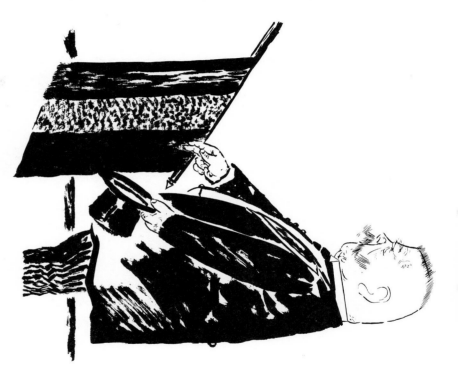

FIG. 24 My Oath. *Knüppel*. NGhK, p. 41.

like Grosz drawings. They lack all of the incisive qualities of the Grosz style of the early twenties.

The style of Grosz's drawings changed over this period of almost six years from *Jedermann* to *Der Knüppel*. This style which was at first clear, harsh, and incisive became dark and cluttered. His content, however, remained consistent: the drawings in these journals were those of a communist attacking the established order of society, which he believed was exploiting the proletariat. The drawings were, of course, primarily negative statements, attacking and trying to destroy. They were not positive statements of communist dogma, but this emphasis is inherent in the nature of the medium as well as in the nature of this

artist. Visual political statements require concrete subjects, and from his revolutionary or opposition position, it was not surprising that Grosz would turn primarily to the negative portrayal of the political scene. It should be noted, however, that Grosz, with only a few exceptions, did not draw cartoons which commented upon specific political events. He was not a journalistic cartoonist. He was a social and political satirist who used caricature as a tool to attack institutions, attitudes, types. When he attacked an individual, it was generally a figure who had attained symbolic and stereotyped value within the communist outlook, e.g., he continued to attack Ebert as the epitome of the socialist leader who had sold out to the ruling classes long after Ebert's death. His drawings in the journals were dominated by the Spartacist-communist outlook of 1919 and usually did not comment upon the current political events of the republic.

In this sense Grosz differed fundamentally from many of his friends among the left-wing intellectuals. Though Grosz associated with writers from the *Weltbühne*, he was never able to share their optimistic faith in the inherent goodness of man nor their confidence in the heritage of liberal social democracy. From this vantage point, the left-wing writers addressed themselves in the pages of *Die Weltbühne* and *Das Tagebuch* to specific problems in the German political scene, hoping to be able to effect change and reforms. Grosz, however, attacked the generalized problems, because both his own skepticism and the negation inherent in the German communist position made illusory any hope for change short of total revolution. The objects of attack for Grosz and for the left-wing writers were similar — conservativism of the churches, prejudice of the courts, resurgent militarism, the right-wing reactionaries in power, the failure of the SPD policies, social and political injustice. Grosz sought to unmask a decadent system; the left-wing writers hoped in these early years to reform the ineffective republic.[37]

Grosz's position was in many ways similar to Kurt Tucholsky's, though Tucholsky never committed himself to communism. In 1919 Tucholsky wrote: "We, the writers of the *Weltbühne* are being reproached for always saying 'No,' for not being sufficiently constructive. We are being accused of rejecting, of criticizing everything, of dirtying our own German nest. And what is worse—we fight hate with hate, force with force, fist with fist." After analyzing the German political situation, where the revolution had failed and the bourgeoisie was antidemocratic, Tucholsky said that there was no alternative but to try to shake the entire

political system: "No, we cannot say 'Yes.' Not yet. We know only one thing: that we must sweep away with an iron broom all that is rotten in Germany. . . . We want to fight with love and hatred."[38] This attitude towards Germany — critics have called it Tucholsky's *Hassliebe*, a mixture of hatred and love — made Tucholsky critical of all aspects of Germany, from the physical appearance of the burgher to his politics. Eventually Tucholsky left Germany for France and then Sweden, seeking a more congenial atmosphere than the Germany he abominated.[39]

Grosz tried to find a positive channel for action through communism, but his attitudes towards Germany often approximated Tucholsky's negativism. Grosz was, however, far more realistic about the working classes than Tucholsky, who, along with most of the writers of the *Weltbühne*, came from a middle class family. Having come from a nearly lower class background himself, Grosz did not romanticize or sentimentalize the proletariat as Tucholsky did in his songs and poems. He was also aware of the extent of its suffering and humiliation. His attacks on Germany, therefore, were aimed against the ruling classes and their oppression of the proletariat. Reinforced by communist ideology, his drawings were fully as negative and destructive as Tucholsky's verbal attacks. He too wanted "to sweep away with an iron broom all that is rotten in Germany," but for several years he hoped that in its place would come a just society for the workers.

CHAPTER 4
COMMUNIST RELATIONSHIPS

IN THE REVOLUTIONARY EXCITEMENT of November, 1918, artists whose pre-war isolation from political and social problems had been shattered by the war banded together in the November Group. Led by Max Pechstein and César Klein, they issued an exuberant manifesto that began with the statement: "We are standing on the fertile soil of revolution. Our motto is 'Freedom, Equality, Brotherhood!'" They dedicated their strength to the moral regeneration of a young, free Germany, to seeking unlimited freedom of expression, and to gathering together all artistic talent to be used for the common good.[1] Artists, architects, poets, and critics of widely varying political and social attitudes joined the November Group until its membership list included most of the illustrious names of the German art world at the end of the war. When George Grosz joined is not clear; it was probably in November since he was in Berlin and very much involved in revolutionary art circles. Grosz himself rarely commented in any of his writings about his membership in any organization, whether artistic or political.[2]

In January of 1919 the November Group published its guidelines. Declaring itself to be the German organization of radical artists, the group claimed the right to determine the future development of art and architecture in the republic. They planned to reorganize museums, to set up exhibits, to approve the architecture of public buildings, and to transform the standards of art instruction.[3] The program was enthusiastic, but the revolutionary élan of the members did not last long enough to implement it. By early 1920, the group had lost its vigor and had become not much more than an exhibiting group.[4] The confusion between revolutionary art, i.e., expressionism and futurism before 1914,

91

and revolutionary politics was partly responsible for this development. After the fervor of the revolutionary days, many artists seem to have recognized that their own concerns were not political and that the proletariat was not amenable to revolutionary art forms. The classic instance of this occurred in the Bavarian Soviet, where workers complained about the expressionistic and stylized woodcut of workers which was used as a symbol of the revolution on the first page of the *Münchener Neueste Nachrichten*. They saw the new symbol as a caricature of the working class and felt they were being ridiculed.[5]

In Berlin, the failure of the November Group to uphold its stated revolutionary goals became so marked that an opposition wing formed within the group. It was not organized but was made up of like-minded artists, many of whom came from the revolutionary wing of dadaism. Grosz, Otto Dix, Raoul Hausmann, Hannah Höch, Rudolf Schlichter, and Georg Scholz formed the core of this opposition. In June, 1921, this opposition group addressed to the November Group an open letter in *Der Gegner* in which they attacked its leadership for denying the original revolutionary goals. The letter recalled the impassioned talk of the November days and the goals that called for a new community of artists within a revolutionary society. It then pointed to the failure of the November Group to work for those goals, its return instead to the concept of revolution in terms of art forms and style, not in terms of society. The letter ended with a plea for artists to commit themselves to the proletarian revolution, to use their skills in building a new community of workers and artists and new proletarian art forms.[6]

As this letter, signed by nine artists including Grosz, indicates, one of the basic problems agitating the politically involved artist in this period was the conflict between formal art and *Tendenzkunst*. (This term defies adequate English translation because it has so many implications: it means a tendentious art; an art which expresses political opinions and ideological presuppositions; an art which is politically committed; an art which is a tool in class warfare; and an art which is propaganda.) For most artists Tendenzkunst was a form to be avoided—an ephemeral form serving immediate and passing causes, whether political, social, or economic. According to this view, formal art dealt with values and stylistic problems which would have meaning to coming generations because they subsumed some element of constant or eternal verity. The contrast, crudely put, was one between Rembrandt and Gillray.[7] For the communist artist in Germany of this period, this dichotomy had no

meaning. Within the Marxist framework there could be no art that was not intimately tied to its contemporary context. Since art was part of the conscious social and political superstructure built upon the foundation of economic realities, art was either directly or indirectly a reflection of those economic relationships. In short, the German communist view was that all art was determined by class relationships.

This viewpoint was most clearly and succinctly expressed by Alex Keil, pseudonym of Ék Sándor, a Hungarian communist artist who worked in the Agit-Prop division of the KPD and in 1934 became secretary in Moscow of the Association of Artists of Revolutionary Russia. He maintained that the Communist party was not bothered by the question of whether to support pure art or Tendenzkunst, because it recognized that all art was Tendenzkunst. Following Marx, Keil stated that art was always determined by the class which possessed the means of production. It was, therefore, meaningless to speak of a proletarian art, for proletarian art and culture could only develop when the proletariat controlled economic and political power. In a revolutionary situation where capitalism was losing control and the proletariat was moving into power, there could develop an interim revolutionary art, produced by an avant garde which had cut its ties to the bourgeoisie and had allied itself to the working classes. The fundamental criterion of revolutionary art was that it must serve the cause of the proletariat in the class war. This meant that not only its form and content had to serve a revolutionary purpose, but that the work of art had to be useful in the class war.[8]

George Grosz's statements published on art in the early 1920s were similar to Keil's viewpoint. For him, art was Tendenzkunst.[9] Grosz's most vitriolic verbal attack on formal art, especially the great masters of German art, was published in the spring of 1920. This was also his first published statement on art. The incident which triggered his violent statement occurred in the days following the Kapp Putsch when a battle took place on March 15 on the Postplatz in Dresden between the Reichswehr under General Maercker and demonstrating workers. Fifty-nine persons were killed and 150 were wounded. Bullets also penetrated the Zwinger Gallery and damaged Rubens's "Bathsheba." Oskar Kokoschka, who was at this time a professor in the Dresden Academy, issued a public appeal to the inhabitants of Dresden asking them to settle their arguments somewhere other than in front of the Zwinger, where works of art could be damaged. He pointed to the possibility of the Allied powers

using this damage as an excuse to rob the German galleries of master-works, and he claimed that the preservation of masterworks, the sacred possessions of the German people, was more important for future generations than all the political dissensions of the present day. He ended with the ironic suggestion that political fights be settled by duels, which were less harmful than civil war.[10]

This appeal of Kokoschka brought a sharp reaction from Grosz and John Heartfield. In "Der Kunstlump" (The Artist as Scab), they blazed away at Kokoschka and the attitude towards art which he embodied. They were particularly infuriated by his reference to works of art as the *heiligsten Güter* (the holy heirlooms or the sacred possessions) of the German people.[11] This, to them, was the essence of the whole bourgeois swindle which manipulated art and culture in order to stupefy the masses and to keep them tractable. The heiligsten Güter of the German nation were, they claimed, not art or culture but productive people. Sacred possessions must be viewed in human terms, not in terms of objects which could be used for profit and speculation by the capitalist class. The health and productivity of the working classes, present and future, were of far greater importance than the maintenance of paintings in art galleries. Far from trying to keep art works, Grosz and Heartfield urged their sale to the Allies in return for bread for the workers and their children. As far as they were concerned, compared to the fact that bullets had also mutilated and killed workers, it did not matter in the least that the Rubens painting had been damaged by a bullet. By appealing to the Dresdeners to place more importance upon the preservation of their art works than upon political battles, Kokoschka, they claimed, was trying to swindle the proletariat, dampen its revolutionary ardor, trick it into losing its class consciousness.[12]

Most art, said Grosz and Heartfield, was produced by minions of the bourgeoisie for the purposes of the bourgeoisie. By dealing with matters of beauty and the spirit, art deluded and emasculated the workers. Art was made possible by the surplus value created by the workers which enabled the capitalist to cover his walls with aesthetic luxuries that had no relevance for the worker. This art was Tendenzkunst because it was produced for the enjoyment of one class, the capitalists, and it was used to sabotage the enemy of that class, the proletariat. For this kind of Tendenzkunst, for these masterworks, Grosz had no use whatsoever. These works of art gave joy only because of the profits involved in their sale; this the bourgeois could appreciate and revel in.

But the worker who was fighting for his very existence and his own future could find in them no meaning, only betrayal and delusion.

Grosz and Heartfield pounded at these ideas from various viewpoints. The article was not a cool, rationally argued essay; it was a call to battle and an attack upon bourgeois art. The heart of their argument was that art was a weapon used by the bourgeoisie to defeat the proletariat; by valuing art and culture more than people, the bourgeoisie was free to destroy its enemy. In order to defeat the bourgeoisie and its exploiting culture, they called on the proletariat to take a stand against the "masochistic awe of historical objects, against culture and art." At the very end of the article, they mentioned briefly that the working class alone could create a new culture for itself.[13]

This polemical article echoed the decrees which Vladimir Mayakovsky's Committee of Futurists promulgated in the Soviet Union shortly after the revolution. In one of them, Mayakovsky declared the end to "the imprisonment of art in those lumber rooms of human genius," palaces, art galleries, libraries, and salons. Raphael should be treated like a White Guard: "It is time for bullets to spatter museum walls."[14] Though Grosz first met Mayakovsky several years later, it is quite possible that he had already heard about these futurist decrees.

Grosz's article was published in the spring of 1920 in *Der Gegner* and in *Die Aktion*, journals which were both fighting the exploitation of the proletariat and trying to deepen the revolutionary consciousness of the worker. It attacked art as part of the bourgeois method of controlling the lower classes, but it did not offer any alternatives. During the summer and fall of the same year, Grosz prepared two statements in which he developed his ideas about the use of art as a weapon to fight the bourgeoisie.

The first of Grosz's statements, titled "Statt einer Biographie" (Instead of a Biography), dated Berlin, August 16, 1920, picked up the argument of "Der Kunstlump" that art was part of the bourgeois social structure. It began with the statement: "The art of today is dependent on the bourgeoisie and will die with it."[15] After pointing out the way in which art works were part of the capitalist cycle of investment, Grosz unfolded the fraud and swindle which he believed surrounded the work of contemporary artists. The artists, deeply involved in a cult of genius and personality, priding themselves on their creativeness and spiritual sensitivity, actually were manipulated and exploited by dealers and patrons who inflated the spiritual value of the works to increase their

market value. The artists themselves, obsessed with personal problems, were far removed from the actual problems of the world, according to Grosz. Their isolation from reality was so great that they believed their experimentation with problems of artistic form actually constituted revolutionary forms of art. Grosz was very scornful about this point. He ridiculed modern artists for thinking they were revolutionary when compared to Hans Makart, the painter of the German bourgeoisie of the 1870s: "Look at Makart, he is a painter of the bourgeoisie, he painted its desires, its subjects, its history,—and you? What are you but miserable satellites of the bourgeoisie? Your snobbish ideas, your strange thoughts, where did you acquire them?"[16] In a series of rapid questions, Grosz attacked the contemporary artist, deriding his failure to work for the future proletarian culture, his inability to understand the workers or to fight the exploiters, and his attachment to formal art. All of these things made him, according to Grosz, into nothing but a flunky for the bourgeoisie, one who, far from being revolutionary, was actually strengthening the ideology of the bourgeoisie: "You pretend to be timeless and stand above party, you keepers of the ivory tower. You pretend you create for man—where is man? What else is your creative indifference and your abstract muttering of timelessness but a ridiculous, useless speculation on eternity. *Your brushes and your pens which should be weapons are hollow straws.*"[17]

Here was the crux of the problem. Since all art, by definition in Grosz's thinking and in the thinking of his contemporary Marxist friends, was an expression of the ideology of an economic class, since it was either consciously or unconsciously Tendenzkunst, it was the responsibility of the artist consciously to make it Tendenzkunst specifically to serve the cause of the proletariat. Insofar as the artist remained indifferent to the reality of the proletarian revolution, he was serving the bourgeoisie, just as Kokoschka had served the ruling classes in Dresden earlier that year. If the artist did not use his brush as a weapon on the side of the worker, it would be a useless tool which could be subverted by the bourgeoisie in their continued perpetuation of the art swindle. Grosz ended this manifesto portion with a call for political commitment: "Come out of your houses even if it is difficult for you, do away with your individual isolation, let yourselves be possessed by the ideas of the working masses and help them in their struggle against a rotten society."[18]

This confession of political commitment placed Grosz squarely in the Marxist tradition. Though Marx did not deny individual creativity, he

had been suspicious of exaggerated individuality in artists; Grosz spoke disparagingly of the cult of genius. Marx made it clear that the intellectual class ultimately served and supported the economically dominant class; Grosz's whole essay was based on this concept as it applied to artists. Following Marx, Grosz rejected the romantic view of the suffering genius preoccupied with his soul and with eternal verities. By writing this particular essay as a statement of political commitment, Grosz expressed his own unwillingness to be treated in romantic terms. The essay was supposedly an autobiographical one, but Grosz would not dwell upon his own individuality: "All the fuss about oneself is entirely irrelevant." This concluding sentence could only come from a Grosz who had consciously adopted the Marxist attitude that put the welfare of the working class above the desire for individuality.

The second statement, written in November, 1920, and published in January, 1921, in *Das Kunstblatt*, was "Zu meinen neuen Bildern" (Concerning My New Pictures). In this essay, Grosz was preoccupied with the same problems: the call to artists for political commitment, the use of art by the bourgeoisie as a weapon against the workers, and the problem of individuality. Asserting that art was a very secondary affair — compared to the political struggle of the workers — Grosz demanded a decision by artists: "Do you stand on the side of the exploiters or on the side of masses?" Grosz rejected the idea that art stood above political struggle. Art and religion were equally, in Marx's term, opiates of the people. The "old swindle of the sublimity and holiness" of art emasculated not only the workers but the artist. Under its banner artists became preoccupied with aesthetic revolutions which ultimately led to "skeptical bourgeois-nihilism" and to the cultivation of individual artistic eccentricity. This eccentricity or nihilism often passed for revolutionary among artists, because most of them failed to understand the real revolutionary issues. Grosz maintained that the truly revolutionary artist would reject past patterns and would enter actively into the working class life. "Go to a proletarian meeting; see and hear how people there, men like you, discuss some minute improvement of their life." Art would be given its revolutionary form and content from participation in the workers' struggle.[19]

Having exhorted his fellow artists, Grosz devoted the rest of the article to the new style he was developing to embody revolutionary ideals. The new drawings, five of which were published with the article, were mechanical, precise constructions of men and machines that seemed to

emerge from an engineer's drafting board rather than from Grosz's pen. Stamped with his name and address rather than signed, they were the impersonal antithesis of his vitriolic caricatures and political drawings (Fig. 25). Grosz explained that these new works were an attempt to give an absolutely realistic world picture which would be comprehensible to every person and which would avoid all of the old sentimentality and romanticism surrounding art. Grosz acknowledged that the inspiration for his new style came from the Italian metaphysical painters, Giorgio de Chirico and Carlo Carrà. Though he explicitly rejected their metaphysical aims, he utilized their forms: rectangular streets defining hard and empty space, regimented perspective, overpowering buildings, puppets superimposed upon the scenes. While the puppets (the *manichino*) of the Italians represented mythical figures in the hollowness of modern times, for Grosz they were to become the new men of the future, a collective concept. By stressing a mechanical conception of man, Grosz tried to eliminate any psychological probing into individual personalities, an artistic tactic which Grosz attributed to such bourgeois artists as Koschka. To produce this objective art, Grosz used quiet colors and undifferentiated, controlled lines to emphasize stability, structure, and utilitarianism. He extolled the objectivity and clarity of engineering drawing and strove for this effect in his new work. Grosz saw the "future development of painting taking place in workshops, in pure craftsmanship, not in any holy temple of the arts. Painting is manual labor. . . ." He had great hope for the future art of the working class. He was convinced that the inevitable proletarian victory over capitalism would replace the anarchistic, bohemian, expressionistic artist with the healthy young craftsman artist. With the victory of the working class, "art will stream out of the narrow confines in which it flows so anemically through the life of the upper 'ten thousand' and will again communicate in a mighty stream with all of working humanity. Then capitalism's monopoly of spiritual things will be ended. Thus communism will also lead to the enrichment and further development of humanity, to the true classless culture." [20]

In this essay and in these drawings, Grosz was grappling with a fundamental problem confronting communist artists and writers: how to implement the ideal of specifically communist art. Preoccupied with the problem of relating a highly individualistic style to the aims of the proletariat, Grosz aimed for a realism which both dissected the present society and pointed toward the future aspirations of the workers. To do

this, he tried to develop a mechanical and objective art which would portray not the individual but the collective man and which would be based on craftsmanship rather than on individual inspiration. The position which Grosz took here was very similar to that of the constructivists and futurists in Russia. In fact, this article in a slightly revised form was published in 1923 in *Lef*, the journal of the futurists in the Soviet Union.[21]

FIG. 25 Republican Automatons, 1920. *Kunstblatt*, p. 15.

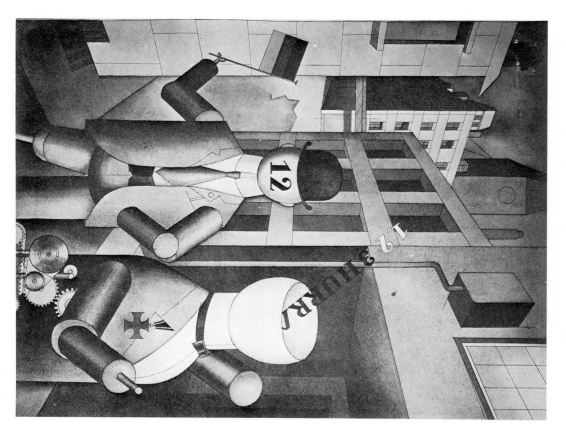

Grosz openly admitted that these works were experimental. The actual drawings fell far short of his ambitious statement about them: they succeeded in portraying neither contemporary social reality nor the future proletarian society. Grosz himself must have quickly recognized the ideological failure of this stylistic venture, for he published only a handful of these drawings in one portfolio and in several journals. He may have been influenced by Lenin's condemnation of constructivism. He also appears to have had a negative reaction to the great exhibit of modern Russian art, featuring the suprematists and the constructivists, which was held in Berlin in 1922. Appalled by Casimir Malevich's square of white on white, Grosz may have decided that this was not a direction in which he wanted to work.[22]

Following his own advice to the revolutionary artists, Grosz took an active part in organizations which were championing both the German worker and the Soviet Union. In 1921 Grosz joined the artists and intellectuals who were working with Willi Münzenberg on famine relief for the Soviet Union. Münzenberg had made a name for himself in the socialist movement shortly before World War I in Switzerland, when he organized the Socialist Youth International. At that time he became a close personal friend of Lenin and one of Lenin's earliest non-Russian followers. Deported to Germany in 1918, he joined Clara Zetkin and Edwin Hörnle in the Spartacist uprising in Stuttgart, for which he served five months in prison. Subsequently, as chairman of the KPD in Württemberg, he fought Paul Levi's right-wing leadership in the party congresses. Turning again to youth movements, he formed the Communist Youth International which was affiliated with the Comintern. By 1921, fully convinced that world communism had to be guided by Russian leadership, he began a fifteen-year period as a brilliant organizer of propaganda networks for the Comintern. At Lenin's request, he concentrated his abilities on organizing an international relief program for victims of the famine in Russia.[23]

One of the immediate tasks which Münzenberg faced was to make the public aware of the need. Since his publishing empire was not yet functioning, Münzenberg worked with Wieland Herzfelde, whose Malik Verlag had a well established reputation among revolutionary workers' organizations and within the book trade in Germany, Austria, and Switzerland. The Malik Verlag handled the publication and distribution of three pamphlets for Münzenberg. The first one, *Hilfe! Russland in Not!* (Help! Russia in Distress!) was published first in *Der Gegner* and then

as a forty-eight page pamphlet. In it, Münzenberg combined contributions from Gorki, Lenin, Mayakovsky, Arthur Holitscher, John Reed, Arthur Ransome, and a number of others with drawings by Käthe Kollwitz and Grosz in such a way as to make the relief of the Soviet Union an appealing and worthy humanitarian cause. The booklet was sponsored by the Foreign Committee for Organizing Workers' Aid for Russia (Auslandskomitee zur Organisierung der Arbeiterhilfe für Russland) which included G. B. Shaw, Upton Sinclair, and Anatole France.[24] The other two pamphlets which Malik published for Münzenberg were sponsored by similar committees. *Sowjetrussland und seine Kinder*, (Soviet Russia and its Children), thirty photograph-filled pages, was issued in two editions of twenty thousand copies each; its sponsor was the Committee of Workers' Aid for Soviet Russia (Komitee Arbeiterhilfe für Sowjetrussland). The last one was a reprint of a speech given by Leon Trotsky in Moscow on August 30, 1921: *Das hungernde Russland und das 'satte' Europa* (Starving Russia and "Satiated" Europe); the Foreign Committee for Organizing Workers' Aid for the Starving in Russia (Auslandskomitee zur Organisierung der Arbeiterhilfe für die Hungernden in Russland) sponsored its publication.[25]

These pamphlets were the beginning of a large and complex organization which Münzenberg formed to promote the relief work. In August, 1921, when Münzenberg issued the call for a committee to organize workers' aid for the Soviet Union, George Grosz was among the first members.[26] Grosz was again among the charter members when in December, 1921, Münzenberg convened German and foreign intellectuals in Berlin to form the International Workers' Aid (Internationale Arbeiterhilfe or IAH). By this time Grosz had achieved some fame as an artist and was, therefore, not out of place among the distinguished figures whom Münzenberg had gathered, including Albert Einstein, Maximilian Harden, Leonhard Frank, Anatole France, Henri Barbusse, G. B. Shaw, and Martin Andersen-Nexö.[27] Along with Otto Dix and Käthe Kollwitz, Grosz designed posters and placards for IAH; they held art exhibits for the benefit of the famine victims; they gave the proceeds from the sale of their drawings and books to the relief fund; they called upon their fellow artists to follow their example.[28] When *Der Gegner* printed an impassioned appeal for artists and intellectuals to come to the aid of the twenty million starving people in Russia, it was signed by Grosz, Kollwitz, and several others in behalf of the Committee for Artists' Aid for the Hungry in Russia.[29] IAH published in 1924 a portfolio, *Hunger*, with drawings from Heinrich Zille, Kollwitz,

and Grosz.[30] In 1923 both Kollwitz and Grosz were among the sponsors for the League of the Friends of the International Workers' Aid.[31]

The success of IAH in enlisting prominent intellectuals was due largely to Münzenberg's shrewd insistence that the organization was independent and supra-political. Münzenberg himself wrote that the goal of IAH was "to reveal the true character of bourgeois-capitalist society . . . to expose the inequities arising under capitalism, to provide aid for those who were victims of the system, and to engender a feeling of solidarity among the masses."[32] He felt this goal could best be achieved by keeping IAH ostensibly independent of the Comintern or of any Communist party. By primarily supporting humanitarian action, IAH was able to attract uncommitted sympathizers to work for proletarian causes. When relief to Russia was no longer pressing, IAH promoted relief to children and striking workers throughout the world. Many left-wing intellectuals, including Kurt Tucholsky and Carl von Ossietzky, who served as successive editors of the *Weltbühne*, participated in the IAH campaigns. In 1924 thirty-seven artists and writers, including Grosz, under the aegis of IAH, appealed for support of the workers in their fight to maintain an eight-hour day.[33] In 1925–26, Münzenberg managed to unite the left-wing intellectuals and the working class parties in an effort to expropriate the lands of the former German princely houses. Again, Grosz was among those who issued public statements calling for support of the movement.[34] IAH also sponsored a wide variety of cultural activities such as poetry and cabaret evenings or dance recitals by Isadora Duncan.

IAH grew into a complex propaganda empire, compared by many to the nationalist propaganda empire of Alfred Hugenberg, which included major newspapers, publishing houses, some radio stations, and the film company Ufa. The Münzenberg "concern" included theaters, film production, publishing firms (the Verlag der Internationalen Arbeiterhilfe and later the Verlag Neues Leben), and newspapers (*Berlin am Morgen*, *Welt am Abend*, *Mahnruf*, *Arbeiter Illustrierte-Zeitung*, *Der rote Aufbau*, *Der Eulenspiegel*).[35] The left-wing intellectuals who worked in all of these ventures constituted "the first fellow travelers in the history of international Communism."[36] Though some of these intellectuals may not have understood the nature of the Münzenberg organizations, Wieland Herzfelde knew that they were virtually a branch of the agitation section of the Third International and that Münzenberg himself represented the Executive Committee of the Comintern in the area of German political-cultural publications. As a member of the KPD, Herzfelde was offi-

cially accountable to the Comintern through Münzenberg. Since the Malik Verlag was a private press founded during the war and financed by Herzfelde himself, however, it was never subordinated to the Münzenberg concern. Herzfelde and Heartfield worked with Münzenberg on several publishing projects; their contact was friendly, but not close. Grosz, of course, also knew Münzenberg personally and must have been fully aware of his ties with the Comintern.[37]

Grosz's work on famine relief was reflected in a furious attack on artists and capitalism which appeared in the catalogue of an exhibit of his drawings at the Garvens Gallery in Hanover in April, 1922. Brief and angry, the statement opened with an assertion reminiscent of his pre-war cynicism: "Man is not good—but is a beast." The rest of this brief statement, however, made it clear that Grosz's skepticism—which was always present—was directed in 1922 against capitalistic institutions which man had created, rather than at mankind in general. Grosz's misanthropy had been diverted into ideologically determined hatred. He claimed that man was a beast because he had created a vile system which separated men into levels of existence: above there were a few who earned millions; below there were millions who were barely able to exist. Grosz pointed specifically to the waste of food in capitalist countries and to the famine deaths in Russia. He condemned the culture and art which were erected upon the privations of the poor. More especially, he condemned the intellectuals, the spiritual leaders, who stood cynically aside and allowed this cultural hypocrisy to continue. Grosz maintained that the belief in the all-holiness of private initiative ruled everything. His work, therefore, found its purpose in trying to shatter this belief and in revealing to the downtrodden the face of the ruling class.[38]

The short statement was accompanied by two illustrations which could almost be called a visual dialectic. Both drawings were entitled "The Dollar 300," referring to the rate of the inflationary exchange. The first showed carousing men, probably profiteers, with a prostitute in an opulent café around a table laden with fruit, wine, and cigars (Fig. 26A). The second revealed the decrepit interior of an attic with a starving worker seated at an empty table and a dying woman on a cot in the background (Fig. 26B).

In the summer of 1922 Grosz traveled to Denmark to join the poet and novelist Martin Andersen-Nexö on a trip to the Soviet Union. The purpose of the trip was to collaborate on a book about Russia. It is probable

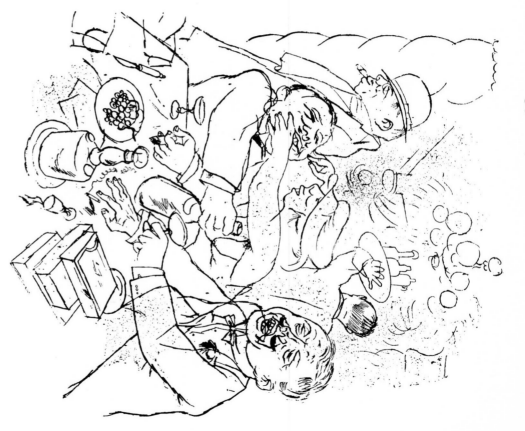

FIG. 26a The Dollar 300, I, Garvens Catalogue. Af, p. 26, as Victoriously We Want to Beat France.

that this trip was planned and financed by Münzenberg. Babette Gross in her account of Münzenberg's work mentions briefly that he commissioned Andersen-Nexö to travel to the Soviet Union and to write a book about it.[39] Grosz and Nexö, who were both active in IAH, had already worked together on a book of tales and parables about the proletariat. The proceeds from its sale were donated entirely to the artists' famine relief fund. Both of them had taken part in the Berlin meetings

FIG. 26B The Dollar 300, II, Garvens Catalogue. Af, p. 52.

of December, 1921, when IAH was formally launched. Once they were in Russia, they joined a group of western intellectuals most of whom were associated with IAH.

Nexö wanted to enter the Soviet Union via Vardö-Murmansk to reconstruct the route of the illegal flights of the czarist days. His deter-

mination to do so involved them in endless problems, not the least of which was a very hostile reception from the local authorities in Murmansk when they arrived in an unauthorized fishing boat. Grosz's first impressions of the new proletarian state were, therefore, unpleasant: the hostility and endless red tape of petty officialdom, the continual attitude of mistrust that marked everyone, the attempts to trap them into admitting they were spies or counter-revolutionaries, and the soul-grinding poverty. For this last, Grosz was not prepared, despite his work with IAH for famine relief: "So my first impression was of hunger, of direct physical hunger Yes, there above me [on the dock] were locusts, I thought, day dreaming; perhaps this is really the land of locusts"[40]

As they moved away from the coast and their identity as guests of the government was established, their reception became more friendly. They were received by heads of various towns as they traveled to Leningrad. There Zinoviev gave them a warm welcome, entertained them several times, and allowed them to use his car to tour the area. Impressed by Zinoviev's colorlessness and by his conscious suppression of individual traits, Grosz commented that the Soviet leaders whom they met seemed to have no private lives. "Many acted like living, red-bound brochures and were proud of it. Naturally they sought, since it was supposed to be the time of the masses, to suppress entirely their little individuality, and would have preferred to have faces of grey cardboard with red numbers on them instead of names."[41] The elegant young man of Berlin cafés, the young artist who prized above all his individual identity and freedom and who was a master at observing the traits and details that characterized an individual must have found this grey facelessness in the proletarian state difficult to digest, even granting its ideological basis. The vision of men with faces of grey cardboard must have seemed uncomfortably close to his own constructivist portrayal of empty cities inhabited by blank mechanical men.

In Leningrad Grosz and Nexö met with a small group of western artists and writers to discuss a project to promote cultural ties between the Soviet Union and sympathetic western intellectuals. Zinoviev outlined a grandiose scheme to establish a "super colossal periodical" which would have its headquarters in Berlin and Paris, would reflect "the enormous power of the cultural front of the Soviet Union," and would, therefore, inspire all of the great cultural leaders (*Geister*) to join. Grosz sensed in this speech both Zinoviev's sharp intelligence and a certain conde-

scension. After his speech, Zinoviev left the group to plan the details. Arthur Holitscher was chosen to be secretary for Germany, because, Grosz noted, he was old, eminent, and gullible. Nexö was the natural leader for Denmark. Of the eight men present, Grosz was most impressed by Max Eastman, the American journalist and editor of the *Masses*, who wore red rubber-soled American boots and kept his head in an English-Russian dictionary throughout the discussion. The whole project, Grosz concluded, was nothing more than a Potemkin village, designed to divert and occupy the western intellectuals.[42]

The Soviet leaders, however, appear to have taken these western sympathizers more seriously than Grosz's skeptical assessment would indicate. A carefully selected group, including the American correspondent Albert Rhys Williams, was invited to the Kremlin to meet Lenin in one of his last public appearances. Accompanied by several men, Nikolai Bukharin and Karl Radek among them, Lenin informally and rapidly shook hands with the visitors before addressing them in German. Grosz was depressed by Lenin's illness which made him wander and stumble in his hour-long speech. Lenin, Grosz said, was supposed to have treasured his work, especially *Das Gesicht der herrschenden Klasse* which had been published the previous year. On another occasion Trotsky spoke to the group and impressed Grosz with his military appearance and brilliant delivery. Radek invited Grosz to visit him in his study in the Kremlin and received him with copies of Grosz's work lying on his desk—an obvious gesture of flattery which Grosz recognized and yet appreciated. Grosz, in return, gave Radek, a fellow pipe-smoker, good English tobacco in tins. Grosz met Lunacharsky, Commissar of Education and Culture, on a special government train traveling from Moscow to Leningrad. Grosz, who was sharing a compartment with Arthur Holitscher, went at about midnight to Lunacharsky's car, where they talked about the Proletarian Cultural and Educational Organization or Proletcult, which A. A. Bogdanov and Lunacharsky had launched but which soon fell into disfavor. Grosz found Lunacharsky to be an intelligent, cultivated man whose whole appearance and outlook was oriented towards the west.[43]

During the five months in Russia, Grosz visited and met many other lesser known individuals within and without the Soviet bureaucracy. He must have encountered the various experimental artist groups. He saw Tatlin's model for the Monument of the Third International and vis-

ited Tatlin at his small home. There, surrounded by chickens and playing his balalaika, Tatlin struck Grosz as a melancholy figure out of Gogol, not as an ultra-modern constructivist.[44]

All in all, Grosz claimed, the visit was not a great success. He and Nexö did not get along well while traveling. Grosz's skepticism kept him from viewing the new communist state with the optimistic glasses that Nexö and many other western intellectuals wore while in Russia. The critical and misanthropic vision—the splinter in his eye—with which Grosz viewed the ruling classes in Germany continued to function in Russia. He returned to Germany neither excited nor disappointed but aware that the Soviet Union was not the place for him or for his kind of art. The book which he and Nexö had planned was neither written nor illustrated.[45]

Walter Mehring has told of a party held by close friends to welcome Grosz back from Russia. They plied him with questions:

"What was it like over there, Böff? Did you see *him*, the old man in the Kremlin?" Grosz merely growled, "There was once a chemist in Stolp, in East Pomerania, a certain Voelzke . . . neat little goatee beard . . . frock-coat . . . upright bearing of a real honest bourgeois—like this . . . ! He had a cure for everything:

'Can I help you?'
'I've got a weak feeling in the pit of my stomach.'
'Effervescent powder. Next?'
'I am desperately in love with Liberty!'
'Blue packet: one dessertspoonful before retiring. And you?'
'I've got a funny rash on my chest—'
'Aha. Syphilis, you swine. Here. Red capsules!'
Three patent medicines for everything! . . . Lenin!!! . . . A little chemist."[46]

The trip to the Soviet Union is generally cited by critics as the point at which Grosz turned away from communism, both because of stories like Mehring's and because of Grosz's own skeptical account. This view neglects the facts that Grosz's account was written some years later and, more important, that Grosz maintained an attitude of skepticism towards all men and institutions. Lenin as a little man dispensing patent medicine for the ills of society: the eyes that saw this were the same eyes that saw Ebert as a little puppet jumping on strings manipulated by Stinnes. Ideological commitment could not mask his vision of weaknesses within men. This incident also revealed Grosz's method

of talking and expressing ideas. He did not talk about abstract ideas; he spoke about politics in terms of people and their actions, and he did this often by creating a scene in which he played all the roles. That he did not glorify Lenin or the Soviet Union did not affect his commitment to the cause of the proletariat within Germany. He continued an active relationship with communist organizations and individuals for several more years after he returned from Russia.

In late autumn of 1922, Vladimir Mayakovsky, the futurist poet of the Russian Revolution, made a trip to the west and spent almost two months in Berlin. Returning home in mid-December, he brought with him three of Grosz's portfolios, including *Ecce Homo*. Though neither Mayakovsky nor Grosz mentioned meeting the other, Wieland Herzfelde says that they met frequently. They could have met when Grosz was in Russia or when Mayakovsky was in Berlin. Russian critics have pointed to the many parallels in the lives and work of both men. Certainly Mayakovsky found Grosz's work exciting. Lecturing on the Berlin scene shortly after his return, Mayakovsky called Grosz "a remarkable phenomenon." In January, 1923, the futurists around Mayakovsky submitted plans for a new journal, *Lef*, to the Central Council of the Russian Communist party. Grosz was listed among the projected contributors to the journal, which was to include both Soviet and foreign writers, critics, and artists. Though futurism was not held in great favor in the party at this time, the plans were accepted and the first issue appeared in March. The second issue featured drawings by Grosz, probably some that Mayakovsky had brought back from Berlin, and Grosz's 1920 essay in which he outlined a mechanical or constructivist approach to art. Also in January, 1923, the weekly magazine, *Krasnaja Niwa*, printed several Grosz drawings. In succeeding years, Grosz's drawings appeared frequently in Soviet magazines and journals. Mayakovsky, whose dream was to create an international front of left-wing art, evidently saw in Grosz a potential ally in the fight for a new revolutionary art. He repeatedly referred to Grosz when he was pleading—in vain—for his red art international.[47]

In January, 1923, the French army invaded and occupied the Ruhr because of the German government's failure to meet reparation payments. The Germans answered by passive resistance throughout the occupied areas. The Berlin government under Wilhelm Cuno endorsed the combined refusal of the workers and the Ruhr industrialists to produce or to

deliver material to the French. Indignation against the French cut across parties from left to right. The Communist party attempted to combine opposition to the French imperialists with their fight against the German bourgeois government. As the *Rote Fahne* urged, "Smite Poincaré and Cuno on the Ruhr and on the Spree." This presented difficulties since the German government was also fighting French imperialism in the Ruhr; thus, at times the communists seemed to make common cause with the nationalists against the French aggressors.[48] The German pacifists and the left-wing intellectuals of the *Weltbühne*, whose editorial policy called for Franco-German cooperation, took a strong stand against the resistance in the Ruhr.[49] Grosz, on this issue, stood between his own party and the *Weltbühne*. He refused to allow any considerations to compromise his stand against German militarism.

On March 2, 1923, the Ruhr-Rhine Press Bureau, the public relations organization subsidized by heavy industry, sent a letter to Herzfelde asking him to persuade Grosz to compose propaganda placards against French militarism. They suggested that Grosz come at their expense to the occupied regions to view the French acts of savagery. Brusquely refusing, Grosz inquired why he had not been approached in 1920 to investigate the savagery of "Noske and Company" in subduing the workers in the Ruhr or in 1921 to see the crimes committed in the military suppression of the strikers in the Leuna Works. "My front is on the Spree. I detest German militarism as much as French militarism."[50]

In a book of drawings, *Abrechnung folgt!*, published in April, Grosz reiterated the same attitude. In one drawing, a French general and a Prussian general shake hands behind the back of a handcuffed worker. The caption: "Against Communism They Are United!" (Fig. 27). On the opposite page, capitalists carouse above the words: "Victoriously We Want to Beat France." According to the *Rote Fahne*, the song which began with those words was sung by German nationalists who had incited workers in Essen to attack French troops at the Krupp works. Thirteen workers were killed and forty-one were wounded when the French fired into the demonstrators.[51] The communist interpretation of the Essen demonstration — that the workers were being massacred for the cause of German bourgeois nationalism — was expressed in two other paired drawings: on one page, aristocratic types with their dueling scars, industrial capitalists, and school masters set upon a French officer with their umbrellas, walking sticks, and a dagger (Fig. 28A); on the facing page, a French officer directs his soldiers to fire into a huddled group of

FIG. 27 Against Communism They Are United!, Af, p. 27. Facing Fig. 26a.

emaciated German workers and children while a fat German professor yells and waves his umbrella in the background (Fig. 28B). The captions: "The Burghers Agitate and the Proletariat Die." Grosz also believed that industry, both French and German, was profiting from the Ruhr occupation at the expense of the working classes. In another drawing, two capitalists, standing astride their respective industries, embrace each other. In place of their heads are long industrial smokestacks labelled "Stinnes" and "Loucheur." These French and German industrial giants have "Two Smokestacks and One Soul."

FIG. 28A The Burghers Agitate —, Af, p. 24.

While Grosz did not want to serve German militarism and nationalism by attacking the French, he also did not want the French nationalists to make use of his drawings to attack Germany. In the spring of 1924 Grosz and his wife traveled to France where he visited his friend Kurt Tucholsky. One evening at Tucholsky's home in Le Vésinet near Paris, Grosz met with a group of journalists from *L'Europe nouvelle* who

wanted to use Grosz's drawings because of their anti-German po-
lemic. Grosz was displeased with the idea.[52] In 1933 he again refused
to allow a French firm to publish his drawings attacking German mili-
tarism. He said at that time that he did not want to be like Tucholsky,
who sat in Parisian cafés eating pastry and writing against Germany.[53]

Articles in *Clarté*, *L'Humanité*, and *L'Europe nouvelle* had made
Grosz's name known among intellectuals in France, though Jean Bernier,
editor of the communist-oriented *Clarté*, reported that Comrade Grosz

during a Paris interview for another journal had expressed great surprise that so few French intellectuals realized his inspiration was communist. Comrade Bernier's record of Comrade Grosz's statements reads so much like a collection of party-line clichés that one wonders whether Grosz was playing the role of "Comrade" or whether Bernier edited the interview into proper party rhetoric. If it was not well known among intellectuals in France that Grosz was a communist, it was known to the police prefecture, which did not want to grant him a permit to travel or stay in France. Pierre MacOrlan, a novelist and a friend who frequently reviewed Grosz's work in French papers, managed to arrange the permit for him.[54]

By 1924 Grosz had acquired considerable fame as a revolutionary artist within Europe. Officially entertained in the Soviet Union and greeted in France as "the great revolutionary artist," Grosz showed signs of an increasing self-consciousness about his role as an artist. Two essays appeared in 1924 in which Grosz began to talk about himself. Instead of passing over his individual development in favor of the ideological polemics on art and society of his earlier essays, he offered to the public an analysis of his own ideological growth as a testimonial to the faith of a revolutionary artist. In one of these essays, which was included in a book of manifestos by young artists, he outlined his artistic training. He concluded his statement with a paragraph on the necessity for viewing art in terms of its social usefulness. He insisted that he preferred the plans of a furniture maker to the abstract murky portrayals of mystic experiences. With social purposefulness, art, he thought, could be a powerful weapon against the brutality and stupidity of men.[55]

The other essay, "Abwicklung" (Evolving), constituted Grosz's major declaration of ideological growth. There was no slackening of ideological commitment in this statement. Writing as a committed communist, Grosz asserted his individuality by tracing his own personal ideological development from pre-war misanthropy to his present position as a Tendenzkünstler. He summed up his own feeling: "Today I don't hate all men without exception. Today I hate evil institutions and the holders of power who uphold these institutions. And when I have a hope, it is this, that these institutions and that class of men who protect them will disappear. My work serves this hope." As a thoroughly political artist, he was able to declare that the events of the political future would be more important in the assessment of his art than were the declarations

of contemporary art critics: "Whether one names my work art is dependent upon the question of whether one believes that the future belongs to the working class." [56]

In June, 1924, the Red Group, Union of Communist Artists of Germany (*Rote Gruppe*, Vereinigung kommunistischer Künstler Deutschlands), was formed by painters and graphic artists who were members of the KPD. The members of the group declared themselves to be filled with the consciousness that a good communist was in the first instance a communist and only secondly a special or skilled worker and that all his ability and knowledge were tools to be used in the service of the class war. The manifesto of the group, which was published in *Die Rote Fahne*, went on to outline a ten-point program which would help the artists work more closely with the central organs of the KPD in order to strengthen communist propaganda and action. The group envisioned itself as a core group which would eventually expand to include all proletarian revolutionary artists in Germany. The officers of the new organization were all close friends: George Grosz was chairman, Karl Witte, vice-chairman, John Heartfield, secretary; Rudolf Schlichter and Erwin Piscator served, but had no special titles. [57]

Whether the impetus for forming this group came from the artists themselves or from the Communist party is not clear. It is probable that its formation was part of the bureaucratization and centralization which took place in the KPD under Ruth Fischer and Arkadi Maslow. Fischer and Maslow, who were elected to the party leadership at the Ninth Congress of the KPD in April of 1924, had emerged triumphant in a party dispute in Moscow earlier in the year. This dispute over the failure of the October Revolution in Germany in 1923 was part of the power struggle between the Stalin and Trotsky factions in the Soviet Union. At issue was the fundamental question of the bolshevization of communist parties outside the Soviet Union. By opposing Trotsky, Fischer and Maslow gained leadership within the German party but also were committed to its bolshevization. Though Fischer's leadership lasted little more than a year, the bolshevization of the party lasted throughout the republic, and German party policies were dictated from Moscow. This bolshevization was accompanied by centralization within the ranks and organs of the party in Germany. [58] It is therefore likely that the Red Group was one manifestation of this centralization. This is indicated by the stress upon party organization and affiliation within the original manifesto of the group, even though the group maintained that it was an independent

organization. The ten points of its program were concerned with organizational problems, not with questions of style or form of art. Apparently the group assumed, following Grosz's 1920 statements, that if the artist was properly allied with the proletariat, his style would be suitable to the cause.

The leadership within the Red Group came from the artist friends whom Grosz and Heartfield had gathered for *Der Knüppel*. In the fall of 1924 they published a lampoon of their own group in *Die Rosarote Brille*, a satirical election issue paper put out by the KPD.[59] Using rose-colored spectacles — or a pink toilet seat — to look at Germany, the paper featured three pages of drawings by Grosz. On one page he attacked artists who supported the republic by floating above politics while praising inner freedom, a position he had frequently attacked in his articles (Fig. 29). Then, on a two-page spread, he lampooned his companions in the Red Group in order to reveal the rottenness of the republic and their hostility towards it. The explanation with the drawings stated that these artists were so thrilled by the arrests and housesearches of Communist party members that they had decided to enter into this wonderful freedom of German democracy by becoming full-fledged bourgeois citizens. Continuing this tongue-in-cheek satire, Grosz drew each artist's way of adapting to bourgeois life: he himself, in this fantasy, became a capitalist; others found it necessary to practice crawling, standing on their heads, drinking beer, and doing other exemplary exercises in order to become good citizens (Fig. 30). These drawings are the closest Grosz ever came to commenting about internal matters in the Communist party.

In reality, of course, Grosz and his friends in the Red Group had no intention of creeping into respectable positions within the republic. They continued to protest against capitalist oppression of the proletariat. For example, in April, 1927, Grosz joined four other artists in sending a telegram to Budapest which protested strongly the court martial and persecution of working class leaders. They also joined in the protest against the execution of Sacco and Vanzetti in that year.[60]

In 1925 Grosz, with Herzfelde's help, revised and organized his articles into a small book, *Die Kunst ist in Gefahr* (Art Is in Danger). The major essay, which gave the book its title, was built around Grosz's 1924 statement, "Abwicklung." Working together, Grosz and Herzfelde transformed the statement into a long analysis of the problems of contemporary art. In the essay, the authors clarified their own understanding

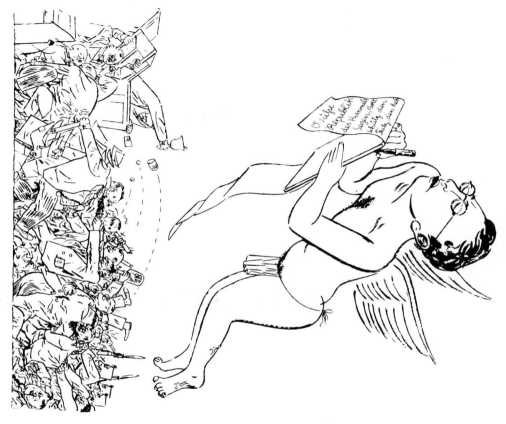

FIG. 29 P. Gast Floats Above the Parties — and Sings the Blessings of Inner Peace, *Rosarote Brille*, p. 10, Gez., p. 107.

of the Marxist view of history: that all culture was dependent upon the means of production in society; that the artist could not stand above his society; that the artist was, therefore, either a supporter of the ruling class—whether actively or passively by his indifference—or of the working class.[61]

After a "gallop" through art history, the authors concentrated upon the contemporary art scene. In their opinion photography and films were responsible for the destruction of art. In reaction to the technical ca-

FIG. 30 *Rosarote Brille*, p. 11. Rudolf Schlichter on the ladder; Otto Schmalhausen on the scooter; Grosz with the broom; John Heartfield [?] standing on his hands.

pacities of films, artists had taken refuge in portraying inner reality, which in turn engendered a reaction to a new objectivity. Constructivism, the best example of the escape from emotionalism into fact, led, by its very nature, to the end of art, because the pure constructivist is an engineer or architect not an artist. In the Soviet Union, the constructivist artist served an important function in the process of industrialization. In the industrialized west, the constructivist would only be assimilated into the industrialized capitalist society.[62] Therefore:

Art is in danger. Today's artist, unless he wants to be useless, an antiquated misfit, can only choose between technology and class war propaganda. In both cases he must give up "pure art." Either he joins the ranks of architects, engineers, and ad men who develop industrial strength and who exploit the world, or he, as depictor and critic of the face of our time, as propagandist and defender of the revolutionary ideas and its followers, enters into the army of the oppressed who fight for their just share of the worth of the world and for a sensible social organization of life.[63]

The last essay in the book was an attack upon Paris's position as the art center of Europe. Grosz saw Paris as a reactionary center of art which was ignoring political revolution while concentrating on aesthetic problems. Referring to the neo-classicism of Picasso, Grosz maintained that the could not find anything noble or classical in "the rubber doll-like, bloated forms which reminded one of elephantiasis." Paul Klee, he said, was occupied with sweet Biedermeierish embroidery. Kandinsky deluded himself, according to Grosz, with projecting music onto a canvas. Kokoschka pushed propaganda for the degenerate burgher. The expressionists tried to paint their own souls, while the futurists thought they could capture movement on paper—all were futile pursuits in Grosz's opinion.[64]

Die Kunst ist in Gefahr was translated into Russian and published in Moscow in 1926. The foreword to the book was written by V. Perzov, a critic whose position was close to Mayakovsky's *Lef* group. Perzov interpreted Grosz's and Herzfelde's analysis of contemporary art as upholding the position of the constructivists. He read their essay to mean that modern artists had to choose between the technological art of industrial production —constructivism — or soul-searching bourgeois art and photography. The latter were, of course, reactionary. The revolutionary artist who was on the side of the proletariat would, according to Perzov's interpretation of Grosz, choose constructivism.

Shortly after the book with its interpretive foreword appeared, Lunacharsky published an article refuting the constructivist interpretation. He insisted that Perzov had misread the final paragraph which presented the artist with the way of the technologist who would exploit the world and the way of the revolutionary artist who would support the proletariat. Grosz, Lunacharsky stressed, was not advocating constructivism which by 1926 was definitely out of favor in the Soviet Union. Instead, he said, Grosz saw the future of art in revolutionary forms for the proletariat. Lunacharsky had great respect for Grosz, whom he had met again in late 1925 and early 1926 during an extended visit to Germany. In his defense of Grosz, he wrote: "George Grosz is one of the greatest talents in modern graphic art. A brilliant, original draftsman, a biting, sharply observant caricaturist of bourgeois society . . . I had in Berlin the rare pleasure of being able to look at almost everything that has come from the hands of George Grosz. It is truly astonishing, not only in the vigor of his talent, but also in the degree of his animosity."[65]

CHAPTER 5

BOOKS AND PORTFOLIOS

CARICATURE, as it has been practiced since the eighteenth century, is a deeply serious form of social satire. Through distortion of ideal canons, it seeks to ridicule and expose. More than that, it accuses and judges those elements in society which need reform. In his study of caricature, Ernst Gombrich noted that the dangerous, virtually magical, element in caricature is the ability "to copy a person, to mimic his behaviour," and in so doing, "to annihilate his individuality."[1] Once a person has been successfully caricatured, he is revealed as a ridiculous figure, which can be devastating for a public leader. The classical illustration of the seriousness with which a ruler views a caricature of himself is Louis Philippe's court action against Charles Philipon for printing caricatures, many by Daumier, that transformed the king into a pear.

Caricature can go beyond specific portraiture. In its broader meaning, caricature refers to any drawing in which the human appearance is consciously exaggerated. A common technique of caricature is the invention of a type through exaggeration of recognized characteristics. A type is generally a concentrated form of a particular class or human attitude, for example, Monnier's Monsieur Prudhomme and Daumier's Robert Macaire. Hence it is apparent that caricature can be effectively wielded only by a person who is in some measure revolting against the accepted norms of society. It is not surprising that Grosz should have utilized caricature as his weapon against the ruling classes of Germany and against the society which he hated. Before the war when Grosz was first experimenting with his sketches outside the Academy in Dresden, he had tried to imitate the popular cartoonists of his day. His motivation was financial—to make money with art—and his cartoons were effete,

stylized, and lifeless. By the end of the war, his drawings had become genuine caricatures, accusing, judging, trying to pass a death sentence against the society which produced war, revolution, injustice, suffering, and death.

Willi Wolfradt, writing about Grosz in 1921, maintained that Grosz went beyond caricature. Caricature, Wolfradt said, was the distortion or accentuation of common phenomena in order to make those features ridiculous, but Grosz's satire was not rooted in ridicule, rather it shocked the viewer to the core of his being. While Daumier's work produced ironic humor, Grosz produced cruel, painful, and biting derision. Caricature exaggerated and distorted man's little weaknesses in order to expose them, but Grosz exposed the essential naked ugliness and sad reality of man. Grosz's work was devastating, in Wolfradt's opinion, because it went beyond caricature's distortion of reality to produce a shocking image of an already distorted reality.[2]

With consummate skill Grosz poured his political convictions into his drawings. His mastery of drawing techniques was of immeasurable importance in the propagation of his political ideas, for it was his drawings which established Grosz's reputation as a communist artist. All of his other activities and statements would have been of little interest if he had been unable to implement his convictions in his art. To be a successful weapon of propaganda, however, caricature had to be more than brilliant: it had to reach the public. Grosz's art would have been a useless weapon without Wieland Herzfelde. The Malik Verlag, which Herzfelde initially created to publish Grosz's drawings, was a monument in the first years after the war to the enthusiastic collaboration of the Herzfelde brothers and George Grosz. Of the 36 titles which the press published from 1919 to 1921, 18 were illustrated by Grosz and 3 were Grosz portfolios. The press steadily increased its output, publishing 140 titles from 1922 to 1932, when it moved to Prague. Of these, 8 were George Grosz books or portfolios; another 10 were books illustrated by him. Until 1925 the bulk of Grosz's published work was done with Herzfelde and the Malik Verlag. Grosz designed the colophons for the press in 1919 and in 1921. The latter depicted a flag with the hammer and sickle, a laurel wreath, and the motto: "Proletariat of the world unite."[3]

The Malik Verlag was committed to Marxism. Though it was a communist press, it was not the press of the Communist party in Germany. Determined that the press be an independent communist voice, Herzfelde

refused financial backing from the Soviet Union or the party.[4] He envisioned the press as an instrument which would increase the class consciousness of the working classes and would intensify their revolutionary spirit. To achieve these aims, Herzfelde published some political studies — works by Lenin, Trotsky, Karl August Wittvogel, and Georg Lukács, for example — but primarily the press published literary works. These ranged from the classical revolutionary literature — the complete works of Leo Tolstoy, Maxim Gorki, and Upton Sinclair — to works by unknown writers. Herzfelde particularly wanted to provide a forum for new writers who understood the revolutionary situation of the working classes or who simply portrayed the despair and degradation of the working classes under capitalism. For example in 1923 Malik published *Die Hütte*, ten stories with a cover drawing by Grosz. The author, Peter Schnur, was, according to the introductory notes, just a simple worker who wrote in his spare time. He had no hope of attaining literary fame and could not write in correct literary German; he did, however, understand his fellow workers and could write their language.[5] Alongside these unknown proletarian writers, Herzfelde published works by new revolutionary talent, particularly Ilya Ehrenburg and Bertolt Brecht. In his memoirs Ehrenburg wrote about his German communist friend Herzfelde, who "always came to the rescue of Soviet authors." In 1928 Mayakovsky wrote from Berlin to Ehrenburg, "All my hopes are in Malik."[6] Malik published in 1924 a German edition of Mayakovsky's *150 Millionen*, a controversial futuristic poem which had displeased Lenin in 1920.[7] Among others who appeared in Malik translations before 1933 were Alexandra Kollontay, Isaac Babel, and Sergei Tretyakov.

To promote the consciously revolutionary aims of the press, many of the books were grouped into series. The Little Revolutionary Library, 1920–23, containing eleven political and social studies, grouped a biography of Lenin by Zinoviev together with Grosz's *Das Gesicht der herrschenden Klasse*. The Red Novel Series, 1921–24, included novels by Franz Jung, Upton Sinclair, Oskar Maria Graf, John Dos Passos, and Anna Meyenberg. Of these, Grosz illustrated the volumes by Jung and Sinclair. The Collection of Revolutionary Plays, 1921–23, grew out of Herzfelde's work with Erwin Piscator.[8]

The overtly revolutionary character of the press did not pass unnoticed by counterrevolutionary and conservative forces. The press was harassed officially and unofficially. Herzfelde was the defendant in several law suits, including the three government trials of himself and

Grosz for publishing drawings which "offended" the German people. Herzfelde found it advisable to open a branch in Vienna in order to protect the press against losing all its stock whenever the government in Berlin confiscated copies of a book. The branch office was maintained for two years, 1924–26, until financial problems forced it to close.[9]

The reputation of the firm as a revolutionary establishment made it difficult for the press to find offices. In 1924 Herzfelde was able to rent spacious and favorably located quarters near the Potsdamer Platz on Köthener Strasse, where the Malik Verlag planned to share space with the Galerie Grosz. Even as Herzfelde and Grosz were moving in, the landlord tried to prevent the move, having found out who his tenants were. Herzfelde managed to insist that the lease be honored but had to move when it expired in a year. While the press and the gallery were at Köthener Strasse, they published a book by the statistician E. J. Gumbel, which revealed the history of political murders carried out by the national secret societies and the illegal or Black Reichswehr during the first four years of the republic.[10] Incensed by the appearance of this book, one of the right-wing nationalist groups which had an office a few doors from the Malik offices reacted by smearing up the plate glass windows and front of the Malik building.[11] Herzfelde was able to turn this political vandalism into good publicity by utilizing photographs of the smeared windows as proof of the validity of Gumbel's book. Malik published four of Gumbel's books dealing with the right-wing murders and the subsequent lenient treatment of the murderers by the prejudiced judiciary. The last one, *Verräter verfallen der Feme!*, had a drawing by Grosz on the jacket.[12]

During the years 1919 to 1925, George Grosz published his work almost exclusively with the Malik Verlag. The George Grosz portfolios and George Grosz books of drawings all appeared with Malik, though he did some illustrative work for other presses. Because Grosz rejected the idea of "art for art's sake" or art as a source of investment for the capitalist,[13] the bulk of his work in the first half of the twenties was published in small inexpensive educational books which were aimed at the general public, particularly the working class. The books, which usually contained around fifty drawings, were meant to educate the workers. Grosz also illustrated a variety of novels, poems, and short stories for Malik. All of these were similarly inexpensive and political in intent. Because even they had to be financed, Herzfelde published expensive portfolios which were consciously priced for the wealthy classes. In revolutionary terms, the capitalist classes could help finance their own

downfall. Grosz's determination to have his work reach the workers and not be just a form of investment for the bourgeoisie was shown by the publication of cheap editions of the expensive portfolios. *Ecce Homo* (1923), *Abrechnung folgt!* (1923), and *Das Gesicht der herrschenden Klasse* (1921), all appeared in a wide range of prices and quality.

Grosz's revolutionary drawings were concentrated in the first four years of the republic. From 1919 to the end of 1923 the republic existed precariously between uprising and strikes from the left and coups and putsches from the right. Radical workers, soldiers' councils, and dissident intellectuals led by the Communist party confronted an assortment of nationalist counterrevolutionary groups allied with the German officer caste and the disaffected soldiers of the Free Corps. For both the right and the left, the government of the republic, which was generally a coalition of Majority Socialists, Center, and Democratic parties, was an obstacle to be removed. The government, afraid of bolshevism, was not so worried about the counterrevolutionary elements in the army and the Free Corps. The frequent strikes—almost 5,000 in 1919—and leftist revolts were crushed, bloodily, by military and Free Corps units under orders from the government.

In January, 1920, a mass demonstration of workers in Berlin was dispersed by troops with machine-gun fire and the successive protest strikes in all parts of Germany were rapidly suppressed with bloodshed by the Free Corps. By March, 1920, the Free Corps felt strong enough, together with nationalist leaders and generals, to overthrow the SPD government. Successful, the Kapp putsch lasted for four days. It capitulated before a general strike called by the socialists and the trade unions. The legitimate government was restored but was immediately faced by leftist insurrection in the Ruhr. The government, after negotiations failed, was forced to authorize the Free Corps to launch a full-scale military offensive in April against the "red army" in the Ruhr. In the white terror which the Free Corps carried out after every communist revolt, hundreds of workers and citizens were "shot while attempting to escape" or sentenced to death by summary "court-martials."[14] In a letter written to his family, a student who belonged to the Von Epp Free Corps described his part in battling the workers in the Ruhr:

No pardon is given. We shoot even the wounded. The enthusiasm is terrific—unbelievable. Our battalion has had two deaths; the Reds 200–300. Anyone who falls into our hands first gets the rifle butt and then is finished off with

a bullet . . . We even shot 10 Red Cross nurses on sight because they were carrying pistols. We shot those little ladies with pleasure — how they cried and pleaded with us to save their lives. Nothing doing! . . . [15]

Two months later George Grosz published his first major portfolio attacking German soldiers and officers.

Published by Malik in June, 1920, *"Gott mit uns"* (God With Us) contained nine original lithographs. Three of them presented collections of military types: the aristocratic, effete officer; the sensual, gluttonous officer; the brutal, animal-like officer; and the enlisted men (Fig. 31). One of these superbly summed up the arrogance and bestiality which

FIG. 31 The Germans to the Front, Gmu, pl. 2, GhK, p. 23.

Grosz saw in the military mentality; its title was "Made in Germany" (Fig. 32). Three of the drawings revealed military men in macabre situations; officers shown against a backdrop of prostitutes with death's heads (see Fig. 21); military doctors pronouncing a skeleton fit for service (see Fig. 19); and an infantry man contemplating grotesquely bloody and swollen bodies which floated in a river below the distant towers of the Frauenkirche in Munich. The remaining drawings dealt with the subjugation of the working class by the military backed by capitalists (Fig. 33). In "Blood is the Best Sauce," a fastidious officer lifts his wine glass to a gross profiteer who is gorging himself while in the background seven soldiers bloodily massacre two workers. The disgusting nature of the drawings was exacerbated by the choice of the title: "Gott mit uns" was the motto found on soldiers' regulation belt buckles during the war.

In 1920 Grosz illustrated five books for the Malik Verlag, of which two were written by close friends. Wieland Herzfelde in *Tragigrotesken der Nacht* (Tragi-grotesques of the Night) recorded a series of dreams, at once surrealistic and political, written from 1913 to 1919. The dreams,

FIG. 32 Made in Germany,
Gmu, pl. 9, GhK, p. 33.
Gez., p. 75.

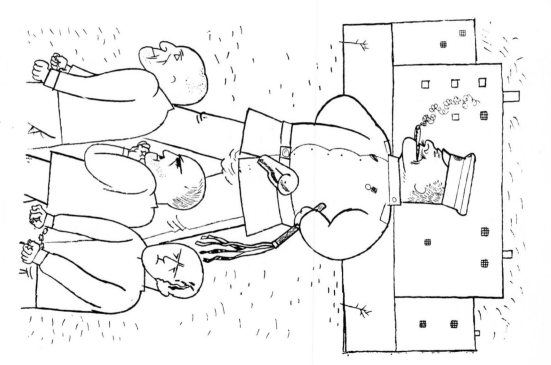

FIG. 33 The World Made Safe for Democracy, Gmu, pl. 7. Herzfelde, *Tragigrotesken der Nacht*, p. 72. GhK, p. 60.

which told of the irrational experiences of the little man in the war, had about them a Kafkaesque quality which was echoed in the twenty-three Grosz drawings (Fig. 34).

The second book by a friend was the *Phantastische Gebete* (Fantastic Prayers) by Richard Huelsenbeck. These dada prayers, a series of short poems, were shocking, impertinent, expressionistic. There was a heavy

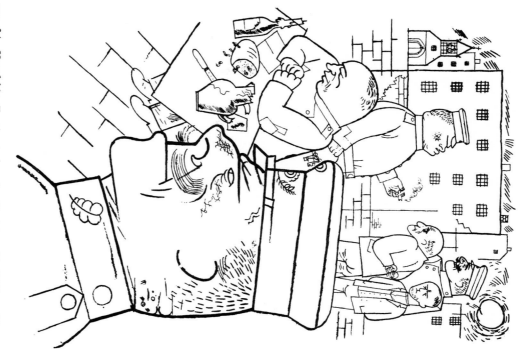

stress on obscene words and images, on corruption, decay, death, sex, and offal. The Grosz drawings were quite different from those accompanying the Herzfelde book. Here "Everyman" was delineated in his baser moments: drinking, eating, vomiting. Even prayer did not banish his animal nature. Here, for the first time in published drawings, Grosz drew "Everyman" explicitly as animal (Fig. 35). Here also the prostitute was portrayed as a vampire who wears a small cross on a velvet ribbon around her neck, and who is accompanied by a skeleton of death.

FIG. 34 Herzfelde, *Tragigrotesken der Nacht*, p. 61. GhK, p. 53.

FIG. 35 Huelsenbeck,
Phantastische Gebete, p. 15.
Gez., p. 119.

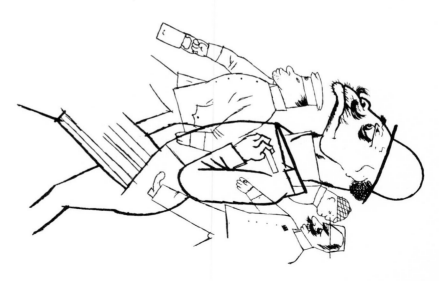

These figures must have fascinated Grosz, for in this same year he took the major illustrations from Huelsenbeck's book and combined them into a nightmarish street scene. The central figure in the scene is a nattily dressed burgher who walks along oblivious of the animals and the vampires who surround him. The resulting lithograph bore not the obvious title which Grosz might have given to it—"Man Is Not Good—But a Beast," a line from his own writing—instead, he ironically titled the lithograph "Man Is Good" (Fig. 36). The lithograph may have been meant to be a satire upon Leonhard Frank's book, *Der Mensch ist gut*, written in 1916–17 and published in 1919. The book, five short stories about the effect of the war upon people, was inspired by a belief in the brotherhood of all men and in the possibility of a world based on human love. As a communist, Grosz would have rejected this utopian optimism. His lithograph, however, was more than a communist satire upon a

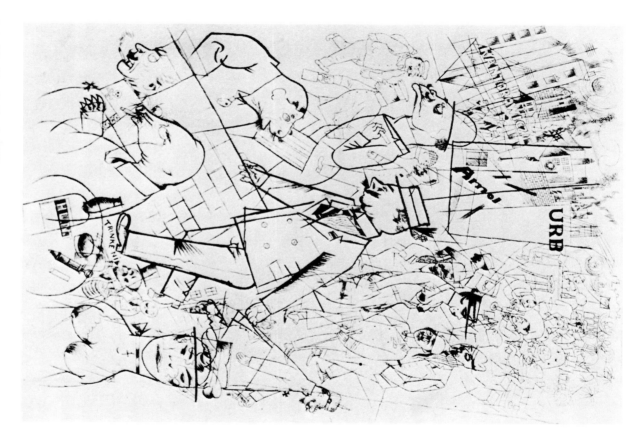

FIG. 36 Man is Good, 1920.

popular socialist book. Taken together with the Huelsenbeck book and its drawings, it reveals the strong misanthropic strain which Grosz was never able to shed completely, even at the height of his commitment to the communist cause. Despite the public statements in which he adhered to the Marxist belief that capitalist institutions were the root of evil, Grosz in these drawings and the lithograph castigated man himself as the source of evil. The use of the ironic title betrays the complexity of his ideological commitment.

Of the other books which Grosz illustrated in 1920 for Malik, two were statements on dadaism by Huelsenbeck and one was a collection of speeches and manifestos dealing with the German handling of the Brest-Litovsk treaty. This book, one of the Little Revolutionary Library, had a Grosz drawing for its cover.

1921 was one of Grosz's most productive years. The political situation continued to be unstable. The Free Corps went underground, but nationalist secret societies dispensed "justice" to "traitors" by means of widespread political assassinations. Former minister of finance Matthias Erzberger and foreign minister Walther Rathenau were the most eminent victims in the 354 political murders committed by rightists from 1919 to 1922. In March communist-inspired workers' uprisings were crushed in the industrial-mining centers of central Germany.

Reacting in his drawings to the continued disturbances, Grosz, who was busy in IAH affairs that year, was able to produce a portfolio and an educational book, and to illustrate eleven books. His portfolio *Im Schatten* (In the Shadow) reflected his work with IAH for oppressed and starving workers. The nine original lithographs portrayed the sick side of life in the city and the types who inhabited it. Against a backdrop of factories spewing smoke and apartment houses falling into decay, ranks of workers march in grim determination (Fig. 37). One drawing showed the contrasting scenes caught in the shadows of dawn: outside on the street the proletariat begin a day of work, while inside the houses the capitalists finish a night of drink and sex (Fig. 38). The rest of the lithographs presented other street types: the crippled war veterans, the beggars, the profiteers, the prostitutes. The worker is the only one of all of these types not portrayed as a degenerate figure.

Das Gesicht der herrschenden Klasse (The Face of the Ruling Class, 1921) was the first of the polemical or educational books designed to enhance the class consciousness of the proletariat. Volume four of the

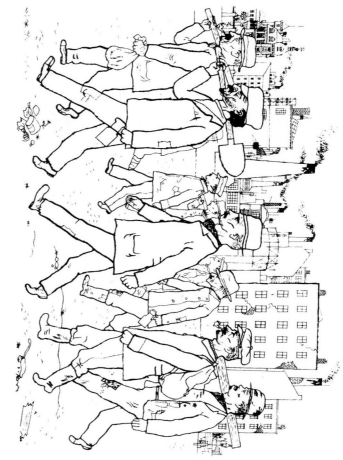

FIG. 37 *Im Schatten. Gez.*, p. 31.

Little Revolutionary Library, it contained fifty-five drawings in a small book format which could be easily reproduced. The book was reissued in three editions for a total of twenty-five thousand copies. Tucholsky, reviewing the book in the *Weltbühne*, urged his readers to get their copies immediately before the police should decide to confiscate the book.[16] The political impact of the drawings was heightened in the books by a very judicious use of ironic captions. Many of these were created by Wieland Herzfelde; others were the result of discussions among the three friends.[17] The irony was often heavy-handed, but the message was always clear. One of their favorite methods was to juxtapose traditional sayings, fragments from songs, or well-known quotations with a drawing which would reveal the total hollowness of the statement. For example, a drawing of an unctuous preacher declaiming to three weary prisoners seated by barbed-wire-covered windows under the bored eyes of a guard was entitled "Come to me, all who labor and are heavy-laden" (Matt. 11:28, R.S.V.) (Fig. 39). Or, equally pedantic, "Shot While Escaping," the verdict that had been widely applied to murdered

FIG. 38　*Im Schatten*. GhK, p. 54, as Five in the Morning.

Spartacists, was appended to a drawing of a worker tied securely to a stake who is being shot by two officers (Fig. 40).

By far the largest number of drawings in *Das Gesicht der herrschenden Klasse* was devoted to the betrayal of the workers by the ruling classes

FIG. 39 Come to Me, All Who Labor and Are Heavy-Laden!, GhK, p. 50.

in the republic. The worker was portrayed as the recipient of injustice at the hands of the judiciary, of useless promises from the clergy, of brutality to his family from the police, of death himself from the soldiers. The worker was shown being deceived, beaten, starved, shot, stabbed, worked to death, imprisoned, and killed in war. A second preoccupation of the book was another attack upon military types. All of the drawings from "*Gott mit uns*" were reprinted in *Das Gesicht der*

FIG. 40　"Shot While Escaping," GhK, p. 39.

herrschenden Klasse, and new military types were added to Grosz's gallery of bestiality. Several drawings disparaged such para-military groups as the *Orgesch* and the *Einwohnerwehr*. Another portrayed the types out of "Kapps Menagerie."

The social and economic dislocation which continued to plague Germany were reflected in another group of drawings presenting types who batten upon society: the whore, the profiteer, the capitalist. One repulsive drawing of a whore and two lascivious old men was called "Pillars of Society." The vampire prostitute, the syphilitic beggar, and the crude profiteer all appeared in these drawings (Figs. 41 and 42). In those years after the war, shrewd businessmen and industrialists like Hugo Stinnes were rapidly accumulating immense fortunes, while rising prices and unemployment caused starvation and despair in the lower classes. The greatest of all the parasites of society from Grosz's viewpoint, therefore, was the industrial capitalist, who through his huge wealth could manipulate people like puppets and who reduced all humanity to things — buildings, factories, and gold. Marx had called this the objectification of social relationships. Specifically, Grosz attacked "Stinnes and Co., or the Hagglers Over Men" in a drawing which showed a worker bound

FIG. 41 Swamp-Flowers of Capitalism, GhK, p. 58.

in ropes standing on top of a conference table surrounded by fat, cigar-puffing men (Fig. 43).

These were the faces of the ruling classes and of the people who surrounded the rulers, as viewed by a communist. Tucholsky commented: "I know no one who has grasped the modern face of the holders of power right down to the last alcoholic veins as [Grosz] has. The secret: he not only laughs, he hates."18 Grosz distilled the essential characteristics of those who made up these classes and combined them into types. The type was Grosz's most powerful ammunition, for its effects were twofold. It opened the eyes of the workers; it educated them to recognize the face of their enemies. But, more than that, it dehumanized those whom it portrayed. It reduced the individual to a less than human figure, one who was worthy of contempt and hatred, but not of compassion.

It was impossible to portray part of the world in caricature, to subject the ruling classes to the George Grosz style, without also portraying the workers in the same fashion. The working class, therefore, be-

FIG. 42 The Gratitude of the Fatherland Is
Assured You, GhK, p. 28.

came a clearly recognizable type in Grosz's world of types. There was
a difference, however. The exploiting classes, those who ruled and those
who battened upon the workers, were characterized by Grosz's pen
through exaggeration and brutalization of gross and unpleasant features.
The worker type resulted from an initially sympathetic treatment of a
working class figure which was then repeated over and over with certain
limited variations. One senses in this characterization a product of an

FIG. 43 Stinnes and Co., or the Hagglers Over Men, GhK, p. 47.

industrial society, a figure whose uniformity suggests oppression and deprivation—the stooped shoulders, the thin slight figure, the shapeless clothes, the automatic marching to work, the resignation. In contrast, the figures of the exploiters and rulers have in common a bestiality which had grown through generations of indulgences in all the sins of power, of pride, of possession, and of the flesh. Günther Anders reports that Grosz's capitalist types were so powerful and incisive that they were used in the twenties in the Soviet Union as archetypes of the capitalist.[19] An increase in class consciousness on the part of the worker was supposed to result from these stylizations: recognition of the capitalist enhanced class hatred; recognition of the worker enhanced class solidarity.

Grosz did not limit himself to caricature of types. His vitriol extended to specific individual caricatures. In *Das Gesicht* a large group of portrait caricatures vilified various government leaders. Most of these had appeared before in the satirical journals of 1919–20, *Der blutige Ernst* and *Die Pleite*. President Ebert, minister of defense Noske, General Ludendorff, and chancellor Konstantin Fehrenbach were all included in Grosz's

rogues' gallery. An unusual collection of government leaders was lumped together in a photomontage celebration of the "Hohenzollern Renaissance" in which Wolfgang Kapp and General Lüttwitz, leaders of the abortive Kapp putsch, are the unhappy bridal couple.[20]

Perhaps the most ominous of the drawings in this book was one with the caption "The Voice of the People Is the Voice of God" (Fig. 44). In it animal-headed people are gesticulating, shouting, jammering; everyone is talking at the same time; everything is incoherent. The wisps of talk indicate right-wing opinions and slogans. Grosz, in this drawing, was attacking the particular German adulation of the *Volk* as a hallowed source of power and action. The drawing, dated 1920, revealed Grosz's awareness of the currents in Germany which became all too apparent after 1932.

The propaganda or educational purpose of *Das Gesicht der herrscheinden Klasse* was quite evident for, with few exceptions, these drawings had all been published elsewhere, either in one of the portfolios, in the satirical journals, or as book illustrations. *Das Gesicht der herr-*

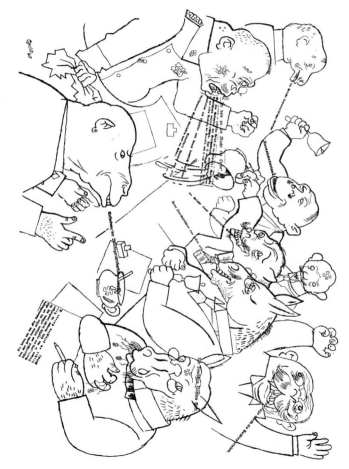

FIG. 44 The Voice of the People Is the Voice of God, GhK, pp. 8–9.

schenden Klasse was published not to present new works of an artist but to distribute a large collection of political caricatures to the widest possible public. *Das Gesicht der herrschenden Klasse* was the epitome of conscious communist Tendenzkunst.

The books which Grosz illustrated for Malik in 1921 were also strong statements of communist ideology. All of them had as their themes the suffering of the proletariat under capitalism and the beginnings of the class warfare against the oppressors. Three of the books appeared as the first three volumes of the Red Novel Series: Franz Jung, *Proletarier* (Proletarians) and *Die Rote Woche* (The Red Week) and Upton Sinclair, *100%*. *Proletarier*, written in the fall of 1920 when Jung, Grosz's dadaist friend who had become a communist activist, was in prison, told the stories of jailed workers. For this, Grosz drew a cover illustration of workers walking past factories. Jung's second book, which contained nine incisive drawings by Grosz, was a detailed account of the events in a week of proletarian revolt. The novel became a searching study of a revolt that failed because of indecision, hesitation, vague goals, and human weaknesses. Jung explored in detail the question of what made soldiers of working class origin willing to terrorize their own people. Grosz's drawings concentrated on confrontations between the soldiers and the people. One illustration so fully distilled Grosz's view of the desperate situation of the worker that he reprinted it in the last edition of *Das Gesicht der herrschenden Klasse* and then included it as an original lithograph in a portfolio which appeared the following year. The drawing and its caption referred to a worker who was dying of consumption: "It is the proletarian illness. A man, who wants to reach the light but is pressed back into darkness" (Fig. 45). Upton Sinclair's *100%* dealt with the same theme, the revolt of workers, this time in America, with the strikes of the IWW and the vicious measures used to suppress them.[21] Grosz's ten drawings, which attempted to be definite illustrations of incidents in the story, were all weak illustrations. They form a puzzling contrast to the strength of the Jung drawings.

Grosz's drawings were represented in another of the Malik's special series, the Fairytales for the Poor. In *Was Peterchens Freunde erzählen* (What Peter's Friends Related), Hermynia zur Mühlen wrote seven fairy tales in which objects in the bedroom of a sick child, the son of a worker, told the tale of their origin. Each tale was an account of the oppression of the poor for the enjoyment of the rich; for example, a bottle was produced by men working in a furnace of hell to provide cool bottles of

FIG. 45 It is the Proletarian Illness, illustration for Jung, *Die rote Woche*, p. 35. GhK, p. 45, as — "and Grants to the Unemployed His Daily Death Benefits." *Räuber*, pl. 8, with the line from Schiller: "Let those swim who can and those who are too clumsy go under." Gez., p. 37, as Triumph of the Machine.

wine for the rich. In the last tale, a snowdrop on the window sill explained that the end of capitalism and the rule of the proletariat were as inevitable as the blossoming of the snowdrops at the end of winter. The Grosz drawings were a strong indictment of the exploitation of the workers.

The Malik Verlag published in 1921 two books on behalf of the Russian famine victims. Grosz worked on both of these. The first one, *Helft! Russland in Not!*, was an IAH publication. The second book, Andersen-Nexö's *Passagiere der leeren Plätze* (The Passengers of the Empty

Seats), fourteen short stories about the suffering of the proletariat throughout Europe, expressed a mood of despair alternating with hope. The despair was concrete and graphic; the hope was vague and allegorical. The theme which unified the stories was that workers living in chains could only be released by death. Grosz's twelve drawings were magnificent portrayals of types of both the ruled and the ruling classes.

Grosz also provided illustrations for a militant little book called *Der Dank des Vaterlandes* (The Gratitude of the Fatherland). The author, Willi Schuster, vividly and bitterly showed how the poor had literally paid with life and limb in the war "for the fatherland," in order to assure luxurious living for the wealthy. Case histories were presented of wounded workers whose disablement prevented them from working, whose disability pay was denied, and whose attempts to beg ended in arrest and prison. The only possible conclusion, Schuster claimed, was class war: "All men to the front. Down with the fatherland of the rich! Our fatherland is revolution, humanity, and communism! If the proletariat is to live, the bourgeoisie must die. Storm the world, you workers." The theme of the book and Grosz's cover drawing were later used by the Communist party for their posters in the December, 1924, elections.[22]

The next productive year with Malik, 1922, continued the ideological work which Grosz had done in 1921. The major portfolio of the year was *Die Räuber* (The Robbers). The lithographs of "*Gott mit uns*" two years earlier had concentrated upon exposing the military class. In a similar way the nine lithographs of *Die Räuber* attacked and unmasked the predatory nature of the capitalists. Each lithograph was accompanied by a sentence from Schiller's play *Die Räuber*, a tragedy about a young man rebelling for personal reasons against society; the result was a revolutionary interpretation of the quotations from the play and a heightened revolutionary tone to the lithographs. Four years later Erwin Piscator gave a similar reading to *Die Räuber* in his production at the State Theater in Berlin.[23] While there is no specific evidence that Grosz's portfolio inspired Piscator, it is quite probable, for they were friends throughout the twenties.

The first plate laid bare in all of its ugliness the industrial capitalist as despoiler of all that surrounded him. The lines from the play make the meaning of the drawing unmistakable: "I will root up from my path whatever obstructs my progress toward becoming the master" (Fig. 46). The hallmarks of the new tyrant as Grosz drew him are an obese body, lumpy genitals, pudgy hands often shown with rings, formal dress, a

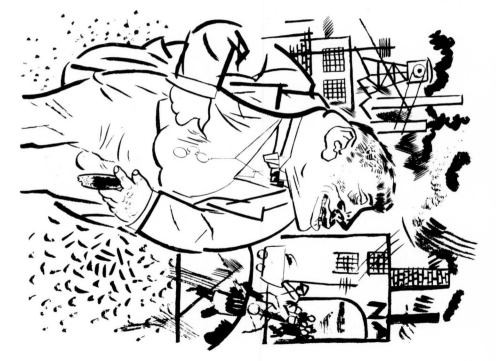

FIG. 46 *Räuber*, pl. 1. Af, 36, as The Director —. *Gez.*, p. 27.

blunt head resting not upon a neck but on folds of flesh which sloped into the shoulders, tiny eyes, a repulsive nose and mouth, and an ever-present cigar. The second plate set three such swollen types against the thin, emaciated figures of workers who stand still and impotent under the gaze of two policemen (Fig. 47). The rapacious nature of the capitalist stood out starkly in the fifth plate with Schiller's reference to wild animals: "Lions and tigers nourish their young. Ravens feast their brood on . . ." (Fig. 48). Grosz further dwelt upon the way in which the German burgher expanded by drawing strength even from those nearest him, his own family. A Christmas scene depicted a fat

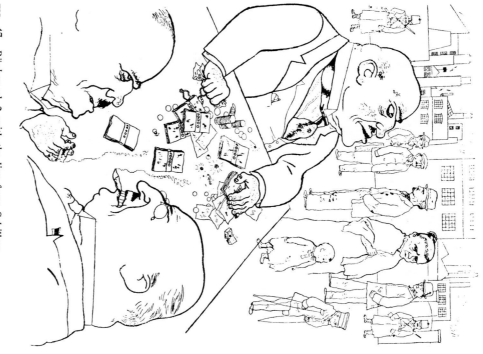

FIG. 47 *Räuber*, pl. 2, with the line from Schiller: "Under my rule things shall be so bad that potatoes and thin beer shall be considered a holiday treat; and woe to him who meets my eye with healthy red cheeks! Pale poverty and servile fear are my favorite colors and in this livery will I clothe you." GhK, p. 22, as The Toads of Capitalism. *Gez.*, p. 67.

satiated man with his two sickly, thin sons. They are playing while a tired-looking mother at the piano sings "Silent Night." This scene of domestic inequality has the father invoking the blessing from Schiller: "The blessing of God is visibly upon me." The portfolio ended with two lithographs of workers. The first one, which had been used in Jung's

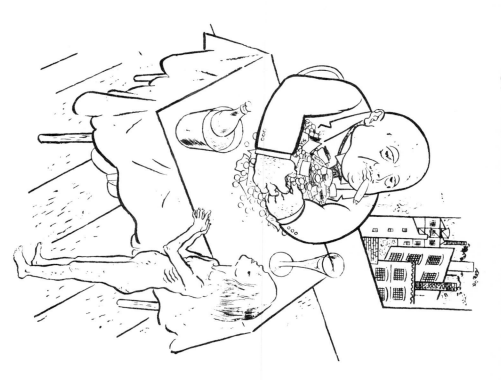

FIG. 48 *Räuber*, pl. 5. Af, p. 14. Gez., p. 47.

Die Rote Woche, showed the dying worker who was unable to survive in the jungle created by the capitalists (Fig. 45), but the last plate was a statement of victory and retribution. Surrounded by graves, a worker with a bloody face stands firmly, resolutely shaking a clenched fist, claiming his day which will bring victory over oppression (Fig. 49).

This last drawing had a curious aftermath. It was reprinted in 1923 in *Abrechnung folgt!* When the Red Frontfighters' League (Roter Front-kämpferbund) was formed, John Heartfield was searching for an insignia for it. He took the upraised clenched fist from this drawing in *Abrech-nung folgt!* and mounted it against a photograph of a massed workers'

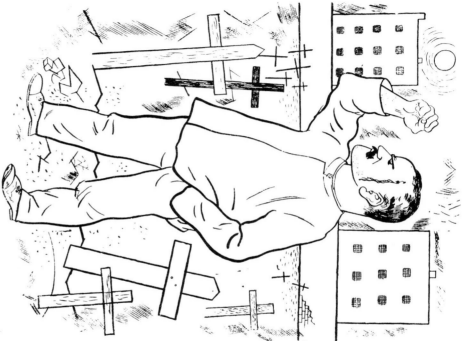

FIG. 49 Over the Graves of March, *Gegner* 3, no. 1. *Räuber*, pl. 9, with the line from Schiller: "Right is with the one who overcomes." Af, p. 15, as Abrechnung folgt.

rally. This photomontage was first printed in the *Arbeiter Illustrierte Zeitung*. A later variation—the fist viewed from the back, mounted on a photograph of the fourth Reichssteffen, or mass rally of the League, May 27, 1928—became their official symbol. Wieland Herzfelde claimed that this Heartfield photomontage inspired the League to use the uplifted clenched fist as its symbolic gesture.[24] This is a rare example of a drawing having concrete, if indirect, effect upon a mass movement.

The figure of a vigorous and rebellious worker with which Grosz ended *Die Räuber* continued in a series of Grosz drawings for Oscar

Kanehl, *Steh auf, Prolet!* (Rise up, Worker). Published by Malik in 1922 as one of the Little Revolutionary Library, the collection of poems formed an insistent call for revolution. The poems were militant; for example, "Summons to Strike" concluded with:

Fluch jedem Hammerschlag für Bürgerbrut.
Fluch jedem Schritt in ihre Sklaverei.
Fluch ihrem Dank. Fluch ihrem Judaslohn.
Euer ist die Erde.
Heraus aus den Betrieben!
Auf die Strasse! [25]

A curse on every hammer stroke for bourgeois brood.
A curse on every step into their slavery.
A curse on their thanks. A curse on their treacherous wages.
Yours is the earth.
Out of the factories!
Into the streets!

The drawings matched the resolution of the poems. While the poems described the blood-sucking burgher, the drawings depicted him guzzling sumptuous meals or sitting astride mounds of money. Two poems and drawings dealt with the plight of the worker held as a political prisoner who waits for the revolution which will free him (Fig. 50).

One of the drawings provided a good contrast between Grosz's worker type and a military type. The worker is a man, wounded, suffering, facing death, but still retaining his humanity. The soldier, heavily armed with pistol, saber, and grenade, has a face so contorted by hatred that it resembles a wizened animal (Fig. 51). It was this creature that had limitless power over the proletariat, for, according to the poem, no one ever made any inquiries into proletarian deaths:

Proletariat erschlagen. Wer fragt danach?
Mörder reiben sich die Hände.
Mörder haben Reisepässe.
Mörder haben milde Richter.
Proletarier erschlagen. Wer fragt danach? [26]

Proletariat slain. Who cares?
Murderers are rubbing their hands.
Murderers have passports.
Murderers have lenient judges.
Proletarians slain. Who cares?

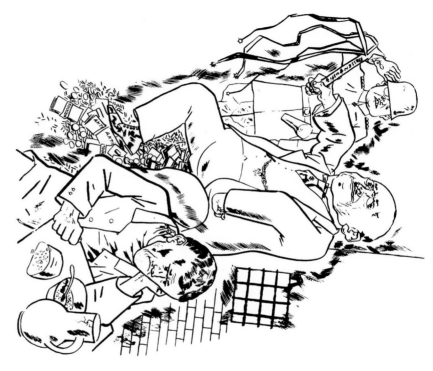

FIG. 50 Kanehl, *Steh auf, Prolet!*, p. 23. Af, p. 57, as If the Workers Want to Stop Being Slaves, They Must Snatch the Knout from Their Masters.

The poems ended triumphantly. The imprisoned worker, the martyred workers, the widows, and the children would be vindicated. The workers, who in all the drawings have clenched fists, march through the streets, no longer bent, no longer carrying tools, carrying instead flags and arms (Fig. 52). These workers, in this final drawing, are determined, calm, and relentless:

> Geheiligt ist unser Krieg.
> Gesegnet sind unsere Waffen.
> Gerecht sind unsere Kugeln.
> Rote Soldaten.
> Auf die Barrikaden![27]

FIG. 51 Kanehl, *Steh auf, Prolet!*, p. 29. Af, p. 55, as Four Years of Murder. The figure of the worker was on the June, 1925, cover of *Knüppel*.

> Holy is our war.
> Blessed are our weapons.
> Righteous are our bullets.
> Red soldiers.
> To the barricades!

This conjunction of militant drawings and poems was pure communist propaganda. It carried an unmistakable message for even the simplest mind in the working class. The heroes of the book were those who held up the example of a successful revolution, Lenin and Lunacharsky, and those who had died in search of revolution, Liebknecht and

FIG. 52 Kanehl, *Steh auf, Prolet!*, p. 33. Af, p. 61, as Awake, Accursed of This Earth.

Luxemburg. The book was a poetic and visual elaboration of "Workers of the world unite, you have nothing to lose but your chains." Solidarity of the workers under the aegis of the Communist party could, according to these artists, bring only hope and victory over the bourgeois enemy.

Despite the failure of the communist uprisings in Germany since 1919, the KPD continued to advocate revolution until the abortive revolts of October, 1923, and the subsequent changes in the party. During that

time, Grosz's name must be included among those who helped to propagate this message and sought to bring the workers out onto the streets. A critic for *Die Glocke*, writing in 1922 in this journal published by Parvus, the maverick socialist, equated Grosz's drawings with Hugo Eberlein's call for the workers to revolt against the republic. He called *Das Gesicht der herrschenden Klasse* an inflammatory article (*Hetzartikel*) in fifty-seven installments against the German republic. He was convinced that the communist Grosz was endeavoring to annihilate the republic.[28]

Grosz illustrated three other books for Malik in 1922. None of the others matched the political vehemence of *Die Räuber* and Oskar Kanehl's book of poems. His six drawings for Franz Jung's third workers' novel, *Arbeitsfriede*, were quiet portrayals of the everyday life of the worker. They were illustrations of the story rather than caricatures aimed at teaching or propaganda.

During the years when his revolutionary drawings were most intense, Grosz was searching in his "constructed" drawings for a style suitable for the new artist-worker in the communist technical society of the future. Unfortunately, the new man in his constructions did not become a figure of hope for the future; he seemed rather to be Grosz's satirical comment upon the facelessness of mass man. Instead of exalting the new industrial society, the pictures revealed its emptiness. In short, Grosz, even in his new constructions, was unable to shed his satirical bent. He could not resist putting macabre features onto the precise engineered heads. These features appeared on two of the first constructions printed in *Das Kunstblatt* in 1921. This was the only published collection of these ideal constructed drawings, and already by the purity of the engineering line was tainted by the caricaturist in Grosz. By 1922 when he published seven drawings in this style, only two of them were pure constructions; these seven appeared in the portfolio *Mit Pinsel und Schere* (With Brush and Scissors) and were now called "materializations." Five of the drawings were truly wild creations of the dadaist Grosz, the photomontage Grosz, the caricaturist Grosz, and the constructionist Grosz. The only traces of the new engineering style were the cold rectangular buildings in the background. The rest of the drawings were a weird concatenation of caricature line and photomontage objects (compare Figs. 25 and 53). The end result of these works was consonant with Grosz's earlier works: they too were satirical attacks upon German society. Instead of heralding a new art form to embody a vision of a new world, Grosz achieved

FIG. 53 *Mit Pinsel und Schere, pl. 2.*

an imaginative variation of his own caricatures. After *Mit Pinsel und Schere* Grosz abandoned his effort to produce mechanical art and returned to his unique style of caricature.

In the midst of the French occupation of the Ruhr and the incredible inflation which followed, Grosz published one of his strongest didactic books, *Abrechnung folgt!* (The Reckoning Follows, 1923). The fifty-seven political drawings, again part of the Little Revolutionary Library, had been executed in 1922 and 1923, and some of them had been published in journals, newspapers, and books.

Grosz may have been indebted to Rosa Luxemburg for the idea which lay behind the title and the cover drawing of *Abrechnung folgt!* It depicted a fat figure licking a huge military boot (Fig. 54). In the summer of 1916 Luxemburg had written "A Policy for Dogs" for an illegal handbill issued by the Spartacus League. In it she described the actions of the boot-licking socialists who would receive their day of reckoning from the workers:

A dog is someone who licks the boots of his master for serving him with kicks for many years.

A dog is someone who gaily wags his tail in the muzzle of martial law and faithfully gazes up to his masters, the military dictators, quietly whining for mercy.

A dog is someone who barks at a person — particularly in his absence — and who fetches and carries for his immediate masters.

A dog is someone who, on the orders of the government, covers the entire sacred history of a party with slime and kicks it in the dirt.

Dogs are and always were the Davids, Landsbergs and comrades and they will get their well-earned kick from the German working classes when the day of reckoning comes.[29]

Grosz used this drawing first for a placard published at the time of Walther Rathenau's assassination and then adapted it to the cover of the book. For those who knew Luxemburg's writing, the drawing would have served to identify the ideology in the book.

As in *Das Gesicht der herrschenden Klasse,* the drawings of *Abrechnung folgt!* dwelt primarily upon the betrayal of the proletariat by the ruling classes. There was, however, a difference of emphasis. *Das Gesicht der herrschenden Klasse,* made up of drawings from the years of revolution and civil war, stressed the role of the military in crushing the workers. *Abrechnung folgt!,* printed while the inflation was proletarianizing the middle class and pauperizing the workers, was aimed primarily against

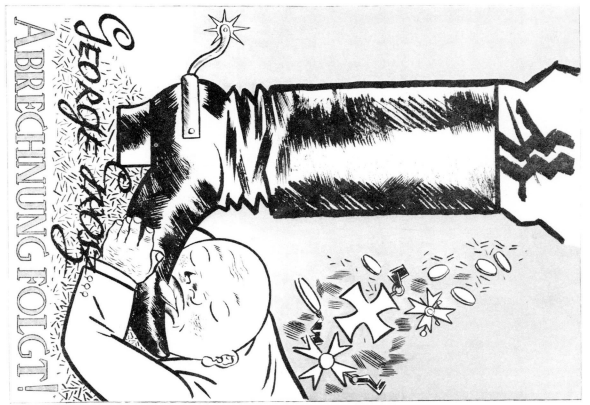

FIG. 54 Af, cover and p. 45.

the capitalists as the enemy of the worker. To be sure the worker-reader understood this point, Grosz included a very didactic drawing with the title "The-Stab-in-the-Back From the Right." Against a background of factories, a worker collapses, stabbed in the back by profiteering (Fig. 55).

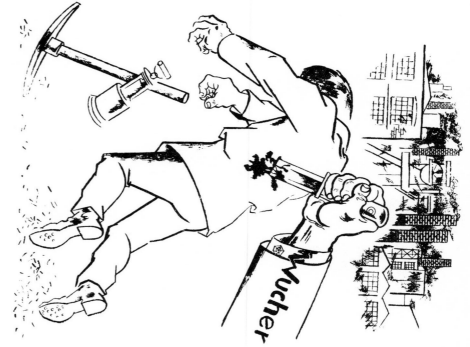

FIG. 55 The Stab-in-the Back From the Right,
Af, p. 54. Gez., p. 61, as Again and Again the People
Suffer for the Ruhr Struggle.

The book wove a counterpoint between drawings of gluttony, wealth, and self-satisfaction and drawings of infirmity, starvation, and destitution. A fat, fur coated, diamond-wearing, cigar-smoking monument to wealth strolls down a street with an emaciated, thinly clad worker who seems to be trapped in an arm-in-arm relationship with the fat man. The caption was "United Front!" This drawing could be a commentary on the unequal united front of workers and industrialists against the French occupation in the Ruhr. Quite a few of the drawings in the book referred specifically or generally to the exploitation of the workers as a result of the Ruhr occupation (Figs. 26–28).

Grosz's view of socialism was summed up in a drawing called "A Half Century of Social Democracy," in which a worker stands humiliated before an arrogant capitalist (Fig. 56). Though the capitalist was usually a stereotyped figure, Grosz did single out one industrial and financial tycoon, Hugo Stinnes, who appeared in four of the drawings. One of

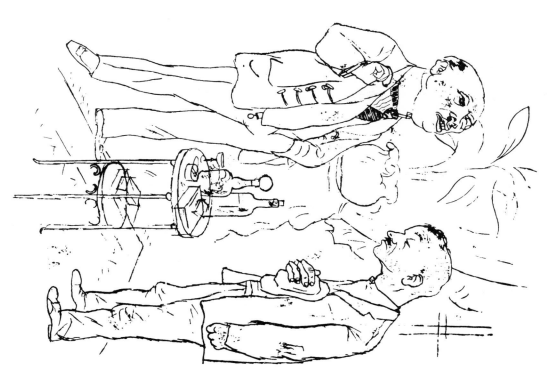

FIG. 56 A Half-Century of Social Democracy, Af, p. 29. *Räuber*, pl. 3, with the line from Schiller: "It is a lamentable role to have to be the hare in this world — but the gracious master needs hares." Gez., p. 35, as Laid Off.

these very clearly stated Grosz's concept of the republic as a tool of the capitalists: "Stinnes and his President" depicted Stinnes, a giant figure, manipulating a tiny puppet wearing an imperial crown who was labeled "Fritz," clearly Friedrich Ebert (Fig. 57). Grosz also portrayed the church as an appendage of capitalism in several drawings. A pair of drawings showed a repulsive capitalist, "The Director—" "— and his Puppets," an ugly Protestant preacher wearing both a crucifix and the iron cross standing on a pile of ruins above a war cripple and a corpse of a soldier. Beside the preacher is a Prussian officer and behind him soldiers and burning houses (Figs. 46 and 58).

Other drawings revealed the impotence of the republic. Not only was it a puppet in the hands of industrialists, it was a scarecrow behind which

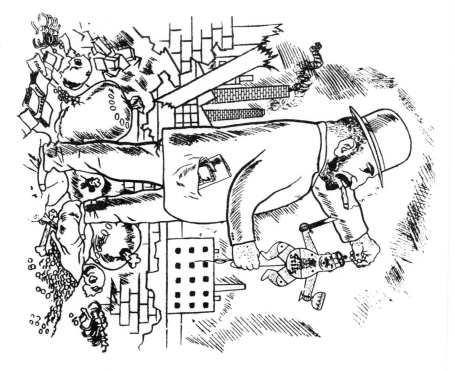

FIG. 57 Stinnes and his President, Af, p. 41.

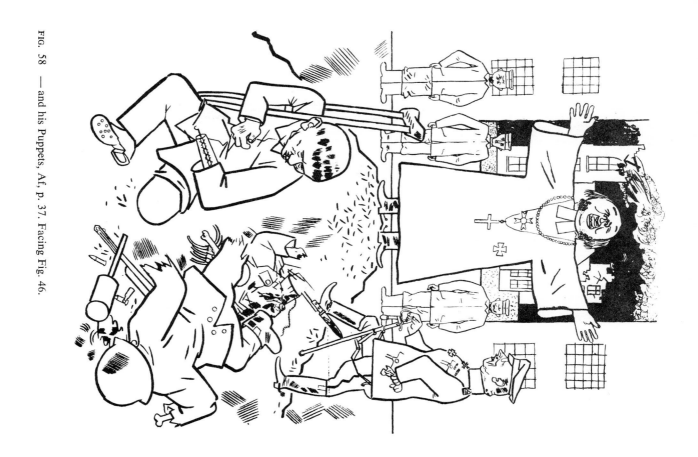

FIG. 58 — and his Puppets, Af, p. 37. Facing Fig. 46.

FIG. 59 The
Republic — A Scarecrow,
Af, p. 44.

a new militarism was flourishing (Fig. 59). Under the sign of the swastika, Grosz portrayed the new militarists as aristocratic figures stockpiling weapons, waiting for their time to turn against the republic and against the worker (Fig. 60). He drew several excellent types, accompanied by slogans that captured the essence of a reactionary and racist attitude in Germany which he saw as dangerous (Fig. 61). Given Grosz's political commitment to the Communist party, he must have meant the title *Abrechnung folgt!* to refer to the day when the worker would claim justice for all of the injuries which were portrayed in these pages. It was, therefore, ironic that in this book Grosz captured so well the reactionary mentality which was going to bring a veritable day of reckoning to Germany under the Nazis.

In late 1922 or early 1923 Grosz published another major work with Malik: *Ecce Homo*, a portfolio which many critics judge to be his best work and the one which is probably most notorious. *Ecce Homo* was

FIG. 61 Jew Get Out!,
Af, p. 53.

FIG. 60 Marloh Now — What a Knight of the
Swastika Wants to Become . . . , Af, pl. 12.

the first Grosz publication done by Herzfelde's press which did not por-
tray explicitly political subjects and which did not deal with the betrayal
of the workers. It was radical and revolutionary in a different way. It
unmasked the private life of the ruling classes in order to discredit them.
Ecce Homo was a merciless document of eroticism. Its drawings reduced
men to their common animal nature. *Ecce Homo* stripped away all of
the fashions and finery of dress, all the pretension of morality, all the
extraneous surroundings of office, study, shop, or home and laid bare
man as a sex-driven creature in his natural habitat—the whore house
or the bedroom.

The drawings ranged over a wide scale of natural and perverse sexual
activity. Lecherous uncles ogle their young nieces (Fig. 62). Sex mur-
derers play cards or scrub their hands after mangling their victims
(Fig. 63). Old men dream dreams (Fig. 64). Young women experi-
ence tumescent ecstasy. "Mummy and Daddy" grapple in grotesque

FIG. 62 Spring's Awakening, 1922, EH, no. 26, Gez., p. 91.

FIG. 63 Sex Murder in the Ackerstrasse, 1916, EH, no. 32. Gez, p. 23.

fury. Brothels abound in activities that titillate jaded senses. A foot fetishist searches for satisfaction. It was a magnificent catalog of erotic activity which marked all sexuality as ugly, bestial, and evil. The use of the theological title conveyed more than an cynical comment on man, for in this portfolio Grosz expressed a medieval theological concept. Sex, in *Ecce Homo*, was sin, one of the deadly sins.

Many people have looked at the *Ecce Homo* and have found in it a brilliant document of the night life in Berlin during the inflationary period of the early twenties (Fig. 65). The profiteers, the prostitutes, and the pleasure-seekers were juxtaposed with the beggars and the dope peddlers; this, it is said, was the corrupt and decadent life of Berlin, captured by a master draftsman and artist.[30] Further, it has been said that the *Ecce Homo* was the product of an artist of Prussian Protestant upbringing who was repulsed by the libertarian nature of the society in Berlin. According to one of his friends, Grosz represented the pure

FIG. 64 Out of his Youth,
1922. EH, no. 3.

Protestant believer who could not accept sin or evil with any of the grace or romanticism of the Roman Catholic. No longer theological or even theistic, the Protestant mission against sin turned into political polemic and propaganda in Grosz's work. But fundamentally it was still the voice of the eternal Protestant raging against this earthly world.[13]

There is much truth in these views, but they miss an essential point about *Ecce Homo*. It was drawn by George Grosz, a Marxist whose avowed purpose was to use art as a weapon against the classes that oppressed the proletariat. *Ecce Homo* was a *document humain* in the tradition of Goya, Degas, and Toulouse-Lautrec, but it was also eroticism in the service of communist propaganda.

FIG. 65 At Night, 1919, EH, no. 34.

While *Ecce Homo* was not polemical in the explicit sense that *Abrech-nung folgt!* was, it had a definite political purpose. It was an attack upon the bourgeoisie. By depicting the bourgeois as a degraded class wallowing in copulation and coition, Grosz could expose their moral hypocrisy. In these drawings Grosz presented a Marxist vision of the dehumanization which takes place within the capitalist society: man has become an object and he treats others as objects.[32] Whereas his earlier portfolios and books had revealed the way in which the exploiting classes under the capitalist system destroyed and degraded the working classes, *Ecce Homo* revealed the way in which the ruling classes ex-ploited, destroyed, and degraded themselves (Fig. 66). This is the

FIG. 66 Silver Wedding, 1922. EH, no. 75.

ultimate weapon in political caricature: to destroy the integrity of a person in his treatment not of his enemies, but of himself and those he loved; to expose a person not for his evil political acts, but for his own degraded and decadent nature. The *Ecce Homo* drawings were a logical outcome of the Marxist view of the decadence and alienation of man which occurs in a capitalist society. The drawings were social criticism and moral accusation used for a political purpose.

Grosz's partisanship is revealed in the fact that there are no worker types in the drawings in *Ecce Homo*. If Grosz had been concerned with criticism of society per se, not with a political end, he would have shown the way in which "all men are beasts." If he had returned to his pre-war misanthropy, he would have depicted the universal nature of eroticism. The sinfulness of sex would have been portrayed as cutting across all the barriers of class and society to reduce all men to beastliness. Instead, Grosz portrayed only the eroticism of the middle classes and the upper classes — the ruling classes (Fig. 67). To make this point explicit, Grosz included a drawing, "Burghers' World," which gathered all the sexual vices together around a central figure who could be the entrepre-

FIG. 67 Studies at the Stammtisch, 1919. EH, no. 10.

neur or pimp or white slave trader who arranged the whole messy scene (Fig. 68). The drawing, by itself, was a compact indictment of the sexual perversions which Grosz, judging by his title, attributed to the German middle class.

The erotic drawings comprised three-fourths of the portfolio. Of the remaining pages, the largest group portrayed types, mostly capitalists, burghers, and profiteers. There were only a few military types. Two fine street scenes, executed in super-imposed planes and simultaneous events, done at the end of the war, brought together all of the Grosz types (Frontispiece). Particularly worthy of notice in the midst of this portfolio of erotic extravagance were four drawings which depicted the same German burgher wallowing, not in sex, but in romantic longing for his Teutonic past. One of these was dedicated to Richard Wagner

FIG. 68 Burghers' World, 1920. EH, no. 18.

(Fig. 69). The others showed a group of old men drinking beer and singing songs from their days in the *Burschenschaft*, the conservative student associations, and an outing of romantic German nationalists.

From 1919 to 1923 Grosz had poured out hundreds of drawings for newspapers, journals, portfolios, illustrated books, and his educational books. These drawings all sprang from his basic commitment to Marxism. As a communist artist he made it his business to attack visually the evils of the republic, to expose its rulers, and to try to increase the class consciousness of the proletariat. These were years of close collaboration with Herzfelde. In 1924 Malik Verlag prepared a collection of

FIG. 69 Memorial to Richard Wagner, 1921. EH, no. 60.

FIG. 70 Daudet, *Tartarin*, p. 7.

Grosz drawings from 1919 to 1923 for a Danish communist publisher. Called *Society Without Veil*, the booklet gathered together the best of Grosz's revolutionary drawings. In 1920 a critic had claimed that in Grosz the period had found the artist who would be needed for its battles. Grosz would be "the sharpest, most ruthless depicter of a rotten time."[33] The drawings in the booklet justified this prediction.

Most of Grosz's energy had gone into the political drawings for Malik. During these years, however, he had illustrated books for several other publishers. These books did not deal with political subjects; most of them were collections of short stories or novels which were either satiric

or grotesque. In one of the books, Grosz's drawings had given definite political overtones to an old classic. Erich Reiss published in 1921 a new edition of Daudet, *Die Abenteuer des Herrn Tartarin aus Tarascon* (*The Adventures of the Tartarin from Tarascon*). John Heartfield planned the layout of the book and Grosz drew over one hundred vignettes, marginal sketches, half- and full-page drawings. The full-page drawings were hand printed, indicating that the book itself was meant to be a work of art. The delightful feature of the illustrations lay in the fact that Grosz chose to use a caricature of President Ebert to represent Tartarin (Fig. 70). By doing so he invested all his drawings, as well as the book itself, with political double-entendre. In that same year Grosz provided drawings of night life and profiteers for Huelsenbeck's novel, *Dr. Billig am Ende*, which was a satire on the social life of war profiteers and swindlers.

In 1923 when inflation had dealt what seemed to be a final blow to the Weimar Republic, when values collapsed along with the mark, when revolution, counterrevolution, and war with France threatened, the old dadaist in Grosz emerged briefly and splendidly. Working with the humorous writer, Alfred Richard Meyer, Grosz produced original lithographs for a limited edition, hand-printed book. The story of a beautiful servant girl's rise from rags to riches solely through her ability to pose provided an excuse for eight light-hearted satirical drawings of a nude. Better than the novel or the drawings was the title: *Lady Hamilton or the Posing-Emma or from Servant Girl to Beefsteak à la Nelson. A Just As Fantastic As Well As Short-Story-Rocking Proliferating Parody; Most Industriously and Most Fleshly Pictured by George Grosz.*

PART III

Towards Nothingness, 1923-33

CHAPTER 6
PARTICIPATION AND PESSIMISM

THE YEAR 1923 was a critical one for Germany, but by its end the country had both weathered major political and economic crises and turned towards a period of new economic and political stability. The last communist attempt to seize power through revolution had been a complete fiasco in October. Under the leadership of Ruth Fischer the party, though nominally more radical and revolutionary, actually devoted its energies to building the organization of the party in accord with the policies of the Comintern.[1]

Grosz, who often claimed that he had a seismographic sense for changing political moods, reflected the communists' loss of revolutionary ardor in his drawings. Grosz's commitment to communism was tied to the terror and tumult of the first years of the republic. With the visible foe, the Free Corps, underground, political assassinations waning, unemployment slowly decreasing as the economy was stabilized, and the government changing through elections and parliamentary reshuffling instead of revolts and putsches, Grosz's aggressive zeal was tempered and his artistic talents were diverted into different channels. His old commitments and ties remained; he was, however, no longer consumed by his revolutionary attitudes. New preoccupations and relationships began to emerge.

The shift in Grosz's work was marked by the fact that the almost exclusive publishing tie between Grosz and Herzfelde was broken. He continued to publish some of his work with Malik, but much of it appeared with other presses. Between 1924 and 1932 Malik published a new book of drawings, a small portfolio, a collection of earlier drawings,

and three books with jacket drawings by Grosz. In those same years, Grosz published two books of drawings and three times as many well-illustrated books for other presses. By the mid-twenties, Grosz was a famous artist who had no difficulty finding a willing publisher. Furthermore, his work lost its polemic tone. Presses which would not have touched his revolutionary works would now publish drawings by a famous, less political artist. By the same token, Malik was not particularly interested in publishing drawings which were not political. Herzfelde suggests that financial considerations may also have been important: the non-political commercial presses could pay better royalties.[2]

In 1925 Grosz published *Der Spiesser-Spiegel* (Mirror of the Philistine) with the Carl Reissner Verlag and in 1930 *Über alles die Liebe* (Love Above Everything) with the Bruno Cassirer Verlag. Both books contained sixty drawings which were called "new drawings" on the title page. The earlier Grosz books and portfolios had been titled "political drawings." The polemical aspect of the early books was entirely missing in these two books. Neither book had sharp, pointed political captions. *Spiesser-Spiegel* had no captions or titles; *Über alles die Liebe* had only short descriptive titles. Neither book contained any political caricatures; neither government figures nor political conditions were attacked. *Spiesser-Spiegel* had a small group of drawings depicting poor people, but the sense of the betrayal of a class was only implied in these drawings.

The subject of most of the drawings in both of these books was similar to that of *Ecce Homo*; the scene, however, had shifted from the whorehouse to the café, from the boudoir to the streets. The relationship between man and woman was no longer erotic or perverse, simply tired or timid (Fig. 71). Conventional mores had reasserted themselves in these drawings, and Grosz no longer tried to tear away the mask and expose the animal. Most of the drawings dealt with street and café scenes, with courting couples and married couples, with drinking and eating (Figs. 72 and 73). Delineations of the new, prosperous, and sedate businessman supplanted the earlier caricatures of profiteer and capitalist (Fig. 74).

Though both *Spiesser-Spiegel* and *Über alles die Liebe* were studies of the middle class, neither book constituted a polemical attack upon that class. Grosz no longer used types as a revolutionary weapon. While he continued to utilize techniques of caricature to depict bourgeois figures whom he saw walking the streets of Berlin (Fig. 75), the types which emerged in these books were created by subtle variations on

FIG. 71 Before an Important Decision, ÜaL, p. 30.

FIG. 72 *Spiesser-Spiegel*, p. 8. Gez., p. 113.

FIG. 74 Migratory Birds, ÜaL, p. 100.

FIG. 73 Without a Profession, ÜaL, p. 32.

FIG. 75 *Spiesser-Spiegel*, p. 43.

reality; they were not the ideological distillations of ideal types which appeared in his earlier books (compare Fig. 76 with Fig. 46). These are the first of Grosz's drawings which could be considered visual documents of the period, because there is little ideological distortion in them. Penetrating descriptions of social reality, they revealed great sensitivity, to detail, to actual people, and to actual scenes. His drawings through 1923 were a completely different kind of record. One looks at them to discover an ideological attitude which was very much part of the current political scene. Caricatures which grew out of an ideological vision of reality, they were intense attacks upon a social and political system. Their attitude of deep hatred, their intent to unmask, destroy, and expose, was, with a few exceptions, missing in the later drawings. This was

the fundamental difference between Grosz's work in the early and the late twenties. The quiet drawings of the later period were not incompatible with a Marxist viewpoint, but they were not revolutionary in intent. The hand that drew them was no longer angry; it had lost its vehemence and fire.

Most of the books which Grosz illustrated from 1925 to 1932 were statements of weariness with the injustice and suffering and boredom of

FIG. 76 *Spiesser-Spiegel,*
p. 15. Gez, p. 115.

the world. This was the period of the new objectivity (*Neue Sachlichkeit*) in literature. Repudiating the excitement of the revolutionary period, many writers became either neutral or embittered satirists. Their works were marked by pessimism and disenchantment. Just as Grosz's drawings in this period were visual analyses of what he saw around him, so these books and their illustrations dwelt on the descriptive. The novel *Port d'Eaux-Mortes* by Pierre MacOrlan and a book of poems by Günther Franzke were marked by a sense of resignation and world-weariness which Grosz's drawings reflected. His illustrations for Ernst Toller's play *Hinkemann* were dominated by a mood of despair.

Symbolic of Grosz's less aggressive attitude were a series of portrait sketches and paintings which date from the mid-twenties. The sketches were descriptive, realistic portrayals of his friends and family. Outstanding among the latter were quiet views of his mother and of his mother-in-law. Working in oils for the first time since the war, Grosz painted portraits of his mother (1926), his brother-in-law Otto Schmalhausen, his friends Felix Weil (1926), Wieland Herzfelde, Walter Mehring, Eduard Plietzsch (1928), and the expressionist poet Max Herrmann-Neisse (1925, Fig. 77). In 1929 Grosz gave a book of original sketches to his wife for Christmas; in them, Grosz, with an unexpectedly gentle touch, captured the movements of his son, Peter, who had learned to toddle during their 1927 stay in Marseilles.[3]

In 1924 G. F. Hartlaub, director of the Mannheim Kunsthalle, coined the term Neue Sachlichkeit while preparing a special exhibit of "artists who have retained or regained their fidelity to positive, tangible reality."[4] Two years earlier Grosz, in a debate over whether a new naturalism or objectivity was appearing in art, had argued in *Das Kunstblatt* that "the so-called new objectivity [*Gegenständlichkeit*] is worthless for us today."[5] Nevertheless, along with Otto Dix and Max Beckmann, he was represented in the Mannheim exhibit by three oils, one a neo-realistic portrait of Herrmann-Neisse, and another the completely unobjective "The Little Sex-Murderer" (1918). The portrait of Herrmann-Neisse was purchased for 2,500 marks by the Kunsthalle for its permanent collection. A decade later this painting was confiscated by the Nazis as a perfect example of degenerate art: not only did it represent a distortion of visual reality, it deemed a hunchbacked Jew to be worthy of portraiture.[6] Though these portraits by Grosz can be reasonably compared to Otto Dix's portraits, the mood of subdued pessimism and resignation in them and in his watercolor street scenes is more evocative of the novels of Alfred Döblin, Hermann Kesten, or Hans Fallada.

FIG. 77 Portrait of the Writer Max Herrmann-Neisse, 1925, oil.

By the mid-twenties Grosz was moving in social circles which included these new pessimistic writers and artists. Herzfelde feels that Grosz's own attitudes in the latter part of the twenties were definitely affected by the people he met through Alfred Flechtheim,[7] one of the leading dealers of modern art in Berlin who became Grosz's dealer in 1923. He also—and this Grosz said was rare for a dealer and an artist—became a good friend. "A man about town who knew everyone and was at home everywhere," Flechtheim was famous for his lavish dinners at which there was always an interesting assortment of actors, writers, theater and film producers, musicians, artists, athletes, bankers, industrialists—a judicious mixture of wealth and culture. In his autobiography, Grosz recounted with relish the evening in which he had met "Svengali Joe," the movie director Joseph von Sternberg, who had dis-

covered Marlene Dietrich. Sternberg and Grosz appealed to each other. Grosz visited him later at the Ufa studio where Sternberg was directing *The Blue Angel*.[8]

Flechtheim, however, can not be held solely responsible for introducing Grosz into the social circles of the cultivated bourgeoisie; during the war Solly Falk had entertained Grosz and taken him to his home in Mannheim where Grosz certainly saw a style of life very different from his attic studio in dismal south Berlin. One evening at Falk's home, Grosz's drinking partner was a commanding general![9] Towards the end of the war Grosz moved out of the working class sector to a garden studio on Nassauische Strasse in Wilmersdorf, a middle class section of Berlin. It must have been a pleasant one, for he continued to work there until he left Germany. On May 26, 1920, Grosz married Eva Peters, a fellow student from Professor Orlik's classes at the Kunstgewerbeschule, who came from a middle class Berlin family. Despite his revolutionary activities Grosz had a warm relationship with his mother-in-law, Anna Peters, who hid him during the dangerous days in 1919.

Not long after their marriage, Grosz and Eva traveled, at their host's expense, to Portofino on the Italian Riviera to spend several happy weeks as guests of Dr. Felix Weil, who later founded the Frankfurt Institute for Social Research. Dr. Weil was, Grosz said, a born benefactor who helped him whenever he was in need. They continued to be good friends after they both fled to New York. At Weil's home Grosz found more new friends and stimulating conversation.[10] Another entrée into Berlin society life for Grosz was, oddly enough, his position as a communist artist. His description of a formal reception at the Soviet Embassy in the late twenties reveals that such a reception was not an uncommon event for him. Old friends encountered on this occasion were the journalists Maximilian Harden and Arthur Holitscher, the actor Sokoloff, the poet Sergei Tretyakov, and the Lunacharskys; old enemies were also present —General von Seeckt and foreign minister Gustav Stresemann.[11]

In Grosz's autobiography there is a curious chapter on "Max Hölz, the Little German Revolutionary Soldier." Max Hölz, whom Grosz called a real hero of the people and one who acted in the tradition of the German robber knights, organized guerrilla bands of striking workers who wreaked havoc on the countryside during the March uprising in 1921. Grosz claimed that he was "the terror of the great capitalists and wealthy

merchants." Arrested and tried, Hölz was imprisoned until 1928. What happened to him when he came out of prison was, according to Grosz, remarkable and noteworthy. "He had become such a significant personage that a certain section of Berlin society lionized him. Those were strange times. Revolutionaries and enemies of the capitalist class were invited and honored by members of that very class. . . . Teas and cocktail parties were given at which they drank to the immediate decline of the West and of the capitalist system." Though Max loved all this, the Communist party did not. "Good comrades were supposed to live like monks, devoted to the Party only; to have one love, the Party; only one vice, Marxism; one look, directed toward Moscow. Hölz was lost. . . . The little Party bureaucrats disliked him. It was a period of Party decisions, permanent sessions and theoretical work. This did not suit the passionate, action-loving Max." He went to Moscow, where he was reportedly liquidated in 1933.[12] What makes this chapter interesting is that Max Hölz is the only German revolutionary about whom Grosz wrote. He mentioned Luxemburg and Liebknecht in one sentence; otherwise, complete silence. One can't help but speculate whether Grosz was telling his own story in the story of little Max. He must have been well aware of the contradictions between his revolutionary stance and his social evenings among the wealthy.

Throughout his life Grosz was a disciplined and industrious worker. Putting in long hours in his studio, he poured out thousands of sketches, finished drawings, watercolors, and oils. He tried periodically to keep a concise record of the works which he sent out to galleries, museums, dealers, journals. He did not like to keep accounts; both Wieland and Eva, his wife, were better at business matters. Though incomplete, his ledger shows that he sent from three to one hundred works to seven or eight galleries or exhibits each year from 1925 to 1932. He also sent works to exhibits of German art in Holland in 1922, Paris in 1924 (Grosz exhibit), Barcelona in 1926, Florence in 1927, Warsaw in 1928, South America in 1930, Yugoslavia in 1931, and Norway and Brussels in 1932. The ledger also reveals that Grosz sent as many, if not more works to journals and magazines.[13]

After *Der Knüppel* folded in 1925, Grosz started submitting his drawings to the same popular journals that had occasionally published his cartoons before the war. Then he was an unknown art student whose cartoons imitated the popular caricaturists of the day; now he was a

famous artist whose style was being imitated by lesser caricaturists. He received from fifty to one hundred and fifty marks per drawing in this period—one of the advantages of the commercial periodicals over the radical political ones. The drawings appeared in different forms in the various magazines. For the *Illustrierte Blatt* Grosz provided short essays with illustrations on a number of topics: Paul Whiteman playing jazz in Berlin, bull fights in Provence, English tourists in a French resort, farmers slaughtering hogs, or a review of different classic traditions of clowning.[14] In *Querschnitt*, Flechtheim's journal of art and criticism, Grosz's drawings were scattered in the margins without comment or caption.[15] *Ulk*, the comic supplement of the *Berliner Tageblatt* which had published his first cartoon in 1910, now presented Grosz's drawings with captions like those in *Der Knüppel*.[16] Grosz published drawings most frequently in *Simplicissimus*, the great Munich satirical periodical. Beginning in 1926 a Grosz drawing was printed every other week or once a month for five years and sporadically after that. The drawings, mostly street or café scenes with conversational captions, were not political, though general political sentiments were expressed now and then in the captions. Some of these drawings were reprinted in *Über alles die Liebe* and *Das neue Gesicht der herrschenden Klasse*.

In 1932 when the political situation was deteriorating rapidly, three of Grosz's drawings were printed in *Roter Pfeffer*, the satirical periodical of the KPD which succeeded *Der Knüppel*. Uncannily, these drawings pick up the heavy dark style which Grosz had been using in *Knüppel* but had not published elsewhere. One was an attack on poverty; one mocked the Nazi fascination with "blood-mystic"; and the third, in the March election issue urging workers to vote for Thälmann, pointed out to the workers that Hitler's promises to end the depression would fatten only the capitalists.[17] Also in 1931 Grosz had several drawings in Münzenberg's satirical journal, *Eulenspiegel*, one of which was in memory of Rosa Luxemburg and Karl Liebknecht.

The shift of emphasis from political polemic to social criticism, from bitter and acid caricatures to detailed and softer drawings, which took place in the second half of the twenties, meant that Grosz's work became generally less offensive and controversial. There was, however, an exception to this generalization. It was the small hand-printed portfolio of drawings selected from the hundreds of drawings which Grosz made for Erwin Piscator's staging in 1928 of *Die Abenteuer des braven Soldaten Schwejk* (The Adventures of the Good Soldier Schwejk) by

Jaroslav Hašek. The drawings of this portfolio, *Hintergrund* (Background, 1928), were simple, crude, and didactically political. It was a genuinely proletarian portfolio, for though hand-printed, it sold for only 1.70 marks. It was produced in collaboration with Herzfelde, but the drawings had grown out of Grosz's collaboration with Erwin Piscator on *Schwejk*.

Grosz was not a newcomer to the theater when he worked on *Schwejk*. He had designed theater sets and puppets with John Heartfield beginning in December, 1919, when they did puppets for the marionette theater in the cabaret, Schall und Rauch, in the cellar of one of the Reinhardt theaters. Together they produced the sets and costumes for the 1920 production of G. B. Shaw's *Caesar and Cleopatra* at the Deutsches Theater and for the 1922 performance of Georg Kaiser's *Kanzlist Krehler* (Clerk Krehler) at the Berlin Kammerspiele. In 1922 Grosz designed giant puppet-like costumes for Ivan Goll's play, *Methusalem*, which was to have premiered at the Neues Schauspielhaus in Königsberg. This performance did not take place, and when the play actually premiered in Berlin two years later, Grosz's designs were not used.[18] Grosz worked in 1923 with Berthold Viertel on the Lustspielhaus production of Georg Kaiser's *Nebeneinander* (Coexistence), designing both the costumes and sets. Heartfield again collaborated with Grosz on the costumes and sets for Shaw's *Androcles and the Lion* at the Residenztheater in February, 1924. Two years later Grosz drew the stage sets for Ernst Toller, *Wandlung* (Regeneration). Grosz prepared the costume sketches for the stage version of Arnold Zweig's *Der Streit um den Sergeanten Grischa* (The Case of Sergeant Grischa) which was produced by the Deutsches Theater in March, 1930. In January of that year he had designed both sets and costumes for Carl Sternheim's *Der Kandidat* (The Candidate) at the Kammerspiele.[19] These designs had all been fairly conventional in the sense of providing stationary stage settings. Grosz's work with Piscator, which began in 1926, was definitely unconventional and definitely political.

Grosz's friendship with Piscator went back to the last months of the war; he joined the Communist party with Grosz, Herzfelde, and Heartfield at the end of December, 1918.[20] Throughout the twenties Piscator was the enfant terrible of the German theater. Completely political, a dedicated communist, he explored and exploited innumerable devices to establish a thoroughly didactic political theater. One of these devices was the use of slides and films to clarify and enhance the political

message of a play. The didactic possibilities of this technique were immense, and Piscator made good use of them in various polemical plays and revues, for example, *Trotz alledem!*, a documentary revue for the 1925 Berlin Communist party day which covered the epoch from the outbreak of the war to the murder of Liebknecht and Luxemburg.[21] Grosz collaborated with Piscator in 1926 on Paul Zech's *Das trunkene Schiff*, a stage version of Rimbaud's *Le Bateau ivre*, produced at the Volksbühne. For this production three screens were set up at the back and sides of the stage. Grosz's drawings, projected onto the screens, surrounded the actors and provided the political and social milieu which became an integral part of the play.[22]

The following year Grosz worked with Piscator to produce *Schwejk*, which opened in January, 1928, at the Nollendorftheater. Grosz was one of several collaborators on this play. Max Brod and Hans Reimann held the stage rights to the novel by Jaroslav Hašek. The manuscript which they produced turned the novel into a military farce, which Piscator found completely out of tune with the epic quality of the novel. Piscator, therefore, invited Bertolt Brecht, Felix Gasbarra, and Leo Lania to rework the manuscript with Brod and Reimann. Grosz joined the group working in a secluded hotel and contributed greatly to the conception of the stage version. Piscator called Grosz the "denkender Zeichner" ("thinking artist") whose ideas coincided remarkedly with his own.[23] Determined to maintain the epic character of the novel, Piscator presented it as a series of restless episodes which swirled around the passive hero Schwejk. To facilitate the rapid sequence of events, he used a double conveyor belt on the stage and cartoon films for the backdrop. The people whom Schwejk, played by Max Pallenberg, encountered as he bumbled through the war were portrayed either in the film, or as giant puppets on the conveyor belts, or as actors with cardboard masks indicating a type.

Grosz had an integral part in the staging of this anti-military play, for he drew the caricatures for the film, and designed the puppets and the masks. The whole presentation of the play coincided with Grosz's earlier didactic drawing. He was a master hand at creating types, and for *Schwejk* he produced forceful and vicious ones. Piscator claimed that Grosz's major achievement in these drawings was that he succeeded through the types in lifting *Schwejk* out of a historical situation into a contemporary reality. The Austrian military doctors, officers, lawyers, and clergymen of the novel became contemporary Prussian-German figures

FIG. 78 Be Submissive to the Authorities, *Hintergrund*, no. 2.

(Fig. 78). This meant that the play was not only an anti-military statement about the war, but that it also became part of the current German political struggle.[24]

Of the more than three hundred drawings which Grosz completed for the play, seventeen were selected for the *Hintergrund* portfolio. The circumstances of the play—a polemic produced by a didactic communist—and the form and price of the portfolio would appear to indicate that Grosz had returned to his active political commitment of the early twenties. An examination of the drawings in the portfolio, however, reveals that Grosz did not recapture his early revolutionary vitality. The drawings in *Hintergrund* were crude, grotesque, and exaggerated, but they lacked the element of conviction and incisiveness which had been present in Grosz's earlier political drawings. (Compare Fig. 79 with Fig. 39.)

A similar lack of political conviction marked the illustrations which Grosz produced for a second book of poems by Oskar Kanehl, *Strasse frei* (Free Streets). This was the only overtly political book for which Grosz did more than a jacket drawing between 1923 and 1930. The poems, which were published in 1928 by a communist press, Der Spartakusbund, continued the vigorous and heavy propaganda of Kanehl's

FIG. 79 The Oupouring of the Holy Spirit, *Hintergrund*, no. 9.

first book which Grosz had also illustrated, *Steh auf, Prolet!* There was nothing politically equivocal about any of them. The martial poems called for revolt, for the rejection of the ministers of the Socialist party who betrayed them, for the armed confrontation of labor and capital, for the unity of working classes throughout the world. While the poems in both books, one published in 1922 and one in 1928, maintained an unflagging militancy, Grosz's drawings, aggressively didactic and angry in the first book, were wearily didactic in the second. The first group was the work of a master graphic propagandist; the second group could have been produced by a second-rate cartoonist (Fig. 80). The only incisive drawings in the book were reprinted from the early twenties. When he sent the drawings for *Strasse frei* to its author, Grosz wrote on the bottom of one. Very laconic, the note conveyed a lack of inter-

FIG. 80 Now They Are Ministers, in Kanehl, *Strasse frei*, n.p.

est in the fate of the drawings: "Dear Kanehl. Put the pictures where they fit in. Call then, perhaps." [25] There could, of course, have been an excited planning session before the drawings were done. If so, the excitement did not last, for this note reveals only a job performed without enthusiasm.

This disparity between Grosz's overt commitment and his conviction had first been articulated in two statements which reached the public

in 1925. In that year Grosz and Herzfelde had published their joint Marxist summary of the problems confronting contemporary artists. Grosz had made it perfectly clear that, as a revolutionary artist, he stood on the side of the proletariat. He condemned not only artists who supported the status quo by disdaining politics, but also the artists who flocked to the side of the workers in November, 1918, hastily poured out red or reddish propaganda, and then, when law and order returned, crept quietly back into their higher regions of art saying: "'What do you want, we are still revolutionary—but the workers are only philistines. In this country one can not make a revolution.'"[26] Among those who deserted the revolution in the first years of the twenties were most of the artists of the November Group, while among his own dadaist friends, Richard Huelsenbeck, Raoul Hausmann, Carl Einstein, and Walter Mehring all turned away from political activity.

Shortly after Malik published this book, a substantial autobiographical statement appeared in *Der Spiesser-Spiegel*. After tracing personal details of his artistic training and early career—details which he had once said were irrelevant—Grosz ended this essay, like all the others, with a manifesto on his view of art as a weapon: "I am convinced that the journalistic work of a respectable, politically knowledgeable artist is very important and necessary." There was a difference of stress in this statement. He spoke of his faith in art as a journalistic tool, not about art as a weapon for the proletariat. He did not mention class war, the cause of the proletariat, or the destruction of capitalism. "The enemy is the compact majority—the brutal mass stupidity." That stupidity he defined as including, on the one hand, the masses, who were the slaves of technology and the devourers of a ready-made culture, and, on the other hand, the holders of power, whom he did not define or describe. Though he called again on artists to leave their isolation and join the fight, this time Grosz wanted them to help in the fight against mass stupidity, not in the class war. Of himself, Grosz said: "It is true that life would be without meaning and purpose, if it did not have the one significance: the fight against the stupidity and voluntary brutality of the contemporary holders of power [*Machthaber*]."[27]

This statement did not contradict *Die Kunst ist in Gefahr*. Art was still to be used as a weapon, but the enemy had changed. The traditional communist enemies were omitted. The holders of power were not necessarily identical with the old ruling classes in Germany. There was a shift from seeing the proletariat as the hope of the future to seeing

the masses as a source of danger. One senses in this essay a resurgence of the young Grosz's distrust of the masses. The revolutionary hopes for a new society based on the proletariat were being replaced by fears of a technocratic society based on the masses and controlled by power elites. Grosz only hinted at this fear in this essay, but the problem of power and developing technology was a major preoccupation of intellectuals at this time.

An expression of this was Heinrich Mann's novel *Kobes*, which was published in 1925 with ten lithographs by Grosz. The story about a little man, an intellectual, who tried to fight the power of big industry gave Grosz the opportunity to caricature Hugo Stinnes. Kobes, the legendary controller of all life by virtue of his position in industry, became Stinnes in Grosz's drawings. The drawings were, for the most part, not exceptional, certainly not anywhere near Grosz's best illustrations. The conjunction of Mann's satirical writing with Grosz's satirical drawings, however, conveyed a deep concern about the growing specter of a technocratic and bureaucratic society whose sole purpose was the holding of power through the manipulation of the masses.

Though the technocracy described in *Kobes* was the product of western industrial society—Grosz's use of Stinnes emphasized this—Grosz recognized fairly early, probably as a result of his trip to the Soviet Union, the similar dangers inherent in the new communist state. By the mid-twenties the bureaucratization which had dismayed him in the Soviet Union spread to the German communists. Like little Max Hölz of his story, Grosz was caught in a period of "party decisions, permanent sessions and theoretical work," and Grosz did not like it any more than he thought Max did. The bolshevization of the Communist parties which had been announced at the Fifth Congress of the Comintern in June, 1924, proceeded throughout the twenties in Germany under Ernst Thälmann. Grosz was unsympathetic to the "little party bureaucrats," none of whom compared in stature to the early leaders of the party, Rosa Luxemburg, Karl Liebknecht, or Paul Levi. He disliked the endless wrangling of party meetings and the rationalizations of the party line.[28] Furthermore, bolshevization was carried over into art.

The Communist party in the spring of 1928 formed a new art organization, the Association of Revolutionary Artists of Germany (Assoziation revolutionärer bildender Künstler Deutschlands, ARBKD). Alex Keil, one of the founders and its historian, said that the fundamental

aim of the ARBKD was to create a revolutionary avant garde of artists who would serve the proletariat in the class war. In order to develop a propagandistic and revolutionary art which could reach the masses, the artists had to be freed from all remnants of the bourgeois ideologies and to be educated in the needs of the masses and the principles of the Communist party.[29] The artist had to become a disciplined party member, working under the direction of the party. The ARBKD was, therefore, an arm of the KPD. The manifesto of the ARBKD, after outlining the Marxist definition of the role of the artist in supporting capitalist society, urged artists to look to the Soviet Union, where true proletarian creativity was flourishing, and then to join the ARBKD as revolutionary artists fighting for the proletariat.[30] The seven statutes of the Association, published later, outlined a tight control by the party over the artists' activity in the class war. The first statute stated that the ARBKD was a sister-organization of the Association of Artists of Revolutionary Russia.[31]

The ARBKD, which superseded the Red Group, represented the final movement away from the revolutionary enthusiasm of the artists of the November Group. The organization was now a party organ which sought to enlist artists on the side of the party. Though Alex Keil claimed it was the first truly revolutionary artist group in Germany, it could better be called a thoroughly bureaucratic organ of the KPD. It is interesting that none of the earlier leaders in the German revolutionary artists' groups seem to have been involved in founding this organization. Grosz, along with Heartfield, entered the ARBKD, but there is no indication that he assumed any leadership or participated in its activities.[32]

Not only did the party attempt to establish close organizational ties with artists, it sought to develop a party aesthetic to which artists would adhere. Works of art were expected to develop out of the needs and standards determined by the party, not out of the revolutionary situation or the needs of the people. For some, there was no contradiction here because the party's concerns were by definition identical with the needs of the people. But Grosz, who was becoming increasingly bothered by the gap between the working classes and the party, refused to conform to party standards in his art. His art of the early twenties had grown out of the revolutionary situation and was a combination of his unique vision and his commitment to communist ideology. In his writings, he had insisted that a revolutionary art emerged when the artist became involved in the revolutionary needs of the proletariat. He had not considered the role of the party in developing criterion for judging revolu-

tionary art. Now, with the development of party-minded aesthetics, Grosz's work came under fire.

The party critics were also caught in a dilemma. Grosz was famous as one of the outstanding revolutionary artists of the fighting period of the German Communist party. Judged by the standards of the prolet-cult, however, his work did not pass muster. Alfred Durus, pseudonym of Alfred Kemeny, a Hungarian communist who came to Berlin in 1920 and became art and literary critic for the *Rote Fahne* in 1924, was re-sponsible for directing the attention of artists to the need for a new image of the worker. In the pages of *Rote Fahne* Durus called for the creation of an optimistic and invigorating portrayal of the proletariat to take the place of the prevailing aggressive attacks on imperialistic society and the negative pictures of the suffering worker.[33] On April 9, 1926, Durus chided Grosz for failing in his political drawings in the last years to portray "the heroism of the revolutionary working classes." By accentuating the weakness and oppression of the proletariat in the bourgeois society, Grosz was indulging in an inaccurate and pessimis-tic evaluation of the strength of the working classes. Two years later Durus softened his criticism. While still critical of Grosz's failure to capture the heroic character of the class war or the activity of the work-ing classes, he recognized that the problem did not lie in Grosz's human inadequacy, but in the fact that Grosz was a satirist. As a satirist, Grosz could not be asked to extol the creative exuberance of the revolution.[34]

By 1931 in an article for one of Münzenberg's papers, Durus had clarified his thoughts on Grosz. Grosz's basic problem was that he was a fighting Spartacist who never developed into a Bolshevik. A revolu-tionary artist in 1919, Grosz had failed to keep up with the times. Even though Durus realized that Grosz was running the danger of becoming a renegade, he still praised his early work very highly:

"George Grosz": his name was through the years in the ranks of the class-conscious proletariat the embodiment of all that was revolutionary in art. Rightly so. For no other German artist so skillfully and so consciously used art as a weapon in the freedom fight of the German working class from 1919 to 1923. *He is one of the first artists in Germany who placed art as "Ten-denzkunst" consciously in the service of revolutionary activities.*[35]

Grosz answered his critics in 1928 in an article written especially for *Prožektor*, a Moscow literary, artistic, and satiric journal one of whose editors was Nikolai Bukharin. Most of the article was an auto-biographical account with particular stress upon his activities during

the war and the revolution (Fig. 81). Turning to the criticism of his portrayal of the proletariat, he said that he was accused of having "a petty bourgeois-anarchistic-prejudiced" view of the workers. His critics wanted the worker to be portrayed as he would be in the triumphant workers' state. Grosz, however, insisted that he did not consider it necessary to satisfy the demands of "Hurrah-Bolshevism," which imagined the proletariat to be "smoothly combed and in an ultra-heroic costume." "I can not imagine the proletariat other than as I depict him. I see him still oppressed, still at the bottom of the social ladder, poorly dressed, poorly paid, in gloomy smelly dens and often sustained by a bourgeois desire to go upwards." Questioning the propaganda value of the false idealization, Grosz felt he could not be accused of an incorrect portrayal of the worker. He reminded the reader that each artist had to work within his own historic situation and that the German workers were not so advanced as the Russian workers in the consciousness of their power. Grosz ended with his familiar affirmation: "To help the worker to understand his oppression and suffering; to make him ascertain openly his poverty and his servitude; to awaken in him self-consciousness; to awaken him for the class struggle—this is the aim of art, and I serve this aim." [36]

Grosz found himself in an increasingly untenable position. The revolutionary party of 1919 which had held out hopes for a new and just society was turning into a regimented bureaucracy. The party which had fought the old ruling classes in the name of social justice was setting up a new authoritarianism which was no more congenial to Grosz than the old had been. Grosz, however, could not simply repudiate the party, because it still stood for social justice and against German militarism. Though Grosz had no illusions about the working classes, he could not tolerate their suffering or their oppression. Worried about authoritarianism in both Germany and the Soviet Union, depressed by the mass society in which the workers' role remained substantially unchanged, fearful of the possibilities of technocracy, Grosz became more and more pessimistic. He rediscovered the cultural pessimism of Nietzsche, Strindberg, and Ibsen. Arguing and debating with Herzfelde, he usually ended up disagreeing with his old friend. Writing about this period he said, "Yes finally my doubts became so strong. I had to quit....that is....I just 'faded' out....." [37] On occasion, his frustration flared out. Hans Richter, a friend from the dada days, told of dining in the late twenties with Grosz, Eva, and a traveler who had just returned from Russia. The

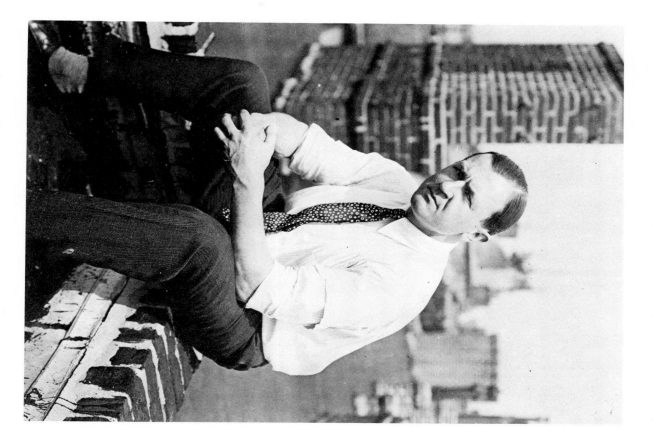

FIG. 81 Photograph of Grosz which accompanied his article published in Moscow in 1928.

traveler, trying to please Grosz, spoke during dinner of the wonders of the Soviet Union. Suddenly without warning, Grosz, who had been growing more and more taciturn, punched the traveler in the mouth.[38]

In 1929 *Das Kunstblatt* published Grosz's "Jugenderinnerungen" (Childhood Recollections); and in 1930 *Kunst und Künstler* printed his "Lebenserinnerungen" (Recollections). Combined, the two ran over forty pages and constituted, next to *Die Kunst ist in Gefahr*, his longest published work in Germany before 1954. The articles were a detailed account of his life which recounted anecdotes out of his childhood in Pomerania and his artistic training in Stolp and in Dresden. These memoirs stopped with Grosz's departure from Dresden for Berlin in 1912. There was, in this whole account of his early life, not a word to indicate any kind of ideological or political involvement. On the contrary, Grosz concluded the articles by emphasizing his completely unpolitical orientation in the pre-war days: "What did I know in that pre-war period . . . of [August] Bebel's [socialist] state of the future? . . . It is scarcely necessary to mention that I was at that time utterly unpolitical. . . ."[39]

There was nothing in these memoirs to deny his political activities. Nonetheless, it is significant that Grosz should have chosen to write in such detail about his childhood—and to publish those details in two of the major art journals of the period. A decade earlier Grosz had refused to write any details about his own life, calling them "the stupid, external accidentals of my life." Now he took refuge in those details from his own political uncertainty. After the 1928 article in the Moscow journal, Grosz did not publish a serious account of his political period.

The Malik Verlag published another major book of George Grosz's drawings, *Das neue Gesicht der herrschenden Klasse* (The New Face of the Ruling Class) in 1930. As the title indicated, it was meant to be another polemical work following *Das Gesicht der herrschenden Klasse*. Again Herzfelde worked with Grosz on the titles, for the ironic captions were present. Political caricatures were included, all of which were reprinted from *Der Knüppel* or from books which Grosz had illustrated. These reprinted caricatures were directed against President Ebert (Fig. 82), who had died in 1925, Kaiser Wilhelm II, who had abdicated, and President Hindenburg. Several drawings attacked rising militarism, ridiculed the donkey of democracy who continually hid behind blinders, and derided the Prussian SPD government for hunting down communists.

FIG. 82 A Son of the People, NGhK, p. 35. First published in *Pleite*, as S.M. Kanehl, *Strasse frei*, n. p.

The betrayal of the workers which so preoccupied Grosz in *Das Gesicht der herrschenden Klasse* had slipped into oblivion. *Das neue Gesicht der herrschenden Klasse* had only a few drawings which described individual workers who were tired or sad. These were accompanied by two drawings of the triumphant worker classes breaking into the sleep of capitalists, as though in a nightmare, and one of an armed worker.

Most of the drawings, however, were not polemical either in content or in tone. They were a continuation of Grosz's graphic description of the social life of Berlin in *Spiesser-Spiegel* and *Über alles die Liebe*.

Street scenes abounded in a myriad of variations, followed closely in number by café, party, or vacation scenes (Fig. 83). The drawings were incisive, penetrating, but not vicious. They did reveal the face of the new ruling class in a series of portrait types of new businessmen and new government officials—all looking very official and very mediocre (Fig. 84).

There were three drawings, buried in the ever-recurrent street and café scenes, which take on significance in the light of later history. One was a reprint of a 1925 drawing of "Hitler, the Savior," that presented a stern-faced Hitler dressed only in a bear skin, with a swastika tatooed on his arm and bear teeth around his neck (Fig. 85). This drawing seems to be a spoof, an attempt not to show Hitler's importance, but to puncture his pretentiousness. By clothing him in bear skins, Grosz was ridiculing Hitler's Teutonic racial romanticism. In this book Grosz did not link Hitler with resurgent militarism, because the military type was conspicuous by its absence. Grosz, however, was well aware of the threat Hitler posed to Germany. There were two drawings of types

FIG. 83 Regulated Traffic, NGhK, p. 99.

FIG. 84　The New Reichstag Marchs In, NGhK, p. 33.

FIG. 85　Hitler, the Savior,
NGhK, p. 57.

who were part of the same romantic impulse that put a bear skin on Hitler. One depicted two hikers, singing in a forest, whose dress and song marked them as members of the *völkisch* youth movement. The other, "Culture Pioneers," showed two sandaled figures in homespun dress and beads carrying symbols of culture and nation—a flag and a violin (Fig. 86).

Das neue Gesicht der herrschenden Klasse revealed the extent to which Grosz had withdrawn from his strong political commitment and

FIG. 86 Culture Pioneers, NGhK, p. 24.

involvement. What was *not* touched upon in these drawings is signifi-
cant. One cannot tell from looking at the many scenes of social life in
Berlin that Germany was in the midst of major unemployment, financial
crises, political crises, and street fighting between rightist and communist
groups. In fact, despite the Hitler caricature, there was no indication
in this book of a situation so troubled that it would succumb to the Teu-
tonic Savior within two years. The political caricatures were all out-
dated and unrelated to the current scene. This is not to say that *Das
Gesicht der herrschenden Klasse* or any of the early portfolios gave an
accurate picture of the historic events out of which they came, but the
early books and portfolios did give an accurate picture of an ideological
position and mood at a specific time, whereas this latest book gave no
indication of an ideological stance. It described without judging. It
did not grow out of moral accusation or out of political passions.

The high level of unemployment which accompanied the depression
made sheer existence a common preoccupation for all but the wealthiest
classes. As a result the *Berliner Tageblatt* in 1931 printed a series of
essays called "Kunst geht nach Brot" (Art Seeks a Livelihood). The in-
troduction pointed out that talent was capital and art was a commodity
for sale in the luxury market. The artist, no longer an alien in the world
of business, had become a shrewd businessman. The newspaper, with
these facts in mind, asked various artists to make a statement about the
material side of their work. Grosz's statement, "Kunst ist vorbei, mein
Lieber!" (Art is Done For, My Friend) was a lively piece of satirical
writing. Cast in the form of a one-sided conversation, jumping back and
forth from one idea to the next, it was very reminiscent of Tucholsky's
"Herr Wendriner" sketches. Not intended to be coherent, it was rather
scornful of the poor philistine who was being addressed in a breezy
Berlin dialect. One senses derisive laughter behind each word.

Nope, really I can't complain, what's the use? . . . You can't blame the
rich people that they've had it up to here with painting? . . . and don't want
to see another picture? First they buy a picture and then later on it isn't even
worth half as much. Nope, one can invest his money better, for the hard
times. . . . The modern architects are absolutely right not to put pictures
on the wall, it makes one distrustful, possibly a map, that makes it nice and
dreamy. . . . Only no oil paintings! Art is done for, my dear fellow! . . .
Art is really only for the artists themselves. No kidding! . . . Yep, I'm
doing just fine. I have four houses in Berlin, two in Charlottenburg, two in
North [Berlin], all fully rented. Now I have bought me a big private car, brand
new, with heating for my feet, and a flower vase

But now I am going to be careful, save some, one never knows what may come. . . . Nope, we painters don't have any problems, we're invited everywhere, always good food, first-class wine, and mighty nice people. Colossal that, sometimes even music. . . . Nope, we won't starve; if one of us hangs himself, it is because he isn't a real artist, but a defeatist who has no inner light. Nope, we won't starve because we have the art dealers—those wonderful unselfish people. . . .

No, I look with happiness and cheer into the future, for I am doing just fine: I have just sold six large oils, one even to the National Gallery, 58 drawings and watercolors, have received two portrait commissions and have the terrific luck to have a city commission (25,000 Mille) in sight

So, head high, hand on the trouser seam, and look happily straight ahead! [40]

Much of the old dadaist emerged in this statement. This was virtually anti-art talk or the spoofing of the dadaist, as well as the Marxist who rejected the whole swindle of bourgeois art. The title was a re-echo of *Die Kunst ist in Gefahr*. The ideas expressed, that art was dead through its irrelevance and that the art swindle continued through the efforts of the capitalistic middlemen, the dealers—these ideas were part of Grosz's communist views, but the means of expressing these ideas was pure dada.

The final statement of Grosz's to be considered was also published in 1931 in *Das Kunstblatt*. In this article, Grosz looked at the society surrounding him and was dismayed. Twelve years under a socialist government, twelve years of fighting for the rights of the worker, had resulted in a miserable industrial society dominated by the machine and the bureaucracy and marked by rising militarism. In describing the ills of this mass society, Grosz was disillusioned with everything. His statement lacked clarity. There was a strong vein of satire which heightened the sense of discouragement. He rejected the contemporary scene, the socialist state, the drive for material improvement, the claims of a rising standard of living. He depicted the mess of the modern industrial society, the waste necessitated by the machine—wasted lives, wasted products—the treadmill of creating unnecessary desires and increasing buying power in order to keep the machines producing. He hated the incessant propaganda of modern advertising, which insidiously made new products essential to the enjoyment of life. He was scornful of the city with its office palaces, department-store cathedrals, and cinema temples. In all this, he saw the masses and the little man, on the one hand, and the machine with its manipulators, on the other, as the pivotal

elements in society. The interaction between the two, the endless struggle for wages and sales, the unceasing production lines, the eternal stress on work, and the all-prevailing materialism — these were the constants of modern civilization. Capitalist or communist, all societies shared in the same goals. America had succeeded; Germany followed. Even in Marxist Russia, America was the model and the fervent goal. Against this background, Grosz still saw the artist as being totally alienated from reality, from nature, from the people. Art was the anemic and pallid tenement child of the city.[41]

Grosz was no longer able to pose any solutions, nor did he point to the struggle of the working classes as bearing the hope of the future. He seemed to have no hope: "certainly we live in a period of transition. All concepts become gradually doubtful . . . and sunset falls on a superannuated liberalism." Freedom had no meaning; values were disoriented. He saw the right and the left dividing ever more definitely into the final battle for power, supported by masses on both sides who were subservient to orders received from above. "Perhaps we have a new Middle Ages before us. Who knows? In any case, the humanistic ideals seem to me to be dying; one does not lay much worth on the human rights which were so ecstatically announced a century ago."[42]

Despite his elegiac mood, Grosz was not entirely able to discard his faith in art. With a fleeting moment of vigor, he cried to artists to tear away the pile of ready-mades, to unmask the machine culture, and reveal the "ghostly Nothing" underneath. He called on artists to regain creative power by returning to the great Germanic tradition of Bosch, Brueghel, and Altdorfer. He seemed to be aware of the weakness of this appeal in the face of the disintegration of values which his article outlined, for he concluded with a tired "Whew! I have spoken."[43]

With this statement, George Grosz moved into the mood that was to dominate his work after 1930. The satirical political activist became increasingly romantic in his work and pessimistic in his outlook. The ideology which had driven him in the early twenties had slipped away leaving him full of doubts and despair about society. In a sense he returned to the attitudes he held before the 1914 war, but his alienation was now more profound. Before the war he had disdained man on a theoretical level, having had little experience dealing with men, and,

at the same time, he had placed great faith in the high value of art and culture. The war made him believe that his escape into art had been self-deception. After the war he dedicated himself to using art as a weapon to fight for a society which would be rescued from evil institutions and regenerated through revolution. Insisting that the artist's pen should be a weapon, Grosz's pen injured and destroyed what it portrayed. Devastating satire, social criticism, caricature, Tendenzkunst—whatever the name given to the art of Grosz—they all contain the concept of negation and destruction. The art of George Grosz intended to pass a sentence of death upon the bourgeois evils of the Weimar Republic; yet, this sentence of death remained on paper. He fought with all his ability, which was considerable, but the evils which he attacked in Germany were too deeply rooted and required more than a bitter, brilliant, and acid pen to destroy them. A decade of political activism seemed to him to have achieved nothing. The specter of a mass society dominated by technology and militarism seemed to negate all his work.

Grosz's drawings and statements in the thirties concentrated, therefore, upon the ugly and the evil. These he could hate and fight unequivocally without becoming messed up in party politics. A new vigor and hatred appeared, quite different from the hatred of the ruling classes which dominated his early works. Now his drawings poured out a hatred of a society which could produce evil and suffering. The best examples of this before he left Germany were the 1932 illustrations for Peter Pons, *Der grosse Zeitvertreib* (The Great Pastime), and Bertolt Brecht, *Die drei Soldaten* (The Three Soldiers). The poems by Pons ranged from the fantastic nightmare to the suffering of old women. Grosz's drawings, therefore, depicted widely varying subjects, but the mood of anger was present in them all. The drawings were an attempt to visualize evil and suffering (Fig. 87). The Brecht poem, ostensibly a book for children, told the saga of three soldiers who brought suffering, disaster, and death to Germany after the war. It was a polemical book, teaching the reader that these soldiers, Hunger, Disaster, and Disease, brought death because they were so displeased with the way the ruling classes treated human beings. Finally they made their way to Moscow, where the people's government rapidly condemned them to death—a death they gladly accepted. Grosz's illustrations were very uneven. They concentrated upon evil to a point of being grotesque rather than powerful. This can be seen in the first drawing of the book, which portrayed the three soldiers at the end of the war (Fig. 88).

FIG. 87 Pons, *Der grosse Zeitvertreib*, p. 34.

FIG. 88 Brecht, *Die drei Soldaten*, p. 2. *Interregnum*, pl. 2, as Spirit of the Century.

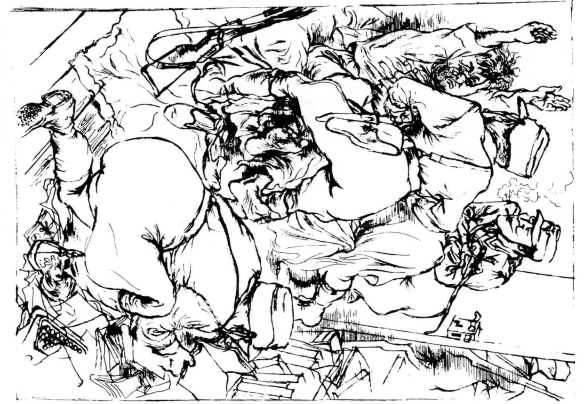

FIG. 89 A Writer, Is He?, *Interregnum*, pl. 45.

Grosz's recapturing of passion and anger in the thirties was probably the result of the civil war which was going on in the streets and of the political campaigning of the last years of the republic. In America Grosz spoke often of his psychic sensitivity towards evil forces. His forebod-

ing of evil became particularly marked in the early thirties; indeed, he decided to leave Germany in 1932 because of it. The satirical drawings which were published in 1936 in America dealt with the evil which overcame Germany. *Interregnum*, his last major portfolio, dwelt obsessively upon evil. The enormity of what he was trying to portray and his own impotence to do anything about it robbed these drawings of the incisiveness and brilliance of his revolutionary post-war drawings. He attempted to portray the excesses of the Nazi regime, but for this caricature was simply not adequate. The result was a crude, heavy, pessimistic style which alternated between emptiness and repulsion (Fig. 89).

Werner Hofmann has contended that the twentieth century brought an end to the art of caricature, for "the horrors of total war and dictatorship have set a boundary to all satire. Such a distorted world cannot be further distorted."[44] Under the impact of totalitarianism, Grosz's pen faltered and finally became silent. When he illustrated books and articles in America, his drawings were illustrations, nothing more. His power of caricature, the George Grosz style, was bound inextricably to the hope and the passion of a revolutionary period. George Grosz hated the ruling classes, but he hated in a context that sought to bring revolutionary change. When all possibility of change became useless, Grosz's drawing pen as a weapon of revolution became useless. Grosz himself sadly recognized this when in 1944 he wrote "In portraying and satirizing the events of the day, the comedies and tragedies of the passing scene, the artist is like a fiddler scraping on too small a violin."[45]

CHAPTER 7
CRITICS AND TRIALS

THE AGGRESSIVE STYLE and polemical nature of George Grosz's drawings evoked strong reactions from those who viewed them. Not unnaturally, criticism divided along political lines. Right-wing nationalists hated him. One critic writing in 1920 called "the German-American George Grosz . . . a painter of horror [*Scheusslichkeit*]." Another, also in 1920, referring to his work as having "the hideous taste of waxworks," wondered when the German people and the press would have the courage and the spiritual strength to reject with indignation the so-called art which was palmed off on them by snobs, spiritual jugglers, profiteers, and aliens.[1]

Grosz received extensive and favorable criticism from left-wing journals. Beginning with Theodor Däubler's article in *Die Weissen Blätter* in 1916, Grosz's work and career were enthusiastically analyzed during the twenties in *Das Tagebuch*, *Die Weltbühne*, and *Die Glocke*. The progressive journals which supported modern art carried frequent critical studies of Grosz. In less than a decade seven books were published on Grosz, with the first excellent monograph appearing in 1921. These articles and books were written by art critics, journalists, and poets. The unanimity of these left-wing critics in their analyses of Grosz was indicative of the unambiguousness of his political drawings. His message came through clearly to his contemporaries, perhaps because his drawings appear to have been the visual counterpart of the thinking of most of these men. In his history of twentieth-century art written in 1926, Carl Einstein pointed out that Grosz's drawings were motivated by intellectual considerations, not by artistic ones. He maintained that

the tremendous appeal of Grosz's drawings within literary or intellectual circles, particularly for those involved in politics, could be explained by this essentially intellectual basis. While Einstein in 1926 found Grosz's moral and political motivation to be a weakness when he viewed Grosz's work in purely artistic terms, Einstein had, in earlier essays, expressed the prevalent opinion of the left-wing writers that Grosz's work was a magnificent visual pathology of a bankrupt society.[2]

Though they used different images to describe the phenomenon, the critics agreed that the fundamental fact about the drawings of Grosz was that in them he laid bare the whole reality, or unreality, of contemporary existence. Kurt Pinthus, writing in *Das Tagebuch* in 1921, believed that whoever looked into *Das Gesicht der herrschenden Klasse* would be confronted with the frightful vision of his own reflected image.[3] Willi Wolfradt, the most sensitive of Grosz's critics, said that Grosz taught his contemporaries to see the nightmarish quality of their own existence; he taught them how to penetrate through the jumble of things and events into their essence; and he forced them to look at life from new angles, the diabolical, the foolish, and the embarrassing. In this sense, Wolfradt said, Grosz's work was a *Spiegelbild* (mirror-image) in which one was confronted with all the impertinence and shamelessness of the times.[4] Max Herrmann-Neisse claimed that Grosz's art provided a true picture of the political and social relationships in contemporary Germany.[5] Grosz's drawings mirrored, for his contemporary critics, an inner reality, a society stripped of its pretensions, the essential relationships between people and classes. His critics understood this and understood that he meant his art to be a weapon. Some recognized this weapon only as a tool employed by a deeply dedicated moralist, but most of his contemporary left-wing critics knew that Grosz was politically committed. For example, in 1920, Dr. Leopold Zahn, editor of *Der Ararat*, the journal published by Hans Golz to promote modern art, called Grosz a "furious Spartacist" whose whole work was a "hundred-fold [cry of] 'tremble bourgeoisie.'"[6]

Left-wing intellectuals were articulate in their appreciation of Grosz's work. It is more difficult to find the response of workers, the class Grosz intended to reach. In one of his articles Alfred Durus included a testimony to Grosz from a Ruhr coal miner who had been a leader in a workers' council during the revolution in 1919:

There is the artist George Grosz; we would really stick up for him. In his caricatures he drew the face of the ruling classes: See, this is how your ex-

ploiters, the "Masters," really look; this is the State, the "authority ordained by God!" We want his Tendenz: the most apathetic proletariat will be aroused when they see these drawings, in the dullest people hate will awake! Yes, that is what we need, boundless hatred, hatred against the exploiters! And the pictures of Grosz breathe hatred which communicates itself to everyone and calls to action! Only such artists mean anything to us.[7]

Grosz reacted to these words of praise in a manner consistent with all his polemical work: "The opinion of this coal miner about my art is a thousand times more important to me than the writings of the bourgeois aesthetes."[8]

Though Grosz wanted to reach the working classes with his drawings, he was, in fact, financially supported by the wealthy classes. It was the capitalists, whom he steadily attacked, satirized, ridiculed, and exposed, who bought his expensive portfolios, his original drawings, and his paintings. To speak in terms of class here is to generalize. Nonetheless, it is safe to say that those who bought these works had to be wealthy, and in Grosz's terms that meant they were capitalists. Grosz's expensive portfolios were sold out, except, of course, when they were confiscated. A brief report in *Der Querschnitt* in 1923 commented on this fact. It noted that Grosz had just issued a new and extremely threatening picture book with the following result: those who were threatened purchased the luxury editions especially prepared for them and then were thrilled with the drawings.[9]

The portfolios which were published after the war were expensive. "*Gott mit uns*," *Im Schatten*, and *Die Räuber*, each containing only nine original lithographs, were printed in limited numbers, 100 or 125 copies, and were priced at 1,500 to 2,000 marks for the luxury editions. There was sufficient demand for Grosz's drawings by wealthy collectors to justify the preparation of luxury editions of his inexpensive educational or propaganda books. *Das Gesicht der herrschenden Klasse* and *Abrechnung folgt!*, which were primarily aimed for large distribution among the lower classes, both appeared also in limited luxury editions. *Ecce Homo* was printed in a larger edition and in a wider variety of prices than were the earlier portfolios. The top prices were expensive and even the lowest prices required a purchaser of some means.

As indicated earlier, this pricing of portfolios for a wealthy market did not negate the propagandist aims of the drawings, even though Nazi spokesmen tried to make this point. Wolfgang Willrich, for example, dwelt at great length upon this fact, trying to prove that Grosz was

really interested only in making money and that his communist dedication, like that of all cultural bolsheviks, was fraudulent.[10] Willrich overlooked the fact that even communists had to have money if they were to continue working and publishing. Wieland Herzfelde made this quite clear in his history of Malik Verlag.

Though he disliked the art market, Grosz had no alternative but to use it. Grosz's dealers, Hans Goltz and Alfred Flechtheim, sold his drawings, lithographs, watercolors, and oils. From 1924 to 1931 his watercolors generally sold within a range of 300 to 500 marks; drawings, 150 to 300 marks; lithographs, 20 to 60 marks. The highest price he recorded in his ledger was 8,000 marks for the oil "Pillars of Society," but the gallery returned it unsold. His income from Flechtheim from mid-1926 to mid-1928 was usually 800 marks each month. It is not possible to tell from the ledger whether this was his total income. This figure may refer only to the works which Flechtheim sold in his gallery. Grosz sent some of his work to Flechtheim, but most of it went directly to galleries or to presses. It is quite possible that these payments came back to Grosz without going through Flechtheim. A safe conclusion, however, is that Grosz had a substantial, if fluctuating income by the latter half of the twenties.

While it is certain that wealthy individuals bought George Grosz's work, there are no articulate voices among these people to explain their patronage of an artist who attacked them. Various opinions can be advanced—that the wealthy patrons were motivated by the same masochistic curiosity that drove the bourgeoisie to attend dada soirées, that certain individuals of wealth either were sufficiently discerning to appreciate the artistic qualities of Grosz drawings or were sensitive enough to recognize some justification in his strictures against German society, or that Grosz's castigations of capitalistic society as embodied in the Weimar Republic fit, in an inverted way, into the general cultural pessimism of many conservatives of the period.

An important factor in the popularity of Grosz's works among the affluent middle and upper classes was undoubtedly the work of Wilhelm Busch. This nineteenth-century satirist had taught the German middle classes to laugh at their own bourgeois conventions and at the hypocrisy of their morality. Busch's caricatures of middle class life continued to be immensely popular in Germany in the twentieth century. Grosz had studied Busch's cartoons avidly when he was still a school boy. He recalled being so fascinated by Busch's work that he stayed up one whole

night copying one of the pictorial stories.[11] While Busch introduced Grosz to the art of caricaturing the middle classes, Busch also prepared the way for Grosz's popularity. It was only a step from enjoying Busch's cheerfully cruel satires to collecting Grosz's vitriolic and polemical ones.

Count Harry Kessler, the most articulate patron of art in this period, had great respect for Grosz and supported him at various times. His diary does not reveal exactly what he thought about Grosz. One can only infer that Kessler's general sympathy for the radical left, his depression over the uninspired petty bourgeois character of the Weimar Republic, and his appreciation of art caused him to support Grosz.[12]

Grosz's drawings in portfolio form did appeal to a wealthy public, and in inexpensive book form they reached a wide public. Whether the public that bought the cheap editions were members of the working class, members of the middle class, or students, is difficult to say. Presumably all of these groups were represented. Herzfelde labeled the large cheap editions Organization Editions, indicating that they were meant to be purchased by members of working class organizations. He believes that the working classes were definitely affected by Grosz's work.[13] One can assume that a fairly substantial number of the cheap picture books were purchased by left-wing intellectuals.

Grosz's drawings could be seen in the twenties in forms other than books and portfolios. During that decade there were George Grosz exhibits in many of the major cities of Germany. Berlin, with the galleries of Flechtheim and Nierendorf, had the largest number of Grosz exhibits. The Galerie Grosz, in conjunction with the offices of the Malik Verlag, was in Berlin. Munich, where Hans Goltz had his Galerie Neue Kunst, saw several Grosz exhibits. In addition to the dealers and galleries that were showing Grosz works, museums throughout Germany were purchasing and hanging his drawings, watercolors, and paintings.[14] While the galleries and museums would largely appeal to the educated, middle, or wealthy classes, the working classes were exposed to Grosz's works in exhibitions sponsored by IAH.

George Grosz's drawings were accessible to people of all classes and of all political persuasions. While left-wing intellectuals, workers, and some wealthy people reacted favorably to his work, it engendered opposition from right-wing nationalists, army officers, and the government, both in the Weimar Republic and later in the Third Reich. Before the end of the war, Grosz had encountered personal threats and attacks from army

officers who were offended by his behavior as a dadaist. Years later in America, he spoke of having frequent fist fights and challenges to duels. He claimed that he had to have a bodyguard when he went to public places in the troubled years at the end of the war.[15] He took an aggressive part in the ridiculously provocative pranks of the dadaists in 1918 and 1919, but it was not until 1920 that Grosz's participation in a dada exhibit resulted in government action against him.

The event which triggered court action was the First International Dada Fair, which was held in July and August of 1920 in Berlin. An art exhibit of 174 dadaist objects, the Fair was openly political and anti-military. Signs such as "Dada fights on the side of the revolutionary proletariat" or "Dada is political" hung on the walls alongside drawings by Grosz and Otto Dix attacking the war and deriding the military. The central room was dominated by the stuffed effigy of a German officer with a pig's head which Rudolf Schlichter created. Hanging from the ceiling, this figure was labeled "Hanged by the Revolution." Grosz's portfolio "Gott mit uns" was one of the featured exhibits.[16]

Not too surprisingly, officers who visited the exhibit found it offensive. A Captain Matthäi, who testified at the subsequent trial, was confident that the whole exhibit was meant to be a systematic baiting of the officers and men of the Reichswehr. He found the Grosz portfolio particularly offensive, especially since two foreigners who happened to be at the gallery at the same time were delighted with it. Though Captain Matthäi insisted at the trial that he visited the Fair unofficially, Kurt Tucholsky believed that he came from the intelligence apparatus of the Reichswehr. On September 9, 1920, two men appeared at the Malik Verlag and took copies of "Gott mit uns." They acted on orders from the police president of Berlin at the behest of the Reichswehr ministry. On October 15 two men again came to the press, said they were from the police president's office, and confiscated the remaining portfolios on the order of the attorney general of the second district court of Berlin. They also took seven original drawings without legal authorization. After reporting these events, Tucholsky commented that the army's anger at Grosz was proof that he had succeeded in portraying them well.[17]

Proceedings were instituted against four dadaists on the charge of insulting members of the Reichswehr: Johannes Baader, as "Oberdada" considered to be the leader of the dadaists; Dr. Otto Burchard, art dealer and owner of the gallery in which the Dada Fair took place; George Grosz, as the creator of "Gott mit uns," Wieland Herzfelde, as its pub-

lisher; and Rudolf Schlichter, for the offensive effigy.[18] The trial took place in April, 1921, in the criminal court of the second district court (Landgericht II) under Judge Oertel. "*Gott mit uns*," the description of the dummies and placards in the room, and the evidence of Captain Matthäi formed the basis of Berlin public prosecutor Ortmann's case. Grosz and Herzfelde, in defense of the portfolio, claimed that it was not aimed against the Reichwehr but was a purely artistic satire of military abuses. Their attorney, Fritz Grünspach, stressed that no person or institution was attacked or offended but a thing, namely, the excesses of militarism. Tucholsky, reviewing the trial, was disappointed with the defense for insisting that the Fair and the portfolio were not meant seriously. Tucholsky, who was himself tried in 1921 for slandering the military in an article called "Officers," took them very seriously and used the trial as the occasion for another of his frequent attacks upon the way in which the Reichswehr used the courts to suppress anti-military writing or art.[19]

Witnesses for the defense were Stefan Grossmann, later editor of the *Tagebuch*, and Dr. Paul F. Schmidt, director of the Dresden City Collection and a critic and patron of the expressionist movement. Grossmann testified that he did not find the mood of obvious caricature offensive, while Dr. Schmidt pointed out that the exhibit must be understood as completely humorous, part of the dadaists' laughter which was directed at everything around them. He stated that "George Grosz was one of the strongest and most significant artists of the present time, not only in Germany, but also in Europe." His drawings had to be considered, in Schmidt's opinion, in artistic terms and as the most important works of art of the period.[20] The commissioner of art for the republic (Reichskunstwart), Dr. Edwin Redslob, also took the stand and energetically defended Grosz's art. These were important evaluations of Grosz's standing in the artistic world, particularly since the statements were made by respected museum directors in a public trial, not by an enthusiastic art critic in an obscure journal. It indicated the rapidity with which Grosz had made a name for himself. The trial helped to increase his notoriety.

During the trial, however, prosecutor Ortmann remained unmoved by the defense's argument of the artistic value of the drawings or their humorous intent. He asked the judge for a six weeks' prison sentence for both Grosz and Herzfelde, for a 600-mark fine for both Burchard and Schlichter, and for dismissal of the charges against Baader,

who had already been certified as insane. The judge chose to fine Grosz only 300 marks, since he was an artist, and Herzfelde 600 marks — "about what it costs to murder a pacifist," commented Tucholsky bitterly. In addition the plates of the portfolio were confiscated and the publication rights given to the Reichswehr ministry. The charges against the other men were dismissed. Both Herzfelde and Tucholsky thought the milder verdict was a result of the appearance of Dr. Redslob, whose position directly under the minister of the interior commanded respect from the Prussian judge. This created difficulties, they said, for the judge who saw conflicting ministries behind the trial.[21] Over a decade later the Nazi art historian Wolfgang Willrich cited this trial to show how cultural bolsheviks had hoodwinked respectable people. He claimed that Dr. Schmidt and Dr. Redslob had overawed the judge by their positions, though in reality they were cultural bolsheviks in league with Herzfelde and Grosz.[22]

There are indications that Grosz's work was subject to other harassment in these years. Paul Westheim, in his obituary of Grosz, said that the government was sufficiently disturbed by Grosz's work not only to confiscate his portfolios but also to seize a monograph written by Willi Wolfradt in 1921.[23] Another reviewer, who was not sympathetic to Grosz, nonetheless deplored the fact that the public prosecutor had confiscated *Das Gesicht der herrschenden Klasse* shortly after its appearance in 1921. He wrote that the outcry in the press against this action was sufficient to cause the book to be released.[24]

Grosz was not the only artist nor was slandering the military the only offence that felt the wrath of the public prosecutor's office. Though the Weimar Constitution guaranteed freedom of expression, public prosecutors made use of Paragraph 184–184a of the German Criminal Code (*Strafgesetzbuch*) which dated from May, 1871, and forbade the publication of obscene or indecent writings or illustrations. Tucholsky claimed that the Berlin public prosecutor, Ortmann, who was prosecutor in the "*Gott mit uns*" trial, could not confiscate enough to satisfy himself. In November, 1920, publishers and booksellers in Berlin were up in arms over the most recent round of confiscations which, Tucholsky said, included, among others, two books by Paul Verlaine, an edition of Schiller with lithographs by Lovis Corinth, a book of Huysmans with lithographs by Willi Geiger, and a collection of Heinrich Zille lithographs.[25]

In 1923 the public prosecutor again moved against Grosz. Using Paragraph 184 he confiscated all unsold copies of the recently published *Ecce*

Homo. Max Herrmann-Neisse wrote an angry article for *Die Aktion* about the *Ecce Homo* confiscation order which stated that "a significant portion of the drawings offend the modesty and moral sense of the viewer in respect to sexual matters, consequently the whole work has an obscene character." The affair, according to Herrmann-Neisse, was an obvious result of the bourgeois attempt to control the proletariat through the fiction of moral standards. The bourgeoisie normally reveled in all kinds of erotic, sentimental, *kitschig* art, but they could not tolerate a highly moral art which showed their private behavior. By revealing this behavior, Grosz was attacking bourgeois control over the proletariat, who could be publicly punished for behaving in the same way. Therefore, the ruling classes had to condemn his work as immoral.[26]

Grosz was brought to trial on February 16, 1924, at the third district court of Berlin. Together with his publishers, Wieland Herzfelde and Julian Gumperz, Grosz was charged with publishing obscene material in *Ecce Homo.* His counsel was Paul Levy. The *Tagebuch* published a transcript of part of the trial. During the extended cross-examination by the presiding judge, Landgerichtsdirektor Ohnesorge, Grosz freely admitted that his drawings were an attempt to portray what he saw in a form critical of society. The judge questioned him on plate after plate from the portfolio trying to force Grosz to agree that he had overstepped the bounds of decency in them. Grosz refused to accept this position, arguing that he portrayed people as he saw them. When pressed to explain a colored plate entitled "Behold, what men!" and that the title portfolio was an expression of "Ecce Homo," Grosz stated that the whole and the drawings taken together were the expressions of a moralist viewing the contemporary scene.[27] During the trial Grosz received the support of such eminent figures as Max Liebermann, the impressionist painter and president of the Berlin Academy of Art, Dr. Edwin Redslob, Dr. Max Osborn, the art critic, and Maximilian Harden, the journalist. The defendants were found guilty and fined 6,000 marks; the offensive plates were confiscated from the remaining copies of the portfolio.[28] Grosz later said he found it both humorous and unjust that his very pessimistic work on man, a work meant to be a moral statement on the depravity and immorality of the German people during the period of inflation should have been judged to be pornographic and lustful.[29]

In 1928 an anonymous denunciation was referred from the office of the police president to the district court in Berlin. The complaint charged Grosz with having committed blasphemy against both the church

and the person of Christ in the drawings of the portfolio *Hintergrund*. Several years earlier, as a result of the problems created by the government's confiscations of art and literature, an arrangement had been made between the art organizations and the judicial authorities that all complaints against artists should be heard first by an official art commission. In this case, however, the art commission was bypassed, allegedly because the commission had authority to deal only with obscenity violations brought under Paragraph 184.[30] Grosz was charged under Paragraph 166 of the 1871 German Criminal Code which protected the institutions of the church from blasphemous attack. Those guilty of blasphemy could receive up to three-year prison terms. Under this paragraph, charges of blasphemy had been brought against Wilhelm Busch's *St. Anthony of Padua* in 1870, James Ensor for "Christ's Entry into Brussels" in 1888, and Max Liebermann for "The Twelve-Year-Old Jesus in the Temple" in 1897. In 1894 Oskar Panizza was involved in a notorious blasphemy trial for his play *Das Liebeskonzil* (The Council of Love), was convicted on 93 counts, and sentenced to one year in prison. Other blasphemy trials followed, including one against Carl Einstein in 1921. Brecht in 1926 had had to justify his poem "Maria" before the attorney general.[31]

The charges against Grosz were, therefore, not unique. Though the charges were religious, the nature of the drawings and Grosz's political past precipitated the trials into a political cause célèbre. The left-wing intellectuals, particularly the *Weltbühne*, championed Grosz.[32] Dr. Alfred Apfel, the eminent liberal lawyer who had defended Max Hölz against a charge of murder stemming from his leadership in the 1921 communist insurrection, and later Carl Ossietzky against charges of espionage and treason, led the three-year legal fight for Grosz because he felt artistic freedom was seriously threatened. Apfel felt that the charges against Grosz had been improperly handled from the beginning. First, he said the official art commission should have been allowed to settle the issue. Second, he claimed it was inexcusable that the originator of the denunciation remained anonymous. The police protection of the complainant's anonymity suggested to Apfel that there might not have been an actual person who was offended by the drawings. Furthermore, a bookseller in Upper Silesia was simultaneously indicted in a separate case for displaying the drawings which had not yet been condemned. This constituted an unprecedented and ominous judicial action against the freedom of both artists and dealers.[33]

In December, 1928, Grosz and Herzfelde, as publisher of the con-
fiscated portfolio, came to trial in Charlottenburg-Berlin in a lay court
(*Schöffengericht*) where the presiding judge, Landgerichtsdirektor Toelke,
was assisted by another trained, professional jurist and by two laymen,
all of whom heard the case, debated together, and passed judgment.[34]
As in the 1924 trial, the *Tagebuch* printed stenographic minutes of the
proceedings. Though Apfel said that Toelke revealed his hostility to
the drawings from the very start of the trial, he did examine Grosz
quite closely and elicited from him fairly long statements about the of-
fensive drawings and about his concept of art. Two of the three draw-
ings which were cited as evidence of blasphemy linked German clergy-
men with militarism (Figs. 78 and 79). The more offensive of the two
identified the outpouring of the Holy Spirit with the preaching of war.
Of these drawings Grosz said that he was not concerned with the possi-
bility of offending someone or breaking a law. To offend or to break a

FIG. 90 Shut Up and Do Your Duty, *Hintergrund*, no. 10.

law, he said, was an almost inevitable consequence of his mission, which he defined only in general terms: namely, that his work was to act as a scourge upon society. Pushed to analyze his motives further, Grosz said that his work was closely tied to politics though not to a political party. He explained that these drawings had not been commissioned by any party but had risen out of a deep inner compulsion to express anguish over the contemporary political scene. At this point, the judge made it clear that he did not want to discuss political questions or positions. Continuing his analysis of his own motivation, Grosz stated that he felt an inner imperative to work with those who fought injustice and brutality. It was this sensitivity to injustice that drove him to satire.[35]

The questioning ended with Grosz's description of the inspiration behind the "Christ With a Gas Mask" (Fig. 90). Though he was charged with blaspheming against the Godhead in this drawing, Grosz conceived of the drawing as being in the German tradition of portraying Christ as a figure denied and rejected. Grosz told of reading the phrase, "Shut up and do your duty" in *Schwejk* and of immediately having a vision of what would have happened if Christ had come to the trenches of the Great War preaching love and brotherhood. He too, Grosz said, would have been told to shut up, would have been given boots and gas mask, and, when he refused to serve, would have been overpowered and crucified again. Though he explained that he had no personal sympathy for Christ, the theological figure, he had tremendous sympathy for the innocent men who were slaughtered in the war. The drawing was meant to express this element of innocence and martyrdom.[36]

Refusing to accept the defense's argument that the drawings were not meant as an offense against the church or as a blasphemous attack upon Christ, the judges on December 20, 1928, found Grosz and Herzfelde guilty and fined them each 2,000 marks instead of two months in prison. The drawings of Christ in the gas mask were all to be confiscated and the plates destroyed. In their summing up, the court concentrated on this drawing and its inscription, "Shut up and do your duty." They contended that these words clearly came from Christ himself; this, therefore, was a blasphemous portrayal of a Christ urging mankind to war.[37]

The appeal was heard on April 10, 1929, in the second criminal court of the third district court in Berlin-Moabit (II. grosse Strafkammer des Landgerichts III Berlin). Apfel was gloomy about the appeal because the presiding judge, Landgerichtsdirektor Siegert, "had the reputation

of being of the sternest, and ultraconservative in his views. The whole Conservative Press and most of the Catholic and Protestant organs had greeted the first verdict with enthusiastic praise."[38] To everyone's surprise, the decision of the lower court was reversed. First of all, Judge Siegert pointed out that the drawings could not rightfully be tried under Paragraph 166 because it explicitly defined blasphemy as verbal or written. After listening to the defense, which included the testimony of Dr. Edwin Redslob that Grosz was a master of graphic art, Judge Siegert concluded that the concentration of the prosecution upon the three drawings was unjust and that, viewed within the context of the whole portfolio, the three drawings could only be seen as an attack upon war and upon the excesses of the church which supported war. Furthermore, the lower court was mistaken in interpreting the "Christ With a Gas Mask." Clearly, Siegert said, Christ was himself a victim of war, crucified by the false representatives of the church who had preached in favor of war. Siegert insisted that far from being blasphemous Grosz was speaking for the millions who disliked war and that he had raised ethical demands of the highest order.[39]

The conservatives were infuriated at the decision. Apfel reported that the following question was asked in the Prussian parliament: "Is the Ministry of Prussian Affairs prepared instantly to relieve Justice Siegert of his duties, as a result of the public indignation which his summing-up in the case against Georg Grosz has aroused?"[40] The prosecution appealed the verdict. Ossietzky said that Siegert was a deliberate jurist whose decisions were unassailable. Therefore, the Supreme Court (*Reichsgericht*) on February 27, 1930, reinterpreted Paragraph 166 to include drawings and stated that the crucial point was not whether Grosz intended to make a blasphemous drawing, but whether his drawings injured the religious perceptions of members of the church. The Supreme Court decision referring the case back to the district court also mentioned that art works fell under the emergency laws for the protection of the republic, which allowed limitation of the constitutionally guaranteed freedom of expression in those cases which endangered the republic.[41] Neither Siegert nor the prosecutor was eager for the judge to preside over the case again, even though it had been referred back to his district court. The new hearings were therefore called while Siegert was on a long holiday, but Apfel refused to attend until Siegert returned. Upon his return Siegert asked to be relieved of presiding over

the case because he no longer considered himself to be impartial. The court refused to accept his withdrawal, probably, Apfel said, because no other judge wanted to touch the affair.[42]

When the third district court convened on December 3–4, 1930, it was so packed with visiting judges and representatives of all the churches that the *Welt am Abend* called it a clerical court (*Pfaffengericht*) and the *Berliner Tageblatt* dubbed it the Moabit Church Council. Experts were called from the Quakers, from the Catholic and the Protestant churches. Helmuth Schreiner, the official witness from the Protestant church (*Evangelischer Oberkirchenrat*), recalled that early on the morning of the trial the Moabit building was besieged by onlookers and witnesses. An extra-heavy police guard surrounded the building and extended right into the court room. The trial turned into a veritable battleground for different concepts of art and religion, of pacifism and war. Dr. Edwin Redslob again defended artistic freedom; Count Harry Kessler spoke as a pacifist and a patron of art. The high point of the trial came in the confrontation between the representatives of the established churches and the pacifist church spokesmen, Dr. Hans Albrecht, a Quaker from Hamburg, and a Pastor Bleier from Berlin.[43]

Grosz testified on his war experiences and the strong aversion to war which he felt. Questioned on his religious position, Grosz stated: "I am fundamentally a religious man. . . . I perceive in religion a marvelous myth." He explained that he had been nominally a member of the Protestant church until the first blasphemy trial. After that verdict, he left the church. Asked why, he said, "The church has not defended me. I stand defenseless in the trials." For this answer, he received the censure of the *Rote Fahne*.[44] This statement hinted at the increasing pessimism of Grosz's thinking in these years. Rejecting the rationalism of Marxism, he was becoming convinced of the irrationality of life. Nevertheless, in the trial he defended his mission as a scourge on the conscience of the German people and as a protest against the brutality and injustice of the time. He insisted that all of his work grew out of its period: "[my work] is inconceivable without these men and without this time......and if one accuses me, then one accuses our time, its horrors, its corruption, its anarchy, and its injustice."[45]

Judge Siegert again acquitted both Grosz and Herzfelde, reaffirming and strengthening his earlier verdict. He did, however, admit that it was possible that the drawings might offend some people who misunderstood their message, but for this Grosz could not be held responsible.[46] The

liberals were jubilant. The public prosecutor again appealed the verdict. Unable to find grounds for reversing Siegert's decision another time, the Supreme Court resorted instead to confiscating all the drawings and having the casts and blocks destroyed. The reason given for this action, despite the acquittal, was that the drawings might be misunderstood and thereby give offense. Apfel was discouraged because ultimately the trials had given the government a means to suppress works of art even when they were vindicated in court and because the left-wing press had not understood this. He concluded his account of the trials: "It is almost superfluous to add that Siegert was one of the first judges to be dismissed by the new [Nazi] regime."[47]

According to Paul Westheim, "all Germany was shocked," shocked at Grosz's drawings and at the idea of a trial for blasphemy in the third decade of the twentieth century. Not too long after the last trial, Westheim was working on a radio program that featured contemporary artists. When he suggested George Grosz as a participant in the program, the reaction of the directors of the Deutsche Welle was strongly negative: "The famous blasphemer on the radio! . . . Impossible" Westheim talked them into having Grosz on the program, assuring them that Grosz was a civilized artist who would discuss intelligently German art. The resulting broadcast was a quiet and sophisticated discussion of the German tradition in art, in which Grosz made the point that he felt the current period to be a transitional one similar to the late Middle Ages and that he saw his own art as being similar to the moral criticism and jeremiah-like art of Breughel, Bosch, and Grünewald.[48] Within the radio station building, Grosz's presence created a sensation. As Westheim and Grosz talked in the small broadcasting room, a steady stream of the station's personnel crowded into the room; they all wanted to see this public menace in the flesh.[49]

In addition to the sort of individual support for Grosz represented by Westheim's defense, there was considerable official activity on the part of the progressive and liberal organizations on Grosz's behalf. The German League for Human Rights (Deutsche Liga für Menschenrechte) and the Committee for the Fight against Censorship (Kampfausschuss gegen die Zensur) each protested the reversal of Siegert's initial acquittal by the Supreme Court. The latter group, which represented all of the important organizations of artists, writers, actors, musicians in Germany, lifted its voice against the prosecutions which were damaging the very existence of Germany as a cultural state. The Supreme Court

decision against Grosz constituted a danger to the freedom of the creative life. This statement, sent to the authorities and published in a leading art journal, was signed by nineteen organizations headed by the Academy of Art.[50]

The Berlin chapter of the Federal Association of Artists in Germany (Reichsverband bildender Künstler Deutschlands) sent a letter on April 9, 1929, to Judge Siegert in which they stated that the artists of Berlin, knowing Grosz and his work, believed that he had no intention of degrading the Christian church but that he wanted to raise moral questions through his drawings. This action, which was taken by the executive directors of the Berlin chapter, turned out to be controversial. One hundred and forty-eight members of the larger federal organization published the following year a protest against the support of Grosz by the Berlin chapter of the Association. These members were offended by Grosz's use of the figure of Christ for tendentious and political purposes. Believing that true art was based on honoring the holy and the sacred, they felt they had to make a public disavowal of this action of the Federal Association of Artists to renounce this protest or to publish the names of the 148 members, suggesting that there would be among the names no artist who had any stature in the art world.[51]

Although in 1929 and 1930 the Federal Association of Artists officially supported Grosz, and only a minority voice among the artists condemned his attacks upon objects of German tradition, this situation was not to last long. Within three years the minority opinion triumphed. In 1929 the League Fighting for German Culture (Kampfbund für Deutsche Kultur) was organized by Alfred Rosenberg as an ostensibly independent organization which sought to rescue German culture from the crisis into which it had fallen. This crisis was defined as one produced by cultural bolsheviks—modern artists, architects, musicians, and writers—whose aim was to destroy German culture in the name of the proletarian world revolution. This convenient epithet, which was applied to a wide variety of contemporary figures, usually with no objective justification, was particularly appropriate as a condemnation of George Grosz. His work was an obvious and natural object of attack for the

League. From 1929 to 1933 Grosz's name was among those most frequently cited as enemies of German culture by the newsletters of the League. He was the only artist whose works were attacked in the pamphlets of the League during its first two years. Passages from his writings were quoted and attacked along with passages from Toller and Tucholsky.[52]

The purification of German art did not wait for the political assumption of power by National Socialism. Projects of purification—removal of museum directors, changes in personnel in important posts—began in areas where government officials were sympathetic, notably in Thuringia and Saxony. In April, 1930, the League succeeded in having dismissed Dr. Hildebrand Gurlitt, director of the Zwickau museum. In the article condemning Gurlitt, Grosz was mentioned with Dix and Hofer as examples of ethical nihilism within cultural bolshevism. Gurlitt, according to the League, deserved condemnation for supporting the art of these men.[53] With the advent of the Nazi government in 1933, the purification of art proceeded rapidly. Since a major part of this program was the simultaneous condemnation of artists and the education of the public to this condemnation, a series of art exhibits began in 1933 which culminated in the Degenerate Art Exhibit in Munich in the summer of 1937.

The pattern for these exhibits was set in an exhibition in Karlsruhe in April, 1933. This exhibit, "Government Art from 1918 to 1933," extended its censure of modern German art to include pre-war impressionism and expressionism.[54] An exhibit in Stuttgart, "The November Spirit, Art in Service of Disintegration," again in 1933, was particularly directed against Dix, Grosz, Beckmann, and Chagall. The Mannheim exhibit of the same year, "Cultural Bolshevism," featured *Ecce Homo* drawings by Grosz.[55] The Degenerate Art Exhibit, which was opened with great fanfare by Hitler and Goebbels in Munich in 1937, toured Germany. With it the Nazis declared the authoritative end to modern art in Germany. This exhibit used the display techniques of the earlier ones: overcrowded walls, offensive labels, citations of purchase prices in inflationary currency to reveal the traitorous misuse of public funds, and prominent display of erotic drawings. In the catalogue, which was a definition and condemnation of degenerate art, not a guide to the exhibit, Grosz's drawings were used to illustrate art that preached sexual corruption and incited class hatred.[56] His work was represented by five oil paintings, two water colors, and thirteen drawings.[57]

The obverse side of these educational art exhibits was the confiscation of sixteen thousand works of modern art from museums. These works were exhibited as degenerate art, sold abroad to help finance Hitler's museum at Linz, appropriated by Goering, or burned. According to the inventory taken from the files of the Reich's Propaganda Ministry, 285 of Grosz's works were confiscated. Two of his large oil paintings were listed at the major sale of degenerate art which was held in Lucerne at the Fischer Gallery in June, 1939.[58]

The banning of the works of degenerate artists applied also to any public discussion of their work. In a letter dated March 3, 1933, Nazi church officials (Deutsche Christen) called for disciplinary action against Pastor Bleier, one of the pacifist witnesses in the 1930 trial, who had scheduled for his parishioners an illustrated lecture on George Grosz titled "Prophet as Blasphemer." The letter cited Grosz's subversive past, his attempts to undermine the state and the church with such drawings as "Christ With a Gas Mask," his activities as a dadaist, his publishing with a bolshevik press, and such traitorous publications as *"Gott mit uns."* According to the Nazi officials, any pastor who would allow discussion of such a man within his parish should be strongly disciplined.[59]

On the other hand, it was perfectly legitimate to utilize the works of degenerate artists for educational purposes in keeping with the Nazi aims. For example, in 1933 a Nazi book very carefully described the bolshevik menace which was threatening Germany. It was delineated in all of its horrors of sexual aberrations, incendiarism, atheism, and terrorism. In this context Grosz's "Christ With a Gas Mask" made an exceptionally appropriate illustration of the godlessness of the cultural bolsheviks.[60] Though Hitler was portrayed as the savior of the whole of Europe from this frightful menace, the authors did not see fit to utilize Grosz's drawing of "Hitler, the Savior."

In a similar way Grosz was an extremely useful artist for Wolfgang Willrich, who published *Säuberung des Kunsttempels* (Cleansing of the Temple of Art) in 1937. His thesis was familiar: modern German art was anarchistic, aimed at destroying German culture and society, directed by communist writers who consciously manipulated the artists. The outcome was cultural bolshevism. To prove his point, Willrich analyzed, extensively, statements in literary journals as well as works of art. Grosz, with his close relationship to Herzfelde and the Malik Verlag, provided excellent examples for Willrich which he used continually. For him, Herzfelde was one of the literary bosses of the "Red Front"

who dictated the programmatic work of Grosz and other artists such as Otto Dix. Willrich was obsessed by the communist plot which involved not only publishers, who planned the communist art, but art critics who praised these works and dealers who sold them. The publishers whom he listed as part of this plot included all of Grosz's publishers. The dealers whom he singled out as centers of communist agitation were Hans Goltz, Galerie Nierendorf, and Alfred Flechtheim, all of whom handled Grosz's art.[61]

The nature of Grosz's art as political and social satire had made his work particularly offensive to the National Socialists, sufficiently so that Nazi antagonism was directed not only against his art but against Grosz himself. The years from 1930 to 1933 had been filled with threats from the Brown Shirts. In the spring of 1932 George Grosz accepted an invitation to teach at the Art Students League in New York. America had always been his escape from reality, and now, following a dream that urged him to flee Germany, Grosz chose literally to escape the situation there.[62] In October he returned from New York to Berlin having decided to immigrate to the United States. After his return, according to Ulrich Becher, he received frequent anonymous calls from the SA. Though more than a decade had gone by, Grosz dealt with these harassment with the same tough insolence that he had used on the Free Corps officers in 1919:

"Listen, you Jewish swine, tomorrow night we are coming and slaughtering you and all your brood."

"Just come," shouted Grosz into the telephone, "I have two pistols, my wife also has two, and my friend Uli has a Basque walking stick with a bayonet! We'll show you what's what!"[63]

Despite his aggressive words, Grosz's foreboding of what the future held for him under Hitler was strong enough to cause him to emigrate with his wife on January 12, 1933, eighteen days before Hitler became chancellor.[64]

On February 27, 1933, the burning of the Reichstag began the assault of the Nazis upon the Communist party. Grosz's empty apartment and studio were searched. He was certain that, if he had been there, he would not have come out alive.[65] Only ten days after the Reichstag fire, on March 8, 1933, Grosz was officially deprived of his German citizenship (*ausgebürgert*). From New York Grosz watched the subsequent destruction of the KPD and was appalled. His commu-

FIG. 91 Photograph of Herzfelde, Grosz, his son Peter, and his wife Eva, around 1932.

nist friends fled, as he had fled. Brecht went to Denmark, then to Russia, and finally reached America. Herzfelde and Heartfield moved the Malik Verlag to Prague, where they continued to infuriate the Nazis by their attacks.[66] In 1938 they fled to London, and in the following year Herzfelde went to New York. Mehring, Huelsenbeck, and Piscator all reached America. Not all of Grosz's friends were lucky enough to escape. Erich Mühsam died in 1934 in the Sachsenhausen concentration camp. Dr. Hans Borchardt survived Dachau to tell Grosz about the horrors of the camps.[67] Tucholsky, Toller, Einstein, Hasenclever, all committed suicide in exile.

In June, 1939, a secret SS document was circulated which listed the most important figures of the "System period" (*Systemzeit*) — the Nazi term for the Weimar Republic — and recorded what had happened to them since the Nazi assumption of power in 1933. It was virtually a report on how well the SS had succeeded in eliminating or silencing what it considered to be the public enemies of the German people. The 553 proscribed men included all the leading public figures of Weimar — politicians, artists, theologians, scientists, journalists. Friends of Grosz

who made the list were Brecht, Dix, Oskar Maria Graf, Kollwitz, Piscator, Toller, and Tucholsky. Of these 553 persons, Grosz was the only one who had been ausgebürgert immediately after the Reichstag fire. This would confirm that, had he been in Germany at the time, he would have been among those immediately arrested. The next group of men to be denied their citizenship on August 23, 1933, according to this document, included the leaders of the Communist party who had succeeded in avoiding arrest and fleeing. Willi Münzenberg, Ernst Toller and Heinrich Mann were in this group. The document contained notes on Grosz which charged him with being "one of the most evil representatives of degenerate art who worked in a manner which was hostile to Germany."[68]

EPILOGUE

THE SADDEST MAN IN EUROPE

Nun scheint mir alles, was ich schätzte, nichtig.
Der Nebel draussen hüllt die Scham nicht ein.
Ich weiss, ich lebte meine Zeit nicht richtig
Und muss mein Leben lang erfolglos sein.

Now all I valued highly seems futile.
The fog outside cannot cloak the shame.
I know I failed to live with my age
And I must be a failure as long as I live.

MAX HERRMANN-NEISSE

GROSZ HAD IDEALIZED AMERICA since he first read Karl May. During the first world war he wrote in a poem of "America! The future!!" He had in 1930 answered a newspaper question about the whereabouts of paradise by locating it in the Rocky Mountains.[1] He did not find paradise in America, though he tried desperately hard to become a complete American. He was determined not to act like an exile, living in the past and waiting to return to Germany. He intended to shed his German identity and sink his roots into the new land. He threw himself enthusiastically into becoming a practical, money-making American, but the ties to Germany were too strong. He wrote sometime later, "I really haven't brought it off. I can never become a genuine American. Thus I am, after all, nothing more than—yes, than a demoralized and forgotten German."[2] Unhappiness, depression, and discouragement marked much of the third of his life which he spent on Long Island. His home

233

became a meeting place for German exiles whom he helped whenever possible. Political discussions were frequent and heated.

Grosz was as aggressive in these political arguments as he had been in the revolutionary days of 1919. He wrote on June 3, 1933, a letter to Wieland Herzfelde in Prague which he never mailed because it was too unadulteratedly "grosz-like," "a colossal tirade of disbelief." In the letter, "the old [uralte] individual Grosz broke out again all too vehemently....and reviled everything from left to right....poured bitter derision and scorn over everything." His second letter which he wrote three days later—and mailed—was much the same, though milder in its tone. For fifteen closely typed pages Grosz spewed out his anger in the two letters.[3] He attacked everything he had done and everything he had stood for in Germany. The core of his bitterness lay in the betrayal by the Communist party of the ideals which he thought it stood for in 1919. He had entered the party with petty bourgeois humanitarian ideals. "Then I had some beliefs . . . a little talented simpleton [Dummkopf] with plenty of hate The pursuit of communist ideals destroyed everything in me."[4] Now the party was completely different from what it had been.

He was obsessed by the basic identity of the Nazis, the fascists, and the communists. They were all manipulators of power; they all demanded a submissive populace; they were all built upon terror and slavery. The Nazis preached race hatred and killed the Jews; the communists preached class hatred and killed the bourgeois reactionaries: "Long live the universal enslavement of the proletariat; long live the poison-gas-military; long live the airplanes with bombs....Hurrah, Hurrah....long live factories and forced labor........long live lies and informers and the GPU and the [German] secret police.........three cheers for 'scientific' communism....three cheers for class hate!!!! three cheers for 'unscientific' fascism with its race hate!!!! Shit on them both..........it's enough to make you sick. It's not for me! Finished!"[5] And in another place: "[I] can not believe in these lofty blood-thirsty half gods...neither in the holy Lenin, nor in the harsh Mussolini, nor in the stern Hitler-father. They all play a great deal with military, tanks, and airplanes. . . ."[6] All of them required obedience—standing at attention. The Marxists and the Nazis played the same game in Germany, but Hitler understood the people better than the communists. The KPD spoke of brotherhood and solidarity of the workers; Hitler, however, from the first acted as a father figure who sternly demanded obedience and promised national honor

in war. "And so....Hitlerman has won the game. Okay! We have lost...."[7] Grosz insisted that Herzfelde must recognize the facts: the communists would not arise again in Germany, because the workers stood behind Hitler. The "red colossus" no longer existed. It did not really matter who had won in Germany; either way terror and suppression would have resulted. Grosz predicted an alliance between Mussolini, Stalin, and Hitler within a few years.

As for himself, Grosz claimed that he was still as unruly and as insubordinate as he was in 1914. He could never stand at attention. His work in the party had left him even more cynical and scornful than he had been in 1914. "Today I have no more illusions. One must fight one's way through...that's all. . . . I say that one must have the courage to be able to look squarely at the real absurdity of all that has happened."[8] Faced with the disintegration of his life and the life of Germany, Grosz could only stress that "the world for me is senseless."[9] At the end of his second letter, this became an affirmation, in a sense, an existential affirmation: "as often before, I greet the great joyful mysterious meaninglessness of life. Outside thunders the elevated, the cars honk. The expresses thunder incessantly down sixth avenue.....living song of a senseless unordered activity....song of this great inhuman-human hard city. To the old singer of democracy, the great Walt Whitman, I feel very close........ . . I am no faint-hearted surrenderer.................I salute only the great marvelous futility and worthlessness!"[10]

Herzfelde, who had barely escaped the Nazis in fleeing from Germany, replied from Prague vigorously denying Grosz's assumption that right and left were in practice the same. Their arguments, though strong, did not destroy their warm friendship, both of which—friendships and arguments—continued after Herzfelde and his wife came to New York. There he re-established his press, but Grosz did not publish anything with him after 1932.

In the summer of 1933 Grosz poured out his bitterness and scorn against Germany on another fellow-exile, Thomas Mann. Grosz, who said he felt in a "funeral-pyre mood," jumped on Mann's confident declaration that Hitler could not last more than six months. On the contrary, Grosz angrily asserted, he would last six or ten years or more and, furthermore, the Germans who had elected him deserved him, just like calves who chose their butcher. Full of misanthropy, hating even the "good Germans" he was having lunch with, Grosz looked at Mann and suddenly realized that neither of them could stand the other.[11]

FIG. 92 Grosz in 1954.

And so, Grosz tried to become an American. He sought to overcome the tensions and forebodings within himself by adopting a totally new outlook. He was going to become a happy, smiling, contented optimist who "hurt no one and gave joy to all." Life, he kept telling himself, "is really more beautiful if you say YES instead of NO."[12] He hoped to become a magazine illustrator, but received only scattered commissions. His work concentrated on oils and watercolors and on positive subjects like landscapes, still lifes, and American street scenes.

But the contradiction was too great, and Grosz became steadily unhappier as the Nazi nightmare expanded into world war. Hans Borchardt

brought news of his ghastly experiences in Dachau. Ernst Toller committed suicide in a New York hotel. Grosz retreated periodically to his studio and drank and drank. Once his friend Ben Hecht joined him at the end of one of his drinking bouts and discovered that Grosz was burning a pile of drawings in the stove. The drawings were crude, horrible, and brilliant. Grosz explained that he drew to rid himself of the ugliness inside and then burned the offensive drawings.[13] He published a series of drawings attacking Nazi Germany in 1936 (*Interregnum*). Working in oils, he produced series of paintings on the themes of ruins, survivors in war-torn cities, death and apocalyptical figures.[14]

In 1942 he wrote to his friend Paul Westheim, who had fled to Mexico: "...once more I am a disciple of Swedenborg...and the world...mine... the world offers itself to me as a thoroughly 'symbolic'...a caricatured heaven....here, Paul....here,...and (Sören Kierkegaardish, Paul)...the hell ...here...behind my chair is an abyss...but I don't glance into it."[15]

The defeat of the Nazis and the end of the war did not lessen his pessimism. At the end of the war he began working on a series of Stickmen paintings which culminated in "The Painter of the Hole." An emaciated and hollow figure wearing an iron collar sitting in a grey landscape, the painter works on a canvas which is a hole (Fig. 93). The artist, explained Grosz, "believed once in a picture, but now there is only a hole without meaning, without anything...nothingness. . . ."[16] Painting the stick-artist over and over, Grosz must have been painting his final self-portraits. Asked by a reporter from *Der Spiegel* in 1954 if he, as the painter of nothing, should not actually stop painting, Grosz nodded his head: "My friend Marcel Duchamp has come to that conclusion; he paints no more. Perhaps there really can be no further representation of the ultimate despair." And, said the reporter, from behind the mask of the jovial Yankee appeared for a moment the face of the "saddest man in Europe."[17]

After the war Grosz at first resisted offers that would take him back to Germany. In the summer of 1951 he returned for a brief visit during which he tried to act as Americanized as possible, and in 1954 he visited Germany long enough to see friends and to design the costumes for *Bilderbogen aus Amerika* (Picture-Sheets from America), a ballet with choral accompaniment produced at the Berliner Komödie. His friends were returning to Germany. Herzfelde, Heartfield, and Brecht had gone back to East Germany; Piscator went to live in West Berlin. For Grosz to return to Germany would have meant the denial of the American

FIG. 93 The Painter of the Hole, 1947, watercolor.

image which he had sought desperately to build. Nevertheless, he finally decided to return to West Berlin.

His friends have recorded several incidents that happened in the week after his much publicized return to Berlin in June of 1959. Wieland Herzfelde recounted an evening spent in a small inn in West Berlin

when Grosz noisily praised Hitler. Anyone who did not know him would, according to Herzfelde, have taken him to be a Nazi; those who knew him realized that this was his way of attacking the hypocrisy of a Germany in which no one but Hitler seemed to have been a Nazi.[18] On the night of July 5, barely six weeks after his return, Grosz was accompanied by a noisy group of friends back to his apartment after a convivial evening spent at Franz Diener's café. It was late and their voices bothered a neighbor who, Ulrich Becher reported, yelled out of a window at them: "I'll send you a wreath of barbed wire." At this Grosz laughed loudly and familiarly, because he suddenly felt at home confronting the militaristic bourgeois attitude which he had once fought so fiercely.[19]

Early the next morning a newspaper woman found him collapsed inside the entry to his apartment house. She called several other workers from the street to help her carry him to his apartment. He died as they tried to move him.[20] When he heard the news of Grosz's death, Walter Mehring was struck by the irony of Grosz's being surrounded at his death by workers who were out at dawn. Grosz had so often depicted the dawn street scene where carousing burghers returning home at dawn met workers going to their labors. It inspired Mehring to write this epitaph:

Dies ist kein dadaistisches Phantasiestück –

oder doch?

Die Zeitungsfrau
Der Eismann
Die Maurer
3 Allegorien
einer

Berliner

GEORGE GROSZ –

Morgendämmerung

umstanden den Sterbenden,
den sie

in eine Wohnung zu schaffen

versuchten –
vergeblich …

Sie hätten von ihm sein können –
Sie waren sein Werk
Keine Künstlerhand
hätte es
so
vollenden dürfen …[21]

Epilogue

This is no dada-fantasy –

 or is it?

The newspaper woman
The iceman
The bricklayers
3 allegories

 of a

Berlin

 GEORGE GROSZ –

 dawn

stood around the dying man
whom they
tried

 to get into a house –

in vain ...

 They could have been by him –
 They were his creation

No artist's hand

 should have

been allowed to complete it
like this ...

REFERENCE MATTER

Notes

PREFACE

1 Gordon A. Craig, "Engagement and Neutrality in Weimar Germany," *Journal of Contemporary History* 2, no. 2 (April 1967):49–63.

2 See, for example, Walter Laqueur, "A Look Back at the Weimar Republic—The Cry Was, 'Down with *Das System*,'" *New York Times Magazine*, 16 August 1970, pp. 12–13, 25–34; Laqueur, "The Tucholsky Complaint," *Encounter* 33, no. 4 (Oct. 1969):76–80; Theodore Draper, "The Ghost of Social-Fascism," *Commentary* 47, no. 2 (Feb. 1969):29–42; Peter Gay, "The Weimar Resemblance," *Horizon* 12, no. 1 (Winter 1970): 4–15; George Mosse, *Germans and Jews: The Right, the Left, and the Search for a "Third Force" in Pre-Nazi Germany* (New York, 1970), pp. 218–25; and Bruno Bettelheim, "Obsolete Youth: Towards a Psychograph of Adolescent Rebellion," *Encounter* 33, no. 3 (Sept. 1969):29–42.

3 Carl E. Schorske, "Weimar and the Intellectuals," *New York Review,* 7 May 1970, pp. 22–27; 21 May 1970, pp. 20–25.

INTRODUCTION: THE MERCHANT FROM HOLLAND

1 Among this group, according to Herzfelde, were Else Lasker-Schüler, Theodor Däubler, J. R. Becher, Martin Buber, Gustav Landauer, Hugo Ball, Albert Ehrenstein, Franz Jung, Richard Huelsenbeck, Ferdinand Hardekopf, Salomo Friedländer (Mynona), and the artists Ludwig Meidner, Heinrich Maria Davringhausen, Max Oppenheimer, Carlo Mense, and Paul Gangolf. Wieland Herzfelde, ed., *Der Malik-Verlag, 1916–1947* (Exhibition catalogue, Dec. 1966–Jan. 1967, Deutsche Akademie der Künste zu Berlin [DDR]), p. 6.

2 The entire account of this evening at Meidner's studio is told in Herzfelde, "The Curious Merchant from Holland," *Harper's Magazine* 187 (Nov. 1943):569–73.

3 Herzfelde, *Malik-Verlag*, p. 7.

4 Herzfelde, "The Curious Merchant from Holland," pp. 573–76. Herz-

felde, ed., *Malik-Verlag*, pp. 9, 36. On the latter page is a speech which Herzfelde gave at the Ten Year Jubilee of the Malik Verlag. In the speech, he told of this conversation with Grosz. The exact wording of these two accounts differs, but the meaning is the same. The speech was published in *Literarische Welt*, 11 March 1927.

5 Helmut Herzfeld took the name John Heartfield during the war in protest against anti-English war sentiments.

6 Herzfelde, interview in his home, Berlin, German Democratic Republic, July 19, 1967; Herzfelde, "Isst George Grosz wirklich von goldenen Tellern?" *Aufbau* 6, no. 1 (1950):86.

7 Walter Mehring, *George Grosz, 1893–1959* (Exhibition catalogue, Oct. 7–Dec. 30, 1962, Akademie der Künste, Berlin), p. 16 [statement on Grosz].

8 Kaspar Hauser [Kurt Tucholsky], "Gesicht," *Die Weltbühne*, 3 July 1924, p. 33. Also in Kurt Tucholsky, *Gesammelte Werke*, ed. Mary Gerold-Tucholsky and Fritz J. Raddatz, 3 vols. (Reinbek bei Hamburg, 1960–61), 1:1182–83. See Harold L. Poor, *Kurt Tucholsky and the Ordeal of Germany, 1914–1935* (New York, 1968), pp. 76–78, for an English translation of the essay.

9 Herzfelde, interview; Ulrich Becher, *Der grosse Grosz und eine grosse Zeit: Rede, gehalten am 7. Oktober 1962 zur Eröffnung der grossen Grosz-Ausstellung in der Akademie der Künste, West-Berlin* (Reinbek bei Hamburg, 1962), p. 12.

10 Thomas Craven, *Modern Art: the Men, the Movements, the Meaning* (New York, 1934), p. 204; John I. H. Baur, *George Grosz* (New York, 1954), pp. 27, 34–37; Ruth Berenson and Norbert Muhlen, "The Two Worlds of George Grosz," *George Grosz*, ed. Herbert Bittner (New York, 1960), p. 19.

11 Herzfelde, interview; Berenson and Muhlen, "The Two Worlds of George Grosz," p. 12; Baur, *George Grosz*, p. 59.

12 Becher, *Der grosse Grosz*, p. 19.

13 Grosz, *Ein kleines Ja und ein grosses Nein. Sein Leben von ihm selbst erzählt* (Hamburg, 1955), p. 21.

14 Facsimile of the inscription in Herzfelde, ed., *Malik-Verlag*, p. 150. For the circumstances surrounding the writing of the essay, see the introductory notes to Herzfelde, "Ein Kaufmann aus Holland," *Unterwegs. Blätter aus fünfzig Jahren* (Berlin, 1961), pp. 114–32.

15 Grosz, "Abwicklung," *Das Kunstblatt* 8, no. 2 (Feb. 1924):34; Paul Westheim, "Erinnerungen an George Grosz," *Die Weltkunst* 32, no. 22 (Nov. 15, 1962):17.

16 Grosz, *Ein kleines Ja*, chap. XV.

17 Peter Gay, *Weimar Culture: the Outsider as Insider* (New York, 1968), p. 102; Hellmut Lehmann-Haupt, *Art Under a Dictatorship* (New York, 1954), p. 26.

18 Ilya Ehrenburg, *Memoirs: 1921–1941*, trans. Tatania Shebunina and

Yvonne Kapp (New York, 1966), p. 16; quoted in Gay, *Weimar Culture*, p. 70; Günther Anders, *George Grosz*, Die kleinen Bücher der Arche (Zurich, 1961), pp. 7–8.

19 Grosz, "Statt einer Biographie," dated Berlin, 16 August 1920, trans. Hans Hess, reprinted *George Grosz, 1893–1959* (Arts Council Exhibition Catalogue, York, London, Bristol, Eng., 1963), p. 11.

20 Grosz, *A Little Yes and a Big No; the Autobiography of George Grosz*, trans. Lola Sachs Dorin (New York, 1946), p. 11. I have slightly revised the translation of this paragraph.

21 Grosz, *Ein kleines Ja*, p. 243.

22 Herzfelde, interview; Herzfelde, "Isst George Grosz wirklich von golden Tellern?" p. 86.

CHAPTER 1: IN LITERARY BERLIN

1 The biographical details of Grosz's youth are drawn from the following articles by him: "Jugenderinnerungen. Mit Photos und Zeichnungen aus der Jugendzeit," *Das Kunstblatt* 13, no. 6 (June 1929):166–74; no. 7 (July 1929):193–97; no. 8 (Aug. 1929):238–42; "Lebenserinnerungen," *Kunst und Künstler* 29 (Oct.–Dec. 1930):15–22, 55–61, 105–11; "Lebenslauf; Notizen für Prozess," December 3, 1930 (Typescript in the possession of the George Grosz Estate, Princeton, N.J.), p. 1; and *Der Spiesser-Spiegel* (Dresden, 1925), pp. 5–9.

2 Grosz, "Lebenslauf," p. 1.

3 Grosz, "Lebenserinnerungen," is accompanied by an excellent sampling of his drawings from the early period in Dresden. For a thorough study of German expressionism, see Peter Selz, *German Expressionist Painting* (Berkeley and Los Angeles, 1957).

4 Grosz, *Ein kleines Ja und ein grosses Nein. Sein Leben von ihm selbst erzählt* (Hamburg, 1955), pp. 97–98.

5 Ibid., p. 100; Grosz, "Abwicklung," *Das Kunstblatt* 8, no. 2 (Feb. 1924): 34; and "Moja Žizn [My life]," *Prožektor* (Moscow) 6, no. 14 (April 1, 1928):16.

6 Peter Selz, *Max Beckmann* (Garden City, N.Y., 1964), pp. 10, 101.

7 For an excellent stylistic analysis of Grosz's work, see John I. H. Baur, *George Grosz* (New York, 1954), *passim*. For drawings and watercolors of this period, see *George Grosz, 1893–1959, A Selection of Fifty Early Drawings From 1910 to 1920* (Exhibition catalogue, Feb. 5–March 2, 1968, Peter Deitsch Fine Arts Inc., New York) and *George Grosz*, Preface, Eila Kokkinen (Exhibition catalogue, March–April 1970, Peter Deitsch Fine Arts Inc., New York).

8 Peter Gay, *Weimar Culture: the Outsider as Insider* (New York, 1968), pp. 102–118.

9 Walter Mehring, *Berlin Dada: eine Chronik mit Photos und Dokumenten* (Zurich, 1959), p. 27; Lothar Lang, ed., *George Grosz, Welt der Kunst*

10 Ibid.

11 Grosz to Herzfelde, New York, 3 August 1933 (Grosz Estate), p. 1. Though Grosz specifically referred in the letter to Wöhlertstrasse in Wedding where he lived with his mother from 1900 to 1902, the ideas expressed refer to his pre-war period in Berlin and to his attitudes in the early thirties. (Grosz used unspaced ellipses of varying numbers in all of his typed statements.)

12 Selz, *German Expressionist Painting*, p. 79.

13 Grosz, "Abwicklung," pp. 33–34.

14 Hi Simon, *Georg Grosz, Twelve Reproductions From his Original Lithographs* (Chicago, 1921), Introduction, pp. 1–6 (Simon is not a completely reliable source; there are some errors in the book). Gottfried Benn, "Nachtcafé, 1912" (Für George Grosz), printed in *George Grosz Ausstellung*, Veröffentlichungen des Kunst-Archivs, no. 1 (Exhibition catalogue, March 29–April 24, 1926, Galerie Alfred Flechtheim, Berlin), p. 9.

15 Grosz, "Lebenserinnerungen," p. 110.

16 Gay, *Weimar Culture*, p. 72; Gordon A. Craig, "Engagement and Neutrality in Weimar Germany," *Journal of Contemporary History* 2, no. 2 (April 1927):49–54.

17 Herzfelde, "The Curious Merchant from Holland," *Harper's Magazine* 187 (Nov. 1943):569.

18 Grosz, "Abwicklung," p. 35; Grosz, *Ein kleines Ja*, pp. 101–2.

19 Kriegsfreiwilliger bei dem Königlichen Preussischen Kaiser Franz Garde-Grenadier-Regiment Nr. 2, according to records in the Krankenbuchlager, Berlin.

20 "George Grosz wird vernommen, Aus dem stenographischen Protokoll des Gotteslästerungsprozesses," *Das Tagebuch*, 22 December 1928, p. 2211.

21 Grosz, "Lebenslauf," p. 2.

22 Letter to the author, 13 August 1970, from Krankenbuchlager, Berlin.

23 Grosz, "Abwicklung," p. 36.

24 Paul Westheim, "Erinnerungen an George Grosz," *Die Weltkunst* 32, no. 22 (Nov. 15, 1962):16.

25 The Grosz Estate owns a large collection of small sketch books in which Grosz made sketches, notes, poems, and addresses. From October, 1915, through 1916, he labeled 7 of these books "Krankenjournal des Dr. William King Thomas, U.S.A." In February, 1916, the address of Dr. William King Thomas changed to Ottawa, U.S.A., and the last address in 1916 was Montreal, Canada, Berlin.

26 Mehring, *Berlin Dada*, p. 31.

27 John Willet, *The Theatre of Bertolt Brecht: a Study from Eight Aspects*, 2nd ed. (New York, 1960), pp. 68–69.

28 Walter Mehring, "Jazzband," *Das Ketzerbrevier* (Munich, 1921), p. 36;

(Berlin, 1966), p. 5; and Richard O. Boyer, "Profiles, Artist: 2. The Saddest Man in All the World," *The New Yorker*, 4 December 1943, p. 42.

also in Mehring, *Die Gedichte, Lieder und Chanson* (Berlin, 1929), pp. 105–7.

29 Walter Mehring, "If the man in the moon were a coon . . . ," *Das politische Cabaret. Chansons, Songs, Couplets* (Dresden, 1920), pp. 71–74.

30 Joachim Ringelnatz, "Daddeldus Lied an die feste Braut," *Kuttel-Daddeldu* (Munich, 1923), p. 8, quoted in Willet, *Bertolt Brecht*, p. 67.

31 Peter Panter [Kurt Tucholsky], "Oase," *Die Weltbühne*, 3 May 1923, pp. 522–23, as quoted in Istvan Deak, *Weimar Germany's Left-Wing Intellectuals: a Political History of the Weltbühne and its Circle* (Berkeley and Los Angeles, 1968), p. 88.

32 Grosz, *Ein kleines Ja*, p. 97.

33 Mehring, *Berlin Dada*, p. 28; Mehring, *Verrufene Malerei. Die Geburtsjahre der modernen Malerei* (Munich, 1965), p. 79.

34 Grosz, *Ein kleines Ja*, pp. 107–9; "Dr. William King Thomas, Krankenjournal, 1916," has a short note to Solly Falk; Hans Reimann, "Monumenta Germaniae: 4. George Grosz," *Das Tagebuch*, 4 August 1923, p. 1117.

35 This account of Grosz's relationship with Goltz comes from ibid. "Krankenjournal des Dr. William K. Thomas [1916]" includes a list of drawings and lithographs which Grosz sent to Goltz.

36 Else Lasker-Schüler, "Georg Grosz," *Neue Jugend* 1, no. 8 (Aug. 1916): 154; trans. Christopher Middleton in Michael Hamburger and Christopher Middleton, eds., *Modern German Poetry, 1912–1960* (New York, 1962), pp. 2–5. Grosz copied the poem into the "Krankenjournal of Dr. William King Thomas, Montreal, Canada, Berlin."

37 "Lied," *Aktion*, 6 November 1915, p. 572; reprinted in Paul Raabe, ed., *Ich schneide die Zeit aus. Expressionismus und Politik in Franz Pfemferts 'Aktion,' 1911–1918* (Munich, 1964), p. 235.

38 Grosz, "Gesang der Goldgräber," *Neue Jugend* 1, no. 11–12 (February–March 1917):242.

39 Bertolt Brecht, "Verschollener Ruhm der Riesenstadt New York," *Gesammelte Werke*, 20 vols. (Frankfurt am Main: Suhrkamp Verlag, 1967), 9:475–83; translated in Willet, *Bertolt Brecht*, p. 68.

40 Grosz, "Aus den Gesängen," *Neue Jugend* 1, no. 11–12 (February–March 1917):243.

41 Grosz, "Gesang an die Welt," *1918: Neue Blätter für Kunst und Dichtung* 1 (Nov. 1918):154.

42 Ibid., p. 155.

43 Grosz, "Kaffeehaus," ibid.

44 Peter Panter [Kurt Tucholsky], "Bert Brechts Hauspostille," *Die Weltbühne*, 28 February 1928, p. 334; also in Kurt Tucholsky, *Gesammelte Werke*, ed. Mary Gerold-Tucholsky and Fritz J. Raddatz, 3 vols. (Reinbek bei Hamburg, 1960–61), 2:1065.

45 Robert Breuer, "George Grosz," *Die Weltbühne*, 10 February 1921, p. 164.

CHAPTER 2: IN ANTI-WAR BERLIN

1 See Wieland Herzfelde, *John Heartfield, Leben und Werk* (Dresden, 1962), for biographical details of the two brothers. After the death of their parents, the brothers assumed the uncontroversial surname of a helpful relative.

2 Wieland Herzfelde, ed., *Der Malik-Verlag, 1916–1947* (Exhibition catalogue, Dec. 1966–Jan. 1967, Deutsche Akademie der Künste zu Berlin [DDR]), p. 8; Herzfelde, "John Heartfield, George Grosz und die Zwanziger Jahre" (Typescript of a speech, George Grosz Estate), pp. 4–5.

3 Herzfelde, *John Heartfield*, pp. 17–18. For the controversy over the development of the photomontage technique, see Hans Richter, *Dada: Art and Anti-Art* (London, 1965), pp. 114–18.

4 For Herzfelde's accounts of the history of the Malik Verlag, see Herzfelde, ed., *Malik-Verlag*, pp. 5–70; Herzfelde, *John Heartfield, passim*; and Herzfelde, "Zur Malik-Bibliographie," *Marginalien: Blätter der Pirckheimer Gesellschaft*, no. 15 (Aug. 1964), pp. 4–32.

5 Herzfelde, ed., *Malik-Verlag*, pp. 15–16; Herzfelde, "Zur Malik-Bibliographie," p. 5.

6 Grosz, "Mondnacht," *Neue Jugend* 1, no. 9 (Sept. 1916):183–84.

7 The name "Malik" came from the title and hero of the novel, *Der Malik*, which was published in serial form by the journals *Der Brenner*, *Die Aktion*, and, after July, 1916, *Neue Jugend*. In his request for a permit to publish, John Heartfield indicated that Malik was a Turkish prince, whose popularization would help the war effort. The permit was granted. Herzfelde sold the publication rights of Lasker-Schüler's novel to the Paul Cassirer Verlag in order to finance the *Kleine Grosz Mappe*. Herzfelde, "Zur Malik-Bibliographie," p. 9.

8 Richard Huelsenbeck, Max Herrmann, and Cläre Öhring were also listed as contributors, Herzfelde, *Malik-Verlag*, p. 73.

9 *Almanach der Neuen Jugend auf das Jahr 1917* (Berlin, n.d.), back cover.

10 See Grosz, *Ein kleines Ja und ein grosses Nein. Sein Leben von ihm selbst erzählt* (Hamburg, 1955), pp. 134–42, for a delightful story about the evening which the dadaists spent with Dr. Stadelmann.

11 Herzfelde, *Malik-Verlag*, p. 16.

12 Sketchbook labeled: "Grosz, Mannheim, September 1917–Juli 1918."

13 Harry Graf Kessler, "Kriegstagebücher" (Schiller Nationalmuseum, Marbach), quoted in Herzfelde, "John Heartfield, George Grosz und die Zwanziger Jahre," p. 10.

14 Herzfelde, *John Heartfield*, pp. 19–20.

15 Grosz, "Lebenslauf; Notizen für Prozess," December 3, 1930 (Typescript, Grosz Estate), p. 2; *Der Spiesser-Spiegel* (Dresden, 1925), p. 9; "Moja Žizn [My life]," *Prožektor* (Moscow) 6, no. 14 (April 1, 1928):17.

16 Richard O. Boyer, "Profiles, Artist: 2. The Saddest Man in All the World," *The New Yorker*, 4 December 1943, pp. 43–44; Grosz, *Ein kleines Ja*, pp. 109–114.

17 Letter to the author, 13 August 1970, from Krankenbuchlager, Berlin.

18 Oskar Maria Graf, *Prisoners All*, trans. Margaret Green (New York, 1943), pp. 157–61; this account was originally published as *Wir sind Gefangene* (Munich, 1927).

19 Wieland Herzfelde, *Unterwegs. Blätter aus fünfzig Jahren* (Berlin, 1961), pp. 93, 134; Herzfelde, *John Heartfield*, p. 16.

20 Grosz, "Lebenslauf," p. 2 (ellipses in the original).

21 Richard Huelsenbeck, "En avant Dada; a History of Dadaism," trans. Ralph Manheim in Robert Motherwell, ed., *The Dada Painters and Poets: an Anthology* (New York, 1951), p. 44.

22 Grosz, "Abwicklung," *Das Kunstblatt* 8, no. 2 (Feb. 1924):37.

23 Ibid.

24 Richter, *Dada*, p. 102; Richard Huelsenbeck, "Erinnerung an George Grosz," *Neue Zürcher Zeitung*, 14 July 1959, as reprinted in Huelsenbeck, *Phantastische Gebete* (Zurich, 1960), pp. 85–87.

25 Erwin Piscator, *George Grosz, 1893–1959* (Exhibition catalogue, Oct. 7– Dec. 30, 1962, Akademie der Künste, Berlin) [statement on Grosz], p. 7.

26 The history of dada is marked by inconsistencies, confusions, and controversies. No two dadaists seem to be able to agree about the events in which they participated. To have kept a record of their activities would have been undadaistic. The spontaneous, iconoclastic, and often uproarious events of dada could easily assume legendary or mythical proportions. Ideological considerations have heightened the controversies between former dadaists over what actually happened. Wieland Herzfelde, for example, believes that dada chroniclers are guilty of blowing up events in order to give dadaism a stature which it did not have. He points to the story, reported by Hugnet and often repeated, that at the end of the war "Herzfelde could be seen in the streets wearing his uniform as an active protest against war: in order to 'dishonor the uniform,' he wore a particularly disgusting one, and, on the pretext of a skin disease, he shaved only one cheek." (Georges Hugnet, "The Dada Spirit in Painting," trans. Ralph Manheim, in *The Dada Painters*, p. 153). In actuality, Herzfelde says that on *one* day only he went to the Romanische Café and surprised his friends with a half-shaven beard. He had been ill for several weeks and when he was able to shave again, he thought his half-shaven face was funny enough to share with his friends. Similarly, Herzfelde objects to the description in the text of Grosz's appearance and behavior. Grosz, he says, never wore military clothes, frock coat, cardboard Iron Cross, or monocle. The death's head, he says, was made for a masked ball in the winter of 1915–16 and Herzfelde, not Grosz, wore it *once* on the Kurfürstendamm. Furthermore, Herzfelde claims that Grosz never acted the role of a Prussian General and was insulting and aggressive in public only when he was drunk. (Herzfelde, comments on the manuscript.) Herzfelde, however, was at the front from late 1917 to mid-1918. The text is based on Grosz's own description of what he did while a dadaist; see the interview reported in Boyer, "Profiles," pp. 46–48. For other accounts of the dadaists' behavior

in Berlin, see Richter, *Dada*, pp. 101–135; Walter Mehring, *Berlin Dada: eine Chronik mit Photos und Dokumenten* (Zurich, 1959); Grosz, *Ein kleines Ja*, pp. 129–34; William S. Rubin, *Dada, Surrealism, and their Heritage* (Greenwich, Conn., 1968), pp. 42–46. See also Hans Arp, Richard Huelsenbeck, and Tristan Tzara, *Als Dada begann: Bildchronik und Erinnerungen der Gründer*, ed. Peter Schifferli (Zurich, 1957); Richard Huelsenbeck, ed., *Dada. Eine literarische Dokumentation* (Reinbek bei Hamburg, 1964); Willy Verkauf, Marcel Janco, and Hans Bolliger, eds., *Dada: Monograph of a Movement*, Visual Communication Books, 2nd ed. (New York, 1961). For a thoughtful discussion of dadaism's challenge to social and political values in post-war Germany, see Allan C. Greenberg, "Artists and the Weimar Republic: Dada and the Bauhaus, 1917–1925" (Ph.D. dissertation, Univ. of Illinois, 1967).

27 The records about these dada meetings are characteristically dada — or confusing. Mehring describes this meeting, but says only that it took place in the spring of 1918, Mehring, *Berlin Dada*, pp. 47–48. He does not indicate whether his description applies to the first or the second of two meetings held in the spring in the Neumann gallery. Motherwell, ed., *The Dada Painters*, p. 364, and Richter, *Dada*, p. 102, report on an evening in February in the Neumann gallery in which Huelsenbeck delivered his "First Dada Speech in Germany." J. B. Neumann commented in 1950: "The gallery was completely wrecked by the audience." Huelsenbeck reprints the speech which he gave on Feb. 18, 1918, in the Galerie Neumann in *Dada. Eine literarische Dokumentation*, p. 30.

28 Richard Huelsenbeck, "Dadaistisches Manifest, Berlin, 1918," trans. Ralph Manheim and reprinted as "Collective Dada Manifesto," *The Dada Painters*, p. 242. Motherwell dates the manifesto as 1920, but Huelsenbeck, *Dada. Eine literarische Dokumentation*, p. 267, definitely identifies the manifesto as the one which he pronounced at the Dada Soirée in April, 1918. Richter, *Dada*, pp. 104–7, reprints the English translation, reproduces the original German form, and concurs in the 1918 date.

29 Huelsenbeck, "En avant Dada," pp. 39–40.

30 "Collective Dada Manifesto," *The Dada Painters*, p. 30.

31 Erwin Piscator, *Das politische Theater*, rev. ed. (Reinbek bei Hamburg, 1963), p. 37.

32 Richter, *Dada*, p. 129; Mehring, *Berlin Dada*, pp. 46–52; Huelsenbeck, "En avant Dada," pp. 45–47. See Ben Hecht, "About Grosz," *Letters from Bohemia* (Garden City, N.Y., 1964), pp. 142–44, for a lively account of a dada evening. Herzfelde, "John Heartfield, George Grosz und die Zwanziger Jahre," pp. 12–14, tells of a February, 1919, matinée in which buffoonery barely masked antagonism between Huelsenbeck and the rest.

33 Mehring, *Berlin Dada*, pp. 50–52. Mehring in this account also includes further details from the matinées in the Tribune in December, 1919. Memories of the race between the typewriter and the sewing machine vary — predictably. Grosz remembered it as six machines of each kind. Herzfelde recalls an anti-war meeting sponsored by Malik Verlag in the

summer of 1917 where the sewing machine sewed an endless band of mourning crepe symbolizing the endless production of war victims while the typewriter symbolized the vain fight to create war enthusiasm. (Herzfelde, comments on the manuscript.)

34 Hugnet, "The Dada Spirit in Painting," *The Dada Painters*, pp. 147–48; origina..y published in Paris in *Cahiers d'Art* 7, 9 (1932, 1934).

35 Huelsenbeck, "En avant Dada," pp. 45–47.

36 Richter, *Dada*, p. 109.

37 Raoul Hausmann, "Der deutsche Spiesser ärgert sich," "Reklame für much," "Was ist dada?" *Der Dada*, no. 2 [1919], pp. 2, 6–8, 7. For accounts of Baader and the National Assembly, see Richter, *Dada*, pp. 126–27, and Mehring, *Berlin Dada*, pp. 54–60.

38 Grosz, "Dada Plakat" ([Berlin], n.d.), private collection of Frau Clare Jung, East Berlin, as quoted in and translated by Greenberg, "Artists and the Weimar Republic," p. 80.

39 Huelsenbeck, "Erinnerung an George Grosz," pp. 85–86.

40 Grosz and Wieland Herzfelde, *Die Kunst ist in Gefahr*, Malik Bücherei, vol. 3 (Berlin, 1925), p. 24.

CHAPTER 3: SPARTACIST PAMPHLETEER

1 Wieland Herzfelde, *John Heartfield, Leben und Werk* (Dresden, 1962), pp. 20–21.

2 Grosz and Wieland Herzfelde, *Die Kunst ist in Gefahr*, Malik Bücherei, vol. 3 (Berlin, 1925), pp. 21–22.

3 For the events of the revolution and for analyses of the aims of the factions within the socialist ranks, see: Werner T. Angress, *Stillborn Revolution: the Communist Bid for Power in Germany, 1921–1923* (Princeton, N.J., 1963); A. J. Ryder, *The German Revolution of 1918: a Study of German Socialism in War and Revolt* (Cambridge, Eng., 1967); and Eric Waldman, *The Spartacist Uprising of 1919 and the Crisis of the German Socialist Movement: a Study of the Relation of Political Theory and Party Practice* (Milwaukee, 1958).

4 Sozialdemokratische Partei Deutschlands or SPD (German Social Democratic Party); Unabhängige Sozialdemokratische Partei Deutschlands or USPD (Independent Social Democratic Party of Germany); Kommunistische Partei Deutschlands or KPD (German Communist Party).

5 Grosz, "Moja Žizn [My life]," *Prožektor* (Moscow) 6, no. 14 (April 1, 1928):18.

6 David Mitchell, *1919: Red Mirage* (London, 1970), *passim*.

7 Grosz, "Moja Žizn," p. 18.

8 For the founding conference of the KPD and membership statistics, see Waldman, *The Spartacist Uprising*, pp. 149–58, and Ryder, *The German Revolution*, pp. 193–99.

9 Wieland Herzfelde, "John Heartfield und George Grosz: zum 75. Ge-

burtstag meines Bruders," *Die Weltbühne*, 15 June 1966, p. 747. Grosz verified the fact that he had been a member of the KPD in Grosz, "Answer to FBI Questionnaire Number II, As sent to Mr. Alfred McCormack, 15 Broadway, N.Y. [May 7, 1955]" (Typescript in the George Grosz Estate).

10 Richard O. Boyer, "Profiles, Artist: 3. The Yankee from Berlin," *The New Yorker*, 11 December 1943, p. 38.

11 Mitchell, *1919*, pp. 107–8; Robert G. L. Waite, *Vanguard of Nazism: the Free Corps Movement in Postwar Germany, 1918–1923* (Cambridge, Mass., 1952), pp. 58–64.

12 A. J. P. Taylor, *The Course of German History* (London, 1945), p. 183.

13 Herzfelde, *John Heartfield*, pp. 20–21.

14 Harry Graf Kessler, 18 January 1919, *Aus den Tagebüchern, 1918–1937*, ed. Wolfgang Pfeiffer-Belli (Munich, 1965), p. 47.

15 Ibid., 28 January 1919, pp. 50–51.

16 Cover reproduced in Willy Verkauf, Marcel Janco, and Hans Bolliger, eds., *Dada: Monograph of a Movement*, Visual Communication Books, 2nd ed. (New York, 1961), p. 105, and Herzfelde, *Malik-Verlag*, p. 140.

17 Walter Mehring, *Berlin Dada: eine Chronik mit Photos und Dokumenten* (Zurich, 1959), pp. 67–70; Wieland Herzfelde, ed., *Der Malik-Verlag, 1916–1947* (Exhibition catalogue, Dec. 1966–Jan. 1967, Deutsche Akademie der Künste zu Berlin [DDR]), p. 24; and Herzfelde, *John Heartfield*, p. 23, and comments on the manuscript.

18 The first number of *Die Pleite* listed no editors or date. It can be dated from Kessler's report that Herzfelde brought the second number of the journal, *Jedermann*, now called *Die Pleite*, to him on March 5, 1919. Kessler was delighted by Grosz's caricature of Ebert on the cover, 5 March 1919, *Aus den Tagebüchern*, p. 67.

19 "Zum ersten Kongress der Kommunistischen Internationale," *Die Pleite* 1, no. 1 (1919):3. See Jane Degras, ed., *The Communist International, 1919–1943: Documents*, vol. 1, *1919–1922* (London, 1956), pp. 1–5, for the text of the invitation, and James W. Hulse, *The Forming of the Communist International* (Stanford, Calif., 1964), chap. 1, for details of the broadcast of the invitation. The printing in *Die Pleite* did not include the list of thirty-nine parties to whom the invitation was addressed or the final section dealing with the organization and name of the new International.

20 "Pleite glotzt euch an restlos," *Die Pleite* 1, no. 1 (1919):2.

21 Grosz, "Moja Žizn," p. 18.

22 Waite, *Vanguard of Nazism*, pp. 68–79; Mitchell, *1919*, pp. 169.

23 See Herzfelde, *Schutzhaft, Erlebnisse vom 7. bis 20. März 1919 bei den Berliner Ordnungstruppen* (Berlin-Halensee, 1919), for his account of his arrest and imprisonment. For the Lichtenberg massacre, see Waite, *Vanguard of Nazism*, pp. 72–74.

24 Kessler, 21–24 March 1919, *Aus den Tagebüchern*, pp. 74–75; Herzfelde, comments on the manuscript.

25 Mehring, *Berlin Dada*, pp. 65–66.

26 Kessler, 14, 16 March 1919, *Aus den Tagebüchern*, pp. 72–73.

27 Ignaz Wrobel [Tucholsky], "Fratzen von Grosz," *Die Weltbühne*, 18 August 1921, p. 184. Also in Kurt Tucholsky, *Gesammelte Werke*, 3 vols. ed. Mary Gerold-Tucholsky and Fritz J. Raddatz (Reinbek bei Hamburg, 1960–61), 1:816.

28 The exact date of the creation of both works is uncertain. Brecht is said to have written his ballad in 1918 while he was in the army, where it became very popular with the enlisted men (Harry T. Moore, *Twentieth Century German Literature* [New York, 1967], p. 37). Grosz's drawing is generally dated from its 1919 publication, but it may well have been done in the last years of the war. The drawing was published in Berlin in *Die Pleite*, which probably did reach Munich, where Brecht was living at the time. Brecht's ballad reached the public with the performance of his *Trommeln in der Nacht* in 1922 in Munich, when it was featured between the acts of the play, but it was not published until 1927 in the *Hauspostille* (Brecht, *Die Hauspostille: Manual of Piety*, a bilingual ed. with English text by Eric Bentley and notes by Hugo Schmidt [New York, 1966], pp. 222–29). Though Brecht and Grosz did not know each other in the immediate post-war years, they did become close personal friends after Brecht moved to Berlin in 1924 and joined the Herzfelde-Heartfield-Grosz-Piscator group. They worked together on several projects in Berlin. After 1933, when both were forced to leave Germany, Grosz returned to the continent in 1935 and visited Brecht at his home in Svendborg, Denmark.

29 Marianne Kesting, *Bertolt Brecht in Selbstzeugnissen und Bilddokumenten* (Reinbek bei Hamburg, 1959), p. 14, reports that Brecht made reference to this saying when discussing his poems.

30 Kessler, 3 May 1919, *Aus den Tagebüchern*, p. 84.

31 Lieutenant Marloh was an officer in the Reinhard brigade of the Free Corps. On March 11 he carried out a Free Corps order to dissolve the unruly and revolutionary Volksmarine Division, which had formed the military backbone of the revolutionary uprisings in Berlin since November, 1918. When the sailors crowded into a building where they had been told they would receive their pay, Marloh picked twenty-nine of them at random and had them machine-gunned. Brought to trial for this offense, Marloh said he had planned to kill three hundred of the sailors. He was acquitted. Reinhard then gave him an honorary appointment in the judiciary section of the Reinhard Free Corps. Waite, *Vanguard of Nazism*, pp. 75–76. The trial of Marloh received a great amount of attention. Kessler wrote of it on Dec. 4, 1919, and characterized Marloh as a "ghastly caricature of Prussian militarism," Kessler, 4 December 1919, *Aus den Tagebüchern*, pp. 94–95.

32 Herzfelde, *Malik-Verlag*, pp. 29–31.

33 Herzfelde, "John Heartfield und George Grosz," p. 747; Herzfelde, "John

Heartfield, George Grosz und die Zwanziger Jahre" (Typescript of a speech, Grosz Estate), p. 15.

34 Kurt Tucholsky, "An George Grosz," *Ausgewählte Briefe, 1913–1935* (Reinbek bei Hamburg, 1962), pp. 166–68.

35 "Bürgers Albdruck," *Der Knüppel* 2, no. 8 (Dec. 1, 1924). On the basis of stylistic analysis, I would attribute this drawing not to Grosz, but to Rudolf Schlichter; it has a heavy maudlin quality foreign to George Grosz's work. It is, however, attributed to Grosz in the by-line below the drawing. This may have been a consciously false attribution, part of the attempt to confuse censors. Whether Grosz drew the picture or not, the fact that his name was put to the picture indicates his endorsement of the idea. He did a rather similar drawing which appeared in *Abrechnung folgt!* (1923), p. 55.

36 For analyses of the conservative judiciary in the republic, see Istvan Deak, *Weimar Germany's Left-Wing Intellectuals: a Political History of the Weltbühne and its Circle* (Berkeley and Los Angeles, 1968), chaps. 9 and 13; Alfred Apfel, *Behind the Scenes of German Justice: Reminiscences of a German Barrister, 1882–1933* (London, 1935), *passim*; and Heinrich Hannover and Elisabeth Hannover-Drück, *Politische Justiz 1918–1933* (Frankfurt am Main, 1966), *passim*. For Grosz's trials, see below, chap. 7.

37 See Deak, *Weimar Germany's Left-Wing Intellectuals*, pp. 18–29, 137–47.

38 Tucholsky, "Wir Negativen," *Die Weltbühne,* 13 March 1919, pp. 279–85, quoted and analyzed in Deak, *Weimar Germany's Left-Wing Intellectuals*, pp. 41–42.

39 On Tucholsky, see ibid., pp. 36–49; and Harold L. Poor, *Kurt Tucholsky and the Ordeal of Germany, 1914–1935* (New York, 1968).

CHAPTER 4: COMMUNIST RELATIONSHIPS

1 "Manifest der Novembristen, 1918," reprinted in Diether Schmidt, ed., *Manifeste, Manifeste, 1905–1933*, Schriften deutscher Künstler des zwanzigsten Jahrhunderts, vol. 1 (Dresden, 1965), pp. 156–57. An English translation can be found in Victor H. Miesel, ed., *Voices of German Expressionism* (Englewood Cliffs, N.J., 1970), pp. 169–70. For an analysis of the November Group, see Allan C. Greenberg, "Artists and the Weimar Republic: Dada and the Bauhaus, 1917–1925" (Ph.D. dissertation, Univ. of Illinois, 1967), pp. 38–40, 55–66. Miesel gives a brief account, as do Schmidt, and Bernard S. Myers, *The German Expressionists: a Generation in Revolt* (New York, 1957), chap. 30.

2 Wolfgang Willrich, *Säuberung des Kunsttempels. Eine kunstpolitische Kampfschrift zur Gesundung deutscher Kunst im Geiste nordischer Art* (Munich and Berlin, 1937), p. 168, includes Grosz's name in a long list of the members of the November Group which he compiled from exhibi-

tion catalogues and from Will Grohmann, *Zehn Jahre Novembergruppe* (Berlin, 1928).

3 "Richtlinien der 'Novembergruppe,' January, 1919," reprinted in Schmidt, ed., *Manifeste*, p. 159.

4 Schmidt, "Foreword," ibid., p. 27; Lothar Lang, ed., *George Grosz, Welt der Kunst* (Berlin, 1966), p. 7; and Myers, *The German Expressionists*, p. 276.

5 Franz Schoenberner, *Confessions of a European Intellectual* (New York, 1965), pp. 117–18.

6 "Offener Brief an die Novembergruppe," *Der Gegner* 2, nos. 8–9 (June 1921):297–301. For analysis of the letter, see Greenberg, "Artists and the Weimar Republic," pp. 64–65; Wieland Herzfelde, ed., *Der Malik-Verlag, 1916–1917* (Exhibition catalogue, Dec. 1966–Jan. 1967, Deutsche Akademie der Künste zu Berlin [DDR]), p. 28; and Herzfelde, "Zur Malik-Bibliographie," *Marginalien: Blätter der Pirckheimer Gesellschaft*, no. 15 (Aug. 1964), p. 17.

7 James Gillray, 1757–1815, English caricaturist. Hofmann says of Gillray's caricatures: "It was with them that caricature became for the first time the weapon of national conscience." Werner Hofmann, *Caricature from Leonardo to Picasso* (New York, 1957), p. 90.

8 Alex Keil [Ék Sándor], "Fünf Jahre Kampf um die revolutionäre bildende Kunst in Deutschland," reprinted in Schmidt, ed., *Manifeste*, pp. 414–23; originally published in *Iskusstvo* (Moscow, 1933). For a helpful summary of the Marxian philosophy of art and the communist theories of art in the twenties in both Germany and Russia, see Donald Drew Egbert, *Socialism and American Art in the Light of European Utopianism, Marxism, and Anarchism* (Princeton, N.J., 1967), pp. 16–30, 39–73.

9 For an excellent analysis of the meaning of the term *Tendenzkünstler* and its application to Grosz, see Günther Anders, *George Grosz, Die kleinen Bücher der Arche* (Zurich, 1961), pp. 24–27. Anders points out that the term has very negative overtones and has generally been used to discredit the artist's work to whom it is applied; his own conclusion is similar to that of the Marxists in the 1920s: all art is Tendenzkunst. Another thoughtful interpretation of Grosz as a Tendenzkünstler and his use of types is Erwin Petermann, "Das war verfemte Kunst: IV. George Grosz," *Aussaat, Zeitschrift für Kunst und Wissenschaft* 1, no. 3 (1946): 20–24. Petermann knew Grosz in Berlin in the early twenties.

10 Grosz and Heartfield included the full text of Kokoschka's manifesto, "An alle Einwohner von Dresden," in their article attacking Kokoschka, Grosz and John Heartfield, "Der Kunstlump," *Der Gegner* 1, nos. 10–12 (n.d.):52–53. For a reprint of portions of the manifesto and Kokoschka's comments upon it, see Edith Hoffman, *Kokoschka: his Life and Work* (London, 1947), p. 143, n. 1; the entire Grosz, Heartfield article was reprinted in *Die Aktion*, 12 June 1920, pp. 327–32.

11 Translation of this term is inadequate to contain the overtones of the words, for example, the evocation of the Holy Roman Empire.

12 Grosz and Heartfield, "Der Kunstlump," pp. 53–55.

13 Ibid., pp. 48–52, 56.

14 David Mitchell, *1919: Red Mirage* (London, 1970), pp. 71–72.

15 Grosz, "Statt einer Biographie," dated Berlin, 16 August 1920, trans. Hans Hess in *George Grosz, 1893–1959* (Arts Council Exhibition Catalogue, York, London, Bristol, Eng., 1963), p. 9.

16 Ibid., p. 10.

17 Ibid., p. 11.

18 Ibid.

19 Grosz, "Zu meinen neuen Bildern," *Das Kunstblatt* 5, no. 1 (Jan. 1921): 11. An English translation can be found in Miesel, ed., *Voices of German Expressionism*, pp. 185–88.

20 Grosz, "Zu meinen neuen Bildern," p. 14.

21 Alexander Uschakow, "Majakowski und Grosz — zwei Schicksale," *Sinn und Form* 20, no. 6 (1968):1464. The title of the article in *Lef* was "Zu meinen Arbeiten."

22 Richard O. Boyer, "Profiles, Artist: 3. The Yankee from Berlin," *The New Yorker*, 11 December 1943, p. 38.

23 Helmut Gruber, "Willi Münzenberg's German Communist Propaganda Empire," *Journal of Modern History* 38 (Sept. 1966):278–83.

24 *Helft! Russland in Not!* (Berlin: Malik Verlag, 1921). Gruber, "Willi Münzenberg," pp. 292–93, definitely attributes the pamphlet to Münzenberg, though Babette Gross does not list it in her bibliography of Münzenberg's books and brochures, Gross, *Willi Münzenberg; eine politische Biographie, Schriftenreihe der Vierteljahrshefte für Zeitgeschichte,* nos. 14–15 (Stuttgart, 1967). The pamphlet is listed in Herzfelde, *Malik-Verlag,* p. 80. In a letter to the author from Berlin, 19 June 1970, Herzfelde confirmed that he had printed the three pamphlets for Münzenberg and discussed the relationship between the Münzenberg concern and the Malik Verlag.

25 *Sowjetrussland und seine Kinder* (Malik Verlag, 1921), and Leon Trotsky, *Das hungernde Russland und das "satte" Europa, Rede in der Vollversammlung des Moskauer Sowjets am 30. August 1921* (Malik Verlag, 1921).

26 Gross, *Willi Münzenberg,* p. 129.

27 Gruber, "Willi Münzenberg," p. 284, also lists Clara Zetkin, Käthe Kollwitz, Arthur Holitscher, Max Barthel, Henriette Roland-Holst.

28 Ibid., p. 285. See the book which Grosz illustrated for Martin Andersen-Nexö in 1921.

29 *Der Gegner* (1921), p. 415; full-page advertisement reproduced in Schmidt, ed., *Manifeste,* p. 269. The title of the committee was Komitee Künstlerhilfe für die Hungernden in Russland.

30 Ibid., p. 458.

31 Werner T. Angress, *Stillborn Revolution: the Communist Bid for Power in Germany, 1921–1923* (Princeton, N.J., 1963), p. 346. The German title was Bund der Freunde der Internationalen Arbeiterhilfe.

32 Gruber, "Willi Münzenberg," p. 286.

33 "An alle Künstler und geistig Schaffenden!" reprinted in Schmidt, ed., *Manifeste*, pp. 327–28.

34 "Aufruf von Intellektuellen vom 5. März 1926 für die Enteignung der Fürsten," reprinted ibid., pp. 367–68. Among those who signed the call were Albert Einstein, Eduard Fuchs, Kurt Hiller, Siegfried Jacobsohn, Alfred Kerr, Käthe Kollwitz, Paul Löbe, Max Pechstein, Erwin Piscator, Heinrich Zille, and Max Barthel. For a description of the campaign, see Istvan Deak, *Weimar Germany's Left-Wing Intellectuals: a Political History of the Weltbühne and its Circle* (Berkeley and Los Angeles, 1968), pp. 159–60.

35 Wieland Herzfelde to author, Berlin, 19 June 1970; Gruber, "Willi Münzenberg," p. 283.

36 Deak, *Weimar Germany's Left-Wing Intellectuals*, p. 162.

37 Wieland Herzfelde to author, Berlin, 19 June 1970.

38 Grosz, "Der Mensch ist nicht gut — sondern ein Vieh!" (Exhibition catalogue, April, 1922, Galerie von Garvens, Hanover).

39 Gross, *Willi Münzenberg*, p. 155.

40 Grosz, "Russlandreise, 1922," *Ein kleines Ja und ein grosses Nein* (Hamburg, 1955), chap. XI, p. 160. In this chapter of his autobiography, Grosz stated that the purpose of the trip was to illustrate the book which Nexö was to write, though he does not mention IAH or Münzenberg. He also outlined the reasons for and the difficulties of the trip through the Vardö-Murmansk route. Herzfelde, who for ideological reasons claims the autobiography is not at all reliable, questions the accuracy of Grosz's account. He says that Grosz was invited by the Russian consul in Berlin to present in Russia an exhibit of his graphic work, which was never held because the drawings were lost in transit. Herzfelde further insists that he had never heard about a book planned with Nexö. Finally, Herzfelde believes the impressions of the Soviet Union which Grosz expressed represented not his feelings during the trip, but feelings which he considered to be suitable and necessary in post-World War II America. (Herzfelde, comments on the manuscript.) This last argument against the reliability of Grosz's account of the trip is weakened by the fact that Grosz did not publish this chapter in the 1946 American autobiography; hence, he did not need to please an anti-communist American audience. He waited until 1953 to present it in a German periodical and then included it in the 1955 German autobiography. Peter Grosz has stated that Grosz hesitated about printing this chapter because he did not want to hurt his friends, who he knew would find the attitudes expressed in it to be unpleasant.

41 Ibid., p. 169.

42 Ibid., pp. 169–70.

43 Ibid., pp. 173–76. For further discussion of the proletcult, see Edward J. Brown, *The Proletarian Episode in Russian Literature, 1928–1932* (New York, 1953), pp. 6–10, and *infra* pp. 192–96.

44 Grosz, *Ein kleines Ja*, pp. 172–73.

45 Ibid., p. 176.

46 Walter Mehring, *Berlin Dada: eine Chronik mit Photos und Dokumenten* (Zurich, 1959), pp. 85–86; English translation in Hans Richter, *Dada: Art and Anti-Art* (London, 1965), p. 113; ellipses are in the original.

47 Uschakow, "Majakowski und Grosz," pp. 1460–65.

48 Angress, *Stillborn Revolution*, pp. 293–99.

49 Deak, *Weimar Germany's Left-Wing Intellectuals*, p. 90.

50 Jacques Sadoul, "Un peintre de la lutte de classe: Georges Gross" (Unidentified newspaper clipping in George Grosz Estate). This article on Grosz in what appears to be a French communist newspaper gives the full text of the letters to Grosz's editor and from Grosz. The letters are dated. For an account of the March, 1921, uprising to which Grosz refers, see Angress, *Stillborn Revolution*, chap. V. The Leuna Works, a large chemical industrial complex in Prussian Saxony, was occupied by the proletarian rebels and became a symbol of the revolutionary cause.

51 Ibid., p. 299.

52 Grosz, *Ein kleines Ja*, p. 180.

53 Grosz to Wieland Herzfelde, New York, 3 June 1933 (Typescript in Grosz Estate), p. 7.

54 Jean Bernier, "Nos interviews: une heure avec Georg Grosz," *L'Humanité*, 20 May 1924.

55 Grosz, "Kurzer Abriss," *Situation 1924: Künstlerische und kulturelle Manifestationen* (Ulm, 1924), pp. 22–24.

56 Grosz, "Abwicklung," *Das Kunstblatt 8*, no. 2 (Feb. 1924):38. This essay also appeared in *G: Material zur elementaren Gestaltung*, no. 3 (June 1924), pp. 39–41.

57 "Kommunistische Künstlergruppe," *Die Rote Fahne*, no. 57 (1924), reprinted in Schmidt, ed., *Manifeste*, pp. 318–19. The manifesto was dated June 13, 1924.

58 For a detailed analysis of these developments within the German Communist party, see Angress, *Stillborn Revolution*, pp. 460–74.

59 *Die Rosarote Brille, Satirische Wahlschrift der KPD* (Fall, 1924). The format of this paper was the same as *Der Knüppel*. It is probable that this was a supplement to or a substitute for an issue of *Der Knüppel*.

60 Schmidt, ed., *Manifeste*, pp. 373–75. The telegram, dated 4 April 1927, was signed on behalf of the Kommunistische Fraktion des Reichsverbandes bildender Künstler Deutschlands by Heinrich Vogeler, Otto Nagel, Rudolf Schlichter, George Grosz, and Franz Gehrig-Targis.

61 Grosz and Herzfelde, *Die Kunst ist in Gefahr*, Malik Bücherei, vol. 3 (Berlin, 1925), pp. 24–26. See the Check List for details of the composition of this essay.

62 Ibid., pp. 8–13.

63 Ibid., p. 32.

64 Ibid., pp. 10, 26, 33–38.

65 Uschakow, "Majakowski und Grosz," pp. 1466–68.

CHAPTER 5: BOOKS AND PORTFOLIOS

1 E. H. Gombrich and Ernst Kris, *Caricature* (Harmondsworth, Middlesex, Eng., 1940), p. 15. For studies of caricature, see Werner Hofmann, *Caricature from Leonardo to Picasso* (New York, 1957); Ernst Kris, *Psychoanalytic Explorations in Art* (New York, 1964), pp. 173–203; E. H. Gombrich, *Meditations on a Hobby Horse and Other Essays on the Theory of Art* (London, 1963) and Gombrich, *Art and Illusion: A Study in the Psychology of Pictorial Representation* (New York, 1961).

2 Willi Wolfradt, "George Grosz," *Jahrbuch der Jungen Kunst* 2 (1921):98.

3 Wieland Herzfelde, ed., *Der Malik-Verlag, 1916–1947* (Exhibition catalogue, Dec. 1966–Jan. 1967, Deutsche Akademie der Künste zu Berlin [DDR]). The catalogue includes a history of the books published by Herzfelde, pp. 5–70, and a detailed bibliography of the books published by the press, prepared by Heinz Gittig and Herzfelde, pp. 71–136. The catalogue is profusely illustrated.

4 Ibid., p. 33.

5 Frida Rubiner, "Foreword," in Peter Schnur, *Die Hütte, Zehn Erzählungen* (Berlin, 1923), pp. 7–8.

6 Ilya Ehrenburg, *Memoirs: 1921–1941*, trans. Tatania Shebunina and Yvonne Kapp (New York, 1966), p. 124.

7 Jürgen Rühle, *Literature and Revolution: A Critical Study of the Writer and Communism in the Twentieth Century*, trans. and ed. Jean Steinberg (New York, 1969), p. 16.

8 For details on these and other series — Unten und Oben, 1922–23; Die Märchen der Armen, 1923–24; Wissenschaft und Gesellschaft, 1924; the Malik Bücherei, 1924–26 — see Herzfelde, *Malik-Verlag*, pp. 33, 34, 74.

9 Ibid., p. 36, and Herzfelde, "Zur Malik-Bibliographie," *Marginalien: Blätter der Pirckheimer Gesellschaft*, no. 15 (Aug. 1964), p. 20.

10 E. J. Gumbel, *Verschwörer, Beiträge zur Geschichte der deutschen nationalsozialistischen Geheimbünde seit 1918* (Vienna, 1924).

11 Herzfelde, who recounted this incident, did not specify which *völkisch* group was involved. Herzfelde, *John Heartfield, Leben und Werk* (Dresden, 1962), p. 26.

12 E. J. Gumbel, *Verräter verfallen der Feme! Opfer, Mörder, Richter, 1919–1929* (Berlin, 1929). A drawing with the same title as this book appeared in Grosz, *Die Gezeichneten* (Berlin, 1930), p. 105. The other Gumbel books which Malik published were *Vier Jahre politischer Mord, Statistik und Darstellung der politischen Morde in Deutschland von 1919 bis 1922* (Berlin, 1922) and *Denkschrift des Reichsjustizministers zu "Vier Jahre politischer Mord"* (Berlin, 1924). For a recent excellent study of political murders in the republic, see Heinrich Hannover and Elisabeth

Hannover-Druck, *Politische Justiz 1918–1933* (Frankfurt am Main, 1966), pp. 1–175.

13 Ernst Fischer, *The Necessity of Art: a Marxist Approach*, trans., Anna Bostock (Baltimore, Md., 1963), pp. 69–70, asserts that "art for art's sake" is nothing more than a mask for the fact that art is produced for profit under the capitalist system.

14 On the Kapp putsch and the Ruhr uprising of 1920, see Robert G. L. Waite, *Vanguard of Nazism: The Free Corps Movement in Postwar Germany, 1918–1923* (Cambridge, Mass., 1952), chaps. 6 and 7; Werner T. Angress, *Stillborn Revolution: The Communist Bid for Power in Germany, 1921–1923* (Princeton, N.J., 1963), pp. 45–46; and A. J. Ryder, *The German Revolution of 1918: A Study of German Socialism in War and Revolt* (Cambridge, Eng., 1967), pp. 237–44.

15 Waite, *Vanguard of Nazism*, p. 182.

16 Ignaz Wrobel [Tucholsky], "Fratzen von Grosz," *Die Weltbühne*, 18 August 1921, p. 184. Also in Kurt Tucholsky, *Gesammelte Werke*, ed., Mary Gerold-Tucholsky and Fritz J. Raddatz, 3 vols. (Reinbek bei Hamburg, 1960–61), 1:816.

17 Herzfelde, interview, 19 July 1967 and letter to the author, 5 September 1968.

18 Wrobel, "Fratzen von Grosz," p. 184.

19 Günther Anders, *George Grosz*, Die kleinen Bücher der Arche (Zurich, 1961), p. 23.

20 The figures in the photomontage represented Erich Koch, Gustav Bauer, Adolf Köster, Hermann Müller, Ehrhardt, Ebert, Otto Gessler, General Baron von Watter, Carl Severing.

21 Malik Verlag published thirty of Sinclair's books, as well as a five-volume edition of his major works. The editions were all fairly large: *Oil* went to 125,000 copies, *Boston* to 75,000. See Herzfelde, *Malik-Verlag*, Bibliography.

22 Willi Schuster, *Der Dank des Vaterlandes* (Leipzig/Berlin, 1921), p. 15. See p. 83.

23 Erwin Piscator, *Das politische Theater*, rev. ed. (Reinbek bei Hamburg, 1963), pp. 89–90.

24 Herzfelde, *John Heartfield*, p. 20. On p. 312, Herzfelde also quoted Louis Aragon's biography of Heartfield, which says: "Es ist bekannt [It is well known] . . ." that the German proletariat took the gesture from a KPD photomontage poster by Johnny Heartfield on which a lifted fist was shown.

25 Oskar Kanehl, *Steh auf, Prolet! Gedichte*, Kleine revolutionäre Bibliothek, vol. 12, 2nd rev. ed. (Berlin-Halensee, 1922), p. 8.

26 Ibid., p. 28.

27 Ibid., p. 32.

28 Paul Mochmann, "Das gezeichnete Pamphlet," *Die Glocke*, 6 March 1922, pp. 1380–85.

29 Rosa Luxemburg, *Ausgewählte Reden und Schriften*, 2 vols. (Berlin,

CHAPTER 6: PARTICIPATION AND PESSIMISM

1 Werner T. Angress, *Stillborn Revolution: the Communist Bid for Power in Germany, 1921–1923* (Princeton, N.J., 1963), pp. 472–78. See also Franz Brokenau, *World Communism: a History of the Communist International* (Ann Arbor, Mich., 1962), *passim*.

2 Herzfelde, letter to the author, 19 June 1970.

3 Grosz, "Peter, 1927, Marseille, Cassis," inscribed: "Meiner lieben Frau, Weihnachten, 1929." (Now in the possession of Peter M. Grosz.)

4 Quoted in Werner Haftmann, *Painting in the Twentieth Century*, vol. 1, *An Analysis of the Artists and Their Works* (New York, 1965), p. 222. See also Peter Selz, *Max Beckmann* (Garden City, N.Y., 1964), pp. 37–39; Selz, *German Expressionist Painting* (Berkeley, 1957), pp. 315–16; Lothar-Günther Buchheim, *The Graphic Art of German Expressionism* (New York, 1960), pp. 55–58; Bernard S. Myers, *The German Expressionists: a Generation in Revolt* (New York, 1957), pp. 280–93.

5 Grosz, "Ein neuer Naturalismus?? Eine Rundfrage des Kunstblatts," *Das Kunstblatt* 6, no. 9 (Sept. 1922):382–83.

6 Franz Roh, *"Entartete" Kunst: Kunstbarbarei im Dritten Reich* (Hannover, 1962), p. 212, lists the portrait among those confiscated from the Mannheim Kunsthalle. Paul Ortwin Rave, *Kunst Diktatur im Dritten Reich* (Hamburg, 1949), p. 79, lists the portrait among those in the Munich "Entartete Kunst" exhibition in 1937.

7 Herzfelde, "Briefe an TB: Wandlung des George Grosz," *Das Tagebuch* (Vienna), 25 February 1956, p. 8.

8 Grosz, *Ein kleines Ja und ein grosses Nein* (Hamburg, 1955), pp. 188–93.

9 Ibid., p. 187.

10 Ibid., pp. 187–88.

11 Ibid., pp. 146–50.

12 Ibid., pp. 150–52; and Grosz, *A Little Yes and a Big No: the Autobiography of George Grosz*, trans., Lola Sachs Dorin (New York, 1946),

1951), 2:561, as quoted in J. P. Nettl, *Rosa Luxemburg*, 2 vols. (London, 1966), 2:614.

30 For one such viewpoint, see Thomas Craven, *Modern Art: The Men, the Movements, the Meaning* (New York, 1934), pp. 212–14.

31 Marc Neven, "Das Phänomen George Grosz," *George Grosz Ausstellung*, Veröffentlichungen des Kunst-Archivs, no. 1 (Exhibition catalogue, March 29–April 24, 1926, Galerie Alfred Flechtheim, Berlin), pp. 13–15. Marcel Ray, *George Grosz, Peintres et Sculpteurs* (Paris, 1927), p. 38, also interprets Grosz in terms of the zealous, iconoclastic, and ascetic Protestant.

32 Fischer, *The Necessity of Art*, pp. 90–91, analyzes the concept of alienation and dehumanization of man in the Marxist theory of art.

33 Alfred Salmony, "George Grosz," *Das Kunstblatt* 4, no. 4 (April 1920): 97.

chap. 15. For Max Hölz's revolutionary actions, see Angress, *Stillborn Revolution*, pp. 146–51; for his trial, see Heinrich Hannover and Elisabeth Hannover-Drück, *Politische Justiz 1918–1933* (Frankfurt am Main, 1966), pp. 216–19.

13 Grosz, ledger book; no signature or title in the book; inscription on fly leaf: "Arbeiten und nicht verzweifeln!" Entries are erratic and not always in chronological order. There are a scattering of notes from 1920 to 1922, but most of the entries begin in 1925 and continue to 1937. (In the possession of the George Grosz Estate.)

14 Grosz, "Paul Whiteman spielt in Berlin: Text und Zeichnungen von George Grosz," *Das Illustrierte Blatt*, no. 28 [1926?], p. 613; "Provençalische Stierspiele: Zeichnungen und Text von George Grosz," ibid., no. 42 [1926?], pp. 1058–60; "Boulogne sur mer, das französische Ahlbeck," ibid., no. 31 [1926?], pp. 682–83; "Exzentrics und Clowns: Text und Zeichnungen von George Grosz," ibid. no. 40 [1926?], pp. 890–91 (clippings in Grosz Estate; no date indicated upon the clippings, but entries in the Grosz ledger book date these publications to 1926); "Schweineschlachten auf dem Lande: Zeichnungen und Text von George Grosz," ibid., no. 46 (November 19, 1931), p. 1215; "Was das Ausland nicht sieht," ibid., no. 50 (1931), p. 1299.

15 *Der Querschnitt*, 5 (1925):193, 194, 195, 197, 227, 335.

16 *Ulk*, 1930: 29 August, 12. 26 September; 3, 17, 24 October; 1931: 1 January, 19 March.

17 *Roter Pfeffer*, 1932: 15 March, 15 May, 15 April.

18 Richard West, "George Grosz, Figures for Yvan Goll's 'Methusalem,'" *Bulletin of the Cleveland Museum of Art* 55, no. 4 (April 1968):90. Though Grosz's designs were not used on stage, three of them were used to illustrate the book by Goll, *Methusalem oder Der ewige Bürger, Ein satirisches Drama, Kostüme und Bühnenausstattung G. Grosz und J. Heartfield* (Potsdam, 1922).

19 Information on Grosz's stage designs comes from his drawings in the George Grosz Estate and from Günther Rühle, *Theater für die Republik, 1917–1933. Im Spiegel der Kritik* (Frankfurt am Main, 1967), pp. 480–85, 840–48; Henning Rischbieter, ed., *Bühne und bildende Kunst im XX. Jahrhundert: Maler und Bildhauer arbeiten für das Theater*, documentation Wolfgang Storch (Velber bei Hannover, 1968), pp. 172–79, 276–77. Andrew DeShong, who is preparing at Yale a doctoral dissertation, "The Theatrical Designs of George Grosz," has checked and corrected my information.

20 Erwin Piscator, *Das politische Theater*, rev. ed. (Reinbek bei Hamburg, 1963), p. 36–37.

21 Ibid., pp. 70–76.

22 Ibid., p. 85, and plates for photographs of sets with films.

23 Ibid., pp. 180–81.

24 Ibid., pp. 190–91; see ibid., chap. 18 for the history of the *Schwejk* production.

25 Original drawings in the George Grosz Estate.

26 Grosz and Wieland Herzfelde, *Die Kunst ist in Gefahr*, Malik Bücherei, vol. 3 (Berlin, 1925), pp. 29–30.

27 Grosz, *Der Spiesser-Spiegel* (Dresden, 1925), pp. 10–12.

28 Grosz, "Answer to FBI Questionnaire Number II, As sent to Mr. Alfred McCormack, 15 Broadway, N.Y. [May 7, 1955]" (Typescript in the Grosz Estate), p. 1; Grosz to Wieland Herzfelde, New York, 3, 6 June, and 3 August 1933 (Typescript ibid.), *passim*.

29 Alex Keil [Ék Sándor], "Fünf Jahre Kampf um die revolutionäre bildende Kunst in Deutschland," reprinted in Diether Schmidt, ed., *Manifeste, Manifeste, 1905–1933, Schriften deutscher Künstler des zwanzigsten Jahrhunderts*, vol. 1 (Dresden, 1965), pp. 415–18.

30 "Manifest der ARBKD," ibid., pp. 385–87.

31 "Statuten der ARBKD," ibid., p. 388.

32 That Grosz was a member of the ARBKD rests solely upon the biographical information about Grosz given ibid., p. 474. For other artists involved in ARBKD, see ibid., pp. 467–93.

33 Ibid., pp. 28–29; for biographical information on Durus, ibid., p. 471.

34 Alfred Durus, *Rote Fahne*, 9 April 1926, 17 February 1928, quoted in Lothar Lang, ed., *George Grosz*, Welt der Kunst (Berlin, 1966), p. 11.

35 Alfred Durus [Alfred Kemeny], "Künstler des Proletariats (17): George Grosz," *Eulenspiegel* 4, no. 7 (July 1931):111.

36 Grosz, "Moja Žizn [My life]," *Prožektor* (Moscow) 6, no. 14 (April 1, 1928):18.

37 Grosz, "Answer to FBI," p. 1; ellipses are in the original typescript.

38 Hans Richter, *Dada: Art and Anti-Art* (London, 1965), p. 114.

39 Grosz, "Lebenserinnerungen," *Kunst und Künstler* 29 (Dec. 1930): 109–110.

40 Grosz, "Kunst ist vorbei, mein Lieber!" *Berliner Tageblatt*, 25 December 1931, Supplement. This is abridged.

41 Grosz, "Unter anderem ein Wort für deutsche Tradition," *Das Kunstblatt* 15, no. 3 (March 1931):79–83.

42 Ibid., p. 79.

43 Ibid., p. 84.

44 Werner Hofmann, *Caricature from Leonardo to Picasso* (New York, 1957), p. 54.

45 Grosz, "On My Drawings," *George Grosz Drawings* (New York, 1944); reprinted in Herbert Bittner, ed., *George Grosz* (New York, 1960), p. 32.

CHAPTER 7: CRITICS AND TRIALS

1 The articles by Otto Alfred Palitzsch from the *Hamburger Fremdenblatt* and R. Braungart from the *Bayerische Kurier* were reprinted in "George Grosz im Spiegel der Kritik," *Der Ararat* 1, no. 8 (July 1920):84–85.

2 Carl Einstein, "George Grosz," *Die Kunst des 20. Jahrhunderts*, Propyläen-Kunstgeschichte, vol. 16, 2nd ed. (Berlin, 1928), p. 165. The earlier essays were Carl Einstein, "George Grosz," *George Grosz Ausstellung*, Veröffentlichungen des Kunst-Archivs, no. 1 (Exhibition catalogue, March 29–April 24, 1926, Galerie Alfred Flechtheim, Berlin), pp. 3–7; and "George Grosz," in *George Grosz* (Exhibition catalogue, Dec. 1926, Kunst Kammer, Martin Wasservogel, Berlin), pp. 1–9.

3 Kurt Pinthus, "So siehst du aus!" *Das Tagebuch*, 19 November 1921, p. 1408.

4 Willi Wolfradt, "George Grosz," *Jahrbuch der Jungen Kunst 2* (1921): 98–100. The article was also published as a book: *George Grosz*, Junge Kunst, vol. 21 (Leipzig, 1921), and was printed in *Der Cicerone* 13, no. 4 (Feb. 1921):103–118.

5 Max Herrmann-Neisse, "George Grosz," *Die Neue Bücherschau* ser. 2, 4, no. 2 (1923):69.

6 Leo Zahn, "George Grosz," *Der Ararat*, Erstes Sonderheft (Katalog der 59. Ausstellung der Galerie Neue Kunst-Hans Goltz, April–May 1920, Munich), p. 1.

7 Alfred Durus [Alfred Kemeny], "Künstler des Proletariats (17): George Grosz," *Eulenspiegel* 4, no. 7 (July 1931):111.

8 Ibid. Durus quoted these words from a 1930 interview with Grosz.

9 *Der Querschnitt* (1923), p. 176, as quoted in Wolfgang Willrich, *Säuberung des Kunsttempels. Eine kunstpolitische Kampfschrift zur Gesundung deutscher Kunst im Geiste nordischer Art* (Munich and Berlin, 1937), p. 57.

10 Ibid., part II.

11 Grosz, "Jugenderinnerungen. Mit Photos und Zeichnungen aus der Jugendzeit," *Das Kunstblatt* 13, no. 7 (July 1929):197.

12 See, for example, the comments on the philistine character of the republican leadership in Harry Graf Kessler, *Aus den Tagebüchern, 1918–1937*, ed. Wolfgang Pfeiffer-Belli (Munich, 1965), pp. 65–66, 79–80.

13 Herzfelde, letter to the author, 5 September 1968.

14 A partial list of the Grosz items confiscated by the Nazis in 1937 revealed that museums in Berlin, Darmstadt, Dresden, Düsseldorf, Essen, Hamburg, Hanover, Karlsruhe, Mannheim, Munich, and Nuremberg owned major Grosz works. See Franz Roh, *"Entartete" Kunst: Kunstbarbarei im Dritten Reich* (Hanover, 1962), pp. 129–243.

Grosz's work appeared in many exhibits in Germany in the 1920s. Here is a partial list of the major Grosz exhibits before 1933:

1920

Galerie-Neue Kunst, Hans Goltz, Munich. George Grosz. April–May. Zingler's Kabinett für Kunst und Bücherfreunde, Frankfurt am Main. Grosz included in a group of modern German artists.

1921

Kestner-Gesellschaft, Hanover. George Grosz and Junge Niederländische Kunst. February–March.

1922

Galerie von Garvens, Hanover. George Grosz. April. Holland exhibit (no details of which gallery or city).

1923

Kunsthandlung Würthle, Vienna, and Galerie Alfred Flechtheim, Berlin. George Grosz. (Probable date).

1924

Galerie Alfred Flechtheim, Düsseldorf. George Grosz and Paul Klee. April.

Galerie Joseph Billiet and Co., Paris. George Grosz. November.

1925

Kunsthalle, Mannheim. "Die neue Sachlichkeit." Max Beckmann, Otto Dix, and George Grosz.

1926

Kunsthandlung Sigmund Salz, Cologne. George Grosz. January.
Galerie Alfred Flechtheim, Berlin. George Grosz. March–April.
Galerie Tannhäuser, Munich. George Grosz. June.
Kunst Kammer, Martin Wasservogel, Berlin. George Grosz. December.

1927

Galerie Alfred Flechtheim, Berlin. George Grosz oils, and Congo sculpture. February.

1928

Piscatorbühne, Berlin. Grosz oils and early political drawings hung in theater during performance of *Schwejk*.

1929

Bruno Cassirer Galerie, Berlin. George Grosz. March.

1930

Bruno Cassirer Galerie, Berlin. George Grosz. October–November.

1931

Palais des Beaux-Arts, Brussels. George Grosz. April.

15 Richard O. Boyer, "Profiles, Artist: 3. The Yankee from Berlin," *The New Yorker*, 11 December 1943, p. 39.

16 Georges Hugnet, "The Dada Spirit in Painting," trans., Ralph Manheim and reprinted in Robert Motherwell, ed., *The Dada Painters and Poets: an Anthology* (New York, 1951), p. 148; Hans Richter, *Dada: Art and Anti-Art* (London, 1965), p. 133; William S. Rubin, *Dada, Surrealism, and Their Heritage* (Greenwich, Conn., 1968), pp. 46–47; Grosz, *Ein kleines Ja und ein grosses Nein* (Hamburg, 1955), p. 132; Peter Panter [Tucholsky], "Dada," *Berliner Tageblatt*, 20 July 1920, also in *Gesammelte Werke*, 1:702–3.

17 Ignaz Wrobel [Tucholsky], "Der kleine Gessler und der grosse Grosz," *Freiheit*, 24 October 1920, also in *Gesammelte Werke*, 1:751–52.

18 For trial proceedings, see "Dada vor Gericht," *Der Ararat* 2, no. 5 (1921): 180–81, as reprinted in Diether Schmidt, ed., *Manifeste, Manifeste, 1905–1933, Schriften deutscher Künstler des zwanzigsten Jahrhunderts*, vol. 1 (Dresden, 1965), pp. 273–75.

19 Kurt Tucholsky, "Offiziere," Aug. 1920, *Gesammelte Werke*, 1:721–24, quoted in Harold L. Poor, *Kurt Tucholsky and the Ordeal of Germany, 1914–1935* (New York, 1968), pp. 121, 248–49.

20 "Dada vor Gericht," p. 275.

21 See Tucholsky's report of the trial, "Dada-Prozess," *Die Weltbühne*, 28 April 1921, p. 454, also in *Gesammelte Werke*, 1:800–4. Wieland Herzfelde's report of the trial is "Die beleidigte Reichswehr," *Der Gegner* 2, no. 7 (1920–21):271–73. For summary of the trial and commentary upon it, see *George Grosz* (Exhibition catalogue, July 3–Sept. 7, 1969, Württembergischer Kunstverein, Stuttgart), pp. 21–22.

22 Willrich, *Säuberung des Kunstempels*, pp. 65–67.

23 Paul Westheim, "Erinnerungen an George Grosz," *Die Welkunst* 32, no. 22 (Nov. 15, 1962):16.

24 Paul Mochmann, "Das gezeichnete Pamphlet," *Die Glocke*, 6 March 1922, p. 1384.

25 Ignaz Wrobel [Tucholsky], "Der Zensor geht um," *Die Weltbühne*, 25 November 1920, p. 616, also in *Gesammelte Werke*, 1:764–66. See another article by Tucholsky on censorship, Ignaz Wrobel, "Die Unzüchtigen," *Die Weltbühne*, 14 September 1922, pp. 288–90, also in *Gesammelte Werke*, 1:1057–59.

1932

E. Weyhe, New York. George Grosz. January–February.
Galerie Abels, Kölner Kunstausstellungen. George Grosz. February.
Galerie Alfred Flechtheim, Berlin. George Grosz: new works. October.
Paris (reviews refer to new Grosz exhibit, but no details as to gallery).

26 Max Herrmann-Neisse, "Der Schlag in den Bürgerspiegel," *Die Aktion*, 15 June 1923, pp. 286–90. See Istvan Deak, *Weimar Germany's Left-Wing Intellectuals: a Political History of the Weltbühne and its Circle* (Berkeley and Los Angeles, 1968), pp. 129–34, on the fight of the left-wing intellectuals for reform in sexual ethics.

27 "Unterhaltung zwischen Ohnesorge und George Grosz," *Das Tagebuch*, 23 February 1924, pp. 240–48.

28 Maximilian Harden, "Drei Fragen," *Die Literarische Welt*, 7 January 1927, p. 2, for details of the trial. *George Grosz* (Württembergischer Kunstverein, Stuttgart), pp. 23–25.

29 Grosz, "Lebenslauf; Notizen für Prozess," December 3, 1930 (Typescript in George Grosz Estate), p. 3.

30 Alfred Apfel, "Rechtspolitische Gedanken zum Prozess George Grosz," *Das Kunstblatt* 13, no. 2 (Feb. 1929):61.

31 Ansgar Skriver, *Gotteslästerung?* (Hamburg, 1962), deals with the history of the Paragraph and the resulting cases; see esp. pp. 61–82, for specific cases mentioned here.

32 Deak, *Weimar Germany's Left-Wing Intellectuals*, pp. 133–34.

33 Apfel, "Rechtspolitische Gedanken," p. 61.

34 For material on the blasphemy trials, see: Heinrich Hannover and Elisabeth Hannover-Drück, *Politische Justiz 1918–1933* (Frankfurt am Main, 1966), pp. 250–51; Skriver, *Gotteslästerung?*, pp. 83–91; Alfred Apfel, *Behind the Scenes of German Justice: Reminiscences of a German Barrister, 1882–1933* (London, 1935), chap. 7; *George Grosz* (Württembergischer Kunstverein, Stuttgart), pp. 27–39.

35 "George Grosz wird vernommen: Aus dem stenographischen Protokoll des Gotteslästerungsprozesses," *Das Tagebuch*, 22 December 1928, pp. 2210–14.

36 Ibid., p. 2215.

37 For Tucholsky's report on the verdict and his commentary, see Ignaz Wrobel, "Die Begründung," *Die Weltbühne*, 19 March 1929, pp. 435–38, also in *Gesammelte Werke*, 3:52–56. The article reprints a good portion of the judge's verdict.

38 Apfel, *German Justice*, p. 125.

39 "Das Urteil im George Grosz-Prozess," *Die Weltbühne*, 7 May 1929, pp. 708–13, has the complete text of the verdict by Landgerichtsdirektor Siegert. For a summary of Siegert's statement, see Apfel, *German Justice*, pp. 126–30.

40 Ibid., pp. 130–31.

41 Carl von Ossietzky, "George Grosz-Prozess," *Die Weltbühne*, 19 December 1962, pp. 1619–20. This article originally appeared ibid., 4 March 1930. See Skriver, *Gotteslästerung?*, pp. 55, 90, for portions of the decision of the Reichsgericht, II. Strafsenat.

42 Apfel, *German Justice*, p. 131.

43 Helmuth Schreiner, "Die Hintergründe des Grosz-Prozesses," *Zeitwende* 7, no. 1 (1931):193–201, is a strong statement of the conservative view

that Grosz's attack upon the churches was actually a screen for a funda-
mental attack upon all authority, or the first move in an attempt to de-
stroy the whole political system.

44 Ibid., p. 198; Walther G. Oschilweski, "Introduction," "Ade, Witbor";
George Grosz (Berlin-Grunewald, 1955), p. xix.

45 Grosz, "Lebenslauf," pp. 3–4. These typed notes in the Grosz Estate
were written for the December 3, 1930, trial. Ellipses in original.

46 "Der geläisterte Christus: Zweites Siegert-Urteil im Prozess George
Grosz," *Die Weltbühne*, 31 March 1931, pp. 311–16. See also Apfel,
German Justice, p. 132, and *George Grosz* (Württembergischer Kunst-
verein, Stuttgart), p. 39.

47 Apfel, *German Justice*, p. 133.

Another footnote to this trial occurred in the spring of 1931 when the
police of Nürnberg-Fürth forbade the publication of Julius Streicher's
anti-semitic yellow sheet, *Der Stürmer*, because of the use made in it of a
caricature of the crucified Christ. Grotesque figures representing the
Catholic Center, the Communist, and the Socialist parties, Jews, and free-
thinkers surrounded the cross, while a Nazi said, "Lord, they want to
betray my people, as they have betrayed you." The police ban charged that
the cartoon was blasphemous because it offensively portrayed the cruci-
fied Christ in the midst of party strife. The Supreme Court, however, de-
cided that this was not a blasphemous representation of Christ, nor an
attack upon the institution of the church, nor an offence against the re-
ligious sensitivity of people. They lifted the ban. See Hannover, *Politische
Justiz*, pp. 252–53, quoting from Procurator [Robert M. W. Kempner],
"Gotteslästerung und Kirchenbeschimpfung von links und rechts," *Die
Justiz* 6 (July 1931):552–57.

48 Grosz and Paul Westheim, "Zweigespräch über deutsche Tradi-
tion, Rundfunk Gespräch, 11 Juni 1931" (Typescript in the Grosz
Estate).

49 Westheim, "Erinnerungen an George Grosz," p. 16.

50 Skriver, *Gotteslästerung?*, p. 91, gives the text of the protest and the list
of signing organizations. This protest originally appeared in *Die Kunstauk-
tion* 4, no. 13 (March 30, 1930).

51 "Künstler gegen die Freiheit der Kunst," *Kunst der Zeit* 1, no. 9 (June
1930):205–6.

52 Hildegard Brenner, *Die Kunstpolitik des Nationalsozialismus* (Reinbek
bei Hamburg, 1963), p. 16, and Part I, *passim*. See also Barbara Miller
Lane, *Architecture and Politics in Germany, 1918–1945* (Cambridge,
Mass., 1968), pp. 149–52.

53 Paul Ortwin Rave, *Kunst Diktatur im Dritten Reich* (Hamburg, 1949),
p. 19.

54 Brenner, *Die Kunstpolitik*, pp. 37–38.

55 Rave, *Kunst Diktatur*, pp. 24–25.

56 Fritz Kaiser, ed., *Führer durch die Ausstellung Entartete Kunst* (Exhibi-
tion catalogue, Munich and all other major German cities, 1937; Berlin:

Verlag für Kultur- und Wirtschaftswerbung, n.d.), pp. 3 (*Ecce Homo*, plates 9, 21, and 26), 5 (*Ecce Homo*, Color plate XIII), and 13 ("Die Besitzkröter").

57 Rave, *Kunst Diktatur*, p. 79.

58 Brenner, *Die Kunstpolitik*, p. 110; Rave, *Kunst Diktatur*, pp. 84–86, states that "Grossstadt" and "Bildnis Walter Mehrings" were the oils which were listed for sale at the Lucerne auction; Roh, *"Entartete" Kunst*, pp. 129–243, gives a detailed list of Grosz's works which were confiscated.

59 Letter printed in Joseph Wulf, *Die bildenden Künste im Dritten Reich: eine Dokumentation* (Gütersloh, 1963), p. 49.

60 *Ein Kampf um Deutschland* (Berlin, 1933), p. 9.

61 Willrich, *Säuberung des Kunsttempels*, pp. 18, 171–72.

62 Grosz, *Ein kleines Ja*, pp. 212–18.

63 Ulrich Becher, *Der grosse Grosz und eine grosse Zeit: Rede, gehalten am 7. Oktober 1962 zur Eröffnung der grossen Grosz-Ausstellung in der Akademie der Künste, West-Berlin* (Reinbek bei Hamburg, 1962), p. 15.

64 Their sons, Peter and Martin, were left with Eva's family in Berlin until Grosz felt he was established in New York and able to bring the boys over.

65 Grosz, *Ein kleines Ja*, pp. 231, 265, and letter to Wieland Herzfelde, 3 August 1933, p. 1.

66 See the account of the Mánesverein exhibition of anti-Nazi art by John Heartfield, Grosz, and others in Prague, 1934, and the resulting crisis in Czech-German diplomatic relations, in Herzfelde, *John Heartfield, Leben und Werk* (Dresden, 1962), pp. 50–58.

67 Grosz, *Ein kleines Ja*, pp. 271–74.

68 Der Reichsführer —SS, Der Chef des Sicherheitshauptamtes, "Erfassung führender Männer der Systemzeit," Juni 1939, Geheim, No. 245 (Records of the Reich leader of the S.S. and Chief of the German Police, National Archives Microcopy No. T-175, Roll No. 451. American Historical Association. American Committee for the Study of War Documents. Washington, 1958).

EPILOGUE: THE SADDEST MAN IN EUROPE

1 Grosz, "Neue Menschen, neues Paradies. Wo man leben möchte, wenn man nach Herzenslust leben könnte: In den Rocky Mountains!" 8 *Uhr-Abendblatt der National-Zeitung*, 19 April 1930, 2nd section.

2 Ulrich Becher, *Der grosse Grosz und eine grosse Zeit* (Reinbek bei Hamburg), p. 17.

3 Grosz to Herzfelde, New York City, 3 June 1933 (not mailed), 6 June 1933 (mailed). The comment about the first letter is taken from the second letter, p. 1 (Typescripts in the George Grosz Estate).

4 Grosz to Herzfelde, 3 June 1933, p. 2.

5 Ibid., p. 5.

6 Ibid., p. 1.

7 Ibid., p. 3.

8 Grosz to Herzfelde, 6 June 1933, p. 3.

9 Grosz to Herzfelde, 3 June 1933, p. 1.

10 Grosz to Herzfelde, 6 June 1933, pp. 6–7.

11 Grosz, *Ein kleines Ja und ein grosses Nein* (Hamburg, 1955), pp. 263–68

12 Ibid., pp. 232–33.

13 Ben Hecht, "About Grosz," *Letters from Bohemia* (Garden City, N.Y., 1964), p. 148.

14 See John I. H. Baur, *George Grosz* (New York, 1954), pp. 34–50.

15 Paul Westheim, "Erinnerungen an George Grosz," *Die Weltkunst* 32, no. 22 (Nov. 15, 1962):17.

16 Baur, *George Grosz*, p. 55.

17 "Grosz: Ein grosses Nein," *Der Spiegel*, 30 June 1954, cover, p. 30.

18 Herzfelde to author, 5 September 1968.

19 Becher, *Der grosse Grosz*, p. 24; and Martin G. Buttig, "Der Tod des alten Dadaisten," *Der Monat* 12, no. 142 (July 1960):83–88.

20 News release from the *Berliner Zeitung*, 7 July 1959, quoted in Walter Mehring, *Berlin Dada: eine Chronik mit Photos und Dokumenten* (Zurich, 1959), p. 7.

21 Ibid., p. 8. The author is grateful to Todd Hanlin for his translation of the poem. Walter Mehring has supplied an alternate treatment of the last portion of the poem:

This is no dada-fancy—

or is it?

The newspaper woman
The iceman
The bricklayers
3 allegories

of an eery

BERLIN

GEORGE GROSZ

mourning around the dying

morning dawn

— trying

to get him

home

in vain

They could have been
done with . . .

by his pencil

. . . a stroke of genius — but

No other artist's hand
should be allowed
to finish
his
work like that . . .

George Grosz Check List

THIS CHECK LIST is devoted to published works by or about George Grosz. I have tried to indicate a small portion of my debt to scholars of German history and art in the notes. Many excellent studies and bibliographies on Weimar Germany are available. Among those which are particularly useful for background information for the study of Grosz are: Istvan Deak, *Weimar Germany's Left-Wing Intellectuals: A Political History of the Weltbühne and its Circle* (Berkeley and Los Angeles, 1968), contains extensive biographical appendices and a bibliography of left-wing intellectuals; Peter Gay, *Weimar Culture: The Outsider as Insider* (New York, 1968), provides a comprehensive bibliography with brief annotations; Werner T. Angress, *Stillborn Revolution: The Communist Bid for Power in Germany, 1921-1923* (Princeton, N.J., 1963), has a helpful bibliographical essay on the literature pertaining to the German Communist party before 1924.

One of the two major sources of information on Grosz is the George Grosz Estate in Princeton, New Jersey, which has, in addition to a large collection of drawings, prints, and paintings, all but one of the portfolios and books by Grosz, a substantial number of the books which Grosz illustrated, and innumerable books which have used Grosz drawings. It contains quantities of uncatalogued books, journals, and newspaper articles about Grosz, including many clippings. There are many of his sketchbooks. The material in the Estate is particularly rich for his American period, since most of the pre-1933 records were destroyed in Berlin. Grosz carefully made copies of his letters, kept notes and records in diaries, and preserved his sketches. All of those after January, 1933, are in the Estate.

The other major source is the George Grosz Archive in the Akademie der Künste in West Berlin. Its collection of books and articles on Grosz was augmented by drawings, collages, and books from Grosz's personal library. There are also files of letters and postcards which Grosz sent or received from his friends. All of this material is carefully catalogued and indexed.

There are many short bibliographies of Grosz's published work, but the only reliable critical bibliography is: Lothar Lang, "George Grosz Bibliographie," *Marginalien. Zeitschrift für Buchkunst und Bibliophilie, Pirckheimer Gesellschaft*, no. 30 (July 1968), 41 pages. After an analysis of Grosz's published work, Lang presents a carefully annotated bibliography of Grosz's books, portfolios, and the books which he illustrated. A good partial bibliography of articles by and on Grosz before 1933 can be found in *George Grosz* (Exhibition Catalogue, Württembergischer Kunstverein, Stuttgart, 1969), pp. 47–49.

For publications of the Malik Verlag, see Heinz Gittig and Wieland Herzfelde, "Bibliographie des Malik-Verlages," *Der Malik-Verlag, 1916–1947* (Exhibition Catalogue, Berlin: Aufbau Verlag for the Deutsche Akademie der Künste zu Berlin [DDR]), pp. 73–136. This bibliography followed the earlier one by Heinz Gittig, "Die Publikationen des Malik-Verlages," *Marginalien: Blätter der Pirckheimer Gesellschaft*, no. 15 (Aug. 1964), pp. 32–52.

I have not included in this bibliography the many journal articles which appeared on his American work during the 1930s and 1940s. Bibliographies of these articles can be found in John I. H. Baur, *George Grosz* (New York, 1954), pp. 65–67, and in Herbert Bittner, ed., *George Grosz* (New York, 1960), pp. 34–43. The latter is not very reliable for material before 1933, but is adequate for the post-1933 works.

The following classification of Grosz's published work has been made to clarify the various categories of material: A. Grosz: Portfolios and Books of Drawings; B. Grosz: Poems and Statements; C. Grosz: Contributions to Journals, 1915–1953; D. Books Illustrated by Grosz; E. Grosz: Exhibition Catalogues; F. Books and Articles about Grosz. Not everything fits neatly; for example, several books of plates of Grosz's drawings which appeared in the 1950s could justifiably be included in Part A; I have chosen to place them in Part F because they are generally retrospective collections of drawings edited by someone other than Grosz. I have attempted to make as complete a listing of Grosz's work before 1933 as I could, except for exhibition catalogues of which I have seen only a portion.

The entries in each category are arranged to stress the chronological development of both Grosz's work and the literature about Grosz.

A. GROSZ: PORTFOLIOS AND BOOKS OF DRAWINGS

THE INFORMATION about editions and prices is drawn from catalogues, portfolios and books, advertisements, and especially from Gittig and Herzfelde, "Bibliographie des Malik-Verlages." The 1924 prices come from *Zeichnungen und Lithographie von George Grosz, Lager Katalog No. 15* (Munich, 1924), referred to hereafter as *Lager Katalog*. According to Herzfelde, all of the works published by Malik except the last two were sold out.

1917

Erste George Grosz Mappe. Berlin: Heinz Barger Verlag (formerly Verlag Neue Jugend), Spring, 1917.

9 original lithographs, 50.3 × 39.1 cm.

120 copies, each numbered and signed:

Nos. 1–5: printed on Imperial Japanese, 40 marks.

Nos. 6–20: the same, 30 marks.

Nos. 21–120: printed on handmade paper, 20 marks.

Lager Katalog (1924) price: 300 marks.

Seven of these drawings were first printed in *Die Weissen Blätter* 3 (Oct.–Dec. 1916):160–66, accompanying an article by Däubler on Grosz.

Kleine Grosz Mappe. Berlin-Halensee: Malik Verlag, Fall, 1917.

20 original lithographs.

120 numbered copies:

Nos. 1–5: printed on Imperial Japanese, signed, 60 marks.

1920

The unbound lithographs were accompanied by a single-fold sheet with a title page and a poem by Grosz, "Aus den Gesängen," with typography and layout by John Heartfield.

Nos. 6–20: the same, 50 marks.
Nos. 21–120: printed on handmade paper, unsigned, 35 marks.

"Gott mit uns." Politische Mappe. Berlin: Malik Verlag, June, 1920.
9 original lithographs.
125 numbered copies:

A. Nos. 1–20:
9 original lithographs and title page, 63.5 × 47 cm.
Printed on Strathmore Japanese, in half-vellum portfolio.
Each plate signed.
2,000 marks.

B. Nos. 21–60:
9 original lithographs, 49 × 35.5 cm.
Printed on heavy handmade paper, in half-silk portfolio.
Each plate signed.
1,000 marks.

C. Nos. 61–125:
9 original lithographs, 49 × 35.5 cm.
Printed on light handmade paper, in half-linen portfolio.
Unsigned.
500 marks.

Titles of the drawings were printed in German, English, and French on the title page of the first 20 copies and directly on the lithographs of the remaining copies.
Lager Katalog (1924) prices: A. 375 marks; B. 250 marks.

1921

Das Gesicht der herrschenden Klasse. 55 politische Zeichnungen. Kleine revolutionäre Bibliothek, vol. 4. Berlin: Malik Verlag, 1921.

1st ed., 1921:
55 political drawings and drawing for book jacket.
1–6,000 copies:
Bound in cardboard, 3 marks.
Bound in half-linen on rag paper, 15 marks.
Deluxe edition:
Signed and numbered.
Bound in half-vellum.
100 marks.

3rd ed., November, 1921:
57 political drawings and new jacket drawing.
13–25,000 copies.

Lager Katalog (1924) prices:
Deluxe edition: 50 copies.
57 drawings, signed and numbered.
Bound in half-vellum.
18 marks.

3rd ed., enl., 1921:
57 drawings.

Cardboard binding, 2 marks.

Half-linen binding, 4 marks.

There is confusion on the editions of this book. Gittig and Herzfelde, "Bibliographie des Malik-Verlages," cite:

1st ed., 1921, 55 drawings, 1–12,000 copies.

2nd ed., 13–25,000 copies.

3rd ed., 1923, 57 drawings.

Lang, "George Grosz Bibliographie," cites:

1st ed., 1921, 55 drawings, 1–6,000 copies.

3rd ed., November, 1921, 13–25,000 copies, 57 drawings.

The copies I have examined substantiate Lang's citations, except:

1st ed., 1–12,000 copies.

Im Schatten, Berlin: Malik Verlag, December, 1921.

9 original lithographs and a lithographed title page, 49.5 × 37.5 cm.

100 copies, each plate signed:

A. Nos. 1–5:

Printed on Japanese paper, in silk portfolio.

B. Nos. 6–20:

Printed on heavy handmade paper, in half-calf portfolio.

1,500 marks.

C. Nos. 21–50:

Printed on heavy handmade paper, in half-silk portfolio.

1,200 marks.

D. Nos. 51–100:

Printed on light handmade paper, in half-linen portfolio.

900 marks.

Organization edition: Unsigned, printed on drawing paper, in cardboard portfolio.

Lager Katalog (1924) prices: C. 150 marks; D. 100 marks.

1922

During the inflationary period, 1922–23, Malik Verlag set a ground price for each book. To arrive at the current sale price, the book-seller multiplied this ground price by a key figure which was sent to him by the press at increasingly frequent intervals. For data on exchange values during this period, see Fritz R. Ringer, *The German Inflation of 1923* (New York, 1969), esp. pp. 78–83.

Mit Pinsel und Schere. 7 Materialisationen. Berlin: Malik Verlag, July, 1922.

Black and white reproductions of colored originals constructed from 1919 to 1922.

7 plates, 32 × 25 cm.

Bound: 2.40 marks.

Loose in portfolio: 4 marks.

Lager Katalog (1924) prices: same as original.

Die Räuber. Neun Lithographien zu Sentenzen aus Schillers "Räuber." Berlin: Malik Verlag, November, 1922.

9 original lithographs and a title page, 70 × 50.5 cm.

100 numbered and signed copies:

A. Nos. 1–5:

Printed on handmade Japanese, in vellum portfolio.

Not placed on public sale.

Nos. 6–10:

Printed on handmade Japanese, in half-vellum portfolio.

Ground price: 300 marks.

B. Nos. 11–45:

Printed on handmade paper, in half-silk portfolio.

Ground price: 150 marks.

C. Nos. 46–100:

Printed on handmade paper, in half-linen portfolio.

Ground price: 100 marks.

Organization edition, 1923:

64 × 47.5 cm.

Unsigned in cardboard portfolio.

Ground price: 3 marks.

Lager Katalog (1924) prices: B, 250 marks; C, 200 marks.

1 9 2 3

Abrechnung folgt! 57 politische Zeichnungen. Kleine revolutionäre Bibliothek, vol. 10. Berlin: Malik Verlag, April, 1923.

100 numbered and signed copies:

Handmade paper in half-vellum.

Ground price: 40 marks.

Bound copies: 2 marks and 3.60 marks.

Lager Katalog (1924) prices: 2 marks and 4 marks.

Ecce Homo. Berlin: Malik Verlag, 1923.

84 drawings, 16 watercolors, title page, and table of contents, 37 × 26 cm.

Deluxe editions:

A. Nos. I–L:

Each plate signed and individually enclosed in a silk case.

100 plates.

Ground price: 600 marks.

B I. Nos. 1–100:

16 watercolors only.

Each signed and enclosed in a half-vellum case.

Ground price: 200 marks.

Regular editions:

B II. 16 watercolors only.

Unsigned and in portfolio.

Ground price: 32 marks.

C. 100 plates, unsigned.

Bound and boxed.

Ground price: 45 marks.

D. 84 lithographs, unsigned.

Bound and boxed.

Ground price: 20 marks.

Lager Katalog (1924) prices: C, 40 marks; D, 12 marks. Though both Herzfelde's Malik Verlag bibliography and the *Lager Katalog* list the publication date of *Ecce Homo* as 1922, the copies Lang examined in Germany and those I have examined all indicate the date as 1923. The *Deutsches Bücher-Verzeichnis* 7 (1921–25):1294, assigns 1922 as the probable date. It also lists 11 watercolors and 66 lithographs which were

reproduced in the same forms, but with different prices from those listed above. There may, therefore, have been two different editions. The Akademie der Künste Catalogue (1962), p. 90, suggests this. Most of the reviews of the book appeared in 1923; however, one reviewer, Stefan Grossmann, in the *Tagebuch*, stated that the book was released in December, 1922. Uschakov says that Mayakovsky returned to Moscow in the fall of 1924, said that a copy of *Ecce Homo*; René Arcos, writing in the *Tagebuch*, returned in December, 1922, with a copy of published with a reduced number of plates and a smaller form (see Part F).

Reprinted:

New York: Jack Brussel, 1965. Introduction by Lee Revens.
New York: Grove Press, Inc., 1966. Introduction by Henry Miller.
Hamburg: Rowohlt Verlag, 1966. Foreword by Günther Anders.

1924

Samfundet uden Slør: Prostitutionens Profeter, Moralsatiriske, G-G-AETS-Teg-ninger. Berlin: Malik Verlag for I.F.A., Copenhagen, 1924.
24 drawings and cover drawing.
Statement by Grosz, p. 5, is translation of "Der Mensch ist nicht gut — sondern ein Vieh," Garvens Catalogue, 1922.

1925

Der Spiesser-Spiegel. 60 Berliner Bilder nach Zeichnungen mit einer Selbstdarstel-lung des Künstlers. Dresden: Carl Reissner Verlag, 1925; rev. ed., 1932.
Biographical statement by Grosz, pp. 5–12.
Introduction by Walter Mehring, "Der Spiesserbiologe," pp. 13–14.
Price: 3.50 and 7 marks.

Reprinted:

Berlin-Grunewald: Arani Verlag, 1955 (without statements by Grosz or by Mehring, substituting a drawing for one of those in the 1925 edition).
New York: Arno Press, 1966.

1928

Hintergrund. 17 Zeichnungen zur Aufführung des "Schwejk" in der Piscator-Bühne. Berlin: Malik Verlag, 1928.
17 hand-printed drawings, title page, and cover drawing.
Loose plates, 17 × 26 cm, in heavy paper portfolio.
1.70 marks.

1930

Die Gezeichneten. 60 Blätter aus 15 Jahren. Berlin: Malik Verlag, 1930.
60 drawings, 28 × 20 cm.
1–9,000 copies, which were not sold out.
Bound: in cardboard, 4 marks; in linen, 6.50 marks.
These drawings were all previously published in portfolios, books, or journals. Drawings from *Abrechnung folgt!, Der Spiesser-Spiegel, Ecce Homo,* and *Das Gesicht der herrschen-den Klasse* predominated.

Das neue Gesicht der herrschenden Klasse. 60 neue Zeichnungen. Berlin: Malik Verlag, 1930.
60 drawings, 28 × 20 cm.
1–8,000 copies, which were not sold out.
Bound: in cardboard, 4 marks; in linen, 6.50 marks.

Brief quotation from *Die Kunst ist in Gefahr* on the page between the Table of Contents and the first drawing: "Ihr gebt vor, zeitlos zu sein und über den Parteien zu stehen, ihr Hüter des 'elfenbeinernen Turmes' in euch. . . . Eure Pinsel und Federn, die Waffen sein sollten, sind leere Strohhalme!"

Reprinted:

Stuttgart: Friedrich Bassermann Verlag, 1966.

Über alles die Liebe. 60 neue Zeichnungen. Berlin: Bruno Cassirer Verlag, 1930.

Brief introductory statement by Grosz.

Bound in linen; 8 marks.

1931

A Post-War Museum. Criterion Miscellany, No. 21. London: Faber & Faber Ltd., 1931.

28 plates, no text.

Drawings all published before, mostly in the 1930 books.

1935

Bagdad-on-the Subway. Six Watercolors of O. Henry's New York. New York: Print Club, 1935.

6 signed watercolors issued in a portfolio.

1936

Interregnum. Introduction by John Dos Passos. New York: The Black Sun Press, 1936.

64 drawings and an original colored lithograph.

Book designed by Caresse Crosby. Included both earlier drawings from Germany and new ones.

1944

George Grosz Drawings. Introduction by Grosz. New York: H. Bittner and Co., 1944.

52 plates of drawings and watercolors done in America.

Grosz: "On My Drawings."

George Grosz: 30 Drawings and Water Colors. Introduction by Walter Mehring. New York: Erich S. Herrmann, 1944.

A survey of his drawings, 1915–1944, about evenly divided between the German and the American periods.

Reprinted:

New York: Paul L. Baruch, Inc., 1948.

B. GROSZ: POEMS AND STATEMENTS

1915

"Lied." *Aktion*, 6 November 1915, p. 572.

1916

"Mondnacht." *Neue Jugend* 1, no. 9 (Sept. 1916):183–84.

1917

"Aus den Gesängen." *Kleine Grosz Mappe.* Berlin-Halensee: Malik Verlag, Fall, 1917.

"Die Artisten," "Gesang der Goldgräber," and "Aus den Gesängen." *Neue Jugend* 1, nos. 11–12 (Feb.–March 1917):236–44.

"Beim Durchgehen der Garderobe." *Der Almanach der Neuen Jugend auf das Jahr 1917.* Berlin: Verlag Neue Jugend, n.d.

"Kannst du radfahren?" *Neue Jugend* (Wochenausgabe, June 1917), p. 1.

1918

"Gesang an die Welt" and "Kaffeehaus." *1918: Neue Blätter für Kunst und Dichtung* 1 (Nov. 1918):154–55 (poems followed an article by Theodor Däubler and were accompanied by four drawings).

1920

Grosz and Heartfield, John. "Der Kunstlump." *Der Gegner* 1, nos. 10–12, pp. 48–56.

The exact dating of this article is not simple. *Der Gegner* did not appear regularly. Twelve numbers (Hefte) were produced in the first volume (I Jahrgang), but two numbers could appear in one month. Each number was separately paginated. After October, 1919, the month was not indicated on the front cover; only volume and number appeared. The first volume began in April, 1919. The second volume, first number, was dated 1920–1921. Thus, on the basis of bibliographic information, it is difficult to say with any accuracy when the article was published. On the basis of internal evidence, it must have been written after the Kapp Putsch in late March, or early April, 1920.

Reprinted:

Aktion, 12 June 1920, pp. 327–32.

1920–21

"Statt einer Biographie." Written in Berlin, August 16, 1920. *Der Gegner* 2, no. 3 (1920–21):68–70. (See above for dating problem.)

Reprinted as "Selbstbekenntnis" in:

Wolfradt, Willi. *George Grosz.* Junge Kunst, vol. 21. Leipzig: Klinkhardt und Biermann Verlag, 1921.

Das graphische Jahr. Edited by Fritz Gurlitt. Berlin: Fritz Gurlitt Verlag, 1921, pp. 50–51; 2nd ed., 1922 (book contained a series of statements and one example of work from many contemporary artists).

Reprinted as "Statt einer Biographie" in:

Catalogue of the exhibits of Kunsthandlung Würthle, Vienna, and Galerie Flechtheim, Berlin [1923].

"Zu meinen neuen Bildern." Written November, 1920. *Das Kunstblatt* 5, no. 1 (Jan. 1921):10–16 (accompanied by 5 constructed drawings).

Reprinted as:

[Zu meinen Arbeiten] *Lef: Zhurnal Ievogo Fronta Iskusstva,* no. 1 (March 1923).

1922

"Der Mensch ist nicht gut — sondern ein Vieh!" Exhibition Catalogue. Galerie von Garvens, Hanover, April, 1922.

"Ein neuer Naturalismus?? Eine Rundfrage des Kunstblatts." *Das Kunstblatt* 6, no. 9 (Sept. 1922):382–83.

The entire September issue was devoted to this question. Answers were printed from leading artists, art critics, and writers.

1 9 2 4

"Abwicklung." *Das Kunstblatt* 8, no. 2 (Feb. 1924):32–38.
1 watercolor and 7 drawings interspersed in the text.

This statement was also published in the undated catalogue of the Kunsthandlung Würthle, Vienna, and Galerie Flechtheim, Berlin. The drawings were later published in *Der Spiesser-Spiegel* and *Das neue Gesicht der herrschenden Klasse.*

[Statement]. *G: Material zur elementaren Gestaltung,* no. 3 (June 1924), pp. 39–41.

This article is a slightly shorter version of "Abwicklung." The introductory paragraphs are different, but Grosz used them again in *Die Kunst ist in Gefahr,* pp. 7–8.

"Kurzer Abriss." *Situation 1924: Künstlerische und kulturelle Manifestationen.*
Ulm: Hermelin Verlag, 1924, pp. 22–24.

1 9 2 5

Grosz and Herzfelde, Wieland. *Die Kunst ist in Gefahr. Drei Aufsätze.* Malik-Bücherei, vol. 3. Berlin: Malik Verlag, 1925.
2 small drawings and cover drawing.

3 essays:

"Die Kunst ist in Gefahr: Ein Orientierungsversuch," pp. 5–32.

"Paris als Kunstadt," pp. 33–38.

"Statt einer Biographie," pp. 39–45.

"Statt einer Biographie" is a composite of three earlier statements by Grosz.

pp. 39–42: "Statt einer Biographie," August 16, 1920, except for the last two paragraphs.

pp. 42–43: statement in the Garvens catalogue, 1922.

pp. 43–44: from "Zu meinen neuen Bildern," November, 1920; only the portions on art and society, not the final paragraphs on his new art.

pp. 44–45: final paragraphs of "Statt einer Biographie."

"Die Kunst ist in Gefahr," the longest essay, was written by both Grosz and Herzfelde:

pp. 5–16: written by both men, discusses the problems of contemporary art.

pp. 16–24: "Abwicklung," from *Das Kunstblatt,* with only a few minor changes.

pp. 24–32: written by both men, reviewing art history in terms of Tendenzkunst.

Reprinted:

pp. 16–24 only, in a revised and somewhat abbreviated form in Florent Fels, *Propos d'Artistes.* Paris, 1925, pp. 78–84.

All, Moscow: State Publishing House, 1926. Introduction by V. Perzov; trans. Z. L. Svarchman.

"Pariser Eindrücke." *Europa auf reisen* (1925), pp. 42–46.
[Biographical statement]. *Der Spiesser-Spiegel.* Dresden: Carl Reissner Verlag, 1925, pp. 5–12.
8-page introductory statement about himself and his art.

1 9 2 6

"aus: *Spiesser-Spiegel.*" *Der Morgen. Ein Almanach.* Dresden: Carl Reissner, 1926, pp. 130–32.

Reprint of the last three pages of the statement from *Spiesser-Spiegel.* Elsewhere in the almanac, five drawings were reproduced, pp. 61, 67, 69, 71, 85, and a photograph of Grosz, p. 32.

1927

"Reportage und Dichtung. Eine Rundfrage." *Die Literarische Welt*, 25 June 1926, p. 2.

Grosz was included in a group of writers — Heinrich Mann, Alfred Döblin, Leonhard Frank, Klabund, Max Brod, and others — each of whom wrote a brief statement on the relationship of reporting and literature.

"Die Entwickelung der heutigen Kunst: Graphik." *Berliner Tageblatt*, 19 March 1927, 1st supplement.

A brief introduction by Max Liebermann, President of the Akademie der Künste, was followed by short statements from Gert Wolheim on painting, Mies van der Rohe on architecture, Ernesto de Fiori on sculpture, and Grosz on graphic arts.

"Nächtliche Begegnung mit Frauen: Moral." *Berliner Tageblatt*, 3 April 1927, n.p.

A brief description of a woman at night in a city and a drawing were printed with statements from four other men.

1928

"Moja Žizn [My life]." *Prožektor* (Moscow) 6, no. 14 (April 1, 1928):16–18.

This autobiographical account, which was especially written for the journal, was accompanied by a photograph of Grosz and 10 illustrations of drawings and oils. The cover of the journal featured Grosz's oil, "Eclipse."

"Randzeichnungen zum Thema." *Blätter der Piscatorbühne*, February, 1928.

Reprinted in:

Erwin Piscator. *Das politische Theater*. Reinbek bei Hamburg: Rowohlt Verlag, 1963, pp. 191–92.

1929

Die Artisten. Litomyšl: Verlag Josef Portman, 1929. 20 numbered hand-printed copies.

Frontispiece and a drawing by Jan Konůpek.

Reprinted from the poems of the same title in *Neue Jugend* 1, nos. 11-12:237, 238, 240.

"Jugenderinnerungen. Mit Photos und Zeichnungen aus der Jugendzeit." *Das Kunstblatt* 13, no. 6 (June 1929):166–74; no. 7 (July 1929):193–97; no. 8 (August 1929):238–42.

1930

Gesänge. Litomyšl: Verlag Josef Portman, 1930. 20 numbered hand-printed copies.

Title-page drawing by Jan Konůpek.

Two poems, "Gesang der Goldgräber," and "Aus den Gesängen," reprinted from *Neue Jugend* 1, nos. 11-12:242–43.

[Introductory statement]. *Über alles die Liebe*. Berlin: Bruno Cassirer Verlag, 1930.

"Lebenserinnerungen." *Kunst und Künstler* 29 (Oct.–Dec. 1930):15–22, 55–61, 105–111.

"Neue Menschen, neues Paradies. Wo man leben möchte, wenn man nach Herzenslust leben könnte." *8 Uhr-Abendblatt der National-Zeitung*, 19 April 1930, 2nd section, n.p.

To a question asked of eminent Weimar figures Grosz answered: "In den Rocky Mountains!," explaining that he could conceive of living only in Germany or in America.

1931

"Das feine Milljöh." *Der Querschnitt* 11, no. 1 (January 1931):14–17.

Typescript for this article is in the Grosz Estate as "Über Film; für Querschnitt." December, 1930; in an issue devoted to studying films, Grosz argued that most motion pictures were insipid manifestations of a machine culture and called for a genuine portrayal of life in Germany. Cover drawing by Grosz.

Kannst du radfahren? Litomyšyl: Josef Portman Verlag, 1931.

20 numbered hand-printed copies.

"Kunst ist vorbei, mein Lieber!" *Berliner Tageblatt*, 25 December 1931, supplement.

Brief statement by Grosz included in a larger article titled, "Kunst geht nach Brot."

"Unter anderem ein Wort für deutsche Tradition." *Das Kunstblatt* 15, no. 3 (March 1931):79–84.

1932

"Briefe aus Amerika." *Kunst und Künstler* 31 (August, September, December 1932):273–78, 317–22, 433–43.

Gedichte und Gesänge (1916–1917). Litomyšyl: Josef Portman Verlag, 1932.

7 drawings and 1 cover drawing.

36 numbered copies.

10 poems: "New York I," "New York II," "Beim Durchgehen der Garderobe," "Kaffeehaus," "Mondnacht," "Die Artisten," "Nachtcafe," "Gesang der Goldgräber," "Gesang an die Welt," "Berlin 1917." The last poem includes portions of "Aus den Gesängen," from the *Kleine Grosz Mappe*.

1933

"Amerikanische Umgangsformen." *Der Querschnitt* 13, no. 1 (Jan. 1933):16–19.

1944

"On My Drawings." *George Grosz Drawings*. New York: H. Bittner and Co., 1944.

1946

A Little Yes and a Big No: The Autobiography of George Grosz. Translated by Lola Sachs Dorin. New York: The Dial Press, 1946.

38 plates and numerous drawings in the text.

The title refers to Grosz's attempt to become an optimistically oriented person in America. He wrote: "Life is really more beautiful if you say YES instead of NO. I can testify to that from experience. If the title of my book seems to have a different connotation, then it is a reflection of my past rather than of my immediate present." In the next paragraphs, he admitted that he was unable to attain this optimism (p. 305). There are various sources for the Yes and No dialectic: among contemporary ones were Brecht's *Der Jasager und der Neinsager* (1929–30) or Otto Flake's *Nein und Ja* (1920).

Reprinted:

Un piccolo Si e un grande No. Milan: Longanesi & Ci., 1948.

Ein kleines Ja und ein grosses Nein. Sein Leben von ihm selbst erzählt. Hamburg: Rowohlt Verlag, 1955.

The German version is longer than the English one. Though published first, the English version was a translation of the German autobiography. Herzfelde inquired in a letter to Grosz

in 1933 about what had happened to the autobiography which Grosz was writing for Wasser-vogel. Though Grosz did not reply to this question, it is possible that he had begun writing this manuscript early in the thirties. Peter Grosz says that the translator of the English version edited, abbreviated, and altered the order of the text. Certainly, the German version is more coherent and consistent than the English one; its chronology is not so erratic. The English text cuts many sections in which Grosz was writing about his friends in Germany; of particular interest is the omission of Chapter 11, "Russlandreise, 1922," pp. 153–76. This chapter was first published in *Der Monat* in May, 1953, and was then included in the German autobiography.

"A Piece of My World in a World Without Peace." Associated American Artists Galleries Catalogue, October, 1946.

A statement coming out of the pessimism and darkness of his later years including: "My world is usually a gloomy and haunted one."

"The Wanderer." *The Encyclopaedia Britannica Collection of Contemporary American Painting.* Chicago, 1946.

Statement accompanying Plate 48: "The Wanderer": "The old man is the everlasting human spirit. . . . here once more he goes through a dark world — through an apocalyptic landscape"

"I Teach Fundamentals." *College Art Journal* 9, no. 2 (Winter 1949–50):199–201.

1949

"George Grosz antwortet. Eine Anklage gegen ihn und ihr Ende." *Die Neue Zeitung,* 31 July 1949, Feuilleton und Kunstbeilage, n.p.

In this letter to the editor, Grosz answers charges which were made in *Neues Deutschland,* the paper of the German Socialist Union party in the German Democratic Republic. An article published on May 5, 1945, had stated that Grosz had turned his back on political work and had become a "forest and meadow painter." *The Neue Zeitung,* 10 July 1948, had repeated these statements. Grosz's angry reply pointed to his oils ("The Pit," "Cain," "A Piece of My World in a World Without Peace") and to the Stickmen series. He claimed that the East German critic had ignored these, especially the Stickmen, because they didn't fit his ideological views.

1953

"Russlandreise, 1922." *Der Monat* 5, no. 56 (May 1953):135–52.

1957

"The Arts in America." *The American People's Encyclopedia, Yearbook, Events and Personalities of 1957.* Chicago, 1958, pp. 110–13.

Contemporary modern art in America, according to Grosz, was the art of nothing, about nothing, with no future.

C. GROSZ: CONTRIBUTIONS TO JOURNALS, 1915–1933

THIS IS a list of the major journals to which Grosz contributed; it is not an exhaustive list of all the journals.

Die Aktion. Berlin. 1911–32. Ed. Franz Pfemfert.
Work by Grosz appeared in the following numbers:
1915: July 24, p. 370: "Der Mörder" (drawing).
November 6, p. 572: "Lied" (poem).

Neue Jugend. Berlin.

1916: July 8, p. 378: "Café" (drawing).

August 5, p. 438: "Federzeichnung" (drawing).

September 30, p. 543: "Im Café" (drawing).

1920: June 12, pp. 327–32: "Der Kunstlump," article by Grosz and John Heartfield.

1921: November 12, p. 632: "Wacht auf, Enterbte dieser Erde!" (drawing from *Im Schatten*).

1922: August 1, title page: "Schande! Gedenkblatt zum 4. August" (drawing).

Neue Jugend. Berlin. 1916–17.

Grosz's contributions to the journal were:

Vol. 1, no. 7 (July 1916):

p. 127: "Durchhalten!" (drawing, 1915).

p. 134: "Die Goldgräber" (drawing).

Vol. 1, no. 8 (August 1916):

p. 154: poem on Grosz by Else Lasker-Schüler.

p. 155: drawing of a nude.

Vol. 1, no. 9 (September 1916):

pp. 183–84: "Mondnacht" (poem).

Vol. 1, no. 10 (October 1916): Theodor Däubler Sonderheft.

p. 201: "Friedvolle Rheinlandschaft" (drawing).

Vol. 1, nos. 11–12 (February–March, 1917):

p. 236: "Sanatorium" (drawing).

pp. 237–38: "Die Artisten I, II, III" (poems).

p. 239: drawing, no title.

p. 240: "Die Artisten, IV" (poem).

p. 241: drawing, no title.

p. 242: "Gesang der Goldgräber" (poem).

p. 243: "Aus den Gesängen" (poem).

p. 244: drawing, no title.

Wieland Herzfelde took over the publication of this journal from Heinz Barger, whose name remained as the publisher, while Herzfelde was listed as the editor. Ostensibly, the journal remained under Barger; hence, Herzfelde's first issue appeared as Volume 1, number 7, in July, 1916, continuing from the numbering of Barger's journal. The February–March, 1917, issue was the first to list Herzfelde as the publisher as well as editor and to appear under the imprint of the Malik Verlag instead of Barger's Neue Jugend Verlag. Helmut Herzfeld (John Heartfield) was the "responsible editor" since Wieland was still a minor. Only five issues were printed before the journal was banned. The unsold copies of these numbers were bound and issued as a single volume in 1921.

Reprinted:

Facsimile edition: *Neue Jugend. Monatsschrift und Wochenausgabe, 1916–1917.* Hilversum: De Boekenvriend and Zurich: Limmat Verlag, 1967. The five monthly numbers and the two news sheets.

Almanach der Neuen Jugend auf das Jahr 1917. Berlin: Verlag Neue Jugend, n.d.

4 Grosz drawings, all of which later appeared in the *Kleine Grosz Mappe*:

p. 61: "Die Kirche."

p. 89: "Die Fabriken."

p. 145: "Strassenbild."

p. 170: "Kaffeehaus."

1 poem:

p. 144: "Beim Durchgehen der Garderobe."

Neue Jugend, Wochenausgabe. Berlin: Malik Verlag, May and June, 1917.

Grosz's anonymous written contributions were:

"Kannst du radfahren?"

"Mann muss Kautschuk-Mann sein!"

Grosz worked with John Heartfield in planning both numbers. The June number was designated as "Prospekt zur Kleinen Grosz Mappe." It contained an advertisement on the inside for the portfolio.

Jedermann sein eigner Fussball 1, no. 1 (February 15, 1919).

7,600 copies published and sold.

Only 1 number appeared before it was banned. Editors: Wieland Herzfelde, John Heartfield, Grosz, and others. Bibliographical information on this is contradictory. The journal lists Herzfelde and Heartfield. Mehring claims that it was produced by Grosz, Heartfield, Herzfelde, John Förste, Carl Einstein, and Mehring (see Mehring, *Berlin Dada: eine Chronik mit Photos und Dokumenten* [Zurich, 1959], p. 64). Bernard Karpel and Willy Verkauf list the editors as Franz Jung and Grosz (see Karpel's bibliography in Richard Huelsenbeck, ed., *Dada. Eine literarische Dokumentation* [Reinbek bei Hamburg, 1964], p. 280, and Willy Verkauf, et al., eds., *Dada: Monograph of a Movement*, Visual Communication Books [2nd ed., New York, 1961], p. 105).

Die Pleite. Illustrierte Zeitschrift. Berlin-Leipzig: Malik Verlag, February, 1919 to January, 1920.

Vol. 1, no. 1 (1919):

No editors and no month listed.

Grosz drawings:

Cover: "Von Geldsacks Gnaden" (caricature of Ebert).

p. 2: "Apostel Philipp [Scheidemann] verspricht seit dem. 9. November andauernd das tägliche Brot."

p. 3: "Spartakus vor Gericht — Wer ist bezahlt?"

p. 4: "Ludendorffs Rückkehr."

"Noske an der Arbeit."

Vol. 1, no. 3 (early April 1919):

No editors listed.

Grosz drawings:

Cover: "Prost Noske!—das Proletariat ist entwaffnet!"

p. 3: drawing of military doctor pronouncing skeleton K.V. or fit for active duty.

p. 4: drawing for *Schutzhaft*.

Vol. 1, no. 4 (May 1, 1919):

No editors listed.

Grosz drawings:

Cover: "Maifeier in Plöizensee."

p. 2: small drawing.

p. 3: drawing of Reichswehr soldier, Free Corps soldier, and an officer.

Vol. 1, no. 5 (December 15, 1919):

Editors: Herzfelde and Grosz.

Grosz drawings:

Cover: "Die deutsche Pest."

p. 4: "Zum Verbot der 'Pleite'; Gustav Gessler."

Vol. 1, no. 6 (early January 1920):

Editor: Herzfelde.

Grosz drawings.

Cover: "Kapital und Militär wünschen sich: 'Ein gesegnetes Neues Jahr!'"

In March, 1919, a brochure by Wieland Herzfelde entitled *Schutzhaft* appeared in place of Vol. 1, no. 2.

No. 7 (July 1923):

Editors: Grosz and John Heartfield.

p. 2: "In der Heimat, in der Heimat, da gibt's ein Wiederseh'n!"

p. 4: Central figures from "Deutschland, ein Wintermärchen."

Grosz drawings (record incomplete):

Parody on the terms "Baltenschweine" and "Noskehund."

Cover: "S.M." (caricature of Ebert).

"Wie werde ich reich?"

Der blutige Ernst. Satirische Wochenschrift. Berlin: Trianon-Verlag, n.d.

Vol. 1, no. 3: "Die Schuldigen."

Editors: Carl Einstein and Grosz.

Typography and layout: Grosz-Heartfield.

Grosz drawings:

Cover: "Wie der Staatsgerichtshof aussehen müsste."

p. 2: 2 marginal drawings.

p. 3: "Zuhälter des Todes," full-page.

pp. 4–6: 5 marginal drawings illustrating "Ludendorffs Tagebuch."

p. 5: "Wiederaufbau," full-page.

p. 8: "Ende eines Kriegsberichterstatters?"

Vol. 1, No. 4: "Die Schieber."

Editors: Carl Einstein and Grosz.

Typography and layout: Grosz-Heartfield.

Grosz drawings:

Cover: "Arbeiten und nicht verzweifeln."

p. 10: drawing of a man.

p. 11: drawing of a man's head.

pp. 12–13. "So leben wir alle Tage!," two-page spread.

Vol. 1, no. 5: "Rückkehr der Monarchie."

Editors: Carl Einstein and Grosz.

Grosz drawings (record incomplete).

Cover: "Rückkehr geordneter Zustande."

p. 19: "Des Volkes Dank ist Euch gewiss."

Vol. 1, no. 6: "Schulze."

Editor: Carl Einstein.

Grosz drawings:

Cover: photomontage (probably Grosz-Heartfield).

p. 3: drawing of a man's head—opposite Einstein's article on Schulze, the eternal burgher.

p. 5: "Schulzens Seele."

p. 8: drawing of a man's head.

p. 10: drawing of a burgher.

p. 12: "Schulze psychoanalysiert."

None of the numbers are dated, but internal evidence indicates that numbers 3 and 4 appeared in mid-1920. Numbers 1 and 2 were edited by John Hoexter. Numbers 3, 4, and 5 are paginated consecutively. Grosz and Carl Einstein prepared an advertising flier for the magazine.

Der Dada. Zeitschrift der Berliner Dada, 1919–20.
Number 1 and 2. Berlin: Verlag Freie Strasse.
Editor: Raoul Haussmann.
Grosz drawing: "Selbstbildnis," in no. 2.
Number 3. Berlin: Malik Verlag, Abteilung Dada, April, 1920.
Editors: Groszfield, Hearthaus, Georgemann (Grosz, Heartfield, and Hausmann).
Cover: Grosz-Heartfield photomontage of a Grosz-Heartfield puppet.

Der Knüppel. Satirische Arbeiterzeitung. Berlin: Vereinigung Internationaler Verlags-Anstalten GmbH, 1923–27.
Grosz drawings appeared in the following numbers:
Vol. 2, no. 4 (July 25, 1924).
1 drawing: "Fürs Vaterland."
Vol. 2, no. 5 (August 10, 1924).
1 drawing: "Borkum, Borkum über alles!"
Vol. 2, no. 6 (August 25, 1924): "6 Jahre 'Frieden.'"
1 caricature of Ebert and Seeckt.
2 full-page drawings attacking the concept that peace had benefited the workers.
Vol. 2, no. 7 (September 10, 1924): "Die neue Aera kommt."
1 caricature of Ebert: "Der Herr im Hause."
1 caricature of Ebert and Ramsay Macdonald: "Die Väter der 'Neuen Aera.'"
1 caricature of Ebert and Ramsay Macdonald: "Friedens Händler."
1 caricature of Ebert and Ramsay Macdonald: "Friedens Händler."
1 portraying poverty and wealth.
1 portraying workers as prisoners.
Vol. 2, no. 8 (December 1, 1924): election issue.
4 drawings, including "Der Esel der Demokratie," "Bürgers Albdruck," and "Der Dank des Vaterlandes ist Euch immer gewiss!"
Vol. 3, no. 1 (January 25, 1925).
4 full-page drawings of workers.
Vol. 3, no. 2 (February 10, 1925): none.
Vol. 3, no. 3 (February 25, 1925): "Die Tscheka kommt!"
Cover: "Spitzel vor die Front."
Vol. 3, no. 4 (end of March 1925).
2 drawings, including a judge examining a worker.
Vol. 3, no. 5 (May 1, 1925).
2 drawings, one of a judge and one of the Reichswehr.
Vol. 3, no. 6 (May 15, 1925): "Der Platzhalter."
Cover: caricature of Hindenburg.
2 drawings of wealthy types.
Vol. 3, no. 7 (June 1925).
Cover: "Ordnung herrscht in Bulgarien."
1 drawing of the new ruling types.
1 drawing of Hindenburg and Otto Braun.
Vol. 3, no. 8 (July 1925).
3 drawings of the new ruling types.

Vol. 3, no. 9 (end of July 1925): "Krieg dem Kriege."
Cover: soldier in gas mask hiding behind Christ who bears the label
"Kultur."
1 drawing of a reactionary Stammtisch.

Vol. 3, no. 10 (September 15, 1925).
1 drawing of a Germanic capitalist.

Vol. 3, no. 12 (November 1925).
1 drawing of the new ruling types.

Die Rosarote Brille. Satirische Wahlschrift der KPD. 1924.
The theme: "Fort mit der Revolution! Auf zum friedlichen Wahlkampf!"
Included three pages of satirical drawings by Grosz.

Die Rote Fahne. Zentralorgan der Kommunistischen Partei Deutschlands. Berlin
and Leipzig: November 9, 1918–32.
Grosz drawings appeared in the following numbers:

1921: May 1.
1923: March 11.
1924: September 20; November 30.
1925: May 13, 14; August 8.
1928: November 7.

Simplicissimus. Illustrierte Wochenschrift. Munich, 1896–present.
Grosz drawings appeared in the following numbers:

1926: February 1, p. 634; February 8, p. 655; March 1, p. 686; March 29,
p. 735; April 12, p. 34; April 26, p. 54; May 31, p. 131; June 28,
p. 170; July 12, p. 202; August 2, p. 234; August 9, p. 247; Au-
gust 16, p. 259; September 20, p. 326; October 18, p. 374; Octo-
ber 25, p. 386; November 8, p. 420; November 22, p. 446.

1927: January 31, p. 590; February 7, p. 607; March 14, p. 670; March 21,
p. 684; March 28, p. 702; May 9, p. 66; June 13, p. 135; July 4,
p. 183; August 15, p. 270.

1928: March 12, p. 674; April 16, p. 30; May 14, p. 91; November 26,
p. 452; December 17, p. 490.

1929: January 14, p. 547; January 21, p. 555; January 28, p. 579; April 8,
p. 19; April 15, p. 35; June 10, p. 125; July 15, p. 191; August 12,
p. 241; August 26, p. 263; September 9, p. 295; September 30,
p. 330; October 14, p. 354; November 4, p. 394.

1930: January 6, p. 504; February 24, p. 590; March 24, p. 638; April 1,
p. 11; August 18, p. 250; October 13, p. 344; October 27, p. 370;
December 28, p. 466.

1931: November 16, p. 394; November 23, p. 406; December 14, p. 440;
December 28, p. 466.

1932: February 21, p. 560; April 24, p. 44; May 22, p. 92.

D. BOOKS ILLUSTRATED BY GROSZ

IN ORDER to provide as complete a record as possible of the books which Grosz
illustrated, I have included items in this list which I have not been able to examine
myself but which are well substantiated. Most of these are found either in Lothar
Lang, "George Grosz Bibliographie," or in Gittig and Herzfelde, "Bibliographie des

Malik-Verlages." Sources for these books are indicated in parentheses at the end of the citation as (Lang) or (Malik) with the number assigned to the books in the respective bibliographies.

1913

Hollaender, Felix. *Sturmwind im Westen. Ein Berliner Roman.* Fischers Roman Bibliothek. Berlin: S. Fischer [1913].
Drawing for the book jacket.

1917

Herzfelde, Wieland. *Sulamith.* Gedichte. Berlin: Heinz Barger Verlag, Kriegsdruck der Cranach-Presse, 1917.
Cover drawing.

This small book of poetry was issued in a limited edition of 200 numbered copies. Like the *Erste George Grosz Mappe,* it bears the name of the Heinz Barger Verlag, even though it was published after the break between Barger and the Herzfeldes. The publication of this book was possible through the help of Count Harry Kessler, whose Cranach Press in Weimar printed it on its hand press.

1919

Firn, Edgar [Karl Döhmann]. *Bibergeil: Pedantische Liebeslieder.* Lyrische Flugblätter. Berlin: Alfred Richard Meyer, Summer, 1919.
Title-page–cover drawing.

Herzfelde, Wieland. *Schutzhaft. Erlebnisse vom 7. bis 20. März 1919 bei den Berliner Ordnungstruppen.* 2 eds. Berlin Halensee: Malik Verlag, 1919.
Identical title-page and cover drawings.

The first edition of this small, soft-bound pamphlet appeared at the end of March, 1919, in place of the second number of *Die Pleite.*

Mehring, Walter. *Schall und Rauch: Einfach Klassisch! Eine Orestie mit glücklichem Ausgang.* Berlin: Fürstner, 1919 (Lang, 7).
Cover drawing and 3 illustrations of the original Grosz-Heartfield puppets for the Schall und Rauch marionette theater.

"Wieland. Kalendar für das Jahr 1919." Wieland, *Deutsche Monatsschrift,* no. 10 (1918–19), title page–p. 13.
Title page and 12 calendar pages, charming drawings with a colored wash.

1920

Brest-Litowsk. *Reden, Aufrufe und Manifeste der russischen Volkskommissare . . . anlässlich der russisch-deutschen Friedensverhandlungen im Winter 1917–18.* Compiled by Ernst Drahn. Kleine revolutionäre Bibliothek, vols. 2–3. Berlin: Malik Verlag, 1920 (Lang, 13; Malik, 20).
Cover drawing.

Herzfelde, Wieland. *Tragigrotesken der Nacht. Träume.* Berlin: Malik Verlag, May, 1920.
2 cover drawings and 22 drawings in the text.

These expressionistic dreams, both fantastic and political, were written from 1913 to 1919. Grosz's drawings portrayed prostitutes, soldiers, officers, prisoners, and hangmen. The first 30 copies were numbered and signed by Herzfelde.

Huelsenbeck, Richard. *Dada siegt. Eine Bilanz des Dadaismus.* Berlin: Malik Verlag, Abteilung Dada, April, 1920.

———. *Deutschland muss untergehen! Erinnerungen eines alten dadaistischen Revolutionärs.* Berlin: Malik Verlag, 1920.

2 illustrations and 2 cover drawings by Grosz, all details from his painting, "Deutschland, ein Wintermärchen."

Dada, 1920.

Cover drawing and 13 drawings in the text.

30 copies were signed by Huelsenbeck and Grosz.

———. *Phantastische Gebete. Verse.* 2nd rev. ed. Berlin: Malik Verlag, Abteilung die Erde, n.d.

Book jacket drawing.

This book was advertised in *Das Kunstblatt 4,* no. 4 (April 1920). I have not seen it; neither has Lang.

Jung, Franz. *Gott verschläft die Zeit. Ein Buch Prosa.* Berlin-Halensee: Verlag die Erde, n.d.

The first edition appeared in the Collection Dada, published in Zurich in September, 1916, with woodcut illustrations by Hans Arp. In 1960 a new edition with illustrations by both Arp and Grosz was issued by Peter Schifferli, Die Arche Verlag, Zurich.

Schönlank, Bruno. *Sonniges Land. Kindergedichte.* 2 eds. Berlin: Paul Cassirer Verlag, 1920.

5 drawings and a watercolor for the cover of the first edition only.

Drawings are whimsical outdoor scenes for poems about familiar household objects, animals, the seasons, and the family, written by the son of Bruno Schönlank, editor of the *Leipziger Volkszeitung.*

1921

Andersen-Nexö, Martin. *Die Passagiere der leeren Plätze. Ein Buch mit 14 Erzählungen und einem Vorspiel.* Berlin-Halensee: Malik Verlag, November, 1921.

Cover drawing and 12 illustrations.

The book was dedicated to "Dem Kämpfenden Russischen Volke." Also, facing the title page was the following statement: "Autor und Illustrator haben ihre Honorare der 'Künstlerhilfe für die Hungernden in Russland' zur Verfügung gestellt." The title of the book comes from the vision which the author had of empty seats on luxury trains which were filled by the ghosts of the poor: only through death could the poor attain a position which was rightfully theirs in life.

Ball, Hugo. *Flametti oder vom Dandysmus der Armen.* Berlin: Erich Reiss Verlag, 1921.

The first edition published in 1918 was without illustrations. According to the Akademie der Künste Catalogue, 1962, Grosz illustrated the 1921 edition. Lang does not list it in his bibliography. I have not seen it.

Daudet, Alphonse. *Die Abenteuer der Herrn Tartarin aus Tarascon.* Translated by Klabund. Berlin: Erich Reiss, 1921.

Colored cover drawing, drawings on end pages, title page, and 97 illustrations, 20 of which were full-page hand-printed drawings.

Reprinted:

Frankfurt am Main: Ullstein Bücher, 1948, abridged.

Frankfurt am Main: Insel Verlag, 1962. Insel-Bücherei 742.

São Paulo: Boa Leitura Editora, n.d.

Frankfurt am Main: Ullstein Verlag, 1965. Ullstein Buch 514.

John Heartfield prepared the layout of the 1921 edition. None of the reprinted editions used all of the Grosz drawings.

Huelsenbeck, Richard. *Doctor Billig am Ende. Ein Roman.* Munich: Kurt Wolff Verlag, 1921.
8 full-page drawings.

The novel was advertised on the back cover of *Club Dada* in 1918 under the title "Das mysteriöse Ende des Doktor Billig," featuring drawings by Grosz.

Jung, Franz. *Proletarier. Erzählung.* Rote Roman Serie, vol. 1. Berlin-Halensee: Malik Verlag, 1921.
Cover drawing.

———. *Die rote Woche.* Rote Roman Serie, vol. 3. Berlin: Malik Verlag, 1921.
9 drawings accompanying the text.

Meyer, Alfred Richard. *Munkepunke Dionysos. Groteske Liebesgedichte.* Das geschriebenes Buch, vol. 7. Berlin: Fritz Gurlitt Verlag, 1921 (Lang, 20).
2nd ed. 1922.
6 original lithographs.
100 numbered copies, of which 20 had hand-colored lithographs.

Mühlen, Hermynia zur. *Was Peterchens Freunde erzählen. Sechs Märchen.* Märchen der Armen, vol. 1. Berlin-Halensee: Malik Verlag, 1921.
Cover drawing and 6 original drawings.
2nd rev. ed. 1924.

Reimann, Hans. *Sächsische Miniaturen.* Vol. 1. Hanover: Paul Steegemann Verlag [1921].
14 drawings.
2nd ed. 1928.
3rd ed. titled: *Die Gadze und andere Sächsische Miniaturen* (Lang, 22).
Further volumes were illustrated by Paul Simmel and Karl Holtz.

Schuster, Willi. *Der Dank des Vaterlandes.* Leipzig and Berlin: Frankes Verlag, 1921.
Cover drawing and 4 drawings in the text.

Sinclair, Upton. *100%. Roman eines Patrioten.* Translated by Hermynia zur Mühlen. Rote Roman Serie, vol. 2. Berlin: Malik Verlag, 1921.
10 drawings.
Successive editions of the novel by the Malik Verlag contained no illustrations by Grosz.

1922

Gasbarra, Felix. *Preussische Walpurgisnacht. Groteskes Puppenspiel (in Knüppelreimen).* Sammlung revolutionärer Bühnenwerke, vol. 9. Berlin: Malik Verlag, 1922 (Lang, 27; Malik, 56).
1 drawing by Grosz; cover drawing by John Heartfield.

Goll, Iwan. *Methusalem oder Der ewige Bürger. Ein satirisches Drama.* Kostüme und Bühnenausstattung G. Grosz und J. Heartfield. Der dramatische Wille, 8. Potsdam: Gustav Kiepenheuer, 1922 (Lang, 29).
3 figures by Grosz.

Graf, Oskar Maria. *Zur freundlichen Erinnerung. 8 Erzählungen.* Unten und Oben, vol. 1. Berlin: Malik Verlag, 1922 (Lang, 28; Malik, 57).
Cover drawing.

Jezower, Ignaz, ed. *Die Rutschbahn, das Buch vom Abenteuerer.* Berlin: Deutsches Verlagshaus Bong & Co., 1922.
"Der Groszmarschall" planned the layout of the book and drew marginal sketches. The title of the book comes from Frank Wedekind: "Das Leben ist eine Rutschbahn."

Jung, Franz. *Arbeitsfriede*. Rote Roman Serie, vol. 4. Berlin: Malik Verlag, 1922. 6 drawings.

Kanehl, Oskar. *Die Schande. Gedichte eines dienstpflichtigen Soldaten aus der Mordsaison 1914–1918*. Die Aktions-Lyrik, Werk 7. Berlin-Wilmersdorf: Verlag der Wochenschrift Die Aktion, 1922 (Lang, 32).
Cover drawing.

——. *Steh auf, Prolet! Gedichte. Kleine revolutionäre Bibliothek*, vol. 12. 2nd rev. ed. Berlin-Halensee: Malik Verlag, 1922.
7 drawings.

Malik-Verlagskatalog. Berlin: Malik Verlag, May, 1922.
Cover drawing.

1st ed. was published by the Prolet Verlag, Erfurt, 1920.

1923

Meyer, Alfred Richard. *Lady Hamilton oder die Posen-Emma oder vom Dienst-mädchen zum Beefsteak à la Nelson. Eine ebenso romanhafte wie auch novellen-schaukelnde durchwachsene Travestie; fleissigst und fleischigst bebildert von George Grosz*. Berlin: Fritz Gurlitt Verlag, 1923.
8 original lithographs.

300 copies of the book were issued. Grosz signed each lithograph of the first 150 copies; of the remainder, he signed only the first two lithographs of each copy.

Reimann, Hans. *Hedwig Courths-Mahler. Schlichte Geschichten fürs traute Heim. Geschmückt mit reizenden Bildern von George Grosz*. Hanover: Paul Steegemann Verlag, 1922.
Drawing for the book jacket and 30 drawings.

——. *Das Paukerbuch. Skizzen vom Gymnasium*. Hanover: Paul Steegemann Verlag, 1922.
Drawing for the book jacket.

Schnur, Peter. *Die Hütte. Zehn Erzählungen*. Foreword by Frida Rubiner. Oben und Uten, vol. 2. Berlin: Malik Verlag, 1923.
Cover drawing.

The drawing is in Grosz's style, but Gittig and Herzfelde do not mention a Grosz drawing for this book. Lang suggests that it was derived from a Grosz drawing, if it was not actually drawn by Grosz.

1924

La Boétie, Etienne de. *Über freiwillige Knechtschaft*. Translated and introduced by Felix Boenheim. Berlin: Malik Verlag, 1924.
Cover drawing.

Written in 1577, this book was published by Malik with a cover drawing taken from *Die Räuber*, Plate 3.

1925

Mann, Heinrich. *Kobes*. Berlin: Propyläen Verlag, 1925.
10 lithographs.

Reprinted:
Frankfurt am Main and Berlin: Ullstein Verlag, 1969.
Berlin and Weimar: Aufbau Verlag, 1969.

1926

MacOrlan, Pierre. *Port d'Eaux-Mortes*. Paris: Sans Pareil, 1926.
8 original lithographs.

Toller, Ernst. *Brokenbrow: a Tragedy*. Translated by Vera Mendel. London: Nonesuch Press [1926].
6 full-page drawings.

Toller's play, *Hinkemann*, was first published in 1922 by Gustav Kiepenheuer, Potsdam, without illustrations. An illustrated edition was announced for 1926 by the Carl Reissner Verlag, but it does not appear to have been published.
French edition: *Hinkemann. Tragédie*. Paris: Les Humbles, 1926.

1927

Herrmann-Neisse, Max. *Einsame Stimme. Ein Buch Gedichte*. Berlin: Martin Wasservogel Verlag, 1927.
Frontispiece: an original portrait lithograph of the poet by Grosz.
900 numbered copies.

Sinclair, Upton. *Die goldne Kette oder die Sage von der Freiheit der Kunst*. Translated by Hermynia zur Mühlen. Berlin: Malik Verlag, 1927.
Cover photomontage-drawing by Grosz and Heartfield.
2nd and 3rd ed. 1928.
The three editions of this work went to 27,000 copies.

1928

Kanehl, Oskar. *Strasse frei. Neue Gedichte*. Berlin: Der Spartakusbund Verlag, 1928.
Drawing for book jacket and 15 original drawings.

1929

Gumbel, E. J. *Verräter verfallen der Feme! Opfer, Mörder, Richter, 1919–1929*. With help from Berthold Jacob and Ernst Falck. Berlin: Malik Verlag, 1929.
Book jacket drawing.

Sinclair, Upton. *Der Sündenlohn*. 3rd rev. ed. Berlin: Malik Verlag, 1929.
Book jacket drawing.

1st ed, 1928, without Grosz drawing.

1931

Franzke, Günther. *Gesänge gegen bar. Chansons und Gedichte*. Dresden: Wolfgang Jess Verlag, 1921.
Cover drawing and 12 drawings.

La Rochelle, Pierre Drieu. *Music Hall*. Paris: Gallimard, 1931.
25 original lithographs.
Limited edition: 10 hand-colored copies; 25 special copies; 300 regular.

This information is taken from advance publicity for the book which is in the George Grosz Estate. I have not seen the book; neither has Lang.

1932

Brecht, Bertolt. *Die drei Soldaten. Ein Kinderbuch*. Versuche 14. Berlin: Gustav Kiepenheuer Verlag, 1932.
25 drawings.

Reprinted:

Berlin and Frankfurt am Main: Suhrkamp Verlag, 1959.

Berlin, DDR: Aufbau Verlag, 1963.

Berlin: Pirated edition, 1970.

Fallada, Hans [Rudolf Ditzen]. *Kleiner Mann — was nun?* Roman. Berlin: Rowohlt Verlag, 1932.

Cover drawing.

Frank, Leonhard. *Von drei Millionen Drei.* Berlin: S. Fischer Verlag, 1932.

Colored book jacket drawing.

Milburn, George. *Die Stadt Oklahoma.* Translated by Hermynia zur Mühlen. Berlin: Rowohlt Verlag, 1932.

Cover drawing, front and back.

The German edition contains eight chapters which were not published in the original American edition, *Oklahoma Town.* New York: Harcourt, Brace & Co., 1931.

Pons, Peter. *Der grosse Zeitvertreib. Gedichte.* Potsdam: Müller and I. Kiepenheuer Verlag, 1932.

Book jacket, 13 small, and 19 full-page drawings.

1934

Ehrenburg, Ilya. *Bürgerkrieg in Österreich.* Schriftenreihe der "Neue deutschen Blätter," vol. 1. Prague: Malik Verlag, 1934.

21 watercolors.

1500 copies, each signed by Grosz.

1935

Henry, O. [William Sydney Porter]. *The Voice of the City and Other Stories.* Introduction by Clifton Fadiman. New York: Limited Editions Club, 1935.

Book jacket drawing (Malik, 271; Lang, 67).

1941

Hecht, Ben. *The Bewitched Tailor.* New York: Viking Press, 1941.

1 drawing.

850 copies, each signed by Grosz and Hecht.

This 8-page pamphlet featured a story from *1001 Afternoons in New York* and preceded the publication of that book.

———. *1001 Afternoons in New York.* New York: Viking Press, 1941.

86 illustrations.

1944

Baron, Sydney S. *One Whirl.* Introduction by Mortimer Hays. New York: Lowell Publishing Company, 1944.

27 illustrations.

The drawings, caricatures of soldiers, generals, heads of government in the mid-1940s, illustrate a story about the ludicrous attempts of the Western Powers to make a peace of appeasement with Hitler and Mussolini.

Dante. *The Divine Comedy*. Modern Library. New York: Random House, 1944. 32 drawings.

Herzfelde says that Grosz accepted this commission for financial reasons.

Mehring, Walter. *No Road Back: Poems*. Translated by S. A. De Witt. New York: Samuel Curl, Inc., 1944. Frontispiece and 1 drawing (from *Interregnum*, pl. 4, p. 63).

1946

Becher, Ulrich. *Reise zum blauen Tag. Verse*. St. Gallen: Verlag Buchdruckerei Volkstimme, 1946. 1 drawing.

1947

Kesten, Hermann. *Happy Man*. Translated by Edward Crankshaw. New York: A. A. Wyn, Inc., 1947. 17 illustrations.
German edition: Potsdam: G. Kiepenheuer, 1932, *Glueckliche Menschen*, with no illustrations.

1955

Miller, Henry. *Plexus. Roman*. Hamburg: Rowohlt Verlag, 1955. Book jacket watercolor.

1956

Wendt, Ingeborg. *Notopfer Berlin. Ein Familien-Roman aus unseren Tagen*. Hamburg: Rowohlt Verlag, 1956. Book jacket watercolor.

Grosz's drawings have appeared in many books other than those which he specifically illustrated. The drawings have been reproduced for ideological reasons in, for example:

Krieg dem Kriege. Leipzig: Die Wölfe Verlag, n.d., p. 40.

A left-wing, probably communist, statement against war, which results from a capitalistic and imperialistic society, containing anti-war poems, photographs of dead men in trenches, and caricatures of capitalistic warmongers. In this last category is a drawing by Grosz from *Das Gesicht der herrschenden Klasse*, p. 26, showing a crippled soldier standing before three rich men in a restaurant. The caption is "Der Dank des Kapitalisten," and underneath, "Die Kerle wollen doch bloss nicht arbeiten." The book probably dates from the mid-twenties.

Ein Kampf um Deutschland. Berlin: Gesamtverband deutscher anti-kommunistischer Vereinigungen, 1933.

This Nazi book printed Grosz's "Christ With a Gas Mask" to reveal the blasphemous horrors of bolshevism.

Other books utilized drawings by Grosz as illustrations of the period. For example:

Moreck, Curt. *Führer durch das 'lasterhafte' Berlin*. Leipzig: Verlag moderner Stadtführer, n.d., p. 119.

This guide to the night life and underworld in Berlin in the mid-1920s used one of Grosz's drawings of a nightclub, "Barbetrieb."

Many journals have reproduced Grosz drawings as examples of the work of a leading German artist. For example:

"Vier Zeichnungen zu Carl Sternheims 'Fossil,'" *Störtebeker*, no. 5 (1924), pp. 101, 105, 109, 113.

Original lithographs of Grosz drawings were occasionally included in portfolios featuring several artists. For example:

Neue europaeische Graphik. Bauhaus Drucke. Portfolio 5. Weimar: Bauhaus, 1921.
1 lithograph by Grosz.

The American Scene, No. 1: A Comment upon American Life by America's Leading Artists. Contemporary Print Group, 1935.
1 lithograph: "The Hero."

Vier Zeilen. Herrenspende des Vereins Berliner Presse. Presse Ball, 1928.
A Grosz drawing of a jazz band player was matted and framed in a cardboard folder which accomaied the program of the Press Ball.
300 numbered copies.

Since Grosz's death in 1959, his drawings have appeared on book covers and as illustrations in a large number of books.

E. GROSZ: EXHIBITION CATALOGUES

1920

"George Grosz." *Der Ararat*, Erstes Sonderheft. Katalog der 59. Ausstellung der Galerie Neue Kunst-Hans Goltz. April–May, 1920. Munich: Goltz Verlag.
5 text illustrations and 8 plates.

This special issue of the journal *Der Ararat* was the catalogue for Grosz's first major one-man show with Hans Goltz. It contained the following articles:
Zahn, Leo. "George Grosz," pp. 1–2.
Wolfradt, Willi. "George Grosz," pp. 3–5, reprinted from *Cicerone*, no. 23 (1919).
Zahn, Leo. "Über den Infantilismus in der neuen Kunst," pp. 5–7, reprinted from *Das Kunstblatt* 4, no. 3 (March 1920).

Katalog der Ersten Internationalen Dada-Messe. July–August, 1920. Kunsthandlung Dr. Otto Burchard, Berlin.

Grosz, Heartfield, and Hausmann arranged the catalogue and the exhibition. Upside down on the front page of the catalogue was printed the following statement from Hausmann: "Der dadaistische Mensch ist der radikale Gegner der Ausbeutung, der Sinn der ausBeutung schafft nur Dumme und der dadaistische Mensch hasst die dummheit und lieBt den Unsinn! Also zeigt sich der daDaistische Mensch als wahRhaft real gegenüber der stinkenden Verlogenheit des in seinem Lehnstuhl verreckenden Familienvaters und Kapitalisten." (Irregular capitalization in the original.)

1921

George Grosz and Junge Niederländische Kunst. XL Sonder-Ausstellung. 20 February–13 March, 1921. Kestner-Gesellschaft E.V., Hanover.
Exhibit of Grosz's oils, watercolors, drawings, and lithographs.

1922

George Grosz. XV Ausstellung. April, 1922. Galerie von Garvens, Hanover.
List of the paintings, montages, watercolors, and drawings in the exhibit.
Brief statement by Grosz: "Der Mensch ist nicht gut."

1923

George Grosz. Katalog der Ausstellung. Eingeleitet durch zwei Beiträge von ihm selbst. Kunsthandlung Würthle, Vienna, and Galerie Flechtheim, Berlin.

8 drawings and lithographs exhibited.

Statements by George Grosz:

"Statt einer Biographie," reprinted from *Der Gegner* 2, no. 3 (1920–21): 68–70.

"Abwicklung," printed in *Das Kunstblatt* 8, no. 2 (February 1924):32–38.

The catalogue is not dated, but the exhibit was apparently held in 1923.

1924

George Grosz. Exposition. November, 1924. Galerie Joseph Billiet and Co., Paris. Preface by Pierre MacOrlan.

2 illustrations.

Zeichnungen und Lithographie von George Grosz. Lager Katalog No. 15. April, 1924. Hans Goltz, Munich.

List of 103 drawings, paintings, and montages.

List of portfolios and books of George Grosz.

List of books about George Grosz.

8 pages of small reproductions of drawings.

Since this is a sale catalogue, the current price of each work is listed.

1926

George Grosz Ausstellung. 29 March–24 April 1926. Galerie Alfred Flechtheim, Berlin. Veröffentlichungen des Kunst-Archivs, No. 1. Berlin: Kunstarchiv Verlag GmbH.

12 drawings.

Brief bibliography.

Statements on Grosz:

Einstein, Carl. "George Grosz," pp. 3–7.

Benn, Gottfried. "Nachtcafé, 1912," für George Grosz, p. 9.

Neven, Marc. "Das Phänomen George Grosz," pp. 10–18, reprinted from *Kölnische Zeitung,* January 3, 1926.

Herrmann-Neisse, Max. "Ecce Homo," pp. 19–21, reprinted from *Querschnitt.*

Fels, Florent. "En Georges Grosz, l'Allemagne trouve son Daumier," pp. 22–24.

George Grosz Ausstellung. 3–21 January 1926. Kunsthandlung S. Salz, Cologne.

2-page folder with brief statement by Paul Westheim.

George Grosz. December, 1926. Kunst Kammer, Martin Wasservogel, Berlin.

11 illustrations.

List of 96 drawings, paintings, and lithographs.

Introduction by Carl Einstein, "George Grosz," pp. 1–9.

1927

Ausstellung von Ölgemälden von George Grosz und Kongo-Skulpturen. 7–26 February 1927. Galerie Alfred Flechtheim, Berlin.

List of 25 paintings.

1931

George Grosz: Neue Werke. 4–22 October. Galerie Alfred Flechtheim, Berlin.

Invitation to the opening lists 13 major museums in Europe and America which currently possessed Grosz works.

1946

George Grosz: "A Piece of My World in a World Without Peace, 1914–1946." 7–26 October 1946. Associated American Artists Galleries, New York.

List of drawings, lithographs, and watercolors.

Bibliography.

Statements:

 Hecht, Ben. "George Grosz."

 Herzfelde, Wieland. "The Man Who Gave Me New Eyes."

 Grosz. "A Piece of My World in a World Without Peace."

1962

George Grosz, 1893–1959. Ausstellung. 7 October–30 December 1962. Akademie der Künste, Berlin.

60 plates.

Catalogue of 308 items.

Biographical chronology and bibliography.

Introductory statements by Erwin Piscator, Walter Mehring, and Friedrich Ahlers-Hestermann.

This was the first major post-war exhibit of Grosz in Germany. The catalogue is a meticulous scholarly compilation. A smaller group of Grosz works were chosen from this exhibit and were exhibited in England and America. The catalogues of these exhibits utilized the material collected by the Akademie der Künste: the Arts Council Exhibitions, the Forum Gallery, Paul Kantor Gallery, and the exhibits organized by the Albertina in Vienna.

Ohne Hemmung; Gesicht und Kehrseite der Jahre 1914–1924 schonungslos enthüllt von George Grosz. 8 October 1962–17 January 1963. Galerie Meta Nierendorf, Berlin.

33 large plates; 66 small drawings.

Statement by Willi Wolfradt, "George Grosz."

The drawings reproduced in this catalogue include many unpublished variations of drawings which Grosz published.

1963

George Grosz, 1893–1959. Arts Council Exhibition, York, London, Bristol, 1963.

12 plates.

Catalogue list of 165 items.

Biographical chronology.

Statements:

 Introduction by Hans Hess.

 George Grosz. "Instead of a Biography," reprint and translation of "Statt einer Biographie."

George Grosz, 1893–1959. 24 September–12 October 1963. Forum Gallery, New York.

Brief catalogue of 91 items.

Biographical chronology.

Introduction by Hans Hess.

1964

Drawings and Watercolors by George Grosz, 1–26 June 1964. Paul Kantor Gallery. Beverly Hills, California.
Introduction by Hans Hess.

1965

George Grosz, 1893–1959. 1965. Graphische Sammlung Albertina, Vienna; Wolfgang Gurlitt Museum, Linz; Landesmuseum Joanneum, Graz.
Catalogue of 104 items.
Biographical and bibliographical data.
Statements:

 Introduction by Walter Koschatzky of the Albertina.

 Analysis of Grosz's work by Walter Kasten.

 Statement on Grosz by Erwin Piscator.

The Unknown George Grosz. 5 November–9 December 1965. B. C. Holland Gallery, Chicago, Illinois.
Exhibition of collages: 4 from 1922; remainder from 1953–58.

1966

George Grosz. Dessins et aquarelles. February, 1966. Galerie Claude Bernard, Paris.
62 works exhibited.
Introduction by Edouard Roditi.

George Grosz, 1893–1959: The New Objectivity. 17 May–30 June, 1966. Austin Arts Center of Trinity College at the Widener Gallery.
List of drawings.

George Grosz: Zeichnungen und Lithographien. 31 July–13 November 1966. Staatliche Kunstsammlungen, Kupferstich Kabinett, Dresden.
16 drawings from the German period.
Catalogue of works exhibited.
Biographical and bibliographical data.
Introduction by Wolfgang Winter.

Wieland Herzfelde rated this statement on Grosz as being closest to a real understanding of the man that had been published up to that time — July, 1967.

1968

George Grosz, 1893–1959. A Selection of Fifty Early Drawings from 1910 to 1920. 5 February–2 March 1968. Peter Deitsch Fine Arts Inc., New York.
50 drawings illustrated.

1969

George Grosz. John Heartfield. 3 July–7 September 1969. Württembergischer Kunstverein, Stuttgart.
29 drawings illustrated.
Catalogue of 90 items.
Biographical data.
Bibliographical list of articles on Grosz.

This excellent catalogue which is bound with the John Heartfield catalogue includes lengthy excerpts from statements by Grosz and from documents and articles on the Grosz trials:

Grosz: "Statt einer Biographie," pp. 7–8.

Statement from *Der Spiesser-Spiegel*, p. 11.

Excerpts from *Die Kunst ist in Gefahr*, pp. 13–19.

Trials: first, pp. 21–22.

second, pp. 23–25.

third, pp. 27–39.

1970

George Grosz. Berlin Drawings and Watercolors. March–April 1970. Peter Deitsch Fine Arts Inc., New York.

61 drawings illustrated.

Preface by Eila Kokkinen.

F. BOOKS AND ARTICLES ABOUT GROSZ

1916

Däubler, Theodor. "Georg Grosz." *Die Weissen Blätter* 3, no. 11 (Oct.–Dec. 1916):167–70.

Preceded by 7 drawings by Grosz, pp. 160–66.

Lasker–Schüler, Else. "Georg Grosz" (poem). *Neue Jugend* 1, no. 8 (Aug. 1916):154.

Subsequently included in her *Die gesammelten Gedichte*, 1917.

1917

Däubler, Theodor. "George Grosz." *Das Kunstblatt* 1, no. 3 (March 1917):80, 82.

1 watercolor (*Ecce Homo*, color plate XIV).

1918

Buschbeck, Erhard. "Der Zeichner George Grosz." *Der Friede* 2 (1918–19):144.

Däubler, Theodor. "George Grosz." *1918: Neue Blätter für Kunst und Dichtung* 1 (Nov. 1918):153–54.

Issue devoted to Theodor Däubler, including an article on Däubler, selections of his poetry, his essay on Grosz, 2 of Grosz's poems, and 4 Grosz drawings.

1919

Däubler, Theodor. "George Grosz." *Das junge Deutschland* 2, no. 7 (1919):175–77.

ten Brook, Joo. "George Grosz." *Der Weg*, nos. 8–9 (1919), p. 4.

1920

Der Ararat (see p. 295).

"George Grosz im Spiegel der Kritik." *Der Ararat* 1, no. 8 (July 1920):84–86.

Three critical and negative views of Grosz's April, 1920, exhibit at Hans Goltz, Galerie Neue Kunst, Munich: R. Braungart, Otto Alfred Palitzsch, and Georg Hirschfeld.

Mehring, Walter. "George Grosz." *Blätter der deutschen Theater* 7, no. 6 (1920-21):8.

Ray, Marcel. "George Grosz." *Les Cahiers d'Aujourd'hui*, no. 1, n.s. (Nov. 1920), pp. 26-33 (3 drawings by Grosz).

Salmony, Alfred. "George Grosz." *Das Kunstblatt* 4, no. 4 (April 1920):97-104 (7 illustrations of Grosz's work).

Wrobel, Ignaz [Kurt Tucholsky]. "Der kleine Gessler und der grosse Grosz." *Freiheit*, 24 October 1920.

Reprinted in Kurt Tucholsky. *Gesammelte Werke*. Edited by Mary Gerold-Tucholsky and Fritz J. Raddatz. 3 vols. Reinbek bei Hamburg, 1960-61, 1:751-52.

1 9 2 1

Breuer, Robert. "George Grosz." *Die Weltbühne*, 10 February 1921, pp. 164-66.

"Dada vor Gericht." *Der Ararat* 2, no. 5 (1921):180-81.

Herzfelde, Wieland. "Die beleidigte Reichswehr." *Der Gegner* 2, no. 7 (1920-21):271-73.

Neumann, I. B. *Bilderheft Nr. 4*. Berlin: Verlag Graphisches Kabinett, 1921 (8 drawings by Grosz).

Pinthus, Kurt. "So sieht du aus!" *Das Tagebuch*, 19 November 1921, pp. 1405-8.

Simons, Hi, intro. *George Grosz. Twelve Reproductions From his Original Lithographs.* Chicago: Musterbookhouse, 1921.

The reproductions, all from the *Kleine Grosz Mappe*, are introduced by a ten-page analysis of Grosz and his drawings. The copy of the book in the George Grosz Estate has this inscription from the author: "To George Grosz/ with salutations from a friend and comrade and admirer—Hi Simons. Chicago, Illinois, U.S.A., 18 December 1921."

Wolfradt, Willi. *George Grosz*. Junge Kunst, vol. 21. Leipzig: Klinkhardt and Biermann Verlag, 1921.

This important monograph contained an excellent analysis of Grosz by Wolfradt, a colored title page ("Schönheit, dich will ich preisen," *Ecce Homo*, Color plate III), 32 plates of drawings, and a statement, "Selbstbekenntnis," by George Grosz. Wolfradt's essay was included in two other Klinkhardt and Biermann publications: "George Grosz," *Jahrbuch der Jungen Kunst* 2 (1921):97-112, illustrated by 12 drawings and 1 original lithograph, "Thomas Rowlandson zum Andenken"; and "George Grosz," *Der Cicerone* 13, no. 4 (Feb. 1921):103-118.

Wrobel, Ignaz [Kurt Tucholsky]. "Dada-Prozess." *Die Weltbühne*, 28 April 1921, p. 454 (reprinted in *Gesammelte Werke*, 1:800-804).

——. "Fratzen von Grosz." *Die Weltbühne*, 18 August 1921, p. 184 (reprinted in *Gesammelte Werke*, 1:815-17).

1 9 2 2

Grossmann, Stefan. "George Grosz." *Das Tagebuch*, 25 November 1922, pp. 1652-53.

Kitt. "Tysklands mest moderne Maler." *Verdens Gang* (Kristiania, Norway), 8 July 1922, p. 2.

Mochmann, Paul. "Das gezeichnete Pamphlet." *Die Glocke*, 6 March 1922, pp. 1380-85.

Mynona [Salomo Friedländer]. *George Grosz*. Künstler der Gegenwart, vol. 3. Dresden: Rudolf Kaemmerer Verlag, 1922.

66-page text with 37 drawings.

Mynona examines Grosz's drawings and statements of purpose in the light of Kantian imperatives, concluding that Grosz must go beyond his Marxist revolutionary principles if he is to become a truly great artist.

1923

Fels, Florent. "Georges Grosz." *Montparnasse*, n.s. 9, no. 22 (April 1923):2–3.

Hermann-Neisse, Max. "Ein Bürgerspiegel." *Die Aktion*, 29 April 1923, pp. 212–15.

———. "George Grosz." *Die neue Bücherschau*, ser. 2, 4, no. 2 (1923):67–70 (1 drawing).

———. "Revolutionärer Anschauungsunterricht." *Die Aktion*, 15 July 1923, pp. 353–54.

———. "Der Schlag in den Bürgerspiegel." *Die Aktion*, 15 June 1923, pp. 286–90.

Loutre, Camille. "Militaires, bourgeois, profiteurs, et gens de peu vus par un dessinateur allemand." *L'Europe Nouvelle* 6, no. 41 (Oct. 13, 1923):1301–5 (issue devoted to "Le visage de l'Allemagne"; article included 17 drawings).

Niehaus, Kaspar. "Graphisch Werk Door George Grosz." *De Telegraaf*, 13 October 1923, p. 9.

Reimann, Hans. "Monumenta Germaniae: 4. George Grosz." *Das Tagebuch*, 4 August 1923, pp. 1114–17.

Sadoul, Jacques. "Un peintre de la lutte de classe: Georges Gross."

A short article from a French communist newspaper, this is a loose clipping from the George Grosz Estate files, with no date or journal heading. The internal evidence suggests the date 1923.

Westheim, Paul. "Der Zeicher George Grosz." *Für und Wider. Kritische Anmerkungen zur Kunst der Gegenwart*. Potsdam: Gustav Kiepenheuer Verlag, 1923, pp. 159–71.

In this collection of essays on artists, Westheim included an essay on Grosz with 5 of his drawings. The same essay appeared with 5 different, excellent reproductions in *Broom: International Magazine of the Arts* (Berlin) 4, no. 3 (Feb. 1923):163–69. The essay was also printed, with the first two paragraphs shortened, in *Dichtung und Welt* (Beilage zur *Prager Presse*), 15 April 1923, and in *Die Glocke*, 14 May 1923, pp. 178–84, with 1 drawing.

1924

Arcos, René. "Chroniques: À propos d'un album. George Grosz et Frans Masereel." *Europe* (Paris), no. 23 (Nov. 15, 1924), pp. 367–70.

Bernier, Jean. "Nos Interviews: Une heure avec Georg Grosz." *L'Humanité*, 20 May 1924.

Fels, Florent. "Propos d'artistes: George Grosz." *Les Nouvelles Littéraires*, 12 April 1924, p. 5.

MacOrlan, Pierre. "Le jour — la nuit: Georg Grosz." *Paris-Journal*, 11 April 1924, p. 1.

Pansa, Raimondo Collino. "Nello studio di Giorgio Grosz." *Il Secolo*, 5 March 1924, p. 3.

Scheffler, Karl. "George Grosz." *Kunst und Künstler* 22 (1924):182–86.

Tavolato, Italo. *Georg Grosz*. Rome: Éditions de 'Valori Plastici,' 1924.

9 pages of French text.

32 plates of drawings.

Also printed in English and Italian texts.

"Unterhaltung zwischen Ohnesorge und George Grosz. Ein stenographisches Protokoll." *Das Tagebuch*, 23 February 1924, pp. 240–48 (trial notes from the *Ecce Homo* trial before the Landgerichtsdirektor Ohnesorge).

Welblund, Aage. "Samfundsreyseren George Grosz." *Social Demokraten*, 5 December 1924.

Wolfradt, Willi. "Die Kunst: *Ecce Homo*." *Der Feuerreiter: Blätter für Dichtung und Kritik* 3, no. 1 (April–May 1924):35–37.

1 9 2 5

Fels, Florent. "George Grosz." *Propos d'Artistes.* Paris: La Renaissance du livre, 1925, pp. 75–84.

This study of modern artists contains an introduction to Grosz followed by a statement by Grosz taken from *Die Kunst ist in Gefahr.*

Panter, Peter [Kurt Tucholsky]. "George Grosz in Paris." *Dame,* no. 18 (May 1925), p. 5.

Westheim, Paul, ed. *Künstlerbekenntnisse: Briefe, Tagebuchblätter, Betrachtungen heutiger Künstler.* Berlin: Im Propyläen-Verlag [1925], pp. 304–8.

Included 6 Grosz poems: "Gedichte," "Gesang an die Welt," "Kaffehaus," "New York," "Gesang der Goldgräber," "Aus den Gesängen," and 1 drawing on an inserted page, "Verlobung unterm Weihnachtsbaum."

Wrobel, Ignaz [Kurt Tucholsky]. "George Grosz als Schriftsteller." *Die Weltbühne,* 13 October 1925, p. 583.

1 9 2 6

Bazalgette, Léon. *George Grosz: l'homme et l'oeuvre.* Paris: Les Écrivains Réunis [1926].

10 pages of text.

27 plates of drawings.

Cürlis, Dr. Hans. *Schaffende Hände: die Maler.* Veröffentlichungen des Kunst-archivs, no. 24. Berlin: Werkkunst Verlag [1926].

Through film clips, photographs, and written analysis, this book tried to capture the tech-niques of drawing used by various artists. A section was devoted to analyzing George Grosz's drawing method.

Scheffler, Karl. "Der Künstler als Journalist: George Grosz." *Kunst und Künstler* 24 (1926):354–59.

6 drawings.

1 9 2 7

"George Grosz." *Kunst und Künstler,* no. 25 (1927), p. 267.

Goll, Ivan. "George Grosz." "900," *Cahiers d'Italie et d'Europe,* no. 4 (Summer 1927), pp. 125–35.

6 drawings.

Reprinted in *Living Age,* no. 333 (April 1928), pp. 635–38.

Harden, Maximilian. "Drei Fragen." *Die Literarische Welt,* 7 January 1927, pp. 1–2.

Kampf, Arthur. "Tiermaske und Charakter: Impressionen des Karikaturisten zur Uraufführung des 'Weber' Filmes." *Berliner Stadtblatt,* 15 May 1927, n.p.

4 animal drawings by Grosz caricaturing figures in the Hauptmann film.

Landau, Rom. "George Grosz." *Arts* 12, no. 6 (Dec. 1927):295–304 (illustrated).

Mehring, Walter. "Porträt George Grosz." *Das Tagebuch,* 12 February 1927, pp. 276–77.

Ray, Marcel. *George Grosz.* Peintres et Sculpteurs. Paris: Les Éditions G. Crès et Cie [1927].

70 pages of text.

40 plates.

René-Jean. "Le dessinateur George Grosz." *Comoedia,* 22 September 1927.

Tavolato, Italo. "George Grosz." *Amauta* (Lima) 1 (March 1927):21–23.

1928

A.B. "Un grand dessinateur populaire: Georges Grosz." *Les Hommes du Jour* (Nov. 1928), pp. 8–9.

Einstein, Carl. "George Grosz." *Die Kunst des 20. Jahrhunderts*, 2nd ed. Propyläen-Kunstgeschichte, vol. 16. Berlin: Propyläen Verlag, 1928, pp. 162–67.

 6 pages of text.

 13 plates.

"George Grosz erhält einen Akademiepreis." *Berliner Tageblatt*, 26 May 1928.

"George Grosz wird vernommen. Aus dem stenographischen Protokoll des Gotteslästerungsprozesses." *Das Tagebuch*, 22 December 1928, pp. 2210–15.

 Stenographic account of the first blasphemy trial before Landgerichtsdirektor Toelke. The protocol covers only the questioning of Grosz.

Knauf, Erich. "In der Feuerlinie: George Grosz." *Empörung und Gestaltung. Künstler-profile von Daumier bis Kollwitz*. Berlin: Büchergilde Gutenberg, 1928, pp. 175–84.

 2 drawings.

Mehring, Walter. "Gott contra Grosz." *Das Tagebuch*, 14 April 1928, pp. 621–23.

1929

Apfel, Alfred. "Rechtspolitische Gedanken zum Prozess George Grosz." *Das Kunstblatt* 13, no. 2 (Feb. 1929):61.

Avermaete, Roger. *George Grosz*. Paris: Arts et Metiers Graphiques, 1929.

Breuer, Robert. "George Grosz." *Deutsche Republik*, 28 March 1929, pp. 816–17.

Däubler, Theodor. "George Grosz." *Das Kunstblatt* 13, no. 6 (June 1929):161–65.

 4 drawings in text.

Glaser, Curt. "George Grosz stellt aus." *Bilder-Courier* (Börsen Courier), 31 March 1929, n.p.

Goll, Ivan. "Pittori Europei: George Grosz." *Oggi e Domani*, 8 December 1930, p. 5.

Niehaus, Kasper. "Duitsche Groep de 'Nieuwe Zakelijkheid.'" *De Telegraf*, 18 May 1929, p. 9.

Scheffler, Karl. "George Grosz: Ausstellung von Zeichnungen und Aquarellen im Verlag Bruno Cassirer." *Kunst und Künstler* 27 (1929):269–72.

Schmidt, P. F. "Georg Grosz." *Wiadomoschi Literackie* (Warsaw), 21 April 1929, p. 2.

 6 watercolors and a photograph of the Grosz family.

"Über die Berufsverhandlung in dem George Grosz Prozess." *Die Menschenrechte*, 20 April 1929, pp. 8–11.

"Das Urteil im George Grosz-Prozess." *Die Weltbühne*, 7 May 1929, pp. 708–713.

Wrobel, Ignaz [Kurt Tucholsky]. "Die Begründung." *Die Weltbühne*, 19 March 1929, pp. 435–38 (reprinted in *Gesammelte Werke*, 3:52–56).

1930

Bazalgette, Léon. "George Grosz." *Chroniques du Jour* 11, no. 7 (July 1930):17–19.

Fels, Florent. "Interviews im Atelier: Grosz." *Die Kunstauktion*, 10 August 1930, p. 7; 17 August 1930, p. 9.

Franke. "George Grosz im Kunstverein Heilbronn." *Neckar-Zeitung*, 31 December 1930, p. 11.

Knoertzer, Cécile. "Livres nouveaux: le dernier ouvrage de George Grosz." *La Revue Rhenane* 12 (March 1930):38–40.

"Künstler gegen die Freiheit der Kunst." *Kunst der Zeit* 1, no. 9 (June 1930):205–6.

Ossietzky, Carl von. "George Grosz-Prozess." *Die Weltbühne*, 4 March 1930 (reprinted in *Die Weltbühne*, 19 December 1962, pp. 1619–20).

Panter, Peter [Kurt Tucholsky]. "Auf dem Nachttische." *Die Weltbühne*, 25 March 1930, p. 466; 9 December 1930, p. 859 (reprinted in *Gesammelte Werke*, 3:392–93, 624. Reviews of *Das neue Gesicht der herrschenden Klasse* and *Über alles die Liebe.*

Schmidt, Paul F. "George Grosz." *Kunst der Zeit* 1, no. 4 (Jan. 1930):81–85.

1931

Apfel, Alfred. "Nachwort des Verteidigers." *Die Weltbühne*, 31 March 1931, p. 317.

Durus, Alfred [Alfred Kemeny]. "Künstler des Proletariats (17): George Grosz." *Eulenspiegel* 4, no. 7 (July 1931):111.

"Der gelästerte Christus: Zweites Siegert-Urteil im Prozess George Grosz." *Die Weltbühne*, 31 March 1931, pp. 311–16.

Hofmann, Herbert. "Auseinandersetzung mit George Grosz." *Deutsche Kunst und Dekoration* 67 (March 1931):364, 368.

Kein, Walter. "A German Caricaturist." *Nation*, 11 February 1931, p. 158.

Koprive (Zabreb), 16 May 1931, cover. Cartoon on cover of child at an exhibit of German art looking at Grosz's painting of Max Herrmann-Neisse.

Rothe, Hans. "Die Liebe mit der Gasmaske." *Die Literarische Welt*, 13 February 1931, pp. 5–6.

Schreiner, Helmuth. "Die Hintergrunde des Grosz-Prozesses." *Zeitwende* 7, no. 1 (1931):193–206.

1932

H. C. "George Grosz." *La Métropole* (Anvers), 1 May 1932, n.p.

Heiberg, Edvard, ed. *George Grosz.* Social Kunst, no. 9. Copenhagen and Oslo: Mondes Forlag, 1932. 2-page introduction on Grosz.

"Un satirique allemand: George Grosz." *Le Rouge et le Noir* (Brussels), 27 April 1932, p. 3. 4 drawings.

Tiljak, Duro. "George Grosz." *Književnik, Hrvatski Književni Mjesečnik* (Zagreb) 5, no. 5 (May 1932):161–64. 4 drawings.

Torres, Domingo López. "Arte Social: George Grosz." *Gaera de arte* (Feb. 1932), p. 2.

1933

Benson, Emanuel M. "George Grosz, Social Satirist." *Creative Art* 12, no. 5 (May 1933):340–47. 10 illustrations. Brief bibliography.

1934

Craven, Thomas. "George Grosz." In *Modern Art: the Men, the Movements, the Meaning*. New York: Simon and Schuster, 1934, pp. 204–217.

1936

Cowley, Malcolm. "A Hymn of Hate. Review of *Interregnum*, by Grosz." *The New Republic*, 23 December 1936, pp. 449–50.

Salpeter, Harry. "Caricature According to Grosz: the Leer of Bitter Faces from Across the Sea." *Ringmaster, the World in Caricature* 1, no. 2 (July–Aug. 1936): 43–45.

1938

Linfert, Carl. "Rückblick auf 'entartete Kunst.'" *Frankfurter Zeitung*, 14 November 1938, p. 4.

1941

Brown, Milton. "Death of an Artist." *Parnassus* 13 (May 1941):194.

Coates, Robert M. "George Grosz, Past and Present." *The New Yorker*, 25 October 1941, pp. 62–64.

1942

"George Grosz." *Current Biography* 3, no. 4 (April 1942):19–21.

1943

Boyer, Richard O. "Profiles, Artist: 1. Demons in the Suburbs." *The New Yorker*, 27 November 1943, pp. 32–43.

———. "Profiles, Artist: 2. The Saddest Man in All the World." *The New Yorker*, 4 December 1943, pp. 39–48.

———. "Profiles, Artist: 3. The Yankee from Berlin." *The New Yorker*, 11 December 1943, pp. 37–44.

Herzfelde, Wieland. "The Curious Merchant from Holland." *Harper's Magazine* 187 (Nov. 1943):569–76.

Reprinted in Herzfelde. *Unterwegs. Blätter aus fünfzig Jahren*. Berlin: Aufbau Verlag, 1961, pp. 114–32.

1945

Herzfelde, Wieland. "George Grosz — einst und heute." *Austro-American Tribune* 3, no. 7 (Feb. 1945):9–10.

Veth, Cornelis. "De Satire in het Hedendaagsche Duitschland." *Maandblad voor Beeldende Kunsten* 10, no. 6 (June 1933):162–73.

Wessel, Wilhelm. "Albrecht Dürer — George Grosz? Natürliches und Artfremdes in der Malerei." *Die HJ*, 16 November 1933, p. 4.

Grosz wrote on the copy in the Estate: "Jan. 1940: gave up social caricature entirely — devote my time to serious painting! Should read: from social satirist to painting! George Grosz."

7 drawings.

1946

Mollino, Carlo. *36 disegni di George Grosz.* Turin: Orma, 1945.
30 loose plates in portfolio.
6-page introduction by Mollino.
Limited edition of 500 copies.
Reproductions, most of which are from *Ecce Homo* and *Spiesser-Spiegel.*

Schniewind, Carl O. "Review of *George Grosz Drawings.*" *Magazine of Art* 38 (April 1945):154–56.

1946

Ballo, Ferdinando, ed. *Grosz.* Milan: Documenti d'Arte Contemporanea, 1946.
5 color plates, taken from *Ecce Homo.*
58 drawings from *Ecce Homo, Das Gesicht der herrschenden Klasse, Spiesser-Spiegel,* and *Abrechnung folgt!*
Introduction by Gillo Dorfles.
Excerpts from *Die Kunst ist in Gefahr.*
Essays by:

Bulliet, C. J., from *The Significant Moderns and Their Pictures.* New York, 1936.

Dos Passos, John, from *L'Italiano* and from *Esquire* (Sept. 1936).

Galtier-Boissière, Jean, and Zimmer, Bernard, from "Berlin, 1930," *Le Crapouillot,* special number: "Les Allemands."

Landau, Rom, from *Der unbestechliche Minos: Kritik an der Zeitkunst.* Hamburg, 1925.

Ray, Marcel, from *George Grosz,* 1927.

Schiff, Fritz, from *La peinture de l'Allemagne inquiète.*

Serouya, Henri, from *Initiation à la peinture d'aujourd'hui,* 1931.

Tavolato, Italo, from *George Grosz,* 1924.

Waldmann, Emile, from *La peinture allemande contemporaine,* 1920.

Wolfradt, Willi, from *Jahrbuch der Jungen Kunst,* 1921.

Klingender, Frances D. "Grosz Goes West." *Contact* (London).
Proofs of the article before it was cut for publication are in the George Grosz Estate with a letter to Grosz from Klingender dated 29 December 1946.

Petermann, Erwin. "Das war verfemte Kunst: IV. George Grosz." *Aussaat* 1, no. 3 (1946):20–24.
10 drawings.

1947

Janson, H. W. "Satirist's Dilemma. Review of *A Little Yes and A Big No,* by Grosz." *Saturday Review,* 11 January 1947, pp. 20–21.

Rewald, John. "Review of *A Little Yes and A Big No,* by Grosz." *Magazine of Art* 40 (Feb. 1947):81–82.

1948

Hofbauer, Imre, ed. *George Grosz.* Introduction by John Dos Passos. London: Nicholson and Watson, 1948.
82 plates, most of them from the German period.

1949

Grafly, Dorothy. "George Grosz: Painter and Prophet." *American Artist* 13, no. 3 (March 1949):20–25, 64–65.

Schlichter, Rudolf. "George Grosz." *Die Kunst und Das Schöne Heim* 47, no. 6 (Sept. 6, 1949):221–22. 2 illustrations.

1950

Herzfelde, Wieland. "Isst George Grosz wirklich von goldenen Tellern?" *Aufbau* 6, no. 1 (1950):86–88.

This defense of Grosz was an answer to the charges against him in *Neues Deutschland* and *Neue Zeitung* (see p. 282).

1953

Ashton, Dore. "An Interview with George Grosz." *Pen and Brush* 1, no. 55 (March 1953):8–9, 12–14.

1954

Baur, John I. H. *George Grosz*. New York: Macmillan Company for the Whitney Museum of American Art, 1954.

59-page text.

Chronology.

Selected bibliography.

39 illustrations.

Biographical and stylistic analysis of Grosz and his work, with heavy emphasis upon his American period.

Bradley, Joseph Crane. "George Grosz: a Study of His Life, Art, and Philosophy." Ph.D. dissertation, University of Wisconsin, 1954.

"Grosz: Ein grosses Nein." *Der Spiegel*, 30 June 1954, cover, pp. 26–30. 6 illustrations. Cover featured photograph of Grosz in 1954.

1955

"*Ade, Wilbo*": *George Grosz*. Introduction by Walther G. Oschilweski. Berlin-Grunewald: Arani Verlags GmbH, 1955. 65 drawings and 20 colored plates; previously unpublished work.

Good introductory analysis of Grosz's work and life.

Muschik, Johann. "Die seltsame Wandlung des George Grosz. Review of *Ein kleines Ja und ein grosses Nein*." *Tagebuch* (Vienna), 30 July 1955, p. 8. 3 drawings.

This article, which was very critical of Grosz's selling out to capitalism, brought an answering letter from Herzfelde, "Briefe an *TB*: 'Wandlung des George Grosz,'" *Tagebuch* (Vienna), 25 February 1956, p. 8. In it Herzfelde conceded that Grosz had become infected with those evils he had sought earlier to destroy.

Schumann, Werner. "Ankläger aus Zorn und Liebe." *Telegraf*, 13 November 1955.

1959

Arts 33 (March 1959):10.

News item of the awarding to Grosz of the 1959 Gold Medal for Graphic Arts.

Brendemühl, Rudolf. "Maler und 'Seelenarzt': Interview mit dem heimgekehrten George Grosz." *Berliner Leben* 8 (July 1959):9.

Huelsenbeck, Richard. "Erinnerung an George Grosz." *Neue Zürcher Zeitung*, 14 July 1959.

Reprinted in Huelsenbeck, *Phantastische Gebete* (Zurich, 1960), pp. 84–90.

Kramer, Hilton. "Editorial: the Death of George Grosz." *Arts* 33 (Sept. 1959):13.

1960

Berenson, Ruth, and Muhlen, Norbert. "George Grosz." *Der Monat* 12, no. 141 (June 1960):20–32. Illustrated.

Bittner, Herbert, ed. *George Grosz*. Introduction by Ruth Berenson and Norbert Muhlen. Essay by George Grosz. New York: Arts, Inc., 1960. German edition: Cologne: DuMont Schauberg, 1961.

18-page text.

108 black and white plates.

6 color plates.

Bibliography of Grosz's works and post-1933 articles.

Statements:

Grosz, "On my Drawings," first published in *George Grosz Drawings*, 1944.

Berenson and Muhlen, "The Two Worlds of George Grosz."

Buttig, Martin G. "Der Tod des alten Dadaisten." *Der Monat* 12, no. 142 (July 1960): 83–88.

1961

Anders, Günther. *George Grosz*. Die Kleinen Bücher der Arche. Zurich: Verlag Die Arche, 1961.

56-page text.

3 drawings.

The second part of this impressive analysis of Grosz's aim and achievement in art was also published in *Jahresring, 1960–61, Beiträge zur deutschen Literatur und Kunst der Gegenwart*. Stuttgart: Deutsche Verlags-Anstalt, pp. 313–22. 2 oils.

Baudy, Nicolas. "George Grosz à Berlin." *Preuves*, no. 126 (Aug. 1961), pp. 37–42. 3 drawings.

Richter, Hans. "George Grosz: Das Feuer." *Dada Profile*. Zurich: Verlag Die Arche, 1961, pp. 56–58.

Sauvage, Léo. "George Grosz en Amérique." *Preuves*, no. 126 (Aug. 1961), pp. 43–51. 3 drawings.

1962

Becher, Ulrich. *Der grosse Grosz und eine grosse Zeit: Rede, gehalten am 7. Oktober 1962 zur eröffnung der grossen Grosz-Ausstellung in der Akademie der Künste, West-Berlin*. Reinbek bei Hamburg: Rowohlt Verlag, 1962.

1963

Dolbin, B. F., and Haas, Willy. "George Grosz." *Gesicht einer Epoche.* Munich: A. Langen, 1962, pp. 42–44.

Westheim, Paul. "Erinnerungen an George Grosz." *Die Weltkunst 32,* no. 22 (Nov. 15, 1962):16–17.

George Grosz. Deutschland über alles. Introduction by Ulrich Becher. Plates selected by Antonio del Guercio. Rome: Editori Riuniti, 1963. 85 works from 1913 to 1936.

Becher's introduction is taken from his speech at the Akademie der Kunste in 1962.

Hoffman, Edith. "Scourge of a Tumbling World." *Apollo 77* (June 1963):486–91. 7 illustrations.

Kramer, Hilton. "The Threepenny Artist." *The Reporter,* 24 October 1963, pp. 57–60.

Melville, Robert. "Arts Council Exhibition." *The Architectural Review* (London) 134 (Sept. 1963):203–4. 3 illustrations.

Roberts, Keith. "Arts Council Exhibition." *Burlington Magazine* 105 (July 1963):339.

Roditi, Edouard. "George Grosz: An Embittered Romantic." *Arts Magazine* 37 (Sept. 1963):18–23. 8 illustrations.

1964

Dos Passos, John. "Satire as a Way of Seeing." *Occasions and Protests.* Chicago: Henry Regnery Co., 1964.

This essay was first published as "Grosz Comes to America," *Esquire* (Sept. 1936); it was also the introduction to Grosz, *Interregnum,* 1937.

Hecht, Ben. "About Grosz." *Letters from Bohemia.* Garden City, N.Y.: Doubleday and Co., Inc., 1964, pp. 133–54.

Herzfelde, Wieland. "George Grosz, John Heartfield und die Zwanziger Jahre." *Die Weltbühne,* 1 July 1964, pp. 846–49.

1965

Kusák, Alexej. *George Grosz.* Prague: Státní Nakladatelství Krásné Literatury A *Uměni,* 1965.
 40-page text.
 105 plates.
 Published also in a German edition with 27-page introduction.

1966

Herzfelde, Wieland. "John Heartfield und George Grosz: Zum 75. Geburtstag meines Bruders." *Die Weltbühne,* 15 June 1966, pp. 745–49.

Lang, Lothar, ed. *George Grosz.* Welt der Kunst. Berlin: Henschelverlag, 1966.
 7 color plates.
 9 black and white plates.
 Brief bibliography and chronology.

Grosz. "Statt einer Biographie," from *Die Kunst ist in Gefahr.*

Good introduction by Lang to the ideological nature of Grosz's art.

Sahl, Hans, ed. *George Grosz: Heimatliche Gestalten*. Frankfurt am Main: Fischer Bücherei KG., 1966.

91 drawings.

26-page text.

Brief chronology and bibliography.

1967

Brecht, Bertolt. "Vorwort zu *Trommeln in der Nacht*: 1. Gespräch mit George Grosz." *Gesammelte Werke*, vol. 17. *Schriften zum Theater*, no. 3: *Anmerkungen zu Stücken und Aufführungen, 1918–1956*. Werkausgabe Edition Suhrkamp. Berlin and Frankfurt am Main: Suhrkamp Verlag, 1967, pp. 960–62.

1968

Uschakow, Alexander. "Majakowski und Grosz—zwei Schicksale." *Sinn und Form* 20, no. 6 (1968):1460–73.

West, Richard. "George Grosz. Figures for Yvan Goll's *Methusalem*." *Bulletin of the Cleveland Museum of Art* 55, no. 4 (April 1968):90–94.

1969

Lowell, Robert. "The Muses of George Grosz." *Notebook, 1967–1968*. New York: Farrar, Straus & Giroux, 1969.

1970

Shepherd, Don. "*Ecce Homo* Revisited." *Mankind* 2, no. 6 (April 1970):52–57. 3 illustrations.

G. TYPESCRIPTS FROM THE GROSZ ESTATE

Grosz, George. "Answer to FBI Questionnaire Number II. As sent to Mr. Alfred McCormack, 15 Broadway, N.Y., no date." Covering letter dated 7 May 1955. Carbon copies.

———. Correspondence with Wieland Herzfelde. May-August, 1933. All the letters are single-spaced typewritten pages.

Herzfelde to Grosz, Prague, 23 May 1933, 4 pages.

Grosz to Herzfelde, New York City, 3 June 1933, 8 pages.

Grosz to Herzfelde, New York City, 6 June 1933, 8 pages (not mailed).

Herzfelde to Grosz, Prague, 20 July 1933, 6 pages.

Grosz to Herzfelde, New York City, 3 August 1933, 4 pages.

———. "Lebenslauf; Notizen für Prozess." 3 December 1933. Grosz's notes for the trial.

———. "Über Film; für Querschnitt." December, 1930.

———, and Westheim, Paul. "Zwiegespräch über deutsche Tradition." 11 June 1931.

Typescript of a radio dialogue which was announced as "Der Künstler als Zeitschilderer," in *Funkstunde*, 5 June 1931, p. 636.

Herzfelde, Wieland. "John Heartfield, George Grosz und die Zwanziger Jahre."
 Copy of a speech given in the late 1960s.

Schmidt, Paul F. "George Grosz," 1929.

 Analysis of Grosz as an artist by Paul Schmidt, who testified for Grosz at most of his trials.

H. MOTION PICTURE

Interregnum. Produced by Charles Carey and Altina Carey. Narrated by Lotte
 Lenya. Script by Mark Ramsay. Directed by Mort Rabinowitz. Education Com-
 munication Corporation, 1960. 28 minutes.

 This film utilizes George Grosz's drawings to portray the social, cultural, and economic
 background of Hitler's rise to power. By skillfully juxtaposing whole drawings or fragments
 from drawings with the narration by Lotte Lenya, the film traces the German scene from the
 late Empire until the Nazi take-over.

Index